DAVID SMITH

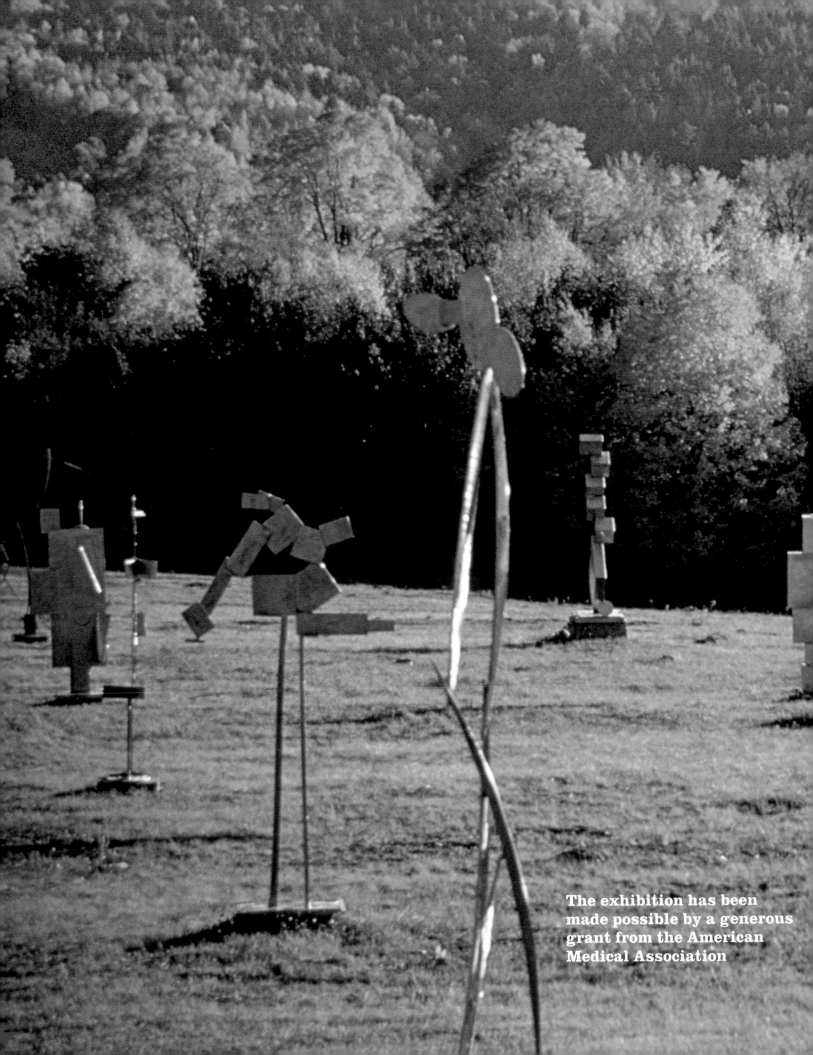

The exhibition has been made possible by a generous grant from the American Medical Association

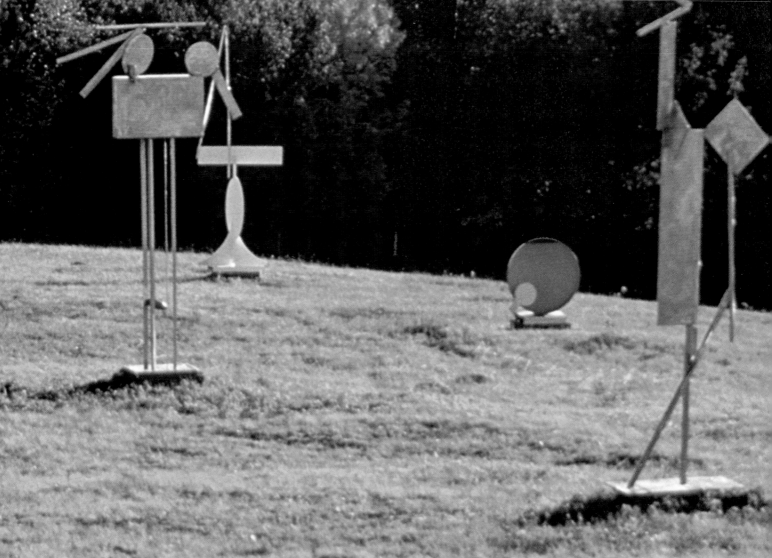

DAVID SMITH

E. A. Carmean, Jr.

National Gallery of Art, Washington

Exhibition dates November 7, 1982 - April 24, 1983.

This catalogue was produced by the Editors
Office, National Gallery of Art, Washington.

Printed by Eastern Press Inc., New Haven,
Connecticut
Typesetting by Composition Systems Inc.,
Arlington, Virginia.

Edited by Lise Metzger, Washington, D.C.

Designed by Susan Lehmann, Washington, D.C.

Library of Congress Cataloging in Publication Data

Carmean, E. A.
David Smith.

Exhibition catalog.
1. Smith, David, 1906-1965—Exhibitions.
I. Smith, David, 1906-1965. II. National Gallery
of Art (U.S.) III. Title.
NB237.S567A4 1982 730'.92'4 82-18964
ISBN 0-89468-061-7

Photo Credits

All photographs are courtesy the lender except for
the following:

Photos by David Smith or photographer unknown,
courtesy of Rebecca and Candida Smith. From the
David Smith Papers, on deposit at the Archives of
American Art, Smithsonian Institution. Plates 1,
4, 5; Introduction—11, 12a, 21, 25, 26, 31a, 31b,
32, 34; Chapter I—1, 2, 3a, 3b, 5, 6, 7, 9, 10, 11,
13, 14; Chapter II—2b, 8, 10, 12, 13a, 13b, 18,
20; Chapter III—1, 2a, 2b, 4a, 4b, 4c, 6, 8, 9a, 9b,
11, 12, 13, 14, 15, 16; Chapter IV—2a, 2b, 3, 8, 10,
12, 13, 14; Chapter V—1, 16, 18, 19, 20, 21, 22;
Chapter VI—3, 4, 11, 12, 13, 15, 16; Chapter
VII—1, 2, 3, 4, 5, 6, 7, 8a, 8b, 9a, 9b, 12, 13, 14,
15, 16, 17, 19, 20, 24, 25, 26.

Photos by Ugo Mulas, courtesy of Antonia Mulas,
Milan: Introduction—1, 12b, 22, 30, 33; Chapter
IV—1, 4, 6, 16; Chapter V—2, 3, 4, 5, 6, 8, 9, 11,
12, 13a, 13b, 14, 15, 17; Chapter VI—7, 8, 9, 10,
19, 20.

Photos courtesy of Robert Motherwell: Introduc-
tion—17, 24.

Photos by Dan Budnik, courtesy of Woodfin
Camp & Associates: Cover, frontispiece, Plates 2,
3, 6, 7, 8; Introduction: 3, 4, 16a-16h, 19a, 19b, 20,
29, 35; Chapter V—10, 23; Chapter VII—23a,
23b, 23c.

Photos courtesy of Michael Tropea: Chapter V—7;
Chapter VI—14.

Cover: North field, Bolton Landing, winter
1962-63.

Endpapers: Plan of sculpture at Bolton Landing
May, 1965.

Frontispiece: South field, Bolton Landing,
Autumn 1965.

Contents

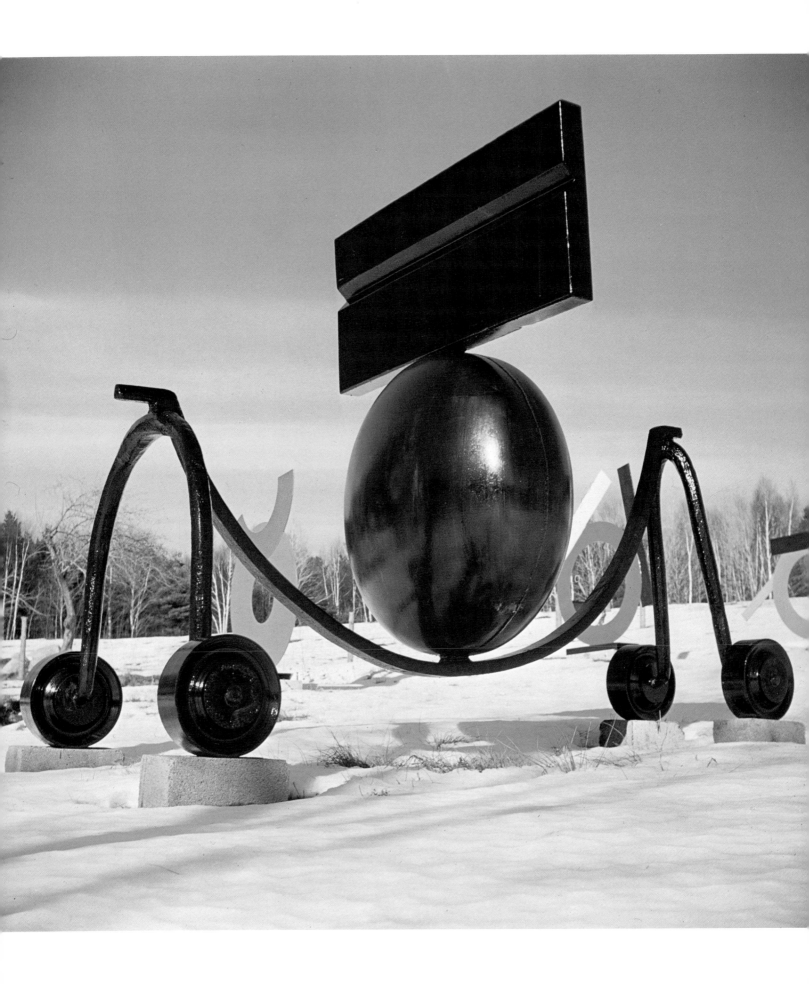

Foreword

Among the highlights at the time of the opening of the National Gallery's East Building in 1978 was the large amphitheater on the upper level devoted to the Voltri sculpture of David Smith, one of the seven artists in the exhibition *The Subjects of the Artist*. Taking full advantage of an adjustable thirty-five-foot-high ceiling and abundant natural light, this gallery was designed to suggest the ancient Roman arena in Spoleto where Smith first exhibited the Voltri series. This Smith arena proved to be so popular that it was kept after the close of *Subjects*, first because of a six-month extension of the Voltri loans, and then to accommodate the continuing exhibition of Smith's work from other series here on loan or part of the Gallery's collection.

The present exhibition, *David Smith*, is a much larger undertaking. Like the *Subjects of the Artist* project, it focuses on the idea of series in Smith's work, but here seven different groupings have been brought together. The exhibition opens with his earliest series, the Agricolas, begun in 1951, made from abandoned farm implements. These are followed by the aloof guardian figures, Sentinels, and the colorful, inventive Zigs and Circles. Smith's Voltri-Boltons, the successor series to his Italian Voltri works, and his Wagons lead to the last years of his life, crowned by the monumental Cubis, which conclude the exhibition.

Obviously our Smith arena, designed for the Voltris, could not house such a large number of works; indeed, the Voltri-Boltons, which are stylistically akin to the Voltris, fill this space. The remaining six series are installed throughout various levels in the central spaces of the East Building, also under natural light, allowing the viewer to see many more works at the same time and study the interrelationships as well as stylistic diversities within Smith's sculpture.

David Smith was organized by E. A. Carmean, Jr., curator of Twentieth-Century Art, who conceived the exhibition and selected its contents, and authored the catalogue. Trinkett Clark, assistant curator in that department, aided in all phases of the project. Lise Metzger and Susan Lehmann were of the greatest help in the production of this catalogue, as were both Composition Systems Inc. and Eastern Press. The complex installation of the works was carried out by Gaillard Ravenel and Mark Leithauser of the Gallery's Department of Installation and Design, in close cooperation with Mr. Carmean. To them, and to the other members of the National Gallery's

Plate 1. *Wagon I*, 1964.

7

staff, and to the many outside contributors who have worked to make this exhibition and publication a reality, goes our warmest appreciation.

We are most deeply indebted, however, to the lenders to *David Smith*. Although Smith is quintessentially an American artist, admiration for his work is international. We especially appreciate the museums and collectors in Ottawa, Toronto, London, Jerusalem, and Cologne for allowing their work to come to Washington. Many American museums and private collectors have given extraordinary consideration in granting us crucial loans. Above all, David Smith's two daughters, Rebecca and Candida, have supported this project from its inception and lent many key works.

Finally, *David Smith* would not have been possible without the generous support of the American Medical Association, whose commitment to this project also includes the creation of a documentary film on the artist now being made by the National Gallery.

J. Carter Brown, *Director*

Plate 2. South field, Bolton Landing, autumn 1965.

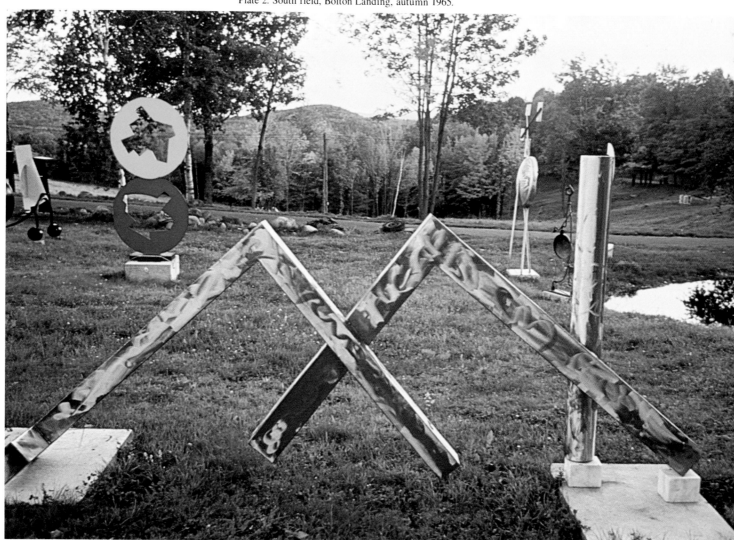

Lenders

Ms. Rena Bransten

The Chrysler Museum, Norfolk, Virginia

Dallas Museum of Fine Arts

Des Moines Art Center

The Detroit Institute of Arts

The First National Bank of Chicago

Nancy and Carl Gewirz

Miss Sarah Dora Greenberg

The Solomon R. Guggenheim Museum, New York

Hallmark Cards, Inc.

Hirshhorn Museum and Sculpture Garden, Smithsonian Institution, Washington, D.C.

Mrs. Marjorie F. Iseman

The Israel Museum, Jerusalem

Dr. and Mrs. Arthur E. Kahn

Howard and Jean Lipman

Mrs. H. Gates Lloyd

Los Angeles County Museum of Art

Dr. and Mrs. Paul Todd Makler

The Meadows Museum, Southern Methodist University, Dallas

Dr. and Mrs. George de Menil

Mr. and Mrs. David Mirvish

Mr. Frederick Morgan

Museum of Art, Carnegie Institute, Pittsburgh

Museum of Fine Arts, Boston

Museum Ludwig, Cologne

The Museum of Modern Art, New York

National Gallery of Canada, Ottawa

Philadelphia Museum of Art

Private Collectors

Sid W. Richardson Foundation

State of New York, Governor Nelson A. Rockefeller Empire State Plaza Art Collection

The Saint Louis Art Museum

Mr. and Mrs. Eugene M. Schwartz

Candida Smith

Rebecca Smith

Guido Goldman Sprinkling Trust

Storm King Art Center, Mountainville, New York

The Trustees of the Tate Gallery, London

Mrs. Norton S. Walbridge

Mrs. Anne MacDonald Walker

Walker Art Center, Minneapolis

Acknowledgments

As the Director notes in his Foreword, this exhibition of sculpture by David Smith is the successor to the National Gallery's 1978-79 show of his Voltri works as part of *American Art at Mid-Century: The Subjects of the Artist*. However, the idea for the present project actually predates the Voltri exhibition: it first occurred when I. M. Pei, the architect of the East Building, the Director and I were beginning to study in model form the various kinds of sculpture which could be installed in the large central courtyard of the new structure, then just underway in construction. We discovered that we were repeatedly positioning models of Smith's work in these areas, and decided then, in 1974, to begin planning toward this exhibition, which will fill the museum with sixty-two major works by the artist.

An exhibition, research project and publication of this scale depends upon the time and efforts of a great many people. Trinkett Clark, Assistant Curator in the Department of Twentieth-Century Art, has played a key role in this exhibition from its earliest stages, and has aided in the development and realization of all its varying aspects. Laura Coyle, also of this department, did back-up research and coordinated the manuscript.

I am also especially thankful to Lise Metzger, the editor of this catalogue, and Susan Lehmann, who designed it, for their very real devotion to this project. Composition Systems Inc., Arlington, Virginia, performed the task of setting the manuscript into type, and Eastern Press, New Haven, Connecticut, organized the catalogue's printing. Phyllis Tuchman kindly served as the reader. Together with the staff in Twentieth-Century, they have worked long hours and at an extended pace to produce the present publication.

Many members of the National Gallery staff contributed. The photography lab made many necessary prints. In the library,

Thomas McGill, Delores Stachura, and Florentina Burigan secured numerous research volumes. The registrar's staff coordinated the difficult job of transporting works of a very large scale, and the sculpture handlers performed the often arduous task of moving them into place. Gaillard Ravenal, Mark Leithauser and I have spent countless hours studying the presentation of *David Smith*, and they and their staff in the Department of Design and Installation have made this exhibition a reality.

Many of Smith's friends and scholars of his work have shared their knowledge, and were important to the project. For their assistance, I would like to thank Anthony Caro, Helen Frankenthaler, Edward Fry, Eugene Goosen, Clement Greenberg, Hilton Kramer, Rosalind Krauss, Robert Motherwell, Robert Murray, Kenneth Noland, William Rubin, Marian Ruggles, Anne Truitt, and Karen Wilkin.

Garnett McCoy, of the Archives of American Art, also deserves special mention here for assisting Miss Clark and me in our study of Smith's papers and photographs housed at that institution. Dan Budnik, who spent many hours photographing Smith at work, made numerous photographs available for this catalogue, and reviewed them and his experiences at Terminal Iron Works. Research of a different kind was made possible by sculptor James Wolfe. Early on I realized that to more fully understand Smith's art it was necessary to actually make a sculpture following his procedures. Mr. Wolfe guided my doing so, including the very difficult are of arc welding, and analyzed Smith's work from a technical point of view.

In addition to their generosity in lending the works which make this exhibition a reality, the private and institutional lenders have also provided us with information from their files, and allowed us to study the pieces in their collections.

Plate 3. *Cubi XVII*, 1965.

11

Plate 4. *Bec-Dida Day,* 1963.

This Smith study could not have taken place without the full participation by his two daughters, Candida and Rebecca. Aside from their many loans to this exhibition, they allowed us access to their father's papers, here in Washington and at Bolton Landing. Candida, Rebecca and Peter Stevens, Rebecca's husband, discussed David Smith's works at length with us, and made it possible to stay for long periods at Terminal Iron Works, in order to study Smith's studios and to walk his sculpture fields. They extended this welcome to the camera crew of Robert Pierce Films Ltd., the co-producer with the Gallery of a film now underway on David Smith and this exhibition.

Both this film and the exhibition were made possible by a generous grant from the American Medical Association. The Association's support for this project has been enthusiastic from the beginning, and they have shared with everyone else committed to *David Smith* in the anticipation of seeing so many major works by this great American artist gathered together.

E. A. Carmean, Jr.

Plate 5. *Zig VII*, 1963.

13

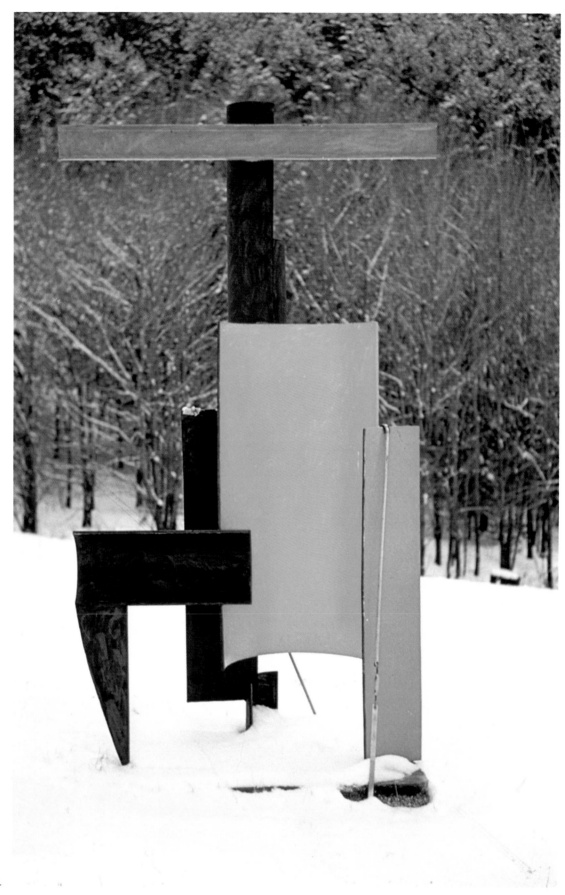

Plate 6. *Zig II*, 1961.

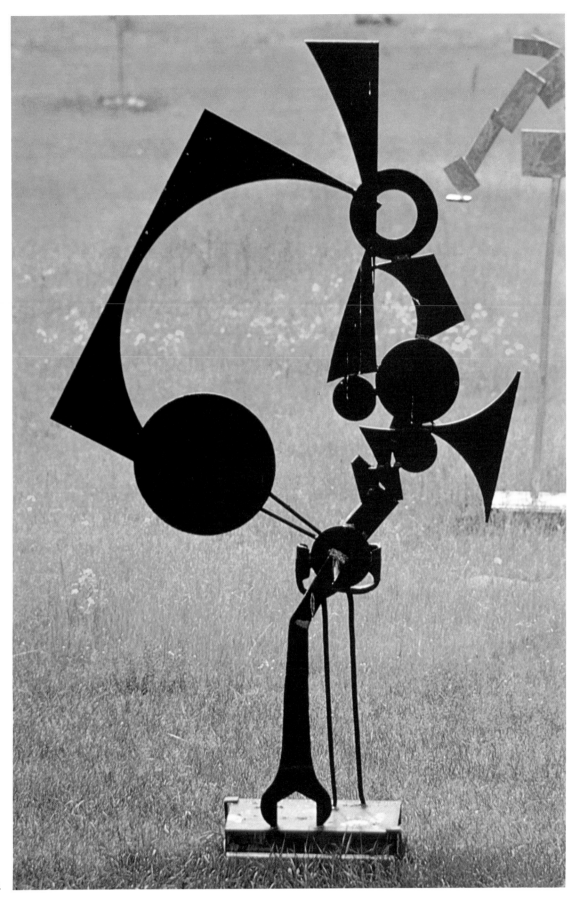

Plate 7. *Volton XVIII*, 1963.

INTRODUCTION **David Smith at Work**

David knew more about how to go about working than any other artist I've ever known personally; in this sense he was an example for us all.

Kenneth Noland[1]

Beginning in 1941, David Smith lived largely apart from New York City and its art world, choosing to reside and work in Bolton Landing, a small isolated town above Lake George in the Adirondack Mountains of upstate New York. In the early years Smith had a rudimentary house and studio, set down in the wide fields of a former fox farm, a cleared space surrounded on all sides by thick forest and mountain ranges. In the winter of 1951/52, closed in even more by the snow and cold, Smith wrote the following passage in a notebook; he is remarkably candid about his ambition and movingly open about the loneliness he was paying to achieve it:

And so this being the happiest—is disappointing, the heights come seldom—the times of true height are so rare some seemingly high spots being suspected later as illusion—such being those contacts with people wherein elation comes related to or in dependence with others—the worth of existence is doubtful but if stuck with it—seems no other way but to proceed—the future—the factory or the classroom both undesirable yet possible at present but in 20 years neither will be open—and, my cause may be no better—can I change my pursuit—not, and have even this much all of which I should be happy with—and nothing has been as great or as wonderful as I envisioned. I have confidence in my ability to create beyond what I have done, and always at the time beyond what I do—in what do I lack balance—ability to live with another person—that ability to have acquaintances—and no friends—what degrees make the difference—or am I unable to give what it takes—apparently I don't know what it is or is it illusion in middle minds—it would be nice to not be so lonesome sometimes—months pass without even the acquaintance of a mind. Acquaintances are pure waste—why do I measure my life by works—the other time seems waste —can the measured life by work be illusion—yet this standard seems farthest from illusion of any measure—and the way it stands much is lacking—and a certain body time tells that it can't be had, if it didn't come by now and so much work yet to be done—it comes too fast to get it down in solids—too little time too little money—why can't it stay as vision—for who else do I make it? Where did I miss in growing or is everybody else that way and lying to themselves with illusions—I can live till May, yet what impends—if I walk 15 miles through the mountains I'm exhausted enough to want to rest and the mind won't—enjoying nature is only occasional and

Plate 8. David Smith in south field, Bolton Landing, winter 1962-63.

17

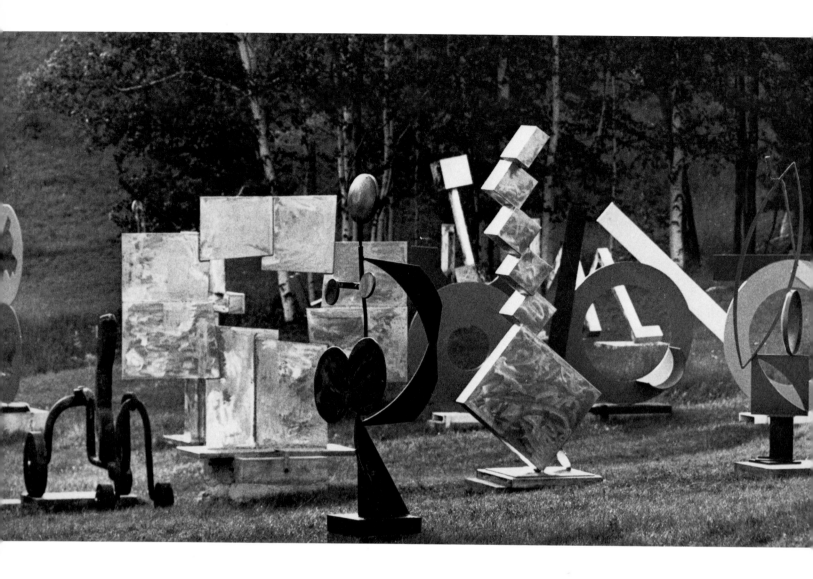

1. David Smith sculpture in the north field, Bolton Landing, 1965.

not complete enough—I hate to go to bed—to stay alive longer—I've slipped up on time—it all didn't get in—the warpage is in me—where do I find it to change—do I like it that way, am I glad it's too late—some yes some no—would financial security help—or why cannot part security till May be some appeasement.[2]

That May, of 1952, did come, and with it Smith began to work in a series, which he called the Agricolas. Although related to his earlier sculpture, the Agricolas differ from them, being larger, more freely composed, and more direct in their statement. They start Smith's mature oeuvre, embodying a sculptural richness that would grow more complex and profound as Smith's career continued. But he did not have the two decades he speculated about. Only thirteen years later, in another May, Smith died when his truck ran off the road and crashed. He didn't "get it all in." No one could have, given the scale of his ambition.

The loneliness he described remained the price to be paid for that career. Only a few friends, and above all his love for his daughters, could add any other proportion to "a life measured by work." Alone in the mountains, Smith carried on a dialogue with the history of sculpture, both its past and

its future, and I believe he felt the latter was largely in his hands. For thirteen years he endured in order to create works "as great and as wonderful" as he had envisioned that winter night. To do so he invented a method of working uniquely his own, and with it a concept of his sculpture that kept it moving and open to invention.

I do not work with a conscious and specific conviction about a piece of sculpture. It is always open to change and new association. It should be a celebration, one of surprise, not one rehearsed. The sculpture is a statement of my identity. It is part of my work stream, related to my past works, the 3 or 4 in process, and the work yet to come. In a sense it is never finished. Only the essence is stated, the key presented to the beholder for further travel.[3]

That stream of creativity was central to Smith's art and is the subject of this essay. It is followed by essays on seven series of sculpture Smith made between the early Agricolas and the Cubis, the latter still in progress when he died. It is argued here that beyond the amazing variety we find in each of the series, the concept of working in a series itself played a generative role in his sculpture, at once focusing and broadening Smith's inventive genius.

Early Years

David Roland Smith was born in 1906 in Decatur, Indiana, a small town twenty-five miles southeast of Fort Wayne, near the Ohio border. Decatur had been settled by Smith's great-great-grandfather, and a frontier spirit— along with a stern Methodist puritanism—must have been held out as examples when he was a child. The patriarch had been a blacksmith, a profession Smith identified with both in making his own metal sculpture and in his name.[4]

Smith grew up in this midwest environment during a period of change, as the machine made its appearance in the home. His father's career was a reflection of these changes; he was the manager of an independent telephone company and an inventor. "When I was a kid, everyone in town was an inventor," Smith later recalled. "There must have been fifteen makers of automobiles in Decatur. Invention was the fertile thing there."[5]

Part of that midwestern environment were the railroads and the factories. In a conversation with Thomas Hess, Smith recalls:

When I was a kid, I had a pretty profound regard for the railroads. I used to sit down on the edge of town and watch the trains go through. I used to hop trains, ride on the tops of boxcars. We used to play on trains and around factories. I played there just like I played in nature, on hills and creeks. I remember when I first sat in my father's lap and steered a car. In fact, I've always had a high regard for machinery. It's never been an alien element; it's been in my nature.[6]

Smith's teenage years, spent in Decatur and then in Pauling, Ohio, a short distance away, saw the small cities of the midwest transformed through the establishment of large metalworking factories, the industrial portion of the postwar economic boom. Smith spent the summer of 1925 working in the Studebaker factory in South Bend, where he learned the technique of welding that eventually became central to his sculpture. At the time, however, he "did it strictly for money—more than I ever made in my life," earning the funds necessary to further his career goal of becoming a painter.[7]

Smith enrolled part-time at the Art Student's League in New York in 1926 (he was then working for a bank), moving to full-time status in the fall of 1927 when he was fired from his banking assignment.[8] Smith studied under John Sloan, a pioneer of the American realist movement twenty years earlier. Smith rejected Sloan's realism, although he did give him credit for introducing him to "cones and cubes and Cézanne."[9]

Smith's real education came from his friends at the Art Student's League, principally Dorothy Dehner, a fellow student whom he married in 1927, and Jan Matulka, an instructor and former pupil of Hans Hofmann in Munich. Through them Smith came into contact with other artists, including the more established John Graham and Stuart Davis, as well as painters just beginning their careers, such as I. Rice Pereira and Adolph Gottlieb.

"In these days it was Cubist talk," Smith later wrote of his friendships in the early 1930s. "Theirs I suppose was the cubist construction. My sculpture grew from painting."[10] Indeed, it did so in a literal manner. By 1932 Smith was making collage constructions that employed various wooden elements of some thickness, applied to the flat support surface but projecting from it into bas-relief. Smith's next move was simply to lift the bas-relief portions into actual space, or as Smith described it, "the next step changed the canvas to the base of the sculpture. Then I became a sculptor who painted his images."[11] As we will see, Smith's sense of his works "growing from painting" and his identity as a painter continued to play a central role in his concept of his works and in his procedures for making them.

Smith continued making these standing constructions into the summer of 1933, combining painted wood, plaster, and wire, along with pieces of coral that he had acquired the previous year in the Virgin Islands (where he had painted freestanding pieces of coral). In addition to their cubist aspects, Smith's constructions reflect an awareness of Russian constructivist sculpture, a knowledge gained from Graham, a Russian emigrant familiar with modern art both in his homeland and in Paris. Indeed, Smith made the works in Bolton Landing, on the farm he and his wife had purchased in 1929; Graham spent his summers less than a mile away.[12]

The autumn of 1933 saw the major change in Smith's work, when he "made up some things and took them to Barney Snyder's garage—a garage in Bolton and welded them together. First iron sculptures I made." Smith accounted for this new direction by his being "prompted by seeing the works of Picasso which I have been told were created jointly with Gonzalez constructed sculptures (see 1932 *Cahier d'Art*). . . . Since I had worked in factories and made parts of automobiles and had worked on telephone lines I saw a chance to make sculpture in a tradition I was rooted in."[13]

Smith's words come from a private autobiography, written around 1950, and not published until 1968. However, they contain ideas that Smith often repeated and they have come to form the basis for our seeing his conversion. Yet exactly what Smith saw, and what he constructed at the time, remains an issue to be more fully explored.[14]

It is clear, however, that Smith's recognition of and identification with the so-called tradition of the welded sculpture of Picasso and Gonzalez (and Gargallo) was an extraordinary perception. Until the publication of their

works in various issues of *Cahier d'Art*, Picasso's and Gonzalez' sculpture formed a virtually private aesthetic, for it was unexhibited and undiscussed. Indeed, the idea of welded sculpture was so remote that when Smith showed one of his first metal sculptures, the *Agricola Head* made in Bolton Landing, to Julien Levy, a New York dealer au courant with European modernism, Levy asked, "This head is not stuck together with chewing gum, is it?"[15]

What needs to be underscored is that Smith's identification with the tradition of Picasso and Gonzalez was in fact his recognition of an implied tradition: Picasso and Gonzalez had begun their own welded works only five years before Smith made his first metal sculpture, and Gonzalez' work had not really begun to develop beyond a decorative vocabulary until 1930.[16] Indeed, not counting Picasso's cubist bas-relief constructions, the tradition consisted of only thirty-eight works before Smith began his own welding.[17] Thus when he began he "found himself face to face with the original assumptions of constructed sculpture, which had hardly been explored."[18]

Terminal Iron Works

When Smith returned to New York from Bolton Landing in the fall of 1933, he purchased a welding outfit and an air-reduction oxyacetelyne torch and began to work in his apartment studio. His welding produced sparks, shooting out from the torch, and Dehner had to follow him around with a sprinkling can to sprinkle water on the things that were catching fire.[19] Their landlord, understandably, became concerned. Smith recalled the solution:

> One Sunday afternoon we were walking on navy pier. Down below on the ferry terminal was a long rambly junky looking shack called Terminal Iron Works. Wife said, "David that's where you ought to be for your work." Next morning I walked in and was met by a big Irishman named Blackburn. "I'm an artist, I have a welding outfit. I'd like to work here." "Hell! yes—move in." With Blackburn and Buckhorn I moved in and started making sculpture there. I learned a lot from those guys and from the machinist that worked for them named Robert Henry. Played chess with him, learned a lot about lathe work from him.
>
> Between Terminal Iron Works at 1 Atlantic Ave. and George Kiernan's Saloon at 13 Atlantic Ave., I met about everyone on the water front in our area—Many who were very good friends provided me with metal—Kind of a nice "fraternity" down there. Enjoyed this. Those guys were fine—never made fun of my work—took it as a matter of course.[20]

In 1939 Buckhorn left his machine business for a government job and sold off the shop's equipment. Smith stayed on at the Brooklyn building using his own welding equipment, thus becoming himself the Terminal Iron Works. The following year electric service was finally available to the Bolton Landing farm, and in the spring Smith and Dehner left New York for the small house on their property. Smith built a studio down the driveway from the house, paying for the necessary technical equipment by taking a job as a welder in a locomotive plant in Schenectady, a position he would continue to hold during the war. The job introduced him to other welding procedures.

Smith christened the new studio Terminal Iron Works after the New York machine shop and because "it closer defines my beginning." He also used

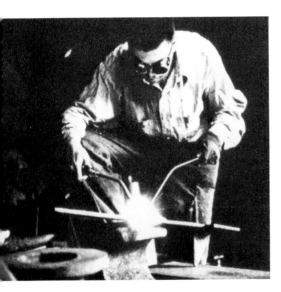

2. Smith working at Terminal Iron Works. Photographer unknown; taken from *Arts*, February 1960.

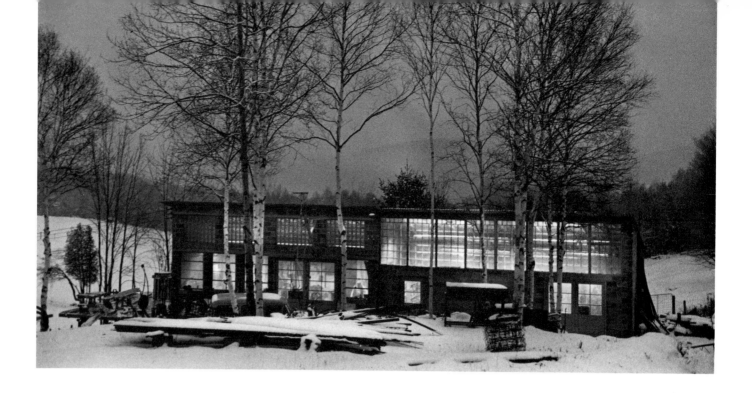

3. Smith's sculpture studio at dusk, 1962.

this name for practical reasons, "because I had already established credit through the Terminal Iron Works in Brooklyn" (which Smith had become the year before), and financial institutions were more likely to lend to a commercial venture than to the studio of a modern artist. (Smith did on occasion use the studio to repair his neighbor's farm machinery.)[21]

Smith also had another reason for using the title, namely the kind of studio he designed: "an industrial factory type . . . because *the change* in my sculpture required a factory more than an 'atelier.'"[22] Smith's studio—or shop, to use his vernacular term—was constructed like a factory workshop. As he later wrote, "The shop is a cinder block structure transite roof and full window of the north windows skylights set at a 30 degree angle. With heat in each end it is usable to zero weather."[23] Later, in 1959, another factorylike space (and, subsequently, another studio) was added to the shop. Thus, to a certain degree, the Brooklyn Terminal Iron Works was re-created in Bolton Landing.

Smith also used his house as a studio for paintings and works on paper, with "drawing tables, etching press, cabinets for work records, photos and drawing paper stock."[24] For a while, the basement of the house was used for storage of sculpture.

Smith's attitude toward his tools and supplies was equally practical and was also drawn from his experience at the Brooklyn Terminal Iron Works:

I do not resent the cost of the best material or the finest tools and equipment. Every labor saving machine, every safety device I can afford I consider necessary. Stocks of bolts, nuts, taps, dies, paints, solvents, acids, protective coatings, oils, grinding wheels, polishing discs, dry pigments, waxes, chemicals, spare machine parts, are kept stocked on steel shelving, more or less patterned after a factory stockroom.

Sheets of stainless steel, bronze, copper, aluminum are stocked in ⅛ inch by 4 foot by 8 foot sheets for fabricating. Cold and hot rolled four foot by 8 foot sheets are stacked outside the shop in thicknesses from ⅛ inch to ⅞ inch. Lengths of strips, shapes and bar stock are racked in the basement of the house or interlaced in the joists of the roof.[25]

That description was written in 1951 when Smith was working under a fellowship from the Guggenheim Foundation. The grant had given him the first opportunity to have an adequate stock of materials:

Maybe I brag a bit about my stock, but it is larger since I've been on a Guggenheim Fellowship than it ever has been before. I mention this not because it has anything to do with art, but it indicates how important it is to have material at hand, that the aesthetic vision is not limited by material need.[26]

The need for an abundant supply of materials remained constant with Smith. James Rosati recalled, "One day, David was purchasing some handmade paper and ordering what he liked by the ream. I jokingly said, 'Gee, it must be wonderful to afford paper like that!' He leaned over and said 'Hell, man, who can afford it? Making art is a luxury.'[27] When Smith was appointed by President Johnson to the National Council on the Arts (the only painter or sculptor), his recommendation for young artists was to 'give them a sum of money to complete their studies and to buy whatever they might need.'"[28]

We will discuss below how Smith used his cache of material in his work. But we should note here that after his stocking up on the Guggenheim fellowship, Smith's sculpture changed decisively, both in scale and intention, beginning with the *Agricola* series. These works employ pieces of scrap metal, another material that Smith began accumulating in some proportion around 1951. By the time of his death in 1965, the pile of "used" metal, located across the driveway from his shop, had grown enormous.

Working Hours

Just as the studio was constructed, outfitted, and stocked like a workshop, so Smith's working hours were almost factorylike. We have rare insight into his workday from three separate accounts that span his mature career. The first is Elaine de Kooning's 1951 *Art News* article, "David Smith Makes a Sculpture," which records her visit to Bolton Landing in the spring of that year. Her information was amplified by Smith's own written description of his working procedures, which he sent to de Kooning, and parts of which have already been quoted above. The second set of accounts comes from Hilton Kramer's 1960 *Arts* article on Smith, for which the artist again supplied a text, as well as annotated photographs of his studio. Finally, three years later Dan Budnik spent considerable time at Terminal Iron Works and was allowed to photograph Smith working. Budnik's account was published in 1974.[29]

Smith wrote to de Kooning:

My work day begins at 10 or 11 A.M. after a leisurely breakfast and an hour of reading. The shop is 800 ft. from the house. I carry my 2 P.M. lunch and return to the house at 7 for dinner. The work day ends from 1 to 2 A.M. with time out for coffee at 11:30. My shop here is called the Terminal Iron Works, since it closer defines my beginning and my method than to call it "studio."

At 11:30 when I have evening coffee and listen to WQXR on AM I never fail to think of the Terminal Iron Works at 1 Atlantic Ave., Brooklyn and the coffee pot nearby where I went same time, same station. The ironworks in Brooklyn was surrounded by all night activity—ships loading—barges refueling—ferries tied up at the dock. It was awake 24 hours a day, harbor activity in front, truck transports on

Furman St. behind. In contrast the mountains are quiet except for occasional animal noises. Sometimes Streevers' hounds run foxes all night and I can hear them baying as I close up shop. Rarely does a car pass at night, there is no habitation between our road and the Schroon River 4 miles cross country. I enjoy the phenomenon of nature, the sounds, the Northern lights, stars, animal calls, as I did the harbour lights, tug-boat whistles, buoy clanks, the yelling of men on barges around the T.I.W. in Brooklyn. I sit up here and dream of the city as I used to dream of the mountains when I sat on the dock in Brooklyn.

I like my solitude, black coffee and day dreams. I like the changes of nature, no two days or nights are the same. In Brooklyn what was nature was all man made and mechanical, but I like both, I like the companionship of music, I sometimes can get WNYC but always WQXR, Montreal, Vancouver or Toronto. I use the music as company in the manual labor part of sculpture of which there is much. The work flow of energy demanded by sculpture wherein mental exhaustion is accompanied by physical exhaustion, provides the only balance I've ever found, and as far as I know is the only way of life.

After 1 A.M., certain routine work has to be done, cleaning up, repairing machines, oiling, patining etc. I tune in WOR and listen to Nick's, Cafe Society, Eddie Condon's, whoever is on. After several months of good work, when I feel I deserve a reward, I go to N.Y., to concerts at YMHA, Gallery shows, museums, eat seafood, Chinese, go to Eddie's, Nick's, 6th Ave. Cafeteria, Artists Club, Cedar Tavern, run into late up artists, bum around chewing the fat, talk shop, finish up eating breakfast on 8th St. and ride it as hard and as long as I can for a few days, then back to the hills.[30]

Not that Smith worked on sculpture every day. As he noted to Kramer in 1959/60: "sometimes I draw for days and it's a balance with the labor of sculpture—to average a drawing for every day I *live* some form of identity."[31] He also painted a great many canvases, especially during the last years of his life.

By 1962, Smith's schedule had become even more conventional, perhaps due to the addition of an assistant. Budnik recounts his first visit to the shop.

It was exactly eight in the morning, the time most workers punch in at factories, and David Smith ran his sculpture studio like a steel-working shop. He was so prolific a sculptor because of this no-nonsense-all-business working atmosphere. . . . For safety, steel-toed shoes made his large feet gigantic. A cap and old vest complemented his functional garb, unmistakably, perhaps intentionally, the look of a worker. And work he did! After introducing me to his helper and long time friend from Bolton, Leon Pratt, the two of them got into the business of making, as he once said, '. . . the best damned sculpture' in America. It was like being in church, serious business, with all non-related conversation confined to coffee breaks.[32]

Procedures

Smith began his sculpture by using one or more of several steps, procedures which were distinct technically but often interrelated aesthetically and, as we will see, designed to maintain Smith's stream of invention. Certain works were first developed in a drawing or a suite of progressively articulated studies. These studies were made on separate sheets of all kinds of paper or in one of the notebooks the artist kept throughout his career. The latter also served as a loosely maintained diary, containing notes, telephone numbers, and references to orders of materials, in addition to the sketches.

4. Smith making *Primo Piano*, 1962-63.

5. Smith drawing on steel, 1961. Photographer unknown; taken from *Arts*, February 1960.

Smith's drawings vary in character. Certain sheets are closely related to finished sculpture and may actually be a record rather than a study. These close resemblances are especially true of earlier works. Other drawings only roughly suggest a sculptural image, and some of them can be less directly connected with known works. There are numerous compositions made by spraying paint onto a linen, canvas, or paper surface, parts of which had been masked off by pieces of metal, wood, and even fruit and vegetables. When these extraneous elements were removed, the remaining spray created negative images of uncovered ground. These sketches also correspond in varying degrees with known sculpture. Although Smith began making the sprays around 1958, they are more prevalent in the later years. He referred to them as "think pieces" or "starting-off points," but the sprays also played a role in the actual studio generation of the sculpture. We can see this in a Budnik photograph that documents the beginning of *Primo Piano II*. Shown behind Smith are two sprays, the upper one partially akin to the work then being made, and the lower one even closer to the already completed *Primo Piano I*. It should be noted, however, that the Primo Pianos, as well as the Circles and to some degree the Cubis, are made of basic geometric shapes in a relatively simple composition, one more suitable for study in this manner.

Smith developed a different form of preliminary drawing for other works; in these instances the sketching was done in chalk directly on the cement floor of the studio. That technique may have emerged in the early 1950s out of his practice of drawing directly onto metal plate with soapstone to outline sculpture elements that would be cut out of the plate by a torch. In a similar way, the chalk drawing on the floor served to indicate elements that would later be fabricated. Unlike a paper study, the original floor sketch was full-scale and would gradually disappear as Smith placed the fabricated elements on top of their chalk counterparts. Drawing on the floor gradually disappeared from Smith's arsenal of devices, although he used the technique as

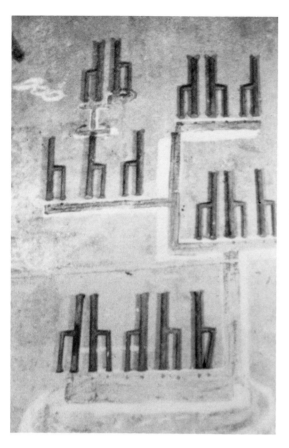

6. *17h's* in progress on studio floor, 1951. Photograph by the artist; taken from *Art News*, September 1951.

late as 1962; when asked about it he observed, "That's when I'm in trouble."[33]

Smith's earlier development of the technique was encouraged around 1950 by his increasing use of found elements: pieces of scrap metal of varying size and character. We can see how floor drawing was a part of his procedure in a photograph recording an early state of the 1951 work *17h's*. It shows the seventeen h's, actually forged elements resembling that letter, arranged on the studio floor, with a proposed structural armature—drawn in chalk—rising from a round base, which is here drawn in perspective. The photograph does not give any clue as to which step took place first, the H's or the drawing, but that is less of an issue because Smith would have readjusted the positions of the foregoing as well as revised the drawing. After reaching the final, or near-final, positions, Smith would have then fabricated the armature from different elements of stock metal.

As we have seen, Smith's work emerged partially out of the aesthetic of the cubist collage and its offspring, the constructivist relief. During the later 1930s and 1940s, that initial source was combined with a growing influence from surrealist art, culminating in tableaulike works such as *Big Rooster* and *Home of the Welder*, from 1945, which tend to describe the subject rather than evoke it.[34] Up to 1951, the surrealist aspects of Smith's work lessened (at least formally) in favor of a return to a more cubist vocabulary. Indeed, a work like *17h's*, with its fusion of found elements and drawn armature, can be directly related to the cubist collage's juxtaposition of pasted paper and charcoal drawing.

With certain works of 1950 and 1951, and especially with the beginning of the Agricolas in the latter year, the connection to cubism was transformed again, only now by another shift in Smith's procedures. With the Agricolas, Smith moved toward constructing his sculpture more and more from found or existing elements, which meant that the use of specially fabricated elements increasingly lessened, eventually serving only to provide the base or disappearing altogether (they would return in the 1960s). In making the shift, Smith transposed his earlier procedures for beginning the work. As with *17h's*, the various existing elements would be spread out on the studio floor, but rather than being connected by a linear chalk sketch indicating imaginary components to be fabricated, here the assemblage was studied entirely from actual material at hand.

That step produced the final kind of initiating drawing in Smith's work. As we will see, the linear structures that Gonzalez made in the 1930s have been seen—in their final state—as drawing *of* steel. In Smith's transformation, his works in their initial state became an act of drawing *with* steel, regardless of whether they were linear and open or bulky and closed.[35]

That is not to say that Smith's work during the 1950s grew apart from Gonzalez' (and Picasso's). In fact, his development during this period must be seen, in part, as a return to and reevaluation of their earlier work (see chapters 1 and 2 on this point). What is important, for our discussion of Smith's techniques, is how the drawn, stylistic characteristics of Gonzalez' and Picasso's art came to be procedural ones in Smith's.

Central to the change that occurred in the works of the 1950s was that by

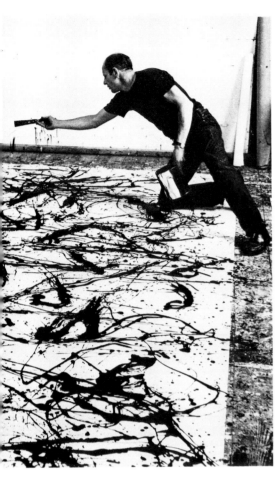

7. Jackson Pollock painting *Number 32, 1950* in 1950. Photograph by Rudolph Burckhardt.

drawing with steel throughout the initial steps Smith could work in a constant flow, or stream, dramatically different from the start-and-stop pace intrinsic to the use of both found and fabricated elements. The new procedure brought Smith's work closer to the paintings of the abstract expressionists, the artists of his own generation, especially in terms of the improvisational qualities of their studio techniques.

It is perhaps with Pollock's work that this connection can be most readily seen. Pollock's classic pictures emerged from his contrapuntal applications of poured paint, made on the horizontal surface of a canvas spread out on the studio floor; Smith's sculpture derives from a similar contrapuntal placement and replacement of elements, also across a horizontal plane. To be sure, each artist arrived at his procedure independently of the other and used the floor for different reasons (Pollock's paint would run down if the canvas were vertical, and Smith's floor supported the weight of his steel pieces).

Pollock's extraordinary procedures became widely known in 1951 with the publication of Rudolf Buckhardt's photographs of Pollock painting *Number 32, 1950*, which illustrated Robert Goodnough's article "Jackson Pollock Paints a Picture" in *Art News*, May 1951.[36] Four months later, Elaine de Kooning's parallel article "David Smith Makes a Sculpture" appeared in the September issue but was illustrated only with photographs of Smith working on sculpture in a vertical position. The more informative photograph of *17h's* early state, which is comparable on the procedural level to *Number 32, 1950*, was not included in the article, although a discussion of drawing on the floor was included in the text.[37]

Smith's procedure remained unseen until the major article by Hilton Kramer in *Arts* (February 1960), for which Smith supplied photographs of sculpture in progress on the studio floor, along with annotated comments made directly on the prints. But the Kramer photographs go beyond providing the premier viewing of Smith's use of a horizontal surface. Taken in the fall of 1959, they reveal not only how far his procedures had changed toward the greater use of found elements but also how these elements were now determining the final character of the work.[38]

The Kramer photographs indicate that Smith worked on numerous pieces at the same time, with the sculptures in various stages of study. These documents also show he now began by painting white rectangular areas on the studio floor, making a neutral and clean ground for studying the sculpture. Because of both the large number of works in progress and a lack of space, similar white areas were also made on the garage floor. Smith also used sheets of steel, which he called palettes, again painted white and placed on boxes outside the studio. We can see these white rectangles as a form of sculptor's paper, a neutral ground against which Smith would draw directly in steel. Once these juxtaposed areas had been covered with steel, the studio floor bore a striking resemblance to the living room and the house studio when the floors there were covered with drawings.

It should be noted that during the welding process the areas of paint around the steel forms would be burnt out by flying sparks, leaving a negative image of the sculpture in the untouched white. It is likely that Smith transferred this sculptural image back into his drawings/studies, replacing

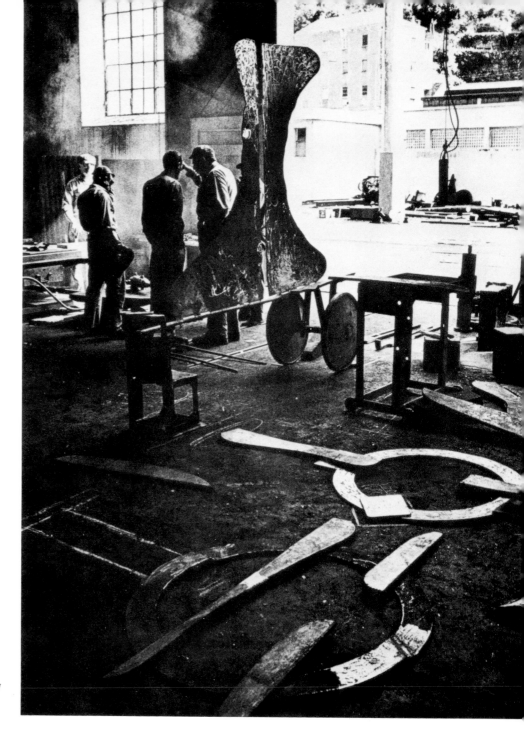

8. Interior of factory at Voltri showing *Voltri XII* and *XV* in early states on the floor. Photograph by Ugo Mulas, Courtesy of Antonia Mulas, Milan. Reproduced from *Art News Annual, 1964*.

the shower of sparks with the spraying of paint. He would repaint the used areas on the studio floor before beginning the next sculpture.

Findings

Smith would begin his sculptural drawing by placing various pieces of steel within the white, painted areas. Whether the initial arrangement was simply a random scattering of individual elements or derived from an earlier idea, the sculpture would develop out of this initial placement, with Smith changing the composition until the juxtaposition of the various elements suggested the direction of the final work. We can see this in one Kramer image, a collage of two photographs that shows *Bouquet of Concaves* in its completed

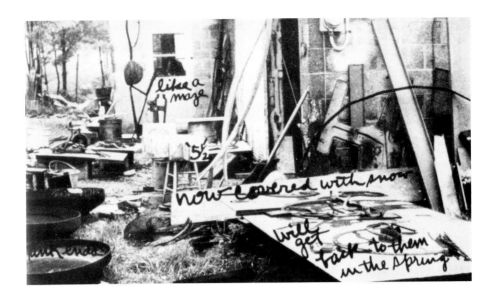

9. Outside Smith's studio, fall 1959. Photograph and inscriptions by the artist; taken from *Arts*, February 1960.

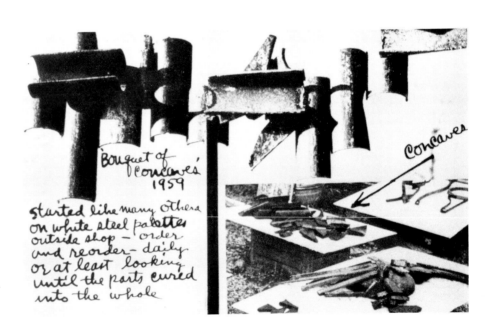

10. Collage of photographs showing *Bouquet of Concaves*, made in 1959. Photograph and inscriptions by the artist. Reproduced from *Arts*, February 1960.

state in the center, with a much earlier stage at the right. There small, curved pieces of steel—marked "concaves" by Smith—are spread out on a white sheet of metal outside of the studio. Smith wrote his procedure on the photograph: "[I] order and reorder daily or at least looking, until the parts cured into the whole."

Smith was, in effect, shifting his preliminary studying, or drawing, of the work from a separate state—either on paper or in chalk on the floor—to a direct use of the actual materials that would constitute part, if not all, of the final work. It is important to underscore how much that was a change from his earlier procedures, which called for a separate design and its subsequent metal fabrication. In the new process, the work was much more found in the

29

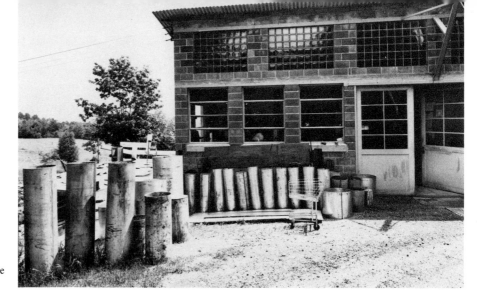

11. Stainless steel materials and forms outside Smith's studio, 1965.

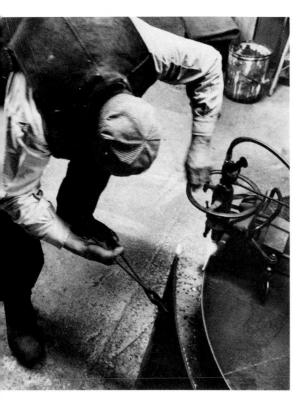

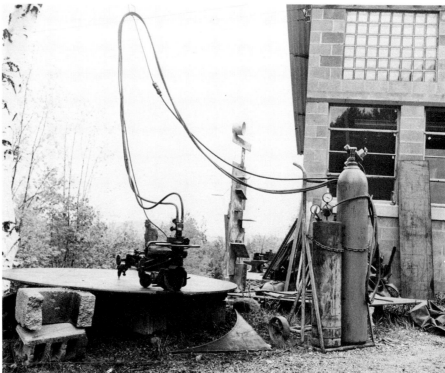

12. Smith cutting out a form from sheet steel, 1963 and right, machine for cutting out forms from sheet steel outside Smith's studio.

procedure of reordering and curing with the real components; that finding became central to his work.

It is also clear that in making the change, the steel material itself took on a greater role. By 1959 Smith would write of his methods:

I cannot conceive a work and buy material for it. I can find or discover a part. To buy new material—I need a truckload before I can work on one. To look at it every day—to let it soften—to let it break up in segments, planes, lines, etc.—wrap itself in hazy shapes. Nothing is so impersonal, hard and cold as straight rolling-mill stock. If it is standing or kicking around, it becomes personal and fits into visionary use. With possession and acquaintance, a fluidity develops which was not there the day it was unloaded from Ryersons' truck.[39]

Given the variety of his work, his method also required a wide range of

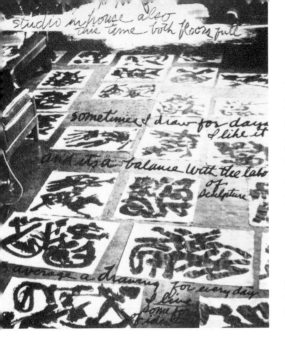

vocabulary in the various metal elements that Smith had on hand, and as we have seen, by the end of his life the stockpile outside the studio had grown enormous. Its contents went from small abandoned hand tools to entire junked tractors. At the same time, other fabricated elements—stainless steel cubes, cylinders, and lozenges were stacked in and around the studio. Smith also manufactured his own random and abstract shapes out of steel plate:

None of these are pre-conceived. None of them are drawn. I take iron and an acety-lene torch which runs on a track and is motor driven and put a tip into the right cutting thickness and I cut shapes out.[40]

13. Floor of Smith's living room, showing draw-ings, and floor of Smith's garage, showing sculp-tures in progress, 1959. Photograph and inscrip-tions by the artist, reproduced from *Arts,* February 1960.

14. Floor of Smith's garage, showing sculptures in progress, 1959 (inverted). Photograph by the artist, reproduced from *David Smith by David Smith*.

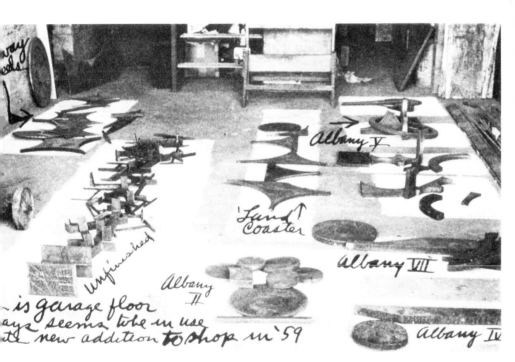

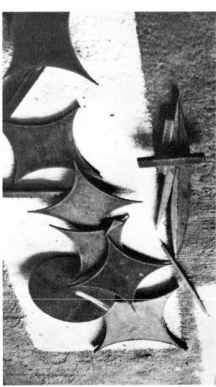

Such a wide-ranging supply was necessary because Smith worked on nu-merous pieces at the same time, and his studies varied widely in their state of completion as well as in their formal characteristics. One Kramer photo-graph in particular shows the garage floor, where Smith had spread out pieces of metal in white areas. Many works are marked by the artist, includ-ing not only the *Doorway on Wheels* and *Landcoaster,* but several of the much smaller Albany works as well (although only some are titled; the later-titled *Albany III* and *XX* lie below *Albany V; Albany VII* is above it). A much different study, made of numerous small angular units, lies between the two Wagons; marked "unfinished" by Smith, it appears to have ultimately been abandoned, for it is unknown in his oeuvre.

Landcoaster, placed in the center of the floor, is in a preliminary stage,

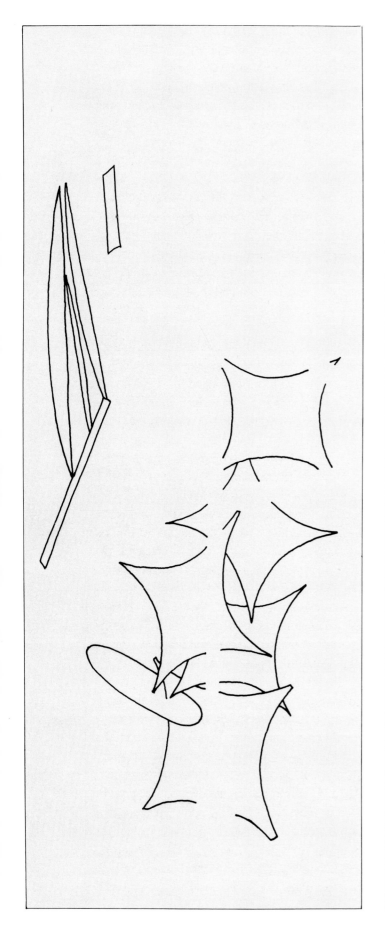

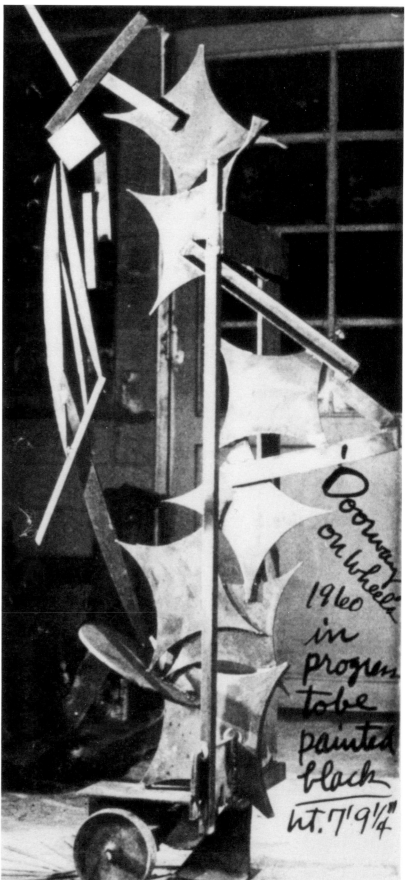

Doorway on Wheels
1960
in progress
to be
painted
black
ht. 7' 9 1/4"

with only the central core of elements assuming roughly their final positions. Even the identifying wheels are absent, although Smith's label of *Coaster* implied their intended addition.[41] By contrast, *Doorway on Wheels* has evolved much further, evident in another photograph taken at the same time but from the opposite side of the room (here inverted for comparison). By making reference to a diagram of *Doorway on Wheels*, we can see that, like *Landcoaster*, Smith has begun with the core elements, here a set of starlike shapes the artist had cut from steel plate. In contrast to *Landcoaster*, the pieces are closer to being in their eventual place. Six starlike planes at the bottom are in their final locations, and two of their joining struts are also indicated. The more complex bunchings of small linear pieces, set apart from the stars, are also present in a near-final form (these grouped pieces eventually moved upward in the completed composition). The lower disk is also shown as part of the work, with a chalk mark to indicate where it was to be cut to create a slit that would allow its insertion at an angle into its adjacent star. Finally, the supporting wheels and frame are shown across the floor beyond the painted area.

As Smith developed this generative procedure, he gained both skill and time, reaching perhaps a peak in the twenty-seven works made in thirty days in Voltri, Italy, and in the twenty-five Voltri-Boltons made in New York upon his return. (See chapter 5 for a discussion of the name *Voltri-Bolton*.) Many photographs by Ugo Mulas record Smith sketching in Italy, but they show only one state of the work. More extraordinary is the sequence of photographs made by Budnik in 1968, which records progressive stages of the sketching of *Votri-Bolton VIII*. Here we can see Smith begin again with a central core, in this instance a circle made of small triangles, to which differently sized disks are juxtaposed. Moving these pieces around, sometimes kicking them into position—Smith described this as "toeing in" to Budnik—Smith eventually adds eight tongs at the top of the work.[42] These elements, brought back from his stay in Italy, first assume a triangular pattern, echoing the small pieces of the circle, before Smith moves them to their slightly askew vertical placement. In a similar manner, he studies the disks in various positions around the perimeter, before they are finally replaced by a rectangle. In the last photograph, the work lies on the studio floor, its sketching complete save for the later addition of a rectangle along one side and for its being welded together and the making of its base.

It is appropriate to examine here the two central aspects of Smith's procedure in working out the composition on the floor, first that it is a form of sketching and second that it involves the use of materials that make up the work itself. As we have seen, the idea of drawing sculpturally with metal goes back to Gonzalez' and Picasso's early works, and Gonzalez even described Piccasso's metal works (and by implication his own) as "to draw in space."[43] But this expression seems more to fit to the graphic vocabulary of the completed works than to the process of their making, especially in light of the numerous paper studies Gonzalez made for his sculpture. By contrast, when Smith's studies for his works were shifted to the metal itself, he actually drew with the steel, rather than make drawings out of steel, as Gonzalez and Picasso had largely done.

15. Smith's *Doorway on Wheels* in progress, 1959-60. Photograph and inscriptions by the artist. Reproduced from *Arts*, February 1960.

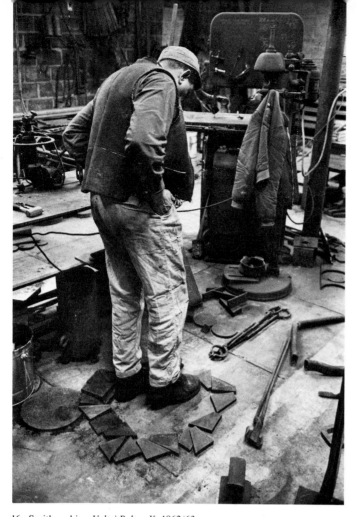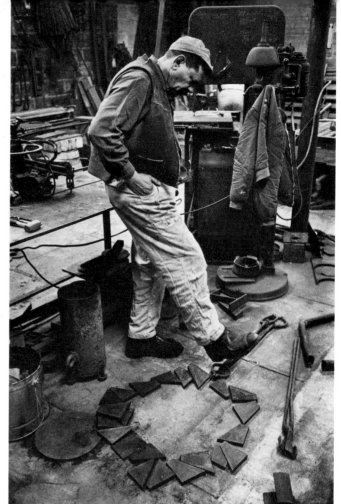

16. Smith making *Voltri-Bolton X*, 1962/63.

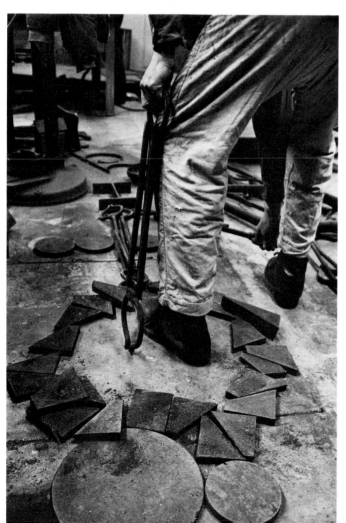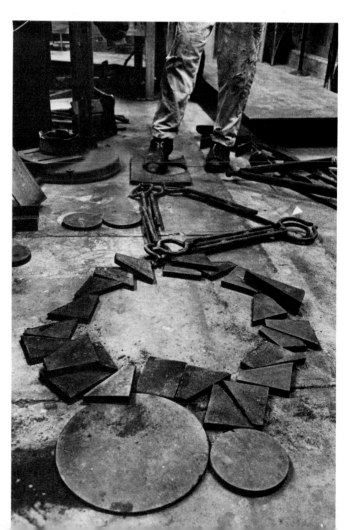

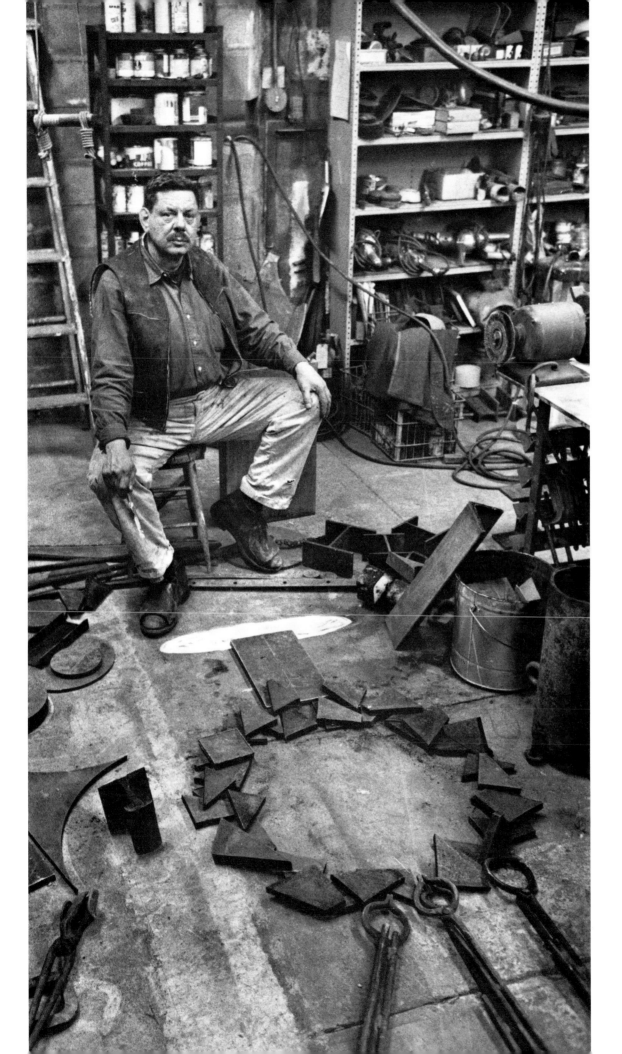

It is in this process of working directly from the beginning with materials, reordering them to find his work, that we find what joins Smith's sculpture to the pictorial works of his abstract-expressionist colleagues, for in their work a similar discovery of the subject takes place in the process of painting. As I have argued elsewhere, it is this arriving at a subject through creating that is the central characteristic of the New York School. That is to say, rather than portraying an existing theme, the meaning of the work emerged only after it was underway.[44] Smith noted:

I try to approach each thing without following the pattern that I made with the other one. They can begin with any idea. They can begin with a found object, they can begin with no object. They can begin sometimes even when I'm sweeping the floor and I stumble and kick a few parts and happen to throw them into an alignment that sets me off thinking and sets off a vision of how it would finish if it all had that kind of accidental beauty to it. I want to be like a poet, in a sense. I don't want to seek the same orders.[45]

We should compare Smith's foregoing description of his work with Robert Motherwell's 1946 observation on making a collage, especially as Motherwell's process was closest in procedure to Smith's:

The sensation of physically operating on the world is very strong in the medium of the papier collé or collage, in which various kinds of paper are pasted to the canvas. One cuts and chooses and shifts and pastes, and sometimes tears off and begins again. In any case, shaping and arranging such a relational structure obliterates the need, and often the awareness, of representation. Without reference to likenesses, it possesses feeling because all the decisions in regard to it are ultimately made on the grounds of feeling.

Like the cubists before them, the abstractionists felt a beautiful thing in perceiving how the medium can, of its own accord, carry one into the unknown, that is, to the discovery of new structures. What an inspiration the medium is! Colors on the palette or mixed in jars on the floor, assorted papers, or a canvas of a certain concrete space—no matter what, the painting mind is put into motion, probing, finding, completing. The internal relations of the medium lead to so many possibilities that it is hard to see how anyone intelligent and persistent enough can fail to find his own style.[46]

17. Collage studio of Robert Motherwell, 1978. Photograph by Steve Sloman.

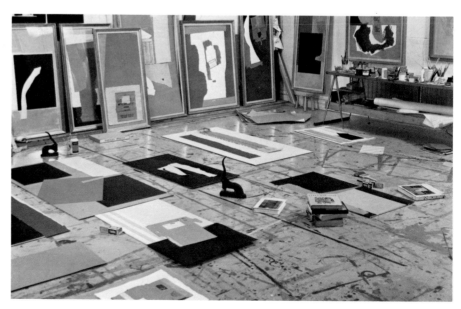

In the end, in the works made in this fashion, the sculptural images were seen by Smith in the union of the disparate elements; their existence lies entirely within the construct of the work, which effects rather than educes them: the "finding" of the construct immediately produces the image, rather than its being recognized and then described.[47]

Planning

Smith's procedure of drawing with steel does not fully apply to the initiation of all his mature works, or even to all of the major ones. Concurrent with the development of this more automatic, free-flowing invention, Smith was also following a second direction in his work, using simple geometric shapes. Within this elemental characteristic we find two separate kinds of works: pieces that are radically simplified in their format and those that are of a complex, constructive nature. The former characteristic reaches its high point in the Circles from 1962, which are composed of as few as two or three elements set on a base. Like earlier works, these (probably) derive from drawings, but their geometric makeup—flat circles and rectangles—-meant that the sculpture moved almost directly from idea to fabrication to assembly. That procedure eliminated the interim, and often crucial, step of collaging across the studio floor. In the case of the Circles, however, the process was still kept open with respect to their finish, as Smith chose to paint them in an intense, multicolored fashion (see chapter 4 and below).

The other direction toward the geometric culminated in the large stainless steel Cubis. With these works it is the component elements themselves—cubes, thick disks, and cylinders—that are simple and geometric, rather than the compositional idea of the work itself. Indeed, the Cubis are Smith's most complex and spatially articulated works, and in making their statements, these pieces often display the same kind of freely arrived at, formal invention that we identify with floor-found work like the Voltri-Boltons. However, the sheer size of the Cubis and the three-dimensional bulk of the separate sculptural elements greatly limited, if not prohibited, the use of the floor in their composition. Smith had to initiate the work in another manner. For certain works he appears first to have studied the composition in spray drawings or paintings and then translated it into the final structure. Several Cubis have spray studies that are directly related formally. For *Cubi XIII*, for example, there is a spray stencil with inscription dating the study fourteen days before the completed sculpture.[48] For other Cubis, Smith invented another form of study: cardboard maquettes.

Again Budnik was present during the use of this procedure and photographed Smith using it. He recalled his December 1962 visit to Bolton Landing:

After opening a fresh bottle of cognac at the end of a good meal, I started to throw the cognac box into the fire. Smith let out a yell and snatched the box from the flames.

"What's the matter? Why are you saving boxes?" I asked.

Smith disappeared into the basement and emerged a few minutes later with a huge armload of liquor boxes. He began to arrange these, taping them together into cardboard sculpture.[49]

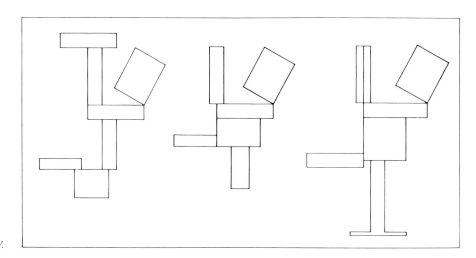

18. Diagram showing development of *Cubi V.*

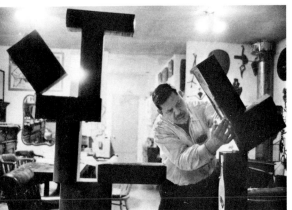

19. Smith making cardboard studies for *Cubi IV* and *V,* 1962.

As Budnik later discovered, these cardboard works were almost identical to *Cubi IV* and *Cubi V,* which Smith made shortly after his evening's carton constructions. The sequence photographed by Budnik agains allows us to follow the evolution of the works, specifically *Cubi V,* which we represent here by means of a diagram. The first photograph (taken from the back side) shows that the essential structure was already established, the wide horizontal pieces at the center, with the angular "Cubi" (a cigar box) tipped on an angle at one end. The counterweighted vertical element is also in place but capped by another horizontal in the first state. The horizontal is eliminated in the second stage of the model construction, as shown in a subsequent photograph, where only the vertical remains, still parallel in plane to its sup-

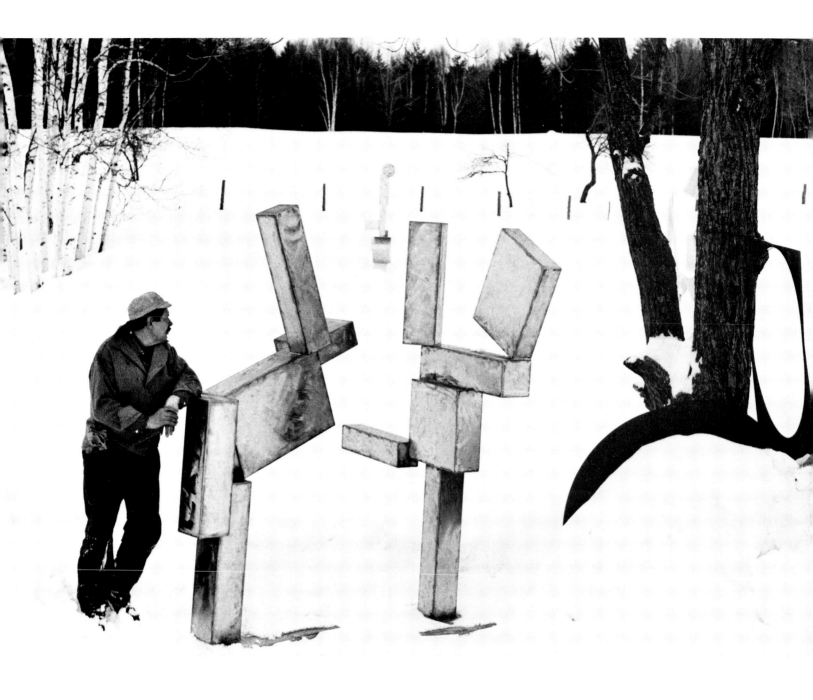

20. Smith with *Cubi IV* and *V*, 1963.

porting beam. This second stage also reveals a consolidation of elements near the center. In the first construction, the upper composition balances on another vertical element, placed atop one end of a rectangular box, with a third horizontal bar hanging off its opposite edge. By the second stage these elements have been rearranged and changed slightly in proportions. The broadest rectangle moves upward and now not only supports the upper structure but partially merges with it because of its wider shape. The lower horizontal now hangs off the bottom corner of this shape, echoing the vertical above and serving to counter the diagonal box above rather than mimicking the crowning horizontal of the first stage. The use of the remaining vertical at the lowest level now establishes the work's central spine and raises the as-

39

sembly up into the air in contrast to the stepping up in the initial stage.

Although this second cardboard model is close to the completed sculpture, study of *Cubi V* shows the subtle shifts Smith made in actually constructing the work. Now the upper vertical element twists forty-five degrees to the frontal plane so that its edge lines up with the corner of the horizontal, and its diagonal orientation responds to the tipping of the rectangle at the opposite end. In a similar refinement, the lower horizontal drops down slightly from the line of the supporting center box, an offset that enlivens this component by making its connection less direct. And finally the central rectangle is lengthened, giving greater height to the entire assembly.

Although Budnik's photographs are the only visual documentation of Smith's use of cardboard boxes for the Cubis, it is possible that numerous other works were also initiated in this manner. Robert Murray recalls seeing such maquettes in Smith's basement after his death.[50] Smith made regular use of this procedure, a fact underscored by his saving the boxes themselves; that is to say, his decision to use the procedure for *Cubi IV* and *V* was planned rather than spontaneous.

Smith clearly developed the maquette sketching in response to the limitations of the sprays. At their best, the paper and canvas studies were only visual approximations, for they could indicate only a two-dimensional plan for the front of the sculpture; that would have been disjunctive, for the Cubis mark Smith's greatest involvement with volume, not only in the cubic forms themselves but also in the overall assembly of the work itself. In this regard, the use of the cardboard boxes allowed Smith to sketch directly with bulky shapes, albeit at reduced scale, thus bringing the Cubis closer in line with the findings process described above.

This is not to say that the Cubis were simply an enlargement of their construction in cardboard. Despite the dual and intersecting problems of weight and bulk that their vocabulary entailed, Smith clearly did improvise in this series, even in the structurally complex "Gates." In describing the first of them, *Cubi XXIV*, shortly before his death, Smith recalled:

Sometimes I work on sculpture and when I turn it over and weld on the bottom and it looks better upside down, I leave it, and that is sort of the way I found the gates or the archways.

I had made a long sculpture, and while I was working on it, I had it on a chain hoist and turned it upright, and it sat like an arch. So I put another form underneath it and made an arch out of it.[51]

Smith was able to find *Cubi XXIV* and "put another form beneath it" with some degree of speed because the forms—the stainless steel cubes—were at hand. Just as Smith maintained his enormous supply of other materials, for the Cubis he created a large stock of prefabricated cubes, disks, and cylinders in varying sizes. Although the work might begin with a general concept, Smith was free to modify or change it at any given moment by resorting to the stock of alternative pieces and directly sketching the actual pieces into the work. Thus, despite the restrictions imposed on his established methods by the formulation of the Cubis, Smith did take steps to keep his construction procedure as close as possible to the stream of improvisation. As Smith himself said:

This is stainless steel, out of series I call Cubi—just a made-up name—and the forms are made up in a very simple cubic or cylinder shapes. . . . I think I am about number 28 now in this group I call Cubi. Every time I do four or five I think I've exhausted my thinking in that way; but then I buy more stainless steel and make more sculptures, but I hope it finishes off pretty soon.

I have made three sculptures in the form of gates, and this is next to the last one. There is a lot of background there, but you will have to separate that. It is kind of big and heavy, and I couldn't move it out to a better location, but, as you see, it is a stainless steel form of just an arch.

I have no ideology in this form—nothing very important—except the way things are going. I have no concept behind it other that myself, and most of these don't vary from just sometimes squares, rectangles, and cylinder forms.[52]

Weldings

Crucial to understanding Smith's sculpture and his working procedures is knowing not only that the components of the works are made of steel and/or other metals but that they are joined by being welded. As we have seen, Smith emphasized that it was this technique as well as the images in Picasso's and Gonzalez' early sculpture that caught his attention. That sculptural process, however new and unexplored, was also a process that Smith himself was acquainted with. Yet given this historic connection and the fact that all of Smith's important work is welded, it is surprising to discover that the literature on Smith only rarely touches on the process itself, on how Smith responded to its implications, and on how the responses characterized his art.

In contrast to the long history of the techniques of carving, modeling, and castings, which reaches back to prehistoric times, the history of welding is virtually as brief as that of the works of art made by using it. Welding is essentially a method of joining materials in which heat is supplied either electrically or by means of a torch. Efficient methods for generating either of these two sources were largely developed only in the last decade of the nineteenth century. The electrical welding process, known as arc welding, emerged in 1892, with the invention of metallic electrode wire, whereas torch welding—known as oxyacetylene or acetylene welding—followed three years later with the commercial development of tanks of oxygen and acetylene gas and of suitable torches.[53]

Acetylene welding became used industrially around 1903, and it was this technique which Gonzalez learned in a Renault factory during the 1910s and subsequently used in welding his own sculpture (as well as Picasso's). Smith used the same process in his work up to the early 1950s (having also gained his knowledge in an automobile plant). Acetylene welding functions by having the torch heat up the two separate pieces of metal at the point where they are to be joined; the pieces are bonded by introducing a compatible filler material. As Gonzalez noted, it is a process like soldering them together, and the rather intimate contact of the procedure encouraged a kind of fine detailing, both in Gonzalez' work and in Smith's early pieces. But as Smith's sculpture grew much larger in scale during the 1950s, he largely abandoned acetylene welding in favor of the arc technique. He did retain part of the acetylene procedure to cut shapes out of stock metal or to cut off unwanted elements once the sculpture was underway.

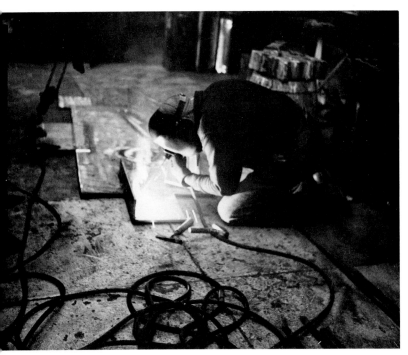

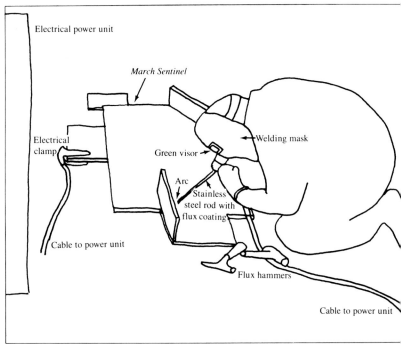

Electrical power unit

March Sentinel

Electrical clamp

Welding mask

Green visor

Arc

Stainless steel rod with flux coating

Cable to power unit

Flux hammers

Cable to power unit

21. Smith welding *March Sentinel*, 1961, and right, diagram showing Smith welding *March Sentinel*.

Although electronic, or arc, welding had been invented first, its commercial development lagged far behind that of acetylene. During the 1910s, when acetylene welding was being used, arc welding had made so little progress that "the common test [for its use] was to drop the piece on the floor to see whether it would hold together."[54] By 1935, however, arc welding came into its own and rapidly achieved commercial acceptance (accounting today for sixty-five percent of welding processes). Presumably Smith learned his skills at arc welding when employed at the locomotive factory during World War II.

The essential difference between the two kinds of welding lies in the method of heating and applying the connecting metal, or weld, to the materials. Where acetylene welding uses a flame to heat both metal elements and a filler rod is inserted to join them, in arc welding this heat is supplied by an electrical connection being made between the rod itself and the metals being joined. We can see the essentials of arc welding in a diagram made after a photograph of Smith welding *March Sentinel* in his studio. Shown on the left is an electrical power source, with two cables extending outward from it (shown in loops on the floor in the photograph). At the left of the sculpture, one of the cables is attached to the work by means of a clamp; the other leads to the electrode rod held by the sculptor. When this electrode touches the sculpture, it completes an electrical circuit (the metal of the sculpture carries current); the touch instantly and powerfully heats the two pieces of metal at that precise point. Withdrawing the rod breaks the current and stops the heating and welding process. The combination of speed and localization became increasingly important as Smith's work grew in scale. The acetylene method produces a less powerful heat, which requires a longer time of application for the metal to reach the temperature necessary for fusion. Although

the longer time was acceptable in smaller works or in pieces that joined thin, drawn elements, if it had been used in large sheets of metal, the acetylene heat would eventually spread through the entire sculpture while taking the time to heat the point of the weld. That would raise the temperature of the entire piece to a dangerous level and introduce the possibility of a wide plate warping. That danger was especially present in stainless steel, which conducts heat rapidly and which Smith made extensive use of during the later years. In other cases, the thickness of the metal—around two inches—was such that the acetylene torch simply could not sufficiently heat the metal to permit a weld. Thus many of Smith's larger works were only possible using arc welding.

As the rod used in arc welding melts, it deposits its material on the sculpture, joining with the heated metal on either side of the seam. In welding a long join, as shown in the diagram, the melting (and shortening) rod is drawn along the seam, heating and fusing as it moves. The melted rod leaves successive puddles in the area of the joining, as we can see in the welding of certain of the Cubis. Such a thickness was not actually necessary for holding the join together, and in other welds (in other works or sometimes in the same sculpture) Smith chose to grind away the excess material in the puddles down to the level of the adjoined elements so that the melted rod almost disappeared. As this inner weld was sufficient to hold the piece together, Smith's choice of leaving the pronounced puddles in other areas must be seen as an aesthetic one, as the grinding down to form a seamless surface must also be.

Given the very large scale of the later Smith sculpture, this attention to the finish of the seams might appear surprising. But this detailing partially derives from the physical factors of welding itself. As we can see in the photograph from which the diagram derives, the electrical connection produces an area of such extremely high temperature at the joint that a spray of molten metal is created. For this reason one must weld wearing a heavy apron, gloves, and a thick welding helmet covering the face and neck. Vision in the helmet is provided through a small opening that is covered with a movable shield of dark green glass. The sparks produced at the welding point are so bright that they require a green lens so dense that it does not permit light under normal circumstances. Thus one arranges the material to be joined by looking at it with the green glass shield up and out of the way, taking every precaution not to touch the electrode rod. When one is ready to weld, the green visor is flipped down, leaving the welder in total darkness. Touching the electrode to the sculpture produces an area of bright, tinted light at the point of contact, with a dim glow extending for about four inches to either side. Everything else is black. Using this small visible zone, limited to less than a foot, the sculptor moves the ever-decreasing electrode along the seam until reaching the end of either the join or the electrode. Again, pulling back breaks the circuit and stops the process. Then the welder lifts the visor in order to see. If a seam is to be continued, a new rod is attached. Even though a Cubi might be eleven feet high, its construction proceeded literally inch by inch. In that sense, Smith knew every aspect of his work's making.

The rods, which are so crucial to the bonding of the weld, must be of a

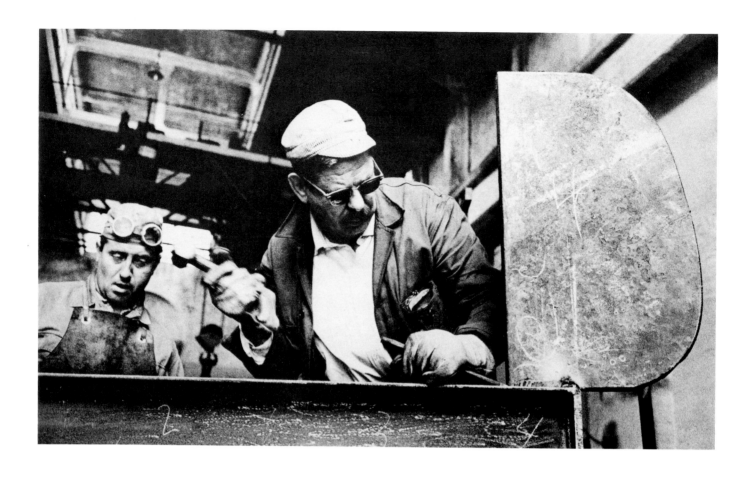

22. Smith making *Voltri IV*, Voltri, Italy, 1962.
Photograph by Ugo Mulas, Courtesy of Antonia
Mulas, Milan.

compatible material. The most direct substance is a simple mild steel with
no alloys, which melts quickly. Smith kept a steady supply of them at hand
in a container, as we see in another photograph showing him welding *Voltri-
Bolton I*. To protect the rod from the air and possible rust, it is covered with
a granulated flux on all sides. During the process of welding, this flux trans-
fers to the puddles of the melted rod and serves to cover the weld, again pro-
tecting it from air. After the weld has cooled, this flux is removed by strik-
ing it with a hammer.

A crucial aspect of arc welding is its speed. Compared to the waiting pe-
riod for heating in the oxyacetylene method, a simple touching with the elec-
trode produces the weld, with only a short period required for the cool-down
of the joined area. Thus, because of arc welding, Smith's physical construc-
tion of the work remained as open and subject to improvisation as was his
technique of sketching with actual materials, the toeing in of the composi-
tion. If Smith gained a sudden, new idea of placement, arc welding allowed
him to add it to the work almost instantly. In a similar and equally crucial
regard, an unsuccessful part could be cut away. This could also occur after
the initial completion of the work, as we can see in a photograph of *Sentinel*,
showing a much different upper area, one which Smith later modified. In-
deed, as early as the Agricolas Smith was making these revisions (see
chapter 1). Thus with welding, the stream of Smith's sculpture—from its
start on *into* construction—remained direct and flexible.

Working Flat

Only one factor slowed the pace of Smith's working methods: the traditional burden of sculpture—the sheer physical weight of its material. That problem was encountered primarily with the mature sculpture, because the work before 1951 had generally been small in scale and often of lighter, linear elements. The lack of mass had allowed Smith to weld his work upright. But in the 1950s and 1960s, Smith's scale increased dramatically, and large, solid sheets of steel were often employed (as in *March Sentinel* just discussed). Weight made it time-consuming to construct the work in its upright position. Smith thus developed a process for partially welding sculpture directly on the studio floor, keeping it in the same horizontal position used for sketching or toeing in. To be sure, some elements were added after the works had been raised by a hoist to their vertical position, as we see in *Voltri-Bolton I*. The Cubis also required various forms of assembly. Nevertheless, Smith's general method of welding the sculpture was similar to his technique for generating the work's identity: By working flat he could change the direction of the work, cutting off or adding on differing elements. Changes could also occur after the work was finished and placed vertically.

Smith's process of working flat was coincident with his conception of sculpture itself. With this process the work is largely oriented toward one principal perspective, namely that which Smith had in looking down on the evolving composition. This point of view created sculpture that was consistently frontal, rather than organized to include wider or different perspectives. That latter characteristic had been the previous aim of sculpture, and Smith was aware that his work was breaking with tradition. As early as 1952 he argued that "for a sculpture, I don't see it from five different angles at once. I see one view. The round is only a series of fronts. [As for] the notion that a good piece of sculpture should be able to roll down a hill—that belongs to another age and I should think a barrel could do it better. Contemporary sculpture is anything a contemporary sculptor wants to make it."[55] Smith also took a similarly defiant attitude toward his more linear works, like the Agricolas:

I have always considered line contour as being a comment on mass space and more acute than bulk, and that the association of steel retained steel function of shapes moving, circumscribing upon axis, moving and gearing against each other at different speeds, as the association of this material suggests.

The overlay of line shapes, being a cubist invention, permits each form its own identity and when seen thru each other highly multiplies the complex associations into new unities.

I do not accept the monolithic limit in the tradition of sculpture.

Some critics refer to certain pieces of my sculpture as "two-dimensional." Others call it "line drawing." I do not admit to this, either conceptually or physically. It may be true in part, but only as one attribute of many, and that by intention and purpose. There are no rules in sculpture. This particular criticism is not sufficient or valid grounds for dismissal.

I make no apologies for my end-views. They are as important as they are intended to be. If a sculpture could be a line drawing, then speculate that a line drawing removed from its paper bond and viewed from the side would be a beautiful thing, one which I would delight in seeing in the work of other artists. The end-view or profile of an interesting person or object arouses the mind to completion of the im-

agined personality and physiognomy, since a work of art or an object of interest is always completed by the viewer and is never seen the same by any two persons.[56]

In a general sense, we could say that Smith's work approaches the bas-relief, assembled in shallow layers against the background plane of the floor. But when lifted off the floor, that background plane disappears, turning the assembled elements into a freestanding sculpture. Smith himself created this analogy to relief constructions in describing his conversion to sculpture: "My painting had turned to constructions which had risen from the canvas so high that a base was required where the canvas should be; I was now a sculptor."[57] In other instances, however, Smith went so far as to deny even being a sculptor: "I belong with painters," he wrote.[58]

Painting

Smith belonged with painters in another sense as well. His method of conceiving and working flat allowed him to introduce ideas native to painting without having to translate them into a three-dimensional vocabulary. The Circles, for example, read as if the painted rings of Noland's targets had been lifted out of their stained canvas support and stood directly in space. By contrast, John Chamberlain's work, drawing on de Kooning's vocabulary, or Mark di Suvero's constructions, echoing Franz Kline's structures, translate the pictorial image into the kind of sculpture in the round from which Smith's art was clearly different.[59]

This ability to take from painting introduces yet another means of working that Smith had at his command: the actual painting of the sculpture or of a detail of its construction. We find this perhaps most clearly demonstrated in the generation of the pictorial *Gondola*. Sometime before making this

23. Smith working on *Gondola,* 1961. Photographer unknown. Reproduced from Rosalind E. Krauss, *Terminal Iron Works: The Sculpture of David Smith,* 1971.

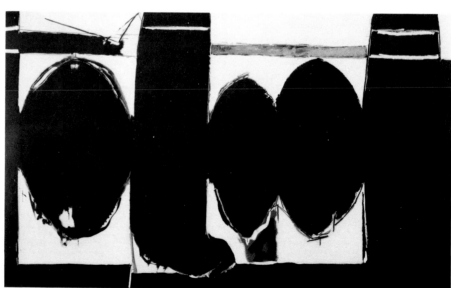

24. Robert Motherwell, *Elegy to the Spanish Republic,* 1971–72. Acrylic on sized canvas, 260.4 x 444.5 cm (102½ x 175 inches). Collection, Robert Motherwell, Greenwich, Connecticut. Not in exhibition.

work, Smith had discussed with Motherwell the idea of the latter making a sculptural version of his painting series, the *Elegies to the Spanish Republic*. "Although David insisted that it could be done, and said he would assist me in making it," Motherwell remembers, "I declined because I could never imagine what an Elegy would look like from the side."[60] We could expect a painter to feel this way. But Smith, working flat, had no trouble approaching the problem from the other direction and in *Gondola* went on to make, in effect, his own Motherwell Elegy.

Crucial to his accomplishment was the fact that he started by painting an Elegy on a sheet of steel plate painted white. As photographs show, this sheet had already been inserted into an enclosing structure of an open rectangle set at a right angle to a large frontal plane, cutting through it along the lower edge. The entire assembly rests on a platform supported by wheels (making *Gondola* part of the *Wagon* series).

On this vertical white plane, resembling an empty canvas, Smith proceeded to paint in a paraphrase of a Motherwell Elegy, first outlining oval shapes then filling them in with black. Even the rough, painterly edges that characterize the Motherwell forms appear in Smith's painted version. These disappear in a subsequent step, when Smith cut away the leftover areas of white field in such a way that the resulting black shapes are given a more geometric vocabulary. In the final sculpture, the Elegy forms stand free in space, lifted from the white ground of their pictorial origins.

This painted-element concept was not unique to or invented with *Gondola*. As another photograph shows, Smith used a similar process in working on *Tanktotem IV*, where a white plane of steel has been put next to the partially completed work; another element is being created by being painted on the sheet. This fabricating against a white surface is similar to sketching with steel against the white area on the floor.

We have no idea how often the process was employed; it may be what Smith meant when he said, "I painted for some years. . . . I always, even if I'm having trouble with a sculpture, I always paint my troubles out."[61]

The completion of the welding assembly and the raising of the work to its vertical position was not the conclusion of the sculpture. For the Cubis and related pieces

the stainless steel is finished by an electric buffing machine (like everybody in garages uses—a revolving carborundum disc); and I have to go over the metal because it gets contaminated with hammers, and even shipping on a truck; and when the metal is dragged off a truck; it gets scratched with natural iron, and then rust streaks come up on it, so it has to be dressed off. I have to leave it out of doors for a while to see if there are any contaminative rust spots on it, and then grind them off later.

It is hollow and not so heavy, and the figuration of the polishing has no particular meaning—that's just a manual working—anymore than in this day and age the stroke of a paint brush has particular meaning. It used to, but I don't think anybody pays too much attention to how the paint is applied. That's just the same way with polish. In polishing, you get a certain reflective power, and a certain scratch on it, so it is not too bright, but just the right amount to reflect the light.[62]

For many of these later works the polishing was done by Leon Pratt, Smith's studio assistant.

In contrast to the stainless steel pieces, the other works that were made in

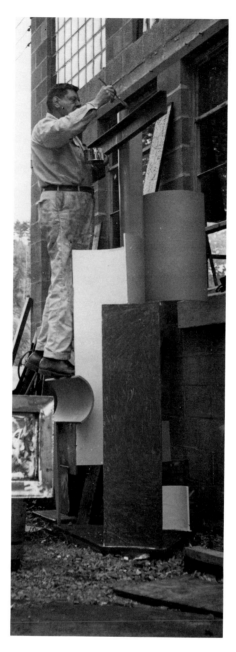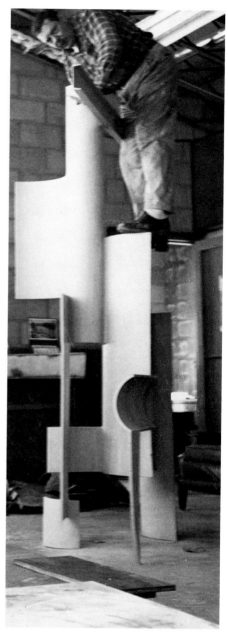

25. Smith working on *Zig II*, 1961.

conventional iron and/or steel were susceptible to rusting when they were exposed to the air and moisture. For certain pieces, such as the Voltri-Boltons, rusting is exactly what Smith desired. This he achieved by placing the works outside until the natural process gave the sculpture the color and look of the oxidation—or patina—he wanted. Weathering would then be stopped by applying a layer of oil, which would seal the surface from contact with the air.

Thirty-six percent of Smith's work after 1960 is painted. The majority of these works use a single color, such as the brick red of *Agricola I* or the black of *Sentinel I*, which works to unify the often disparate parts of the sculpture and to disguise their previously functional identity.

In some pieces of more abstract shapes, such as *Zig I*, Smith employed a

two-toned pattern applied in brushstrokes that are as random as the polishing marks on the Cubis. Again, this paint surface works to unify the sculptural elements. But in other works, Smith used paint for the opposite purpose, namely to stress the separate identity of various elements by painting them different colors. In these polychrome works it is the multiplanar orientation of the composition that dominates the sculpture.[63] We can see how effective the use of differently colored areas is by comparing *Zig II* with a photograph of the work covered only by a solid yellow coat of primer paint. Where our attention is drawn to how alike the rounded forms are in the initial stage, once painted in multiple tones these shapes assume much more pronounced, individual identities.

The decisions about the color of the sculpture, especially the polychrome works, were also a part of Smith's open, evolving method of working. Rather than painting certain works immediately after their construction, Smith chose to apply only a primer and a white underlayer, then set the work aside, studying it to determine its correct polychrome. In the case of the Circle pieces, for example, Smith studied them for about a year before deciding on their coloration and returned to study them after they had been painted to see if changes were necessary. Smith noted of this process:

I don't have any wonderful aesthetic ideas about painting. Sometimes, if I have made an error in mixing some paint some place, the wrong paint one place turns out to be the right paint that goes on this one, or else I pour a few cans together, and it comes out real nice, so you convince yourself that that's the right color for this one. I have to paint them wrong and look at them and sometimes change all the various old formalities, or even change the colors—it takes a little time, and it is funny where you draw the line. Sometimes you have to change the whole thing and sometimes it is kind of raw; and after you look at it a while, your laziness convinces you that you do not have to paint it again. I don't know where you draw the line. I guess you work on averages.[64]

Smith was clearly bothered more by color in his work than any other aspect. He discussed it in an interview with Thomas Hess:

I'm still working on that. I've made two sculptures in tune properly between color and shape. But I've been painting sculpture all my life. As a matter of fact, the reason I became a sculptor is that I was first a painter.
Why do you always choose bright colors?
Because they are more difficult.
Wouldn't it be easier to start with grays?
Yes, it would be easier to state color in a gentle monochrome manner, except it doesn't speak to me as strongly. I could work in whites and blacks, but I think I'd have to work twenty years before I can paint circles in bright colors that succeed, and the minute I succeed, I would be done; that would be ended. When you get a unity, it's got to end something.[65]

At other times Smith could be poetic about nature and its inspiring hues, as in a note about "the April beauty of true color before it's struck with green." Another work, *Tanktotem X*, gained its color from Smith's vegetable garden:

I depended upon the flowers and tomatoes to carry that one out, but it is painted sculpture. I actually think the garden had something to do with [it] unconsciously. I wasn't trying to use any colors that were in the garden, but I actually think that the colors I saw influenced the painting of the sculpture.[66]

"Making a Lot"

If Smith's methods could not overcome his doubts about color or other aspects of his work, they nevertheless allowed Smith to simply go around the problems by continuing the creative outflowing of sculpture. As Smith observed in reference to a 1961 exhibition, "all the work there was painted. . . . Some of them were not so successful, but I make a lot of sculptures so it doesn't matter."[67]

The idea of making a lot is a central one to Smith's art and to his concept of the stream of identity. As we have already seen in the 1959 photograph of the garage studio floor, he usually worked on more than one piece at a time. That insured that Smith would not get stuck on one work and end up waiting to resolve it before moving on to begin the next work. Any problem piece could be ignored until its resolution came to him. It is important to realize that this putting aside could occur at every step in his procedures—from letting the elements cure to partially welding the works to applying the primer coat and a white layer.

However, from the photographs that we have, it appears that Smith rarely returned to revise a completed work after it had left the studio, aside from painting it. Even if it was a problem, as he suggested in his comment on the 1961 exhibition, Smith simply accepted that less than successful works would emerge out of his creative flow. He could do so because within the large number of works made he believed that he would eventually create a great work.

As with so many other aspects of his sculpture, an acceptance and continuity emerged with the Agricolas and other series made during the early 1950s. In 1956, Greenberg would write that

in recent years he has become more consistent, and the successful pieces come more steadily. It used to be that a period of expansion and trial and error during which new ideas were explored, with much attendant failure, would be followed by a much shorter one of consolidation in which there was a higher proportion of success to failure. Now Smith seems to be able to proceed more rapidly and directly from conception to realization. . . . The elegance of the figure pieces in Smith's recent "Tank Totem" series has a tenseness, and tension . . . [while a] varied fusion of felicity and ruggedness distinguishes the dozen-odd pieces of Smith's "Agricola" series.[68]

And Smith made a lot of sculpture. Indeed, despite the tremendous increase in the scale and in the mass of his work after 1952, Smith's rate of making sculpture also rose dramatically during this period. He described 1952 as a record year for sculpture, having created a total of twenty works, yet ten years later he would make twenty-seven monumental pieces at Voltri, Italy, during only a one-month stay, a creative performance that has acquired the status of a near-legend.[69] In the twenty years between 1932 and 1952, Smith made 263 works, often of intimate scale, a schedule that averages out to a little over thirteen works a year. During the following thirteen years, up to his death in 1965, he completed 413 works, averaging almost thirty-two a year; in just the last four years of his life, the number reached nearly forty works a year, and that included the monumental Cubis.[70]

One of the richest and most provocative periods of Smith's sculpture was the four months between October 1962 and January 1963, when he concen-

	SUNDAY	MONDAY	TUESDAY	WEDNESDAY	THURSDAY	FRIDAY	SATURDAY
OCTOBER 1962		1	2	3	4	5	6
	7	8	9	10	11	12 Circle I	13
	14	15	16	17	18	19 Circle IV	20 Circle II
	21	22 Circle III	23	24	25 Primo Piano I	26	27
NOVEMBER	28	29	30	31 Albany XI	1	2 Albany VII	3
	4	5	6	7	8	9	10
	11	12 Primo Piano II	13	14	15	16	17
	18 2 Circle IV	19	20	21	22	23 Wind Totem	24
DECEMBER	25	26	27	28	29	30	1
	2 Voltri-Bolton V	3 Voltri-Bolton IV	4 Voltri-Bolton III	5 Voltri-Bolton II	6 Voltri-Bolton I	7 Voltri-Bolton VI	8
	9 Primo Piano III	10	11	12	13	14	15
	16	17	18	19 Voltri-Bolton VII	20	21 Voltri-Bolton IX / Voltri-Bolton X / Voltri-Bolton XIX	22
	23	24 Cubi VIII	25	26	27	28	29
JANUARY 1963	30 Volton XIII	31	1 Volton XI	2 Volton XII	3 Volton III	4	5
	6	7	8	9	10	11	12 Volton XIV
	13	14 Volton XV	15	16	17 Cubi IV Cubi V?	18	19
	20	21	22	23 Volton XVI	24	25	26
	27 Voltri-Bolton XVII	28 Untitled	29 Volton XVIII	30	31		

trated on three very different series of work: the polychrome Circles, the improvisational Voltri-Boltons, and the heroic Cubis. Many of the works made during this time are documented by Budnik, who began his photographing of Smith's work and activities during that December. But we can also identify the precise completion dates of most of Smith's work during this period because the majority of pieces are not only signed and titled but dated by year, month, and day.[71] A chart showing the schedule of these four months is shown here.

Circle I was the first work completed in October; it is dated "10-12-62." *Circle II* followed on 20 October, and *Circle III* was completed two days after that. However, as the chart shows, *Circle IV* was completed on the 19th, before its two numerically preceding works. This numeration does not mean that Smith simply misnumbered the works. A similar and even more irregular pattern is found with the initial works in the *Voltri-Bolton* series, begun in December. Here, like the extraordinary pace of the inspiring *Voltri* series, Smith made a piece a day, between the 2nd and 7th of the month, basing the works on tools and other materials shipped to him from Voltri. But the first work, *Voltri-Bolton I,* was not completed until 6 December; *Voltri-Bolton V* was actually the first work completed, having been finished on 2 December. The photograph showing the welding of the former suggests that Smith may have finished sketching a work, then numbered its parts and set them aside for later welding, clearing the floor for other works. (Another possibility for this numbering is discussed in chapter 5.)

In a similar way during this four-month burst of activity, *Cubi IV* was completed on 17 January, although Smith had finished *Cubi VIII* on the preceding Christmas eve. Indeed, the Cubis show the greatest irregularity between the sequential numeration of the work and its actual date of completion. For example, *Cubi I* is inscribed "David Smith March 4—63 Cubi I," dating it shortly after the three-month period under discussion. But more importantly, it dates over sixteen months after the completion of *Cubi IX,* which had been exhibited at Spoleto along with the *Voltri* series.

The fact that these wide differences between the numeration and dates of completion occur in such a random pattern clearly suggests that Smith numbered the work—and gave the series title—with the conception of the work, rather than its completion.

In the case of the Circles, their formal character suggests they were largely made, rather than found. Smith would have had to make the large circular rings of each piece, cutting them out of steel plate. The existence of notebook drawings showing various configurations of the pieces suggests their simultaneous conception.

The Cubis, however, suggest yet another procedure. Here the completion sequence of the first twelve pieces is as varied as that of the early Voltri-Boltons, running *III, IX, VII, IV, V(?), I, VI, VII, II, XI, X, XII.*[72] But, as we have seen, the temporal separation from *Cubi III* and *IX* to *X* and *XII* is much greater than that for either the Circles or the Voltri-Boltons. This gap would imply that some of the Cubis were studied in some form of drawing or painting and that these initial compositional ideas were allowed to cure or to be further studied in another form, such as the carton maquettes. In this

regard, we should note that the maquette constructions of *Cubi IV* and *V* were made in December 1962, a month before the works themselves were constructed but also a year after *Cubi III* and *IX* had been completed.

Many Series

It is important to realize that while Smith was making these *Cubi* studies at night he was working on the early Voltri-Boltons during the day. During this four-month period Smith was constructing not only the *Cubi* and *Voltri-Bolton* series, but also the *Circle* and *Primo Piano* series. Thus when he was "making a lot of sculpture," he was making a lot of different sculpture. Furthermore, the practice of working in various series allowed ideas to cross, or stream, back and forth between them. The series overlap each other, and as one came to a conclusion, others would be under study.

It is argued in the essays that follow that in certain works Smith drew directly upon other works by other artists, ranging not only from Motherwell's *Elegies* and Noland's *Targets,* as we have seen, but also from Adrian de Vries' *Mercury* to Gottlieb's *Bursts*. Other works derive from Smith's own earlier sculpture, sometimes with surprising directness. In other works, the touching of one element to another might be recapitulated in a work completely different in character. In *Voltri-Bolton XVIII*, the arcing element at the outside of the work is most likely the remnant of steel from the sheet used by Smith to cut out a positive circle; it is visible, yet unused, leaning against a tree in a photograph taken of Smith with *Cubi IV* and *V.*

That Smith's stream meant making a lot of sculpture simultaneously in different styles may have encouraged his working in series. That is to say, the general concept of the series was useful in keeping certain directions, or points of view as Smith called them, in focus within the flow of his work. The series concept organized his work yet allowed for the flexibility of his stream; he could work within its broad perimeters until he had "exhausted its point of view."[73]

To be sure, Smith never defined a series as tightly as Noland's *Targets* or Morris Louis' *Unfurleds,* for example, where the works are essentially explorations of a formal theme that has a specific, central basis. Smith's series are largely defined by either a thematic basis, as in the Sentinels, Circles, and the Wagons, or by a shared use of materials, as with the Agricolas, Zigs, Voltri-Boltons, and Cubis. But within each series we still encounter wide formal and linguistic varieties.

Working in series was something that emerged with regularity during the 1950s. By 1956 it was a strong and distinguishing enough characteristic of Smith's art for Greenberg to call attention to it. He wrote:

That Smith shows everything he finishes, and that he has had a high frequency, at least in the past, of failure to success, has caused many misconceptions about his art. That he works, moreover, in such a diversity of manners (as well as tending to violate presumable unity of style within single pieces) does not make it easy to form a clear idea of his achievement as a whole. Add to this the fact of an almost aggressive originality, and we can understand why the art public and its mentors, while not exactly refusing their admiration, have not yet accepted his work in a way that would bring prizes, commissions, and the purchases of important pieces by museums and other public or semi-public agencies.[74]

We can now see that it is that diversity that not only makes Smith's oeuvre as rich and complex as it is but to some degree also played an important role in the expansion and articulation of his sculptural vocabulary.

The Fields

Smith retained possession of the vast majority of his pieces. Of the 193 works made from 1960 on, only twenty-two were sold and a few given away as presents during his lifetime. To be fair, this lack of sales was not entirely due to ignorance of the importance and quality of Smith's sculpture: Smith priced his works very high—at times higher than Picasso's sculpture—both as a reflection of what he thought it was worth vis-à-vis other sculpture and because he wanted it around him.[75]

Smith had few choices for indoor storage of his sculpture. Certainly some smaller pieces were kept in his house and on the platform that surrounded it on one side, off the living room. Other works were kept in the studio, although this area was small enough to be filled rather quickly. By 1959 Smith had fully utilized not only what he could of this studio area but had filled up the garage with sculpture, creating a gathering so dense one can barely make out the individual pieces.

The section of the driveway and platform outside of the studio also provided an area for putting works, but this appears to have been used primarily

26. Smith studio, date unknown.

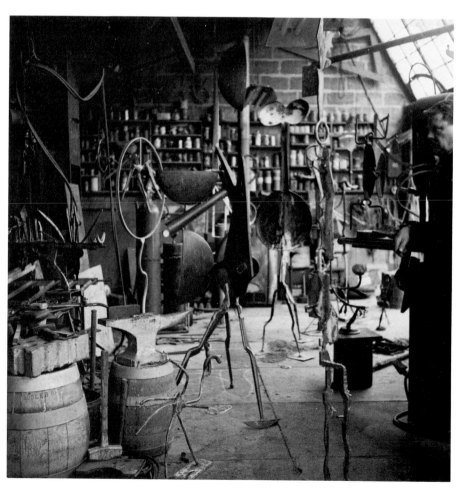

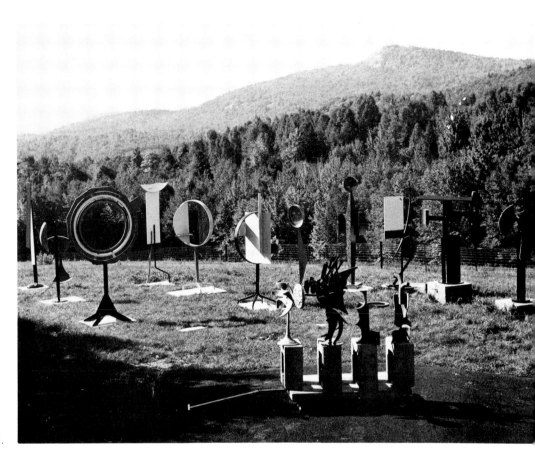

27. East field by Smith's house, 1961.

for pieces recently completed. Smith had begun using this space along with that of the house platform as early as 1952, as a photograph of Agricolas and other works makes clear, and he continued to use it into the 1960s, as a photograph of just-finished Voltri-Boltons indicates. At other times, the area of driveway outside of the densely packed garage was also used.

But none of these areas was sufficient, and the garage largely prevented Smith from seeing his work. The answer came in using the two large fields of the Bolton Landing property. Eventually Smith's installation of his sculpture around his studios would make Terminal Iron Works one of the most spectacular experiences in American art.

Exactly when Smith began to install his sculpture in the field, rather than simply placing them there, is not clear. We do know that as early as the 1930s Smith photographed his work in the field, often placed on top of a stool or chair. But these works are fairly small, and could not be permanently placed out-of-doors. Indeed, one could argue that these photographs were taken in the fields solely because of the good, available natural daylight as opposed to artifical studio lighting; but the fact of so many of these photographs existing argues against it. Furthermore, Smith developed in these photographs a kind of standard setting, showing the sculpture close up and from below so that they appear more monumental. This is especially true when they are seen with the sky and mountain ranges of Bolton Landing slightly out of focus in the background. This kind of photograph re-

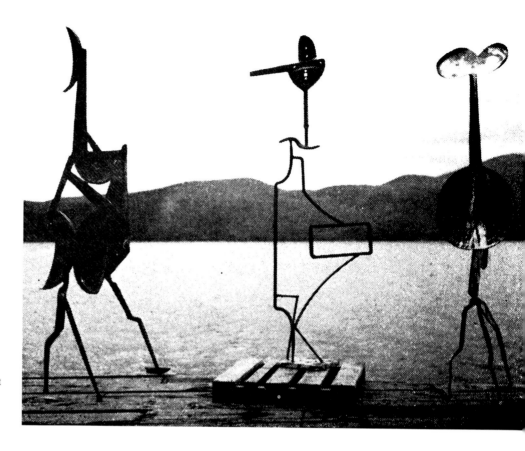

28. Smith sculpture photographed on town pier at Bolton Landing, before Lake George. Photograph by the artist, reproduced from *Arts*, February 1960.

mained constant with Smith, augmented only by another format, where he drove the sculpture down to the town pier and photographed it against the horizontal expanse of Lake George. These photographs indicate Smith's interest in at least seeing, if not actually installing, his work in juxtaposition with the heroic scale of the forest-covered ranges surrounding Bolton Landing. Certainly, this vision of his works had become a major factor by 1950, when Motherwell wrote a catalogue note for Smith's exhibition at the Marion Willard Gallery. Drawing upon a long conversation with Smith (which began a life-long friendship), Motherwell wrote:

When I saw that David places his work against the mountains and the sky, the impulse was plain, an ineffable desire to see his humanness related to exterior reality, to nature at least if not man, for the marvel of the felt scale that exists between a true work and the immovable world, the relation that makes both human.[76]

Then in 1954, as a film made by Ilya Bolotowsky shows, Smith put *Agricola I* out in the north field, perhaps the first work to be installed there.[77] *Agricola I* remained there for many years.

By 1956, Smith's work had grown enormously in scale, which may have encouraged him to put more pieces into the fields. We should note that he wrote to Marion Willard in this year, stating that he wanted the sculpture shown in her gallery returned to him, to be planted in the fields (the plant choice especially interesting in light of the *Agricola* series; see chapter 1). Eyewitness accounts also date the beginning of the more densely populated

field to this time.[78] And from Smith's own notes, we know that 1957 was the terminus post quem for this usage.

This is not to say that the fields at Terminal Iron Works were filled with sculptures during the later 1950s. Smith seems to have been reticent or at least concerned about how such an installation of his works would be perceived. In the notes he wrote for the special Smith issue for *Arts* magazine in February 1960, Smith observed:

Most of my sculpture is personal, needs response in close proximity and the human ratio. The demand that sculpture be outdoors is historic or royal and has nothing to do with the contemporary concept. It needn't be outside any more than painting. Outdoors and far away it makes less demand on the viewer—and then it is closer in scale to the most vociferous opinion-makers today whose acquaintance is mostly from reproductions.

In saying this, he clearly had in mind the pure steel/iron works as well as the painted sculpture, for he continued:

An exception for me started in 1957 with a series of stainless steel pieces from nine to fifteen feet tall. They are conceived for bright light, preferably the sun, to develop the illusion of surface and depth. Eight works are finished, and it will take a number of years on the series to complete it. Stainless steel seems dead without light—and with too much, it becomes car chrome.[79]

These works lead eventually through the later Sentinels to his last great series, the Cubis, which were constructed to respond exactly to Bolton Landing's environment (see chapter 7). As Smith wrote:

This is the only time—in these stainless steel pieces—that I have ever been able to utilize light, and I depend a great deal on the reflective power of light. In this case, it is late afternoon, and there is a sort of golden color reflected by the late afternoon sun in the winter; and it [the sculpture] reflects a rather golden color; and when the sky is blue, there is a blue cast to it. It does have a semi-mirror reflection, and I like it [stainless steel] in that sense because no other material in sculpture can do that.[80]

Five of these initial outdoor works were illustrated in the *Arts* issue, in a wide-angle shot taken by Smith. This photograph reveals that at this date, at least June 1959 given the inscription of *Sentinel V,* the south field was still largely empty.

By 1961 the fields had undergone significant changes and had begun to take on their dense character. As Frank O'Hara demonstrated in an *Art News* article, one now found "along the road up to the house a procession of new works, in various stages of painting." Moreover, the south field was now much more installed, as O'Hara noted:

The house commands a magnificent view of the mountains and its terrace overlooks a meadow "fitted" with cement bases on which finished stainless steel and painted sculptures were standing. . . . The contrast between the sculptures and this rural scene is striking: to see a cow or a pony in the same perspective as one of the *Ziggurats,* with the trees and mountains behind, is to find nature soft and art harsh; nature looks intimate and vulnerable, the sculptures powerful, indomitable. Smith's works in galleries have often looked rugged and in-the-American-grain, which indeed they are in some respects, but at Bolton Landing the sophistication of vision and means comes to the fore strongly. Earlier works mounted on pedestals or stones about the terrace and garden seem to partake of the physical atmosphere, but recent works assert an authoritative presence over the panorama of mountains, divorced from nature by the insistence of their scale and the exclusion of specific references to natural forms.[81]

By 1965 the Terminal Iron Works, by now a landmark, had become even more spectacular. Clive Gray visited Bolton Landing with Helen Frankenthaler, Robert Motherwell, and Mr. and Mrs. Alexander Liberman a weekend before Smith died.

All of us were stunned by the pageantry of his sculpture, which he had ranged outside like an army of behemoths massed down the grassy slopes which opened out from the forests . . . he enjoyed our gaping enthusiasm at what he called his sculpture farm.[82]

Eighty works were planted in the fields, with another eight underway on the studio floor or other areas; this does not count the smaller pieces installed around the house.[83] *Cubi XXVI* had just been completed and rested on the sculpture deck outside the studio. We can gain a clear idea of how the fields looked through a remarkable decision by the three trustees of the Smith estate, Ira Lowe, Greenberg, and Motherwell. With extraordinary foresight, they commissioned Ugo Mulas to make a complete record of the fields (and the studios), a project Mulas undertook only five weeks after Smith's death, before anything had been moved.[84] Using these photographs as a guide, we have created the plot plan of Bolton Landing, indicating the approximate position of every major work then installed on Smith's sculpture farm.

The Field in 1965

Terminal Iron Works is actually located outside and above the community of Bolton Landing, placed on the side of a mountain north of the town, looking down over Lake George. The western border of the property is determined by a road, which runs uphill to the north. Smith owned the land stretching from this road up to the top of the mountain on the east and to the top of the

29. Aerial view of Smith's house, studio, and sculpture fields at Bolton Landing, looking north.

30. South field, Bolton Landing.

hills in the northern and southern directions. The flatter area between the road and these rising areas had been cleared (for the previous fox farm) and roughly formed a rectangle, bordered on the north, east, and south by forest and along the western or road edge by a stand of birches.

The entrance to Terminal Iron Works occurs at approximately the two-thirds mark to the north along the tree line. Immediately through the gates stands Smith's long studio, the driveway passing between it and a grove of trees, around which his junk and steel plate piles were kept. Then curving slightly to the left and downhill the drive straightens and goes gradually uphill to the house, forking to run either directly to the garage under the house, or turning to the left and moving more steeply to the front door. On the north side of the house stood buildings used as studios and makeshift guest bedrooms. Smith's vegetable and tomato garden was also in this area.

On the opposite side of the house was the stone-paved deck outside the living room with its large windows: Both overlooked the south sculpture field, which stretched downhill from the house to the forest. As the plan indicates, the sculpture in the south field was generally aligned to face the house, placed in a north-south axis. The works in the north field were placed on an east-west axis.

Both the plan and Mulas' photographs show that the south field was less densely populated with works than the companion north field. The south field was considerably larger, however, so that the works are distributed over a greater area. The photographs give a somewhat distorted record of the in-

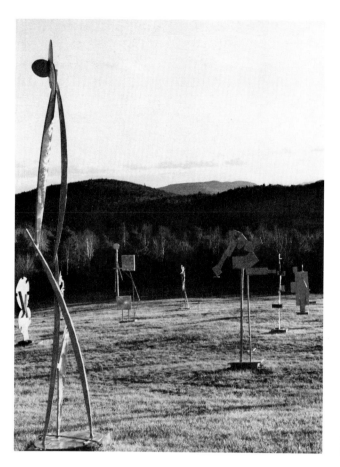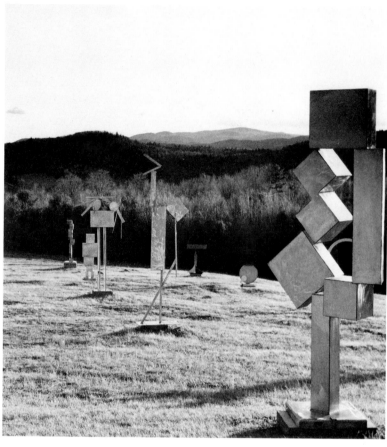

31. South field, Bolton Landing.

stallation, however, because the camera could not capture the wide sweep of the field as well as its depth, especially the vista seen toward Lake George. In this regard photographs taken off to the side indicate the presence of works that are not seen in the central perspective.

As the photographs and plan make clear, the works were lined up in parallel patterns, creating six rows of planted sculpture. Each work rests on a concrete pad or base, and most turn their front, or predominant view, toward the house. The major exception to this is the outer row toward the west. Largely a line of wide and horizontal works, these works are placed on end with respect to the house. In effect they create a wall around this area of the field, in fact the only line that opens into an adjacent field, that being the empty one to the south of the driveway, between the house and the studio.

The idea of this wall is even more interesting when we realize that standing in the center of it was *Cubi XXVIII,* with *Cubi XXVII* at one end; both of them were referred to by Smith as "gates."[85] And in this context they function as such, opening into the field behind them, a space filled with abstract yet figurative sculpture and centered around the observing Sentinels placed in the middle of the expanse. Intended or not by Smith, the feeling of this figural presence in the field is a real one, derived primarily from the verticality of the majority of the works and their association with the human figure. But a figuration also emerges from the radical naturalness and yet man-

60

made character of the work. Nor is it unique to the field at this time. Four years earlier, Frank O'Hara had been struck by it, and wrote:

Outside the studio huge piles of steel lay waiting to be used, and along the road up to the house a procession of new works, in various stages of painting, stood in the attitudes like a *Sentinel* or *Totem,* or *Ziggurat;* not at all menacing, but very aware.[86]

The works in the north field were also placed in linear alignment, here in four major rows running parallel to the drive, with the sculpture placed to face toward the west. Again, an exterior row contains works turned on end, two of the Wagons and another unpainted *Primo Piano.* Another work, *Wagon III,* also sits in this alignment, but out of a definite row.

Smith's use of the south field apparently was begun later than that of the north and initially for different reasons. Certain photographs taken around 1960 indicate that little if any sculpture was out in the south field, a conclusion supported by the fact that Smith sent no photographs showing any to Kramer for the 1960 *Arts* issue. Even by the following year this area may still have been largely unused; O'Hara's account speaks only of works lining the drive, especially telling in contrast to his description of the populated north field. Indeed, as late as 1962, few works were in the south field, documented by the photographs taken by Budnik upon his arrival. Most of the works were clustered down by the pond.

A later photograph, taken in the spring, shows a quite different case: Now the field is fully populated with works set upon concrete posts or bases. The majority of these new additions are Voltri-Boltons, the works made by Smith during the interim winter months. This suggests that at this stage Smith still thought of the south field as a storage area, a place where he could keep recently completed work. In this regard, the bases merely made it a slightly more formal arrangement than that of the works lining the road two years earlier. Yet as Smith continued to make sculpture, it was this south field

32. North field, spring 1963. Inscriptions by unknown hand.

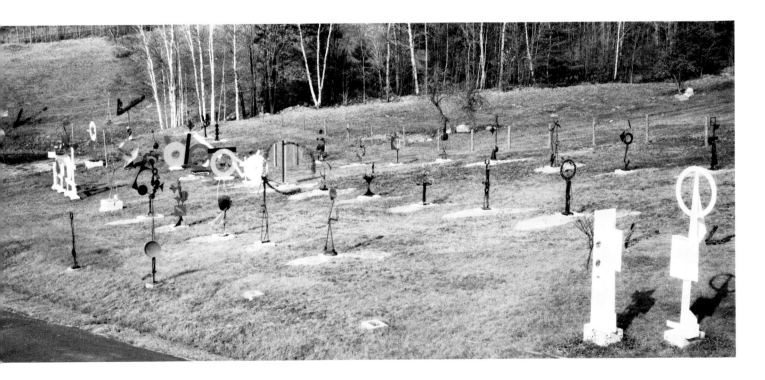

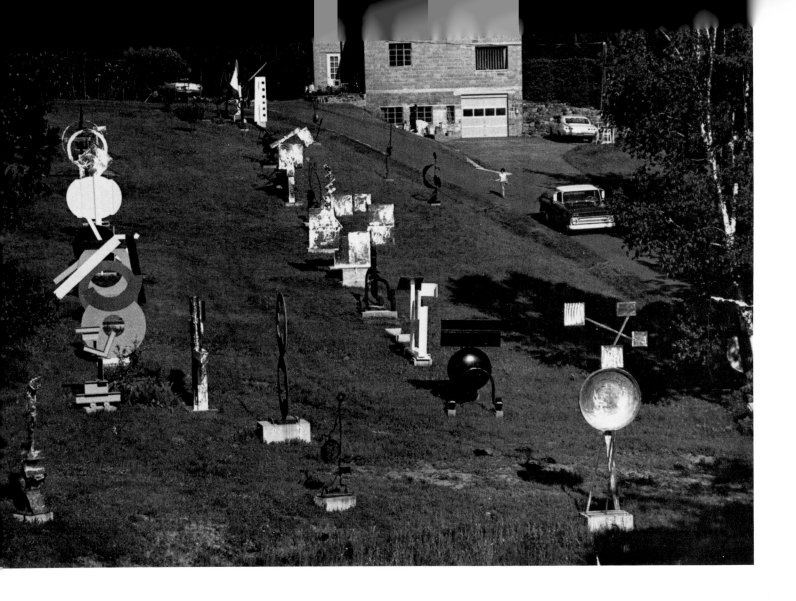

33. North field, June 1965.

more than the north that received the bulk of the work, collecting pieces to an incredible density at the time of his death. Even if Smith, in moving works into this area, initially thought of it as simply a receiving area, he began to use the arrangements for other reasons. For example, the first three Circles were probably conceived as independent works, rather than the tri-part unity we now conceive them to be. Indeed, when they were initially installed in the south field they were placed in positions so that each roughly sits on its own point of a triangle, facing inward. However, by the time of Budnik's arrival, Smith had reoriented them to the now traditional concentric alignment. During the next two years they remained in their location, while other works in the *Circle* series, such as *2 Circle IV* and *Oval Nose,* were brought into conjunction with them. Not until the following October, a year after *Circle I* had been completed, did Smith add the last initial *Circle* series piece, *Circle V,* to this ensemble, filling in its back opening and making the larger composition into a four-part work (the title *Circle IV* had been previously used for a work kept in the north field, one not adaptable to the initial two *Circle* pieces).

In other instances, Smith moved pieces into the south field so that he could study them in unison. That ranged from moving *Cubi IV, V, XV,* and

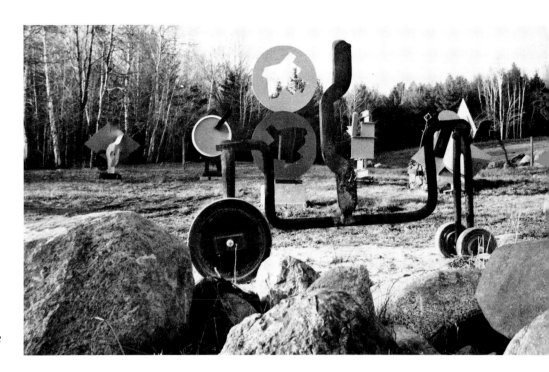

34. North field with *Wagon II* in the foreground and *2 Circle IV* behind it. In the back row, left to right, *Zig VII, Zig VIII, Untitled (Zig VI?),* and *Zig IV.* Date unknown.

the unfinished *X* into the middle of the second row, which brought them into comparison with the much more linear Voltri-Boltons, to a massive transfer of the Zigs, completed sometime briefly before his death. We can see the results of this shift in the background of a photograph of *Wagon II,* which records an irregular row comprised of *Zig VII, Zig VIII,* and the much earlier *Zig IV.* Indeed, this photograph supports the opinion (argued in chapter 3) that the work that Smith placed between *Zig VIII* and *Zig IV* is not in fact *Untitled* but rather is *Zig VI,* the work missing in the numerical sequence.

Sculpture of the scale of these works, and of the *Cubi* "Gates" in the north field, weigh an enormous amount and required the assistance of Smith's neighbors and a tractor to move them around. Clearly these positionings and repositionings were important to Smith.

The role these varying conjunctions played in his work was to support its ongoing development and to enable Smith to learn from his own work. As Smith said of individual pieces:

When it [the sculpture] is finished there is always that time when I am not sure—it is not that I am not sure of my work, but I have to keep it around for months to become acquainted with it and sometimes it is as if I've never seen it before and as I work on other pieces and look at it all the kinship returns, the battle of arriving, its relationship to the preceding work and its relationship to the new piece I am working on. Now comes the time when I feel very sure of it, that it is as it must be and I am ready to show it to others and be proud I made it.[87]

Of those sculptures yet to be made:

My sculpture and especially my drawings relate to my past works, the 3 or 4 works in progress and to the visionary projection of what the next sculptures are to be. One of these projections is to push beauty to the very edge of rawness. To push beauty and imagination farther toward the limits of accepted state, to keep it moving and to

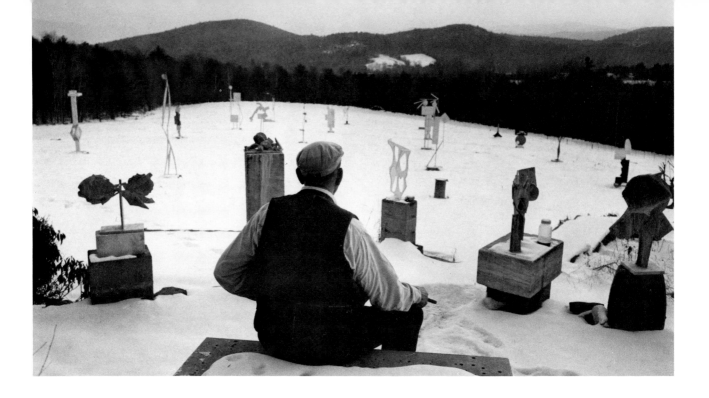

35. Smith studying the sculpture in the south field, 1962 or 1963.

keep the edge moving, to shove it as far as possible towards that precipitous edge where beauty balances but does not topple over the edge of the vulgar.[88]

In that sense the two sculpture fields, with their rearrangements, meant a constant source for Smith of creative ideas; and it is no wonder he wanted to keep them around him, where he could sit and study them for hours: "My sculpture is part of my world; it's part of my everday living; it reflects my studio, my house, my trees, the nature of the world I live in."[89]

In the end, the fields at Bolton Landing were the final aspect of the work stream, the statement of Smith's identity. And to reach that stream he had to merge himself almost totally with his sculpture and live in isolation at Terminal Iron Works:

The insecurity of other things has forced work so much so that work is now a catharsis—and my only security.

The conscious things like cooking, cleaning, must be done with music or hastily because work interruption was in a state of challenge and its return is anticipated and awaits a certain battle I must win or culminate.

Yet lonesomeness is a state in which the creative artist must dwell much of the time. The truly creative artist is projecting towards what he has not seen, and can only take the company of his identity. The adventure is alone and the process itself becomes actuality. It is him and the work. He has left the subject behind.[90]

Given what Smith wrote about his loneliness in 1951 before he began the Agricolas, it is appropriate to note that at the end of his life, despite what his sculpture had cost him, his work, his daughters, and his sense of the creative stream did cause him moments that broke through his feelings of despair. "Real beauty in life," he wrote,

is well fed girls in the house, black night, totally quiet except for symphony from WQXR—cleaned up shop—acid etching name and date on last finished work, new one going on the floor, and finished work about, sometimes the consciousness and the sequence bring the greatest glory I get.[91]

Smith's sculptural stream, from *Agricola I* to *Cubi XXVI*—from the first to the last series—is one of the most extraordinary events in American art.

Notes

1. Kenneth Noland in Cleve Gray, ed., "David Smith," *Art in America, 54* (January–February 1966), 44.

2. David Smith, *David Smith by David Smith*, ed. Cleve Gray (New York, 1972), 170.

3. Gray, *Smith*, 164.

4. Sam Hunter, "David Smith," *The Museum of Modern Art Bulletin, 25* (New York, 1957), 3.

5. David Smith in "The Secret Letter" (interview with Thomas B. Hess) in Garnett McCoy, ed., *David Smith* (New York, 1973), 177.

6. Smith, "Secret Letter," 176.

7. Smith in Gray, *Smith*, 24.

8. Smith in Gray, *Smith*, 24.

9. Smith in Gray, *Smith*, 24.

10. David Smith, "Notes on My Work," *Arts, 34* (February 1960), 44.

11. David Smith in Katherine Kuh, *The Artist's Voice* (New York, 1962), 224.

12. Paul Cummings, *David Smith: The Drawings* [exh. cat., Whitney Museum of American Art] (New York, 1979), 12.

13. Smith in Gray, *Smith*, 25.

14. Karen Wilkin's recent essay is a step in this direction; *David Smith, The Formative Years* [exh. cat., Edmonton Art Gallery] (Edmonton, 1981).

15. Smith in Gray, *Smith*, 26.

16. Gonzalez had been trained in decorative metal work by his father, and his family had formed a workshop in this tradition.

17. See Josephine Withers, *Julio Gonzalez: Sculpture in Iron* (New York, 1978), and Werner Spies, *Sculpture by Picasso* (New York, 1971).

18. William Rubin, *Anthony Caro* [exh. cat., Museum of Modern Art] (New York, 1975), 21.

19. Wilkin, *Formative Years*, 9.

20. Smith in Gray, *Smith*, 25.

21. Smith in Gray, *Smith*, 31. Smith would often trade repairs for scrap materials.

22. Smith in Gray, *Smith*, 31.

23. David Smith, "Notes for *David Smith Makes a Sculpture*," *Art News, 68* (January 1969), 47.

24. Smith, "Notes for *Makes a Sculpture*," 47.

25. Smith, "Notes for *Makes a Sculpture*," 47.

26. Smith, "Notes for *Makes a Sculpture*," 47.

27. James Rosati in Gray, "David Smith," *Art in America*, 46.

28. Gray, "David Smith," *Art in America*, 25.

29. Elaine de Kooning, "David Smith Makes a Sculpture," *Art News, 50* (September 1951), 38–41, 50–51; Smith, "Notes for *Makes a Sculpture*"; Hilton Kramer, "The Sculpture of David Smith," *Arts, 34* (February 1960), 22–41; Smith, "Notes on My Work," 44; Dan Budnik, *The Terminal Iron Works* [exh. cat., American Federation of Arts and participating museums] (Albany, 1974).

30. De Kooning, "Smith," 56.

31. Smith on a photograph illustrating Kramer, "The Sculpture of Smith," 48.

32. Budnik, *Iron Works*, 3.

33. Smith in "Secret Letter," 181.

34. See Wilkin, *Formative Years*, for a discussion of the 1940s. *House of the Welder* is discussed in detail in Edward Fry, *David Smith* [exh. cat., The Solomon R. Guggenheim Museum] (New York, 1969), 40–41.

35. Although the relationship between Gonzalez and Smith and their drawing in the air appears throughout the literature, it is discussed in stylistic terms rather than as procedural steps.

36. Robert Goodnough, "Jackson Pollock Paints a Picture," *Art News, 60* (May 1951).

37. "Some works start out as chalk drawings on the cement floor," said Smith in his note to de Kooning; for full text see Smith, "Notes for *Makes a Sculpture*," 46.

38. The photographs would here have been taken during the fall in order to be published in the February 1960 *Arts*, given the two to three months needed for preparation of the magazine. The photograph could have been taken even earlier, with Smith's inscription added in the fall. See note 41.

39. Smith, "Notes on My Work," 44.

40. David Smith, "Some Late Words From David Smith," ed. Gene Baro, *Art International, 9* (20 October 1965), 50.

41. Smith's inscription suggests that he had clearly added the wheels to this piece, at least as an idea. However, the photograph may be of an earlier state, with Smith's descriptions added later. See note 38.

42. Budnik, *Iron Works*, 4.

43. Gonzalez in Withers, *Gonzalez*, 136.

44. For a discussion of this point see E. A. Carmean, Jr., Introduction in *American Art at Mid-Century: The Subjects of the Artist* [exh. cat., National Gallery of Art] (Washington, 1978).

45. Smith in Gray, *Smith*, 78.

46. Robert Motherwell, quoted in E. A. Carmean, Jr., *The Collages of Robert Motherwell* [exh. cat., The Museum of Fine Arts] (Houston, 1972), 91.

47. Carmean, Jr., in Introduction, *Subjects*, 33.

48. Both illustrated in Fry, *Smith*, 156–157.

49. Budnik, *Iron Works*, 14.

50. Robert Murray in conversation with the author.

51. Smith in Baro, "Late Words," 50.

52. Smith in Baro, "Late Words," 49.

53. My discussion of welding is drawn from conversations with James Wolfe, a New York sculptor, who not only answered many questions about procedure but guided me through my actual making of a small work following steps Smith would have used, and from Clarence E. Jackson, "Welding," *Encyclopedia Americana, 28* (New York, 1965), 599–603.

54. Jackson, "Welding," 600.

55. Smith in Belle Krasne, "A David Smith Profile," *Arts, 26* (1 April 1952), 13, 26.

56. Smith in Gray, *Smith*, 68.

57. Smith in Gray, *Smith*, 68.

58. Smith in Gray, *Smith*, 106.

59. See Rubin, *Caro*, 22.

60. Motherwell in conversation with the author.

61. Smith in an interview with David Sylvester, in McCoy, *Smith*, 172.

62. Smith in Baro, "Late Words," 49.

63. Smith objected to the word polychromed, saying: "Now that's a dirty word, 'polychrome.' What's the difference between sculpture using color and painting using color?" In "Secret Letter," 182.

64. Smith in Baro, "Late Words," 49.

65. Smith in "Secret Letter," 182.

66. Smith in Baro, "Late Words," 49.

67. Smith in Baro, "Late Words," 49.

68. Clement Greenberg, "David Smith," *Art in America, 44* (Winter 1956–57), 33.

69. See Carmean, Jr., "David Smith: The Voltri Sculpture" in *Subjects*.

70. This count is based on the entries in Rosalind E. Krauss, *The Sculpture of David Smith* (New York, 1977).

71. Smith switched back and forth between a sequence of day/month/year and month/day/year, making positive dating of some works problematic. The period discussed here was selected because the dating is supported by the evidence in Budnik's photographs.

72. *Cubi V* is not dated by an inscription but first appears in the fields paired with *Cubi IV*.

73. Smith in Baro, "Late Words," 50.

74. Greenberg, "Smith," 30, 33.

75. The count is based on Krauss, *The Sculpture*. For a discussion of Smith's prices, see Rosalind E. Krauss, *Terminal Iron Works: The Sculpture of David Smith* (Cambridge, Massachusetts, 1971), note 13, page 60.

76. Robert Motherwell in Gray, "Smith," *Art in America*, 37.

77. It is not clear from the film if Smith is putting *Agricola I* there for the first time or reenacting its installation.

78. Kramer in conversation with the author.

79. Smith in "Notes on My Work," 44. Interestingly, Smith later wrote in 1962 that using the fields was not planned: "I put my works in the fields. That was an emergency, lacking storage space. I did not conceive a field complex, but since it grew out of necessity I accept it." In "Report on Voltri," in Garnett McCoy, ed., *David Smith* (New York, 1973).

80. Smith in Baro, "Late Words," 49.

81. Frank O'Hara, "David Smith: The Color of Steel," *Art News, 60* (December 1961), 33–34.

82. Gray in *Smith*, 15.

83. This count is based on the Mulas photographs; the identification of certain works draws from later photographs taken by Budnik.

84. Certain pieces appear outside in Mulas' photographs, but other photographs indicate these were moved out of the studio for better lighting. They are not included in the accounting here.

85. Smith in Baro, "Late Words," 49.

86. O'Hara, "Color of Steel," 32.
87. Smith in Gray, *Smith*, 57.
88. Smith in Gray, *Smith*, 77.
89. Smith in Gray, *Smith*, 135.
90. Smith in Gray, *Smith,* 169.
91. Smith in Gray, *Smith*, 137.

1. Deck outside Smith's studio in winter 1952. *The Hero* (Brooklyn Museum of Art) is the large sculpture at the left, and *Agricola I* (unfinished) is at the right.

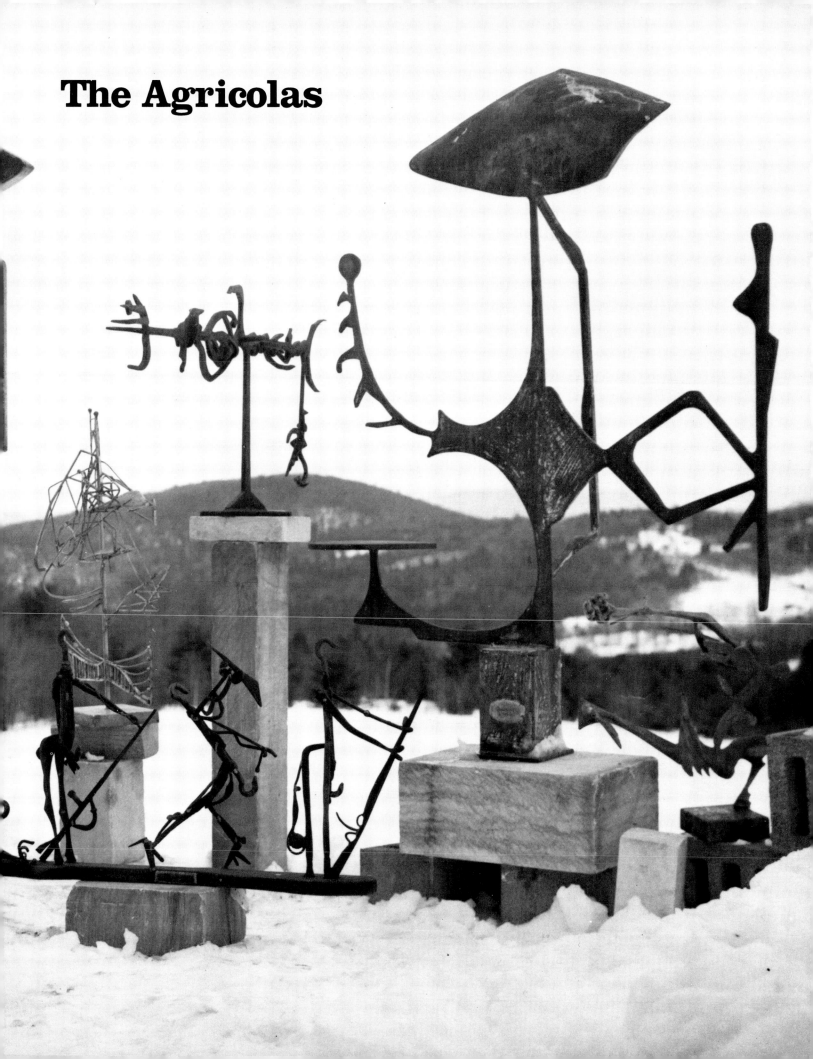

The Agricolas

Agricolas

1. *Agricola I,* 1951–1952
 steel, painted red (K-264)
 186.7 x 140.3 x 62.6 cm (73½ x 55¼ x 24⅝ inches)
 inscribed on front, left corner: David Smith G 2
 Hirshhorn Museum and Sculpture Garden, Smithsonian Institution, Washington, D.C.

2. *Agricola V,* 1952 (July)
 steel (K-269)
 90.2 x 71.1 x 26.7 cm (35 x 28 x 10½ inches)
 inscribed on back of base plane: 1952 / David Smith AGRICOLA. V.
 Collection of Mr. and Mrs. Eugene M. Schwartz

3. *Agricola VIII,* 1952 (August)
 steel and bronze, painted brown (K-272)
 80.7 x 54.0 x 47.6 cm (31¾ x 21¼ x 18¾ inches)
 inscribed on plate welded to base plane: David Smith / 8 AGRICOLA VIII / 1952
 Collection of Candida and Rebecca Smith. Courtesy of M. Knoedler & Co., Inc., New York

4. *Agricola X,* 1952
 steel, painted red (K-274)
 88.0 x 32.1 x 68.3 cm (34⅝ x 12⅝ x 26⅞ inches)
 inscribed on plate welded to base plate: David Smith / AGRICOLA X / 1952
 Collection, Mrs. Norton S. Walbridge

5. *Agricola XIII,* 1953 (February)
 steel and stainless steel (K-285)
 85.1 x 106.7 x 26.7 cm (without base) (33½ x 42 x 10½ inches)
 inscribed on base: David Smith 2/14/53 / AGRICOLA XIII (ARK.)
 Collection, Dr. and Mrs. Arthur E. Kahn

6. *Agricola 54,* 1954
 steel (K-319)
 89.5 x 22 x 34 cm (35¼ x 8½ x 13½ inches)
 inscribed on plate at base: 5/12/54 / David Smith
 Philadelphia Museum of Art, Purchased: Fiske and Marie Kimball Fund

7. *Agricola XVII,* 1957
 steel (K-412)
 61.6 x 21.6 x 28.6 cm (24¼ x 8½ x 11¼ inches)
 inscribed on plate welded to base: David Smith 7/10/57 / AGRICOLA XVII 1957
 Collection of Candida and Rebecca Smith. Courtesy of M. Knoedler & Co., Inc., New York

8. *Agricola XXI,* 1959
 steel (K-454)
 101.6 x 81.3 x 25.4 cm (40 x 32 x 10 inches)
 inscribed on vertical column just above base, appears reading downward from left to right:
 David Smith AGRICOLA XXI 11/2/59 (The *g* in Agricola is upside down.)
 Collection, Mr. Frederick Morgan

CHAPTER 1 The Agricolas

Agricola: 1. a cultivator of land; 2. of the gods: a patron or tutelary deity of agriculture.

The White Latin Dictionary[1]

By almost all accounts David Smith's work of 1951 and 1952 marks the dividing line in his oeuvre, separating his sculpture into its early phase and that of his mature career. That change is largely identified with five major pieces. The first, and most often cited of these is *Australia*, the abstracted form of a "huge, insectorial bird," completed in 1951.[2] Measuring almost 80 inches by 107 inches, *Australia* dwarfs all of Smith's previous works, of which only one sculpture exceeded four feet in any direction. The same sense of a new, much bigger scale also applies to the four other key works. Both *The Banquet* and *Hudson River Landscape*, also from 1951, stretch out horizontally to achieve their immense size, and *The Hero* and *Agricola I*, both dating 1951/52, are big, vertical compositions. Of these latter four, *Hudson River Landscape* is closest to *Australia* in critical and art historical prominence in accounts of Smith's maturation.[3]

Leaving aside questions of quality, which all five works share, *Agricola I* plays the most crucial role in the emergence of Smith's work in the 1950s. It gains that distinction principally from the fact that with *Agricola I*, alone among these five works, Smith introduced into his art the concept of working in a serial manner, a central characteristic of his mature career (see Introduction) and a principle that had only been broached in his plaquettes, *The Medals of Dishonor*.[4] Smith made sixteen works in the *Agricola* series between 1951 and 1959 and possibly more, for the numbering is very inconsistent. It misses *XIV* to *XVII*, *XIX*, and *XX*, but includes *Agricola 54*. Smith also retitled an earlier work of 1933 *Agricola Head*, thus adding it to the series.

Agricola I and the other Agricolas also differ from the other key works of 1951/52 in the material that Smith used for them: abandoned or disused pieces of farm machinery. Hence the series title, *Agricola*, which is Latin for "farmer." This particular material, in turn, generated a new kind of figura-

2. Smith with *Australia*, 1951. (Collection, The Museum of Modern Art, gift of William S. Rubin). Photographer unknown. Not in exhibition.

tion in Smith's art, one that would remain at the core of his sculptural thinking until his death. To be sure, not all of the Agricolas are figural, but with the use of the new material came a kind of abstraction also new to Smith's art and of equal importance. Finally, the Agricolas, and especially *Agricola I,* differ from the other four contemporary pieces of 1951/52 in how its figuration was arrived at or extended, in particular the manner in which Smith used external sources. That change, in turn, led to a new kind of thematic presentation in certain pieces.

Past Tools of Agriculture

Given the location of Bolton Landing in rural upstate New York, Smith would have seen abandoned farm implements almost daily, and such material would have been of widely ranging vintage. He would have had direct access to it, given the contacts made in doing repair welding on neighbors' equipment. "Up here [in Bolton Landing] you trade a lot, help each other out," says his daughter Rebecca Smith. "He was always getting things."[5] As

with other found elements that were constantly being added to his cache of material supplies, Smith would have collected farm items during the nine years of the *Agricola* series. And he continued to do so after the series ended, acquiring entire tractors shortly before his death (see chapter 6).

Smith also stockpiled other kinds of elements with functional character for use in other series, such as the wheels that support the Wagons or the tools that appear in the *Voltri* and the *Voltri-Bolton* series. Given this wider use of mechanical or functional components, and especially their introductory and focal employment in the Agricolas, it is important to know Smith's attitude toward them. He wrote:

The agricola series are like new unities whose parts are related to past tools of agriculture. Forms in function are often not appreciated in their context except for their mechanical performance. With time and the passing of their function and a separation of their parts, metaphoric changes can take place permitting a new unity, one that is strictly visual.[6]

The way in which Smith transformed these elements into sculpture by means of a visual unity was central to the maturation of his work.

The idea of a mechanical part playing a role in modern art goes back to the Italian futurists and the Parisian artists allied with them, such as Raymond Duchamp-Villon. In their works the machine, an image of the industrial age, was used largely for iconographic reasons; the machine rarely exercized any formal influence. Duchamp-Villon's *Horse*, for example, contains passages that make explicit references to mechanical elements, but the passages are rendered in what is essentially a traditional manner. By contrast, Smith's works, like the Agricolas, avoid both conventional depiction and the creation of an industrial icon.

The direct inclusion of a mechanical piece into a sculpture—rather than its depiction—began, interestingly, with the works of Duchamp-Villon's brother, Marcel Duchamp, including his *Bicycle Wheel* and *Urinal*. These works created a lineage that continues to Tinguely and his moving sculpture machines; the central aspect of one of the sculptures is our recognition of its elements being what they are. Again, by contrast, in *Agricola I* and in Smith's other works, even if we recognize what the particular piece actually is—a plow share, for example—that knowledge does not play a role in understanding the character of the work itself (see below).

Gonzalez and Picasso

The usage of mechanical and other useful, real elements for principally formal reasons—rather than thematic ones—began with the works of Gonzalez and Picasso in the later 1920s. Their extraordinary invention and articulation of welded metal sculpture became the tradition to which Smith so quickly and firmly allied his art. Gonzalez' and Picasso's works were vertically composed out of a wide variety of metal objects that they either found (especially Gonzalez) or acquired for the works.

In certain works by Picasso, the variety of component parts—as well as their manner of assembly—was left visible as part of the aesthetic of the work. As Werner Spies observes:

The novel feature of the sculptural synthesis produced by these individual motifs is

its material, tactile richness. The varied techniques employed (the back of the head is of wrought iron, other parts are welded, still others bolted together) and the diversity of the pieces of metal that compose the sculpture, some of them used as found and others trimmed to shape, combine to make total perception difficult for the beholder. Here, far more than in the Cubist constructions, the material is permitted a voice of its own. No attempt has been made to conceal its diversity and the multiplicity of techniques employed, nor to camouflage the numerous joints and welds. The blacksmith's technique itself, in its crudest possible guise, is integrated in the work.[7]

In other cases, such as the *Head of a Woman,* Picasso knew the kind of shape he wanted and then thought of the appropriate source material. As Spies relates:

[Picasso] told me that it suddenly occurred to him to construct the back of the head out of colanders. "I said to González, go and get some colanders. And he brought back two brand-new ones."[8]

Gonzalez also used scrap iron in his sculpture, indeed almost exclusively, for his desperate financial condition would have precluded the purchase of new steel stock or the sending out for new commercial ingredients, such as the colanders that the—by this time—rather wealthy Picasso could certainly afford. However, Gonzalez' use of scrap iron was considerably different from Picasso's, for in Gonzalez' hands the metal was cut, shaped, or worked in such a way that it lost most, if not all, of its initial identity. The exception to this was the way in which his metal had already been aged, giving it a sort of industrial patina or pitted surface that gives the works a rugged appearance. It was perhaps logical that Gonzalez would handle scrap iron in this fashion, given that he had been trained as a metalworker, whereas Picasso had no such skills and depended upon Gonzalez to weld his constructions. But there was also a difference in their aesthetics. In Gonzalez' sculpture, the abstract materials are also composed more abstractly. To be sure, figuration is a consistent feature of his work, but it is largely achieved by the manner in which his sculptural drawing resembles a schematic drawing of a figure, whereas Picasso's work often employs metal elements because they resemble a more traditional, bulky conception of parts of the figure. In Gonzalez' *Femme se coiffant,* for example, the iron elements are positioned so as to resemble a rough drawing of a woman arranging her hair; her legs and torso are rather easy to see in the lower components, but the upper passages are almost obscure in their diagrammatic character: the semicircle as her head, the bent metal to the right as her arm, the zig-zag passage on the left as an outline of the fall of her long hair. By contrast, in Picasso's *Head of a Bull,* our understanding of what the work represents depends solely on reading the bicycle seat and handlebars as a bull's head; but this representation functions by the resemblance of the construction to a conventional bull's head. Furthermore, its magic lies in the image emerging from the juxtaposition of the two elements. They remain unaltered, and it is quite possible to see them also for what they are, unlike Gonzalez' worked iron.

Agricola I

In making *Agricola I,* Smith firmly merged these two differing strains of earlier welded sculpture. He used farm implements in an unaltered state,

much like Picasso had used colanders or bicycle parts, but did not rework them as Gonzalez would have done. And like Picasso, Smith allowed entire natural objects to stand for things, such as the plow blade at the top of the sculpture, which serves as a head. I say "stands for" rather than represents for here the head remains abstract, certainly featureless; its image is indicated more by placement rather than resemblance. As such it corresponds more to Gonzalez' method of depiction.

Other farm tools are also identifiable in *Agricola I*, although they are less legible in their original, functional roles. The long vertical element on the left, with its bumps, is perhaps some form of gearing, and the upper bow of the right, with its serrated projections, is a small plow or earth-turning element. Indeed, it is possible that *Agricola I* is made entirely from such once-useful agricultural tools, but if so, we cannot specifically identify the parts. The reason parallels the merger of Gonzalez' and Picasso's aesthetic discussed above. Again, Smith used unaltered elements in part, if not all, of the lower portions of the sculpture, corresponding to Picasso's direct employment of actual material; but unlike Picasso, Smith combined these elements in a compositional manner so that their identity is either made secondary or lost entirely, thus recalling Gonzalez' handling of abstract, worked scrap iron. In *Agricola I*, this lessening of identity takes place in two interrelated ways. First, Smith joined the elements in such a way that the forms either merge together directly, so that no part-to-part differentiation is visible on sculptural terms, and second, what seams do exist were covered when Smith painted the sculpture. Indeed, this all-over coat of brick red further fuses the once-separate elements into a seamless construct by making the surface appear continuous. We can see how unifying the paint is by means of a photograph of *Agricola I* in an unfinished state. Without paint the parts seem far more distinct in character, especially the plowshare at the top. These photographs also reveal that changes were made in Smith's conception of *Agricola I*, as he later reversed its frontal orientation. Originally it stood with the vertical element on the right, as we see in a group shot that indicates the signature plate on the now opposite side. In flipping *Agricola I*, Smith also had to reverse the bowing element that he wanted on the back of the work, standing out from the largely planar organization of the sculpture. Another photograph shows that this piece was initially attached to what is now the front. The same photograph also reveals that the small circle at the end of the serrated curve was originally a flat disk facing frontally, which Smith later twisted to the side, perhaps in order to have it echo the flat horizontal plane below.

Mercury

Although the presence of figuration in Smith's sculpture has long been observed to be a central aspect of his work, it has been discussed as something developed within the context of his work, whether the figure is seen as only a "pretext" for sculpture, as Greenberg proposed, or the result of an "obsessiveness with images," as Krauss believes.[9]

The major change in our understanding of the nature of Smith's figuration came in 1976 when Phyllis Tuchman observed that *Agricola I* was not sim-

Agricola I (unfinished).

3. Right. David Smith. *Agricola I*, 1951–52. Steel, painted red, 186.7 x 140.3 x 62.6 cm (73½ x 55¼ x 24⅝ inches). Hirshhorn Museum and Sculpture Garden, Smithsonian Institution, Washington, D.C.

ply a generalized figural image but a particular one that could be connected to the work of another artist.[10] To be sure, previous analyses of Smith's sculpture had made comparisons between it and other two- and three-dimensional works by other painters or sculptors, but these relationships were largely seen as broad stylistic affinities. By contrast, Tuchman pro-

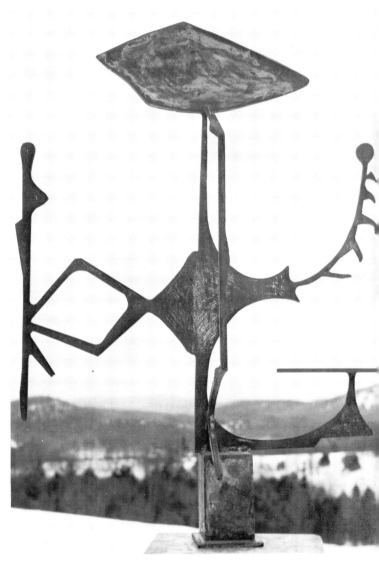

Agricola I (unfinished).

4. Attributed to Adriaen de Vries. *Mercury*, 1603–13. Bronze, 177 x 48.5 x 94.9 cm (69⅝ x 19 x 37¼ inches). National Gallery of Art, Washington, D.C., Andrew W. Mellon Collection, 1937. Not in exhibition.

posed that the 1951 sculpture was based on a specific object. The overall figural imagery of *Agricola I* is relatively easy to identify: the large head, the vertical central body core, the extended arms, and the supporting leg. What Tuchman observed is that the arrangement of these larger forms and of their details makes a direct reference to the famous sculpture of *Mercury,* at-

tributed to Adrian de Vries. This large seventeenth-century bronze is in the collection of the National Gallery of Art, exhibited prominently above the fountain in the central rotunda of the West Building. As Smith was frequently in Washington during this period, lecturing at American University in 1951 (the year *Agricola I* was begun), it is highly probable he knew the work directly, and he certainly would have known it from reproductions. As Tuchman pointed out, Smith's sculpture repeats the winged foot of *Mercury* (here turned to the front), the extended arm, and the cradled caduceus with its entwined vine. Even the lifting rhythm of *Mercury*'s movement is persistent in *Agricola I*. Following Tuchman's lead, we can now see that this *Mercury* variation is not an isolated instance in Smith's career. Indeed, in the six other series discussed in this catalogue, the Sentinels, Wagons, and Circles all begin with a variation upon a work of another artist, whereas the Zigs, Voltri-Boltons, and Cubis rely on conventions within Smith's own previous work.

In making the *Mercury* variant, Smith further merged, as well as changed, the Picasso-Gonzalez strains. Gonzalez' sculpture was largely developed first in a series of drawings, which move from realistic images to abstracted figures, the latter corresponding with the eventual sculpture. The final sculptural work was made from abstract iron elements that matched the drawn or planate sections in the paper sketch. By contrast, in Picasso's work, whether they were initially sketched or not, the real objects that are used are incorporated into the context of the sculpture by their resemblance to the specific passage of the figure. Smith, in composing *Agricola I,* clearly chose to create a figure that had Mercury as its underlying base, but his manner of reordering the figure is taken from, and yet is much different from, the procedures used by his predecessors. Like Picasso, Smith worked with unaltered objects—his farm tools—but where Picasso's joined colanders looked like a head, Smith's plow only vaguely recalled one, and certainly not the head of *Mercury*. Indeed, Smith's parts were used abstractly, and it is their location and interplay with each other that makes them analogous to their counterparts in the Adrian de Vries' sculpture. In that regard, Smith was much closer to Gonzalez' kind of metaphoric representation. But by using already extant, varying shapes of metal to parallel an extant image, Smith eliminated the sketching and fashioning found in Gonzalez' work. Like Gonzalez, Smith fused his tools into a seamless image by placement and paint, in contrast to the less-absorptive structures of Picasso.

Antiquity

Agricola I, with its theme of the figure in motion, is not unique in the *Agricola* series, although its large scale and refined, graceful composition make it the dominant work and justifiably the most famous. Two other pieces in the series, *Agricola V* and *VI*, present running figures and share in *Agricola I*'s frontal, or planate, organization of the overall composition.

In *Agricola V,* a rather abstract configuration is placed on top of an arc that turns up to the midpoint of the figure. The two legs are formed by a single element, almost vertical for the front leg, while the other curves out and trails behind, ending at a perforated plate set at a right angle to the major

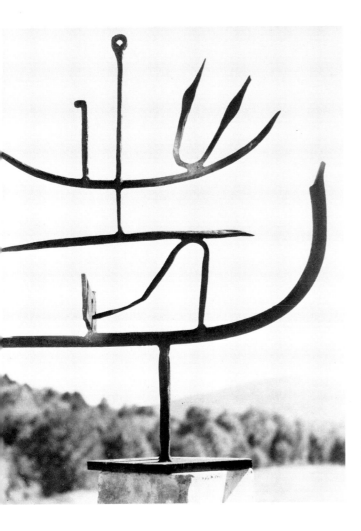

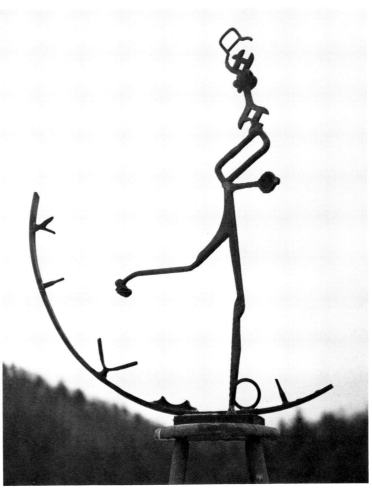

5. David Smith. *Agricola V,* 1952. Steel, 90.2 x 71.1 x 26.7 cm (35 x 28 x 18¾ inches). Collection, Mr. and Mrs. Eugene M. Schwartz.

6. Right. David Smith. *Agricola VI,* 1952. Steel, cast iron, and stainless steel, 106.7 x 84.5 x 28.6 cm (42 x 33¼ x 11¼ inches). Collection, Eugene von Stanley. Not in exhibition.

plane. In contrast to this side view of the striding legs, the upper torso is turned frontally, a long horizontal for the hips, a curving horizontal with attached elements for the arms, and a long piece for the spine, ending with a flattened circle with a hole for the head.

Agricola VI is also set on a curve—here a half-circle. The figure in this work is much easier to read, indeed almost academic. Again a long vertical stands for the forward leg; the back one is a similar piece, but the presentation is much more conventional in design, including the foot. The upper torso is a set of interconnected pieces, leading to the open head. Even the arm in front, balancing the trailing leg, is easy to decode.

Like *Agricola I,* these two pieces appear to be based on other works of art, although no specific source is identifiable. Nevertheless, with its side legs and frontal torso, *Agricola V* recalls similar configurations found in ancient Greek art, such as the Gorgon from the Corfu temple. *Agricola VI* is even closer to the striding single figures often seen in Greek vase painting, especially in light of its supporting part-circle. Many writers on Smith's later works comment on his classicizing tendencies, especially when working with irregular materials, such as the Italian steel elements used in the Voltris and Voltri-Boltons (see chapter 5). But in studying these early Agri-

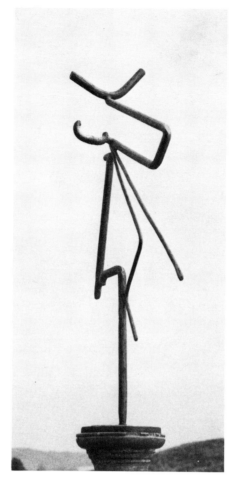

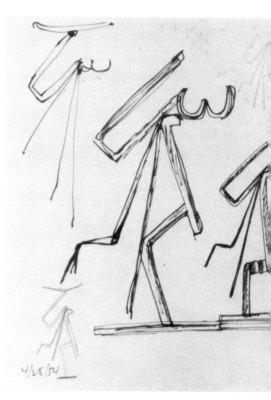

7. David Smith. *Agricola 54,* 1954. Steel, 89.5 x 22 x 34 cm (35¼ x 8½ x 13½ inches). Philadelphia Museum of Art, Purchased: Fiske and Marie Kimball Fund.

8. David Smith. *Drawing,* 1954. Ink with pencil, 27 x 21 cm (10⅝ x 8¼ inches). Courtesy of Mekler Gallery, Inc., Los Angeles. Not in exhibition.

colas, we can see that direction was already thematically established in his work. In a sense, by using such extant figuration ideas—not for replication, but for figural syntaxes—Smith could force the identities out of his farm tools by making them immediately assume another identity in the new structure.

Smith's use of these antique images and subjects raises questions of their themes. That is especially true of *Agricola I,* for this work was among the first set out in the fields, placed there as early as 1954, as we can see in a film made that year by Ilya Bolotowsky, which shows Smith installing it. As discussed in the Introduction, Smith referred to "planting" his sculpture in the fields around his studio, and often called Terminal Iron Works his "sculpture farm," an analogy between his planted sculpture and the rows of crops—especially tall corn—he would have seen every summer growing up in Indiana. In this regard, the structural god of *Agricola I,* which was made from farm tools and which stood in the south field, suggests a correspondence to the second meaning of the Latin word *agricola:* a deity of agriculture.

Gonzalez

Other Agricolas are representational in character, although they appear less specifically based on antique images. In these works Smith may have composed the sculpture from any of the techniques in his battery of initiating a structure (see the Introduction). *Agricola 54,* so named because of its date rather than place in the sequence, was first developed in drawing, such as those on a page in a notebook that Smith used at various times between 1954 and 1964.[11] The page shows five variations of *Agricola 54,* the two in the center more highly finished. The consistent use of the open rectangular, broadly defined shape at the top in each sketch suggests the element had already been selected for *Agricola 54,* for it occurs in the final work as well. Other components are also indicated, such as the double curve—or *W* shape—or the long descending pieces, but these aspects are not so specifically defined. The various images also show Smith trying different compositions. The two descending bars are shown with the bent one in the outer position: That position is reversed in the final sculpture. Smith tried the composition with the *W* in the two large images, without the *W* but with a wide curve at the top in one sketch, without either the *W* or the curve in another, and lastly, with both in the least finished study. Interestingly, this double addition is what Smith finally chose.

Even given this page of studies showing Smith trying alternative ideas, it is clear that *Agricola 54* had precedents in Gonzalez' work, not only in finished sculpture but in Gonzalez' graphic studies as well. This is another indication of Smith's growing interest in Gonzalez—increasingly in favor over Picasso—which would culminate in 1956 with Smith's long essay on Gonzalez' work and with Smith's first *Sentinel.*

Aspects of Gonzalez' work also inform *Agricola VIII,* a large abstract head. As discussed in the Introduction, Smith's first welded sculptures were a series of heads that were based on similar works made by Gonzalez from 1929 to 1931. Smith returned to that initial concept in making *Agricola VIII,* creating a flat, semioval shape made of two arcs and using different farm tools, pedals, and blades abstractly keyed off of the frame. The work is closer to the open style of Gonzalez' works than to Smith's own earlier heads, which are rather tightly composed. Nevertheless, Smith moved to include one of these earlier heads as the precursor to his Agricolas by retitling the work *Agricola Head.* This work with its overlapping bands and tall neck is in turn echoed in a later Agricola, number *XVII,* where a large, round tool sits upon a smaller linear torso and legs.

Abstraction

In other Agricolas, Smith moved toward the abstract composition already implied in *Agricola I* and partially stated in the pedals of *Agricola VII.* In doing so, his art took even further steps toward its later phases, where figuration and other themes are metaphorically expressed by abstract configurations.

We can see this development take place in *Agricola X,* one of Smith's simplest and purest works. *Agricola I* had been about the poise of a figure in

9. David Smith. *Agricola VIII,* 1952. Steel and bronze, painted brown, 80.7 x 54 x 47.6 cm (31¾ x 21¼ x 18¾ inches). Collection, Candida and Rebecca Smith, Courtesy of M. Knoedler & Co., Inc., New York.

10. Below. David Smith. *Agricola XVII,* 1957. Steel, 61.6 x 21.6 x 28.6 cm (24¼ x 8½ x 11¾ inches). Collection, Candida and Rebecca Smith, Courtesy of M. Knoedler & Co., Inc., New York.

11. Below right. Group photograph taken at Bolton Landing, showing (left to right) *Agricola Head, Chain Head, Saw Head,* all 1933.

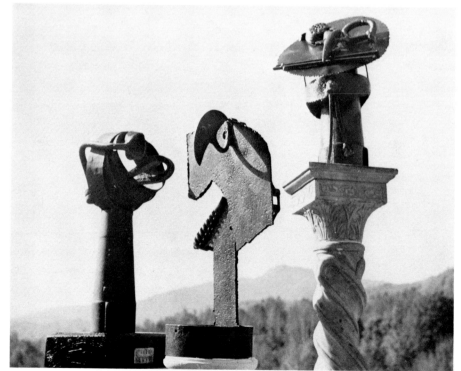

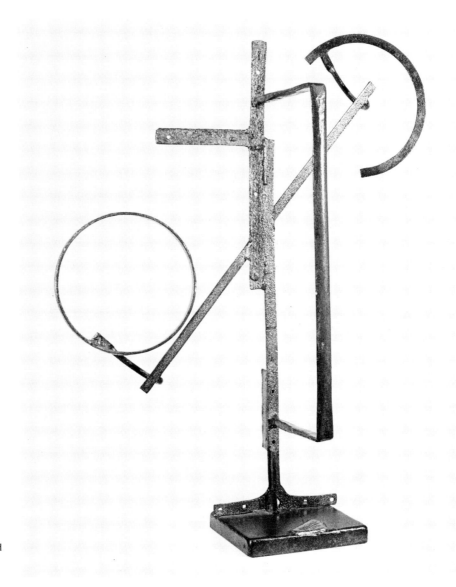

12. David Smith. *Agricola X*, 1952. Steel, painted red, 88 x 32.1 x 68.3 cm (34⅝ x 12⅝ x 26⅞ inches). Collection, Mrs. Norton S. Walbridge.

the air; *Agricola X* is about balance itself. Indeed, its structure is almost that of a balance, a kind of teeter-totter of farm tools.

The play between a circle and a circular segment also occurs in *Agricola XIII*, another of the abstract works in the series. But little else is common between that work and *Agricola X*. The composition of *Agricola XIII* is more free-form, as the various components twist in and out through space and across the visual plane. Unlike the straight, geometric character of the earlier balance work, small, eccentric pieces appear at various points in *Agricola XIII*, including inside the semicircle and at the outer edge of the full ring. Fry correctly identified this work as "the first of a group of line drawing sculptures which Smith produced in 1953–54."[12] Smith accepted the irregularities of his farm tools as a natural aspect of drawing itself, similar to the way in which chalk or ink is often uneven as it crosses the paper.

Agricola XXI, from 1959, is one of the last works in the series and shows

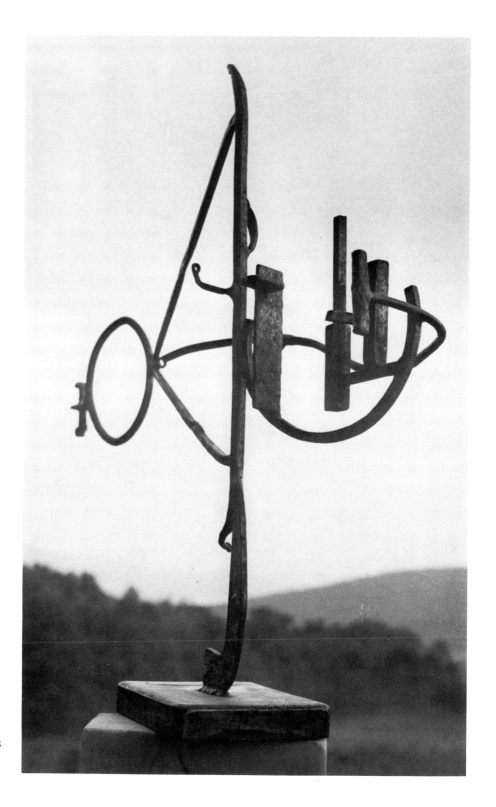

13. David Smith. *Agricola XIII*, 1953. Steel and stainless steel, 85.1 x 106.7 x 26.7 cm (33½ x 42 x 10½ inches). Collection, Dr. and Mrs. Arthur Kahn.

how considerably Smith's art had changed in the intervening eight years since the starting of *Agricola I*. The shift was principally toward a clearer structure, often, but not always, using fewer and more delicate elements than the previous works. *Agricola XXI* is by no means a simple composition, being as loaded with small pieces as *Agricola VIII*, the earlier head to which it invites comparison. But *Agricola VIII* creates its image out of the syntax

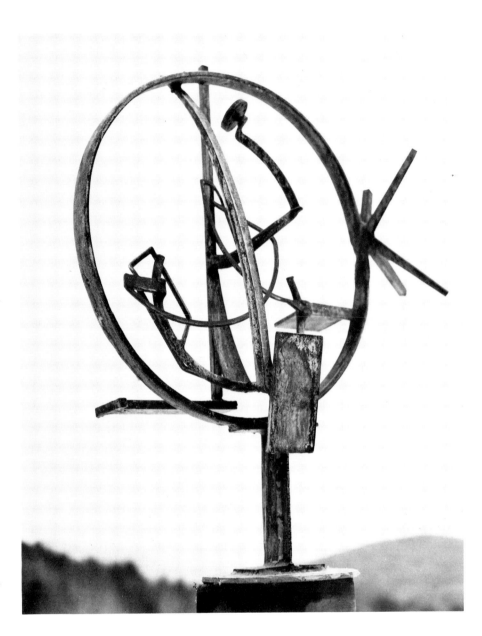

14. David Smith. *Agricola XXI*, 1959. Steel, 101.6
x 81.3 x 25.4 cm (40 x 32 x 10 inches). Collection,
Mr. Frederick Morgan.

of its elements; what we know of its appearance comes from seeing the way
in which the different pieces fit together. *Agricola XXI*, by contrast, is orga-
nized around the large open rings supported by an offset plinth. This clear
and recognizable shape serves as a ground for the different pieces, as they
more freely float through or attach to the large central opening. To be sure,
the touching of these elements to the circle and to each other is still intimate
in scale, even more so than in the grander articulation of the Mercury of
Agricola I. But in *Agricola XXI*, these parts are also somewhat disembodied,
for they do not build toward a composite, larger structure but rather serve as
embellishments on something larger. In this regard, the circle of *Agricola
XXI* predicts the flat disks of the *Circle* series, which began three years later,
and the free employment of the farm tools forecasts Smith's abstract—and
direct—use of the similar Italian implements in the Voltri-Boltons.

Notes

1. John T. White, *The White Latin Dictionary*, (Chicago, 1941), 29.

2. Edward Fry, *David Smith* [exh. cat., The Solomon R. Guggenheim Museum] (New York, 1969), 69.

3. Part of this prominence may derive from the fact that Smith discussed the origins of *Hudson River Landscape* on several occasions in articles, lectures, and his notes; see Fry, *Smith*, 79.

4. The small size and the plaquette conception of the medals makes them much different from the later, much larger series. Smith referred to the medals as a series in his autobiography, written about 1950; David Smith, *David Smith by David Smith*, ed. Cleve Gray (New York, 1972), 25.

5. Rebecca Smith in conversation with the author, 1982.

6. Smith in Gray, *Smith*, 74.

7. Werner Spies, *Sculpture by Picasso* (New York, 1971), 74.

8. Spies, *Picasso*, 75.

9. Clement Greenberg, "David Smith's New Sculpture" in Garnett McCoy, ed., *David Smith* (New York, 1973), 221; Rosalind E. Krauss, *Terminal Iron Works: The Sculpture of David Smith* (Cambridge, Massachusetts, 1971), 56.

10. Phyllis Tuchman in conversation with the author.

11. After this essay was completed, another drawing appeared, from the same notebook, also showing studies for this work and suggesting that *Agricola 54* went through a much more complicated development. The *54* in the title of this sculpture is traditional rather than specifically Smith's. It does not appear on the sculpture.

12. Fry, *Smith*, 85.

1. Sculpture by David Smith placed on driveway outside his studio. *Sentinel I* is second from the left, and *Sentinel II* is fifth from the left.

The Sentinels

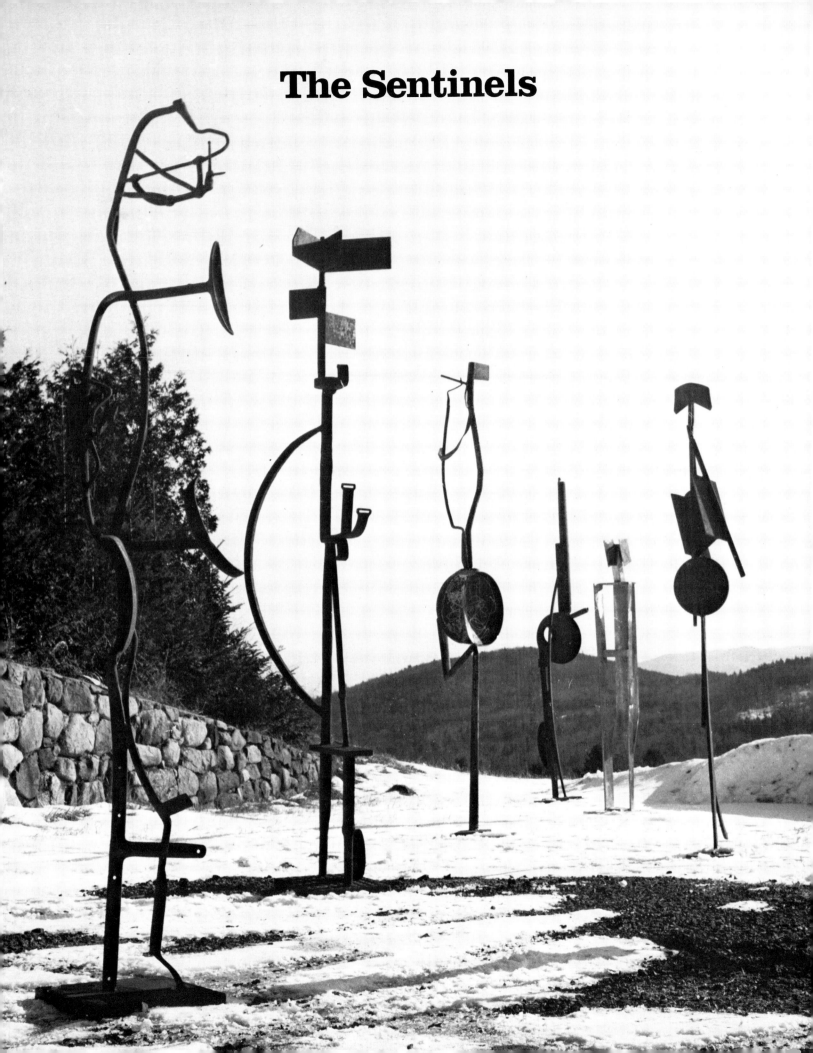

Sentinels

1. *Sentinel I*, 1956
 steel (K-382)
 227.6 x 42.9 x 57.5 cm (89⅝ x 16⅞ x 22⅝ inches)
 inscribed on plate welded to right-hand side of upper right wing:
 David Smith / SENTINEL I /10-20-56
 National Gallery of Art, Washington, D.C., Gift of the Collectors Committee, 1979

2. *Sentinel II*, 1956–1957
 stainless steel (K-430)
 181.3 x 36.8 x 36.8 cm (71⅜ x 14½ x 14½ inches)
 inscribed on top of base, upper left: David Smith /SEN II 56-57
 Hirshhorn Museum and Sculpture Garden, Smithsonian Institution, Washington, D.C.

3. *Sentinel III*, 1957
 steel, painted red (K-431)
 212.7 x 68.6 x 41.3 cm (83¾ x 27 x 16¼ inches)
 inscribed on plate welded at base: David Smith / 3.23.1957 / SEN III; and in yellow paint at center:
 Becca; in yellow paint near top: DIDA 2; in black paint on lower plane: 19; in black paint on middle:
 TERMINAL IRON WORKS / BOLTON LANDING, N.Y.; in black paint on upper plane: 57
 Anonymous Loan

4. *Sentinel V*, 1959
 stainless steel (K-470)
 373.4 x 121.9 x 40.6 cm (147 x 48 x 16 inches)
 inscribed on plate welded to base plane: David Smith / 6.12.1959 / SENTINEL V
 Collection of Candida and Rebecca Smith. Courtesy of M. Knoedler & Co., Inc., New York

5. *Two Circle Sentinel*, 1961
 stainless steel (K-529)
 219.1 x 134.6 x 69.9 cm (86¼ x 53 x 27½ inches)
 inscribed on plate welded to second lowest projection: David Smith / FOR ISEMAN / May 1, 1962;
 and on projection at bottom center: David Smith 2-11-1961
 Lent by Marjorie F. Iseman

6. *Sentinel*, 1961
 stainless steel (K-526)
 269.2 x 58.4 x 41.9 cm (106 x 23 x 16½ inches)
 inscribed on base plane: David Smith / Dec. 7, 1961
 Collection of Candida and Rebecca Smith. Courtesy of M. Knoedler & Co., Inc., New York

The Sentinels

They become kind of personages and sometimes cry out to me that I should have been better or bigger, and mostly they tell me that I should have done that twelve years before—or twenty years before.

David Smith[1]

Although Smith worked in series, and despite the fact that he gave certain series titles that are specifically referential (including the Agricolas, Wagons, and Sentinels) the literature on his oeuvre is virtually silent on how Smith extended his different thematic concerns over many works and on what a series as a whole implies. Partial exceptions can be found in the various discussions of individual pieces, the most notable being the comments by Edward Fry in his Guggenheim catalogue.[2]

Only one major essay is addressed to the larger question of Smith's themes, the long analysis of his career made by Rosalind Krauss in her *Terminal Iron Works*.[3] In her survey Krauss sought to establish that Smith's art was decisively governed by three major imagistic concerns: the cannon, the totem, and the sacrifice.[4] But in seeking to understand Smith's work in this manner, Krauss had to impose her categories from the outside, placing her own broad reading of imagery on the sculpture. Nothing made or written by Smith himself specifically indicates these three Kraussian themes. Of her themes, only the totem is reflected in Smith's *Tanktotem* series title. Smith clearly created specific groupings in his work, and it is necessary that Krauss' argument ignore these distinctions. In her totem category we find not only the Tanktotems—the logical members—but Sentinels and Cubis as well. To be sure, Krauss' arguments do shed light on implicit imagery in the work, but understanding Smith's explicit themes—as seen in his various series—remains unanswered.

The works in Smith's *Sentinel* series are perhaps the most difficult to group, from either a formal or a thematic point of view. Comprising nine pieces, the *Sentinel* series varies widely in its sculptural vocabulary and in its materials. For example, *Sentinel I* is an open linear composition, constructed of mechanical components and painted black, whereas the last four works are flat plane compositions made of burnished stainless steel. Two of

the middle works, *Sentinel III* and *IV*, differ not only in their makeup, collaged elements of industrial steel, but also in their support; they rest on wheels rather than the flat bases used in the others.[5] *Sentinel II* and *V* are also made of stainless steel, but they differ not only from the other works but from each other as well.

Figuration

What holds the Sentinels together is that in each work the specific characterization of the compositional juxtaposition is the same. The pieces are all figural in design, and they share the imagery of an upright, straight-spined, or stiff personnage, one as rigid as the collective title implies. Underscoring the stiff figural attitude is the way in which the Sentinels are all largely contained in their demeanor, no piece making a bold gesture. Their restraint and emphatic vertical orientation makes them aloof, a sense broken only by the heads on each *Sentinel*. Separated from the bodies, and thus more emphatically present, the heads have a feeling of activity, which suggests the head is watching, again as the series title implies. Frank O'Hara observed in 1961, after seeing the pieces at Bolton Landing, "they stood there like a *Sentinel* . . . not at all menacing, but very aware."[6]

There is a potential danger in understanding the Sentinels in such a literal manner. William Rubin has shown that there is a natural tendency to read a vertical composition as a figure; whereas if the same elements were placed in a horizontal pattern, they are not so readily perceived as such.[7] It is possible that we are projecting onto the abstract composition aspects of attention or watchfulness that might not have been intended by Smith. Such projection has increasingly become a factor in the recent literature on the abstract painters of Smith's generation, where the artist's similar use of a suggestive title has been taken by scholars as basis for explicit, detailed readings of abstract forms, readings which have subsequently been proven to be erroneous.[8] In the case of the Sentinels, we must ask whether the sense of them as guardian or sentry actually resides in their formal figuration or in our approach to them. That is a crucial question, for this perceived quality is what binds them together.

Sentinel I

Like *Agricola I, Sentinel I* is composed, at least in part, of mechanical pieces. For example, the long diagonal across the center is a large tire rod, and the short curved pieces at center are looped straps. Even the base is an industrial step, its flat surface covered with a corrugated pattern. That element is combined with other pieces to create long, thin, almost entirely straight lines of black, making *Sentinel I* one of the most geometric and restrained of Smith's open and linear figural sculptures. Like *Agricola I,* it is composed around a central vertical spine, here made of three sequential elements, the center one slightly offset. The majority of the other elements are attached to or pass by the vertical in perpendicular fashion, setting up a tight design. That strictness is relieved only by the curvilinear bow at the center—itself, however, a conventional form—and the two round disks (also conventional), one on a horizontal plane at the near top, the other set on the ver-

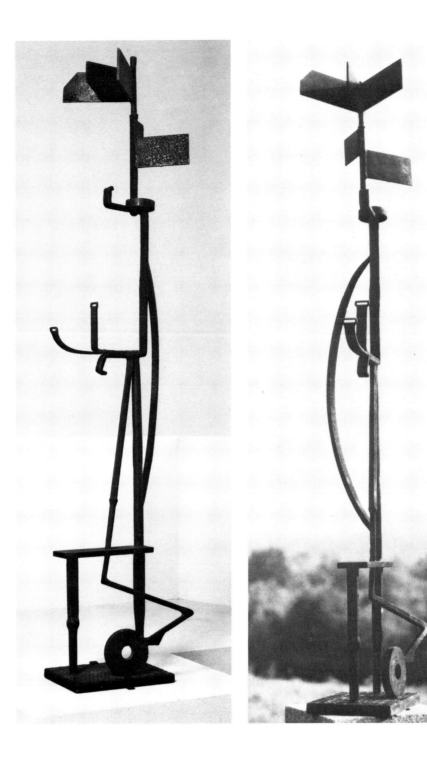

2. David Smith. *Sentinel I,* 1956. Steel, 227.6 x 42.9 x 57.5 cm (89⅝ x 16⅞ x 22⅝ inches). National Gallery of Art, Washington, D.C., Gift of the Collectors Committee, 1979.

tical at the bottom. The most visually active part is the diagonal line descending from near center, which turns in the other direction and then back again to touch the lower circle.

We can read some general figural qualities in *Sentinel I:* the head formed by the short planes at the top and the horizontal disk establishing the neck; the upper torso in the set-back vertical; and the legs in the long vertical passage. Beyond this, the rigid composition of the spine and the three large planes of the head suggest attention, but still in a general fashion. What

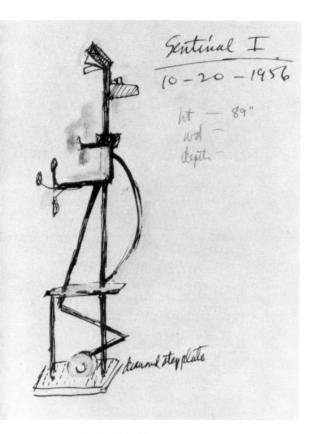

3. David Smith. *Sentinel II*, 1956. Drawing, ink, 27 x 21 cm (10⅝ x 8¼ inches). Courtesy of Mekler Gallery, Inc., Los Angeles. Not in exhibition.

makes the reading more sure in its figural and thematic aspects is that like *Agricola I* this *Sentinel* is based on another work by another artist. I argue that *Sentinel I* is a direct variation of Julio Gonzalez' *Cactus Man Number Two* and that in making this heir Smith was conscious of both its figural and thematic meanings.

Gonzalez

Gonzalez' work, as we have seen, was more influential on Smith's early sculpture than Picasso's. Smith refused to meet Picasso in 1935 because he would have had to call him *maître,* but he did go to Gonzalez' studio (although Gonzalez was out of Paris at the time). And Smith's notes repeatedly refer to Gonzalez.[9]

About a year before Smith completed *Sentinel I,* he immersed himself in Gonzalez' work and life in preparation for his article "Gonzalez: First Master of the Torch," published in the February 1956 *Art News* in conjunction with the Gonzalez retrospective at the Museum of Modern Art.[10] During his research and review, Smith must have again studied Gonzalez' *Cactus Man Number Two* and then transformed the sculpture into the basis for his first *Sentinel*. It is apparent when the two works are visually juxtaposed that *Cactus Man Number Two* parents the figural forms used by Smith. As I have previously written:

Cactus Man Number Two follows general figural formulations, the neck of the figure indicated by the slender connection approximately two-thirds of the way up the figure, the waist of the man located at the top of the oval cactus shape. These major joinings occur as well at those points where the formulations of the piece itself change—from the solid, oval shapes of the lower anatomy to the solid, planar shapes forming the chest area, which curves up and to the right from the waist (indicated also by incised lines at the outer edge which mark the spine) to the flat, planar treatment of the head. While the figure is at first difficult to "read," the general anthropomorphic arrangement does make identification possible.

Cactus Man Number Two stands firmly on the ground, with one leg composed of the oval "cactus" shape, the other an oval shape to the viewer's right, with toes reaching out across the ground (this is more emphatic in the drawing) and an ankle bone marking the top of the foot, indicated more clearly in the drawing by a round ball.

Reaching out to the left of the neck along the shoulder line, then turning up vertically, are the figure's two arms and hands, held defiantly into the air. . . .

The head of *Cactus Man Number Two* is the most difficult to decipher, sharing the surrealist Picasso's extreme displacement and abstraction of elements. At the very top of the figure are two tubular horizontal shapes, projecting in opposite directions, standing for the eyes of the man (the one to the viewer's left has a flat projecting shape above it which may suggest the eyelashes or eyebrow). Attached to the flat, planar surface below the eyes are six pointed cactus bristle shapes, sticking out horizontally which serve as the hair of the figure. The lower jaw of the head makes a horizontal line to the left of the narrow neck, the chin forming a right angle by turning up vertically. The profile of the face descends from the left eye, directly down, then curves back up to meet the vertical line of the chin.

Gonzalez uses an X-ray vision technique to show the interior of the mouth, revealing four pointed teeth with their tips focused outside the head. The nose, as Gonzalez has done in the earlier "masks," is indicated by the triangular cutout "impression" on the solid shape directly opposite the mouth.

90

4. Julio Gonzalez. *Cactus Man Number Two,* 1939. Ink and watercolor, 36.8 x 26.7 cm (14½ x 10½ inches). Collection, The Museum of Fine Arts, Houston. Not in exhibition.

The five parallel pegs attached to the right of the head, which look as if they were cut from the interstice between the teeth, are most likely, a moustache.[11]

Sentinel I corresponds in almost every way. The trio of planes at the top recalls the upper eye elements in the Gonzalez head, and the bent bracket strap at the upper disk echoes the rectangular chin of *Cactus Man Number Two.* Other strips in *Sentinel I* repeat the motive of the upheld hands, and the long curvilinear element recalls the torso bow of the Gonzalez sculpture. Even the lower area, with its open rectangle and diagonal passage, echoes the corresponding section in Gonzalez' work.

Cactus Man Number Two was completed between 1939 and 1940, and this dating gives a clue to the origins of its imagery. Essentially the sculpture is the defiant Spanish peasant—the "Cactus Man."

The sense of suffering engendered by the harsh physical dislocations, sharp angles, and the elevation of the head speak eloquently of the pain of the Spanish Civil War. Nevertheless, *Cactus Man Number Two* remains a defiant figure, in the hands raised in a gesture of anger and in the bold upright vertical emphasis of the composition. This militancy is supported by the inclusion of the rifle leaning at the waist of the figure, its trigger area cut out in a circular scoop above the ankle. Attached to the end of the gun by three horizontal struts is a thick, blunt (perhaps broken?) bayonet, its handle marked by a series of parallel bands. This object, with its movement to the left and then up in a vertical passage, recalls the same path made by the arms and hands, and thus completes the gesture of defiance.

Gonzalez' *Cactus Man Number Two* is, then, to be understood as an armed Spanish peasant in the role of patriot. Firmly tied to the land, as the cactus—the lower part of his anatomy—is rooted to the soil of Spain, *Cactus Man Number Two* rises to fight against the forces of facism. In effect, Gonzalez sets before us a biological transformation as a political act; the men of Spain will remain part of their land yet they will take on alternate duties to defend it.[12]

When I first wrote the above analysis of *Cactus Man Number Two* in 1973, it was regarded as the first detailed analysis not only of this work but of any of the works in Gonzalez' complicated linguistic program.[13] It now seems clear that Smith not only understood both the formal and the thematic thrust of this work but used both as the basis of *Sentinel I.* Just as Smith had in *Agricola I* used farm machinery parts to create a structure analogous to *Mercury,* so here the various elements were assembled to recall metaphorically the defiant Spanish defender. And just as he drew on both the heroic scale and lifting poise of *Mercury* for *Agricola I,* he also paid close attention to the basic attributes of *Cactus Man Number Two,* especially the rigid stance of the body and its uplifted head, in creating *Sentinel I.* These aspects of guarding and defending in the Gonzalez sculpture are transposed and juxtaposed in Smith's work to the attributes associated with the role of the sentinel—watching and at attention; they are the same attributes that occur in the other Sentinels.

Sentinel II

Smith also began the second sculpture in the series, *Sentinel II,* in 1956 but did not complete it until the following year. *Sentinel II* remains among the most mysterious images of his career, principally because of the address of its formal characteristics. It is one of the few Smith pieces that is basically

91

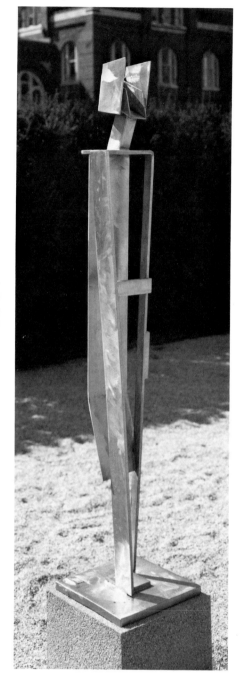

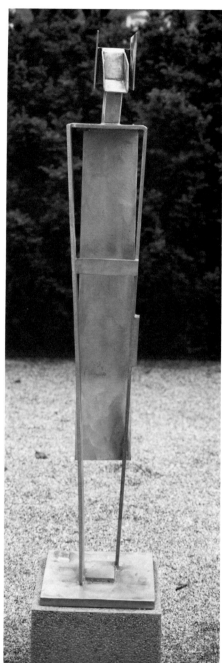

5. David Smith. *Sentinel II*, 1956–57. Drawing, marker and ballpoint, 27 x 21 cm (10⅝ x 8¼ inches). Courtesy of Mekler Gallery, Inc., Los Angeles. Not in exhibition.

6. Right. David Smith. *Sentinel II*, 1956–57. Stainless steel, 181.3 x 36.8 x 36.8 cm (71⅜ x 14½ x 14½ inches). Hirshhorn Museum and Sculpture Garden, Smithsonian Institution, Washington, D.C.

symmetrical, and that trait alone separates it from the other Sentinels. The difference is further exaggerated by the clear implications of figural volume that the work contains.

Like the other pieces, *Sentinel II* spells out the essential aspects of its figuration in a rather clear manner. An upper boxlike form serves as the head, supported by a thin, planar neck. The solidity of this boxlike form, even if opened at the front, gives the head the sense of enclosed space, radically different from the line and plane construction of *Sentinel I*. Beneath the box

head the shoulder line is established, terminating at the point where the arms drop down; these in turn merge with the legs to create dominate verticals on each side. But, again, unlike the central vertical spine of *Sentinel I,* here the arms and legs establish a perimeter, and the central core of the work remains an unfilled area between them. Like *Sentinel I,* the second work also uses an irregular line to establish the bulk of the body, here a bent plane running from the neck to the knees somewhat like the curving line of *Sentinel I.* In *Sentinel I* this line springs from the central spine and metaphorically states volume, but in *Sentinel II* the bent plane serves instead to close partially the back of the structure, creating a much more traditionally defined figure.

To be sure, *Sentinel II* retains the stiff, watchful demeanor of the other works in the series; indeed, if anything, the symmetry and inclusive nature of its structure make the work even more aloof. The solidity, when combined with its other features, suggests again the classicizing tendancy in Smith's art, in particular the rigidly frontal, iconic stance of the Greek kouros figures.[14]

Sentinel III and IV

Sentinel II also differs from the initial work in the series in its material: stainless steel as opposed to painted mechanical elements. Indeed, *Sentinel II* was Smith's first major piece in this material, occurring immediately before he began the tall linear structures of 1957–59, which ultimately led to the massive Cubis.[15] Smith would also return to stainless steel for the last five Sentinels made in 1960–61.

Sentinel III and *IV,* the intervening works, share a common material that separates them from the other Sentinels: industrial steel stock, or I beams. Smith selected beams of varying widths and cut them into varying lengths. These units gave him a new kind of vocabulary to work with, composed of elements that were different from each other in size and proportion yet were also of the same family of forms, being much more closely related to each other than the widely defined pieces of farm or mechanical implements. Smith had used related, even identical, elements before, as in *17h's,* but these units were attached to a larger, linear matrix; in *Sentinel III* and *IV,* there are no interval elements and the I beams supply the structure itself.

The lack of secondary elements was, of course, a logical development out of the discoveries made in the *Agricola* series and in *Sentinel I* (as well as other works). But in these Sentinels, rather than aiming to merge the disparate pieces together, Smith let the I beams largely keep their own identity. Their identity is lost only under the stronger authority of their figural references, which in turn emerges from the formal syntax created by the individual elements and not their specific identities.[16]

Sentinel III and *IV* also differ from the other works in the series and from all of Smith's previously completed work in their lower supporting elements. Both rest upon wheels, those in *Sentinel III* probably taken from an abandoned railway baggage cart; the wheels in *Sentinel IV* appear to be a section from some form of tripartite industrial steel. These wheels give each *Sentinel* a special character, the illusion that the piece is movable, a kind of sentry capable of being rolled into position. *Sentinel IV* can literally be moved,

7. Kore, probably before Antenor, c.530–525 B.C.. Athens, Akropolis Museum. Photograph taken from Gisela Richter, *A Handbook of Greek Art.* Not in exhibition.

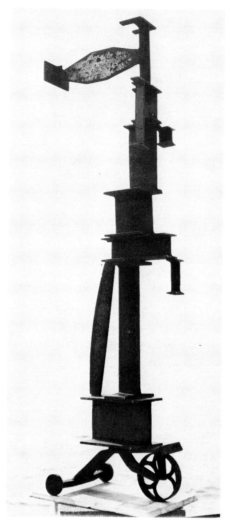

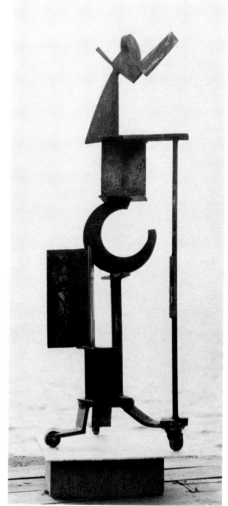

8. David Smith. *Sentinel III*, 1957. Steel, painted red, 212.7 x 68.6 x 41.3 cm (83¾ x 27 x 16¼ inches). Anonymous loan.

9. David Smith. *Sentinel III*, 1957. Drawing, marker, 27 x 21 cm (10⅝ x 8¼ inches). Courtesy of Mekler Gallery, Inc., Los Angeles. Not in exhibition.

10. Far right. David Smith. *Sentinel IV*, 1957. Steel, painted black, 203.2 x 73.7 x 81.3 cm (80 x 29 x 32 inches). Private Collection. Not in exhibition.

11. David Smith. *Sentinel IV*, 1957. Drawing, ink, 27 x 21 cm (10⅝ x 8¼ inches). Collection, Mr. Earle Colman. Not in exhibition.

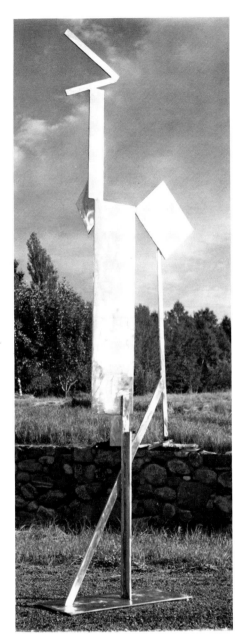

12. David Smith. *Sentinel V,* 1959. Stainless steel, 373.4 x 121.9 x 40.6 cm (147 x 48 x 16 inches). Collection, Candida and Rebecca Smith, Courtesy of M. Knoedler & Co., Inc., New York.

whereas with *Sentinel III.* Smith noted that "this wheel turns and these are stable, but you can sort of pick up the back end and shove it—it does help to go that way."[17]

Practical as these wheels may be, they also serve a formal purpose in each sculpture. The I beams of both Sentinels are thick and blocklike in contrast to the linear or planar elements that make up the preceding works. These earlier components allowed Smith's sculpture to stand—rather than rest—upon the base, but the heaviness of the Sentinels' I beams would have placed them directly upon the base, giving the support a sense of dead weight and mass. By slipping in the wheels under these two works, Smith separates the mass from the ground and gives the forms a visual as well as actual sense of energy.

Because of the wheels and the I beam construction, the figural aspects of these two works, especially *Sentinel III,* are less clearly apparent then in the first two sculptures. In *Sentinel III* no strong division between head and torso on the vertical axis is used; instead, our identification of the head derives from the long horizontal piece extending backward from the upper I beam. The waist is suggested by the longer beam at the midsection, and some sense of volume comes from the long, bowed pieces at the lower rear. In *Sentinel IV,* the head is more fully articulated, raised up on the triangular neck, and the shoulder is definitely stated. Likewise, the hip region is apparent in Smith's shift to an arclike form at the center. Countering this reading of the spinal figure is the flat, rectangular plane at the back of the arc and the long straight bar running on the front of the sculpture. Both serve to broaden the size of the sculpture and shift attention away from the shaping of the core units.[18]

Sentinel V

After completing *Sentinel III* and *IV* in 1957, Smith dropped the theme until 1959, when *Sentinel V* was completed. In 1961 four more works were added to the series. Like *Sentinel II,* these later constructions are made from stainless steel. In 1957/58 Smith began a set of stainless steel works sharing stylistic affinities, but which the artist decided not to project as a series.

In making *Sentinel II,* Smith had to fabricate the various stainless steel components from sheet stock, which forced him to use a much different procedure from that developed with the found elements in the Agricolas and used in creating *Sentinel I.* The making of *Sentinel II* was at once an advancement, given its new material, and a retreat, because of the necessity to stop and fashion its components.

With *Sentinel V,* and the other non-*Sentinel* works related to it, Smith tried another method. He appears to have cut rectangles and circles of varying sizes out of stock stainless steel plate, using an arc torch. These pieces, along with linear components of similar stainless steel struts, formed a supply of elements that could be worked into the sculpture, thereby making the process more akin to that used in the Agricolas and other works, despite the great difference in the characteristics of the materials. Thus Smith would have been able to compose *Sentinel V* by spreading a variety of stainless steel planes out on the studio floor and joining them with struts of different sizes.

The very thinness of the parent sheet and its being cut into flat planes are two factors that give the works their severely flat quality; that sense is further underscored by the light-reflecting nature of the material, which makes the surface seem less physical than a rusted steel or painted part might appear (see chapter 7). Indeed, the last five works in the *Sentinel* series are Smith's flattest figural sculpture.

The figural characteristics that we would expect of a work in this series are all clearly apparent in *Sentinel V*. Two legs, one vertical and the other diagonal, are formed out of long struts, and a long rectangular plane serves as the torso. Arms and hands are created out of squares turned on cornerpoints to form diamonds, one diamond jutting off perpendicular to the torso plane, the other connected to a vertical strut that descends to the diagonal leg, a passage reminiscent of the independent vertical in *Sentinel IV*.

A tall vertical plane, very narrow in comparison with the forms used for the torso and the arms, serves as the neck of the figure and gives it a greater sense of being tall, overscaled, and ultimately aloof. Crowning the figure are

13. David Smith. *Two Circle Sentinel,* 1961. Stainless steel, 219.1 x 134.6 x 69.9 cm (86¼ x 53 x 27½ inches). Lent by Marjorie F. Iseman.

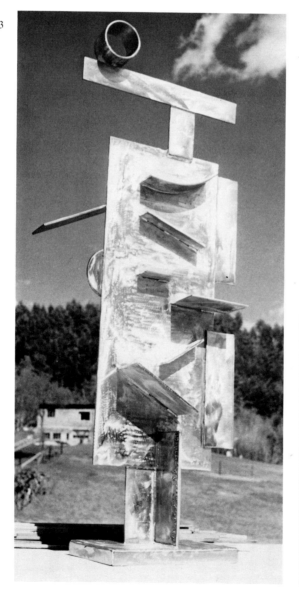
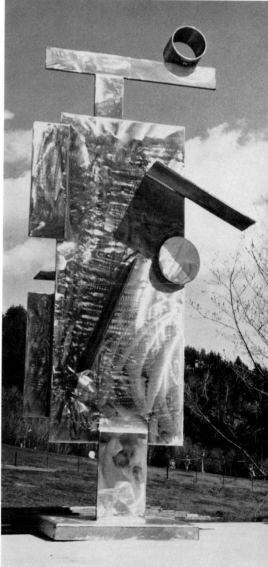

two smaller pieces joined together to make a V-shaped head, which creates an image that focuses its attention in one direction.

Flat Planes

The four remaining Sentinels, all from 1961, divide into two pairs: The first, made at the beginning of the year, employed a dominant vertical rectangle of sheet stainless steel; in the second pair, completed at the end of 1961, each work is an assemblage of much smaller planes of the same stainless material.

Two Circle Sentinel, completed on 22 February, and *March Sentinel*, finished the following month, use a related schema for establishing the sentry. Each has a body composed of a single large sheet lifted into the air by a smaller rectangle, representing the legs of the figure. The neck and head in *Two Circle Sentinel* are formed from a short, vertical rectangular plane and a long horizontal. Along the left upper edge of this latter element is an open round tube that gives the figure a metaphorical eye, or scope. In *March Sentinel*, the upper area is broken by a flat rectangle at the extreme right and a line at the center, when seen from a frontal position. But viewed from the side, this line becomes the conclusion of a band of steel that runs diagonally from the base and then moves vertically up the front of the work. At the top, however, this band turns outward by ninety degrees, creating an inverted L-shaped form that projects forward, creating the clear suggestion of a head.

The long central plane in *March Sentinel* is only one of many such bands of stainless steel seen on edge to the dominant lateral sheet. The back of *March Sentinel* and both the front and the back of *Two Circle Sentinel* contain several of these shortened elements crossing the sheet at varying angles, but always set perpendicular to it. In *Two Circle Sentinel*, one band on each side and on each face extends beyond the edge of the massive central plane, and in the upper area a third is curved across the surface. Another band in this work projects outward from the lower legs rectangle. Working with these elements are other, smaller planes and flat circles that are applied flat to the larger torso sheet of each work and placed along the exterior edges so that only a small part of them is actually attached to the central plane.

Cubism

As we have seen, both this simplified geometric vocabulary and the use of stainless steel had begun four years earlier in Smith's work with the several tall plane and rod structures, such as *8 Planes 7 Bars*, and had been continued into *Sentinel V*. The later 1961 Sentinels can be seen as Smith's move toward monumentalizing the achievements of these earlier works, accomplished in these later works by massing the forms together and subjecting this geometric vocabulary to the tighter requirements of abstract figuration. *Two Circle Sentinel* and *March Sentinel*, as well as the two that follow, are a transition between the lighter abstract compositions of 1957/58 and the heroically scaled Cubis, which began in the fall of 1961.

Because of their conservative use of a limited range of geometric forms, the later Sentinels have been called "cubist" or "cubist-derived," although little specific analysis of their relationship to cubism exists.[19] Their trued

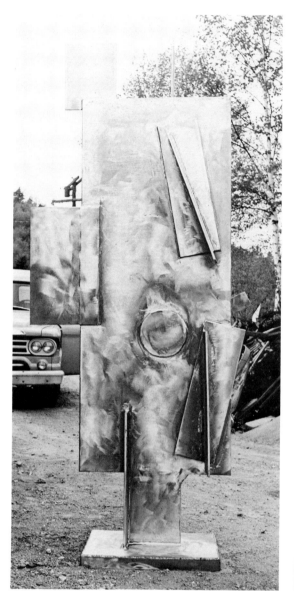

14. David Smith. *Match Sentinel*, 1961. Stainless steel, 258.5 x 111.8 x 50.2 cm (101¼ x 44 x 19¾ inches). Collection, Dr. and Mrs. Paul Todd Makler. Not in exhibition.

15. Pablo Picasso. *Harlequin*, late 1915. Oil on canvas, 185.5 x 105.1 cm (72¼ x 41⅜ inches). The Museum of Modern Art, New York. Acquired through the Lillie P. Bliss Bequest. Not in exhibition.

and faired vocabulary and their relative flatness does connect the later Sentinels, and especially the first pair, with works made in the synthetic style of cubism. Such a relationship derives partially from the process of this form of cubism, for its compositions are, or are based on, the flat planar overlapping or juxtapositions developed in paper collage. But these early cubist works are fairly intimate in scale, in contrast to Smith's massive Sentinels. Only in later cubist works, such as Picasso's *Harlequin* of late 1915, do we find synthetic cubist structures at a dimension large enough to allow the relationships between these works and those of Smith to be telling.

Smith surely knew this Picasso painting because it entered the collection of the Museum of Modern Art in 1950.[20] Its subject—a full-length figure—would have been especially pertinent to the Sentinels, for like Smith's sentries, Picasso's *Harlequin* is a tall figure constructed out of flat planes. In the

16. Pablo Picasso. *Nude*, 1910. Charcoal, 48.5 x 31.5 cm (19¹/₁₆ x 12¹⁵/₁₆ inches). The Metropolitan Museum of Art, The Alfred Stieglitz Collection, 1949. Not in exhibition.

17. Pablo Picasso. *Femme Nue*, 1910. Oil on canvas, 187.3 x 61 cm (73¾ x 24 inches). National Gallery of Art, Washington, D.C. Ailsa Mellon Bruce Fund, 1972. Not in exhibition.

painting two overlapped elements establish the entertainer's form rather than the single dominant sheet of the Sentinels. Nevertheless, this kind of massing in the center of the Picasso can be related to Smith's structure, as can the manner in which the unfinished canvas held by the *Harlequin* remains flat and juts out into space like the attachment of the perimeter planes in *Two Circle Sentinel* and *March Sentinel*.[21] In the latter work, Smith's inverted L-shaped band is an exact paraphrase of the white head of the *Harlequin* at the upper left of Picasso's picture. And in a less strict way, this painted passage and the long white one for the entertainer's feet are recalled in the head of *Two Circle Sentinel*, only now with its eye moved up as a separate element. Even the shorter curves and straights on the flat steel planes of both Sentinels echo Picasso's cubist composition.

One central aspect of these two Sentinels does set them apart from the style of synthetic cubism with its flat, evenly painted planes: the light-reflecting properties of the stainless steel material, particularly the diffusing effects caused by Smith's randomly placed burnished marks. But these are the very qualities that can be connected to cubism in its early state—the analytical style—where certain areas were loosely painted in whites and grays,

acquiring an almost metallic sheen.[22] In the earlier style of cubism, these luminescent passages are juxtaposed to straight, decidedly linear elements, a contrast much like we see crossing the surfaces of the two Sentinels. Indeed, the zig-zag of the long band in *March Sentinel* suggests the bent knee of a figure and, in combination with the atmospheric markings on the large burnished plane, recalls a similar linear structure as seen in a 1910 Picasso drawing of a nude. The drawing also includes the full and semicircles we find in both Sentinels.[23]

Lectern Sentinel and *Sentinel*

Similar aspects of the 1910 drawing also appear in *Lectern Sentinel*, one of the last two works in the series. Built into a vertical structure out of short, overlapping rectangular elements, the work is in certain ways even closer to the works of Picasso, given their emphasis on a composition using multiple planes. The relationship to cubism is also apparent in the way in which some diagonals are given greater presence in *Lectern Sentinel*.

Like the other Sentinels, *Lectern Sentinel* is figural in its organization: a vertical orientation, a separation of parts within that structure, and the clear changing of the sizes of those parts. In *Lectern Sentinel*, lower elements create the kind of joined legs we find in *Two Circle Sentinel* and *March Sentinel*, but they are given greater clarity in *Lectern Sentinel* by being elongated to an approximate natural length. The waist area is also made more prevalent by the use of two wider planes. The shoulders are not so pronounced as the preceding two Sentinels, and the head and neck are borrowed directly from *Two Circle Sentinel*.

Sentinel, the last sculpture in the series, develops out of the same multiple plane organization. Like those in *Lectern Sentinel*, the rectangles here tilt in and out as they move upward from the base to the waistline, before the composition straightens and rises through two longer planes. The head is supplied by a flat disk. In making these figures out of sequences of planes rather than out of a single uplifted sheet, *Sentinel* and *Lectern Sentinel* mark a return to the principles of *Sentinel III* and *IV*. *Sentinel* also marks a return to the initial work, *Sentinel I*, and its source sculpture, Gonzalez' *Cactus Man Number Two*, through its rectangular arms and hands placed out to the left near the waist and in its elongated neck and head. As discussed in the Introduction, this change was made after the initial completion of the sculpture. The new location of the arms and hands and the internal rhythm of the sculpture also recall Picasso's 1910 nude discussed earlier (see the Introduction). At the same time, the more isolated position of the head, raised on its vertical rectangle far above the zig-zag folds of the torso and legs, gives *Sentinel* the same sense of distance and aloofness that characterizes the other works in the series.

Installations

Like the planting of *Agricola I* in the north field at Bolton Landing, Smith's installation of these Sentinels also raises questions of their imagery. The first two sculptures were initially kept on the pavement of the driveway, outside of the garage/studio at the house, where they were photographed with

18. Left. David Smith. *Lectern Sentinel*, 1961. Stainless steel, 258.5 x 83.8 cm (101¾ x 33 inches). Whitney Museum of American Art, New York. Not in exhibition.

19. David Smith. *Sentinel*, 1961. Stainless steel, 269.2 x 58.4 x 41.9 cm (106 x 23 x 16½ inches). Collection, Candida and Rebecca Smith, Courtesy of M. Knoedler & Co., Inc., New York.

other works of the period. *Sentinel I* eventually moved to one of the rows in the north field, sitting amidst the Voltri-Boltons near the vegetable garden. *Sentinel V* was also first placed in the area by the garage with other stainless steel pieces, subsequently moving to the middle of the south field. In both cases, Smith's installation appears to be casual, simply grouping works made during the same period or comparing them with subsequent series.

But his latter placement of *Sentinel V* and the locations of *March Sentinel* and *Sentinel* seems more determined. In each case the work was not installed with a gathering of other pieces from the same period but separated

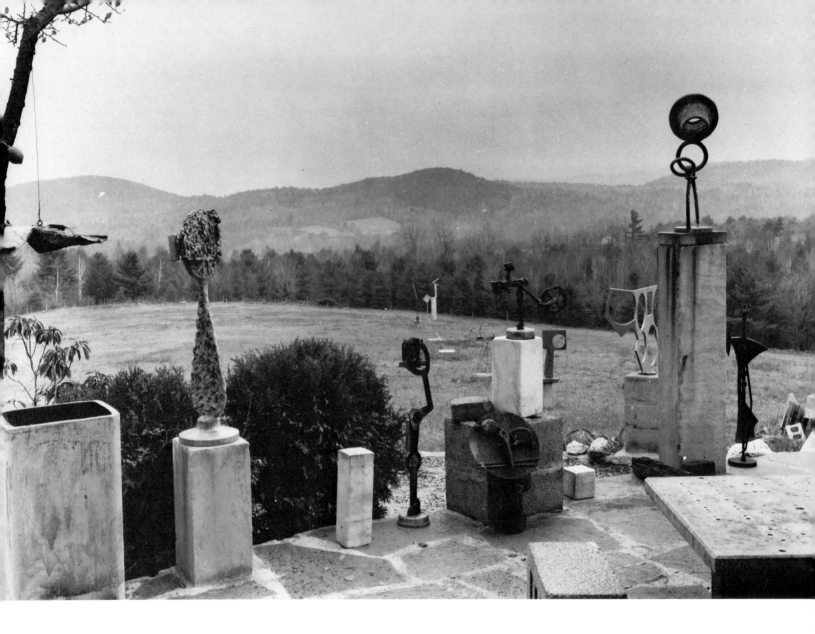

20. The south field at Bolton Landing showing
Sentinel V in the distance.

and sited so as to underscore their characteristics of watching and remote-
ness. *March Sentinel* was placed in the center of the north field so that it
seems to command the area, looking out over it to the north and sitting be-
hind the wall formed by the *Cubi*, *Zig*, and *Primo Piano* gates. The last
work in the series, *Sentinel*, was one of the first installed in the south field,
placed at the backside of the pond and aligned so that its bright stainless
steel surface could be reflected in the water. Its aloof countenance was em-
phasized by its relative inaccessability behind this area of water, over which
its highly held head flatly stares toward the road and the studio. In these
works, more than any others, Smith reinforced their imagery by means of
their location.

Notes

1. David Smith, *David Smith by David Smith*, ed. Cleve Gray (New York, 1972), 87.

2. Edward Fry, *David Smith* [exh. cat., The Solomon R. Guggenheim Museum] (New York, 1969).

3. Rosalind E. Krauss, *Terminal Iron Works: The Sculpture of David Smith* (Cambridge, Massachusetts, 1971).

4. Krauss, *Terminal Iron Works*, 56.

5. The figural qualities of these two Sentinels make the wheels more a part of a base than part of a wheeled structure, such as the Wagons (see chapter 6). On this point see Fry, *Smith*, 101.

6. Frank O'Hara, "David Smith: The Color of Steel," *Art News, 60* (December 1961), 32.

7. William Rubin, *Anthony Caro* [exh. cat., The Museum of Modern Art] (New York, 1975), note 15, page 176.

8. See William Rubin, "Pollock as Jungian Illustrator: The Limits of Psychological Criticism," *Art in America, 69* (November 1979).

9. David Smith, "Notes on My Work," *Arts, 34* (February 1960), 44.

10. David Smith, "Gonzalez: First Master of the Torch," *Art News, 54* (February 1956).

11. E. A. Carmean, Jr., "Cactus Man Number Two," *Bulletin, The Museum of Fine Arts, Houston, 4* (Fall 1973), 42–43.

12. Carmean, Jr., "Cactus Man," 43.

13. See Josephine Withers, *Julio Gonzalez: Sculpture in Iron* (New York, 1978), 97–98.

14. On this point in related works by Smith, see Krauss, *Terminal Iron Works*, 152–153, and E. A. Carmean, Jr., "David Smith: The Voltri Sculpture," *American Art at Mid-Century: The Subjects of the Artist* [exh. cat., National Gallery of Art] (Washington, 1978), 223–226.

15. Smith had used stainless steel earlier but in smaller works, such as *Agricola XIII* in the present exhibition. Dan Budnik recalls Smith saying the cost of stainless steel prevented him from using it extensively for the ten years before 1960/61, in conversation with the author, 1982.

16. For a thorough discussion of syntax in modern sculpture, see Rubin's text in *Caro.*

17. David Smith, "Some Late Words From David Smith," ed. Gene Baro, *Art International, 9* (20 October 1965), 50.

18. For a discussion of a similar, albeit more abstract, usage of I beams in Caro's work, see Rubin, *Caro* 47–48.

19. See Sheldon Nodelman, "David Smith," *Art News, 67* (February 1969), 57.

20. It was discussed even earlier by Alfred Barr in *Picasso: Fifty Years of His Art* (New York, 1946), 93.

21. For a discussion of this unpainted canvas, see William Rubin, *Picasso in the Collection of the Museum of Modern Art* (New York, 1972), 98, 100.

22. Certain paintings by Picasso also use a green tone that makes the grays even more metallic.

23. This drawing and its companion painting were illustrated and discussed by Barr, *Picasso*, 72–73.

1. South field, Bolton Landing, with *Zig III*.

The Zigs

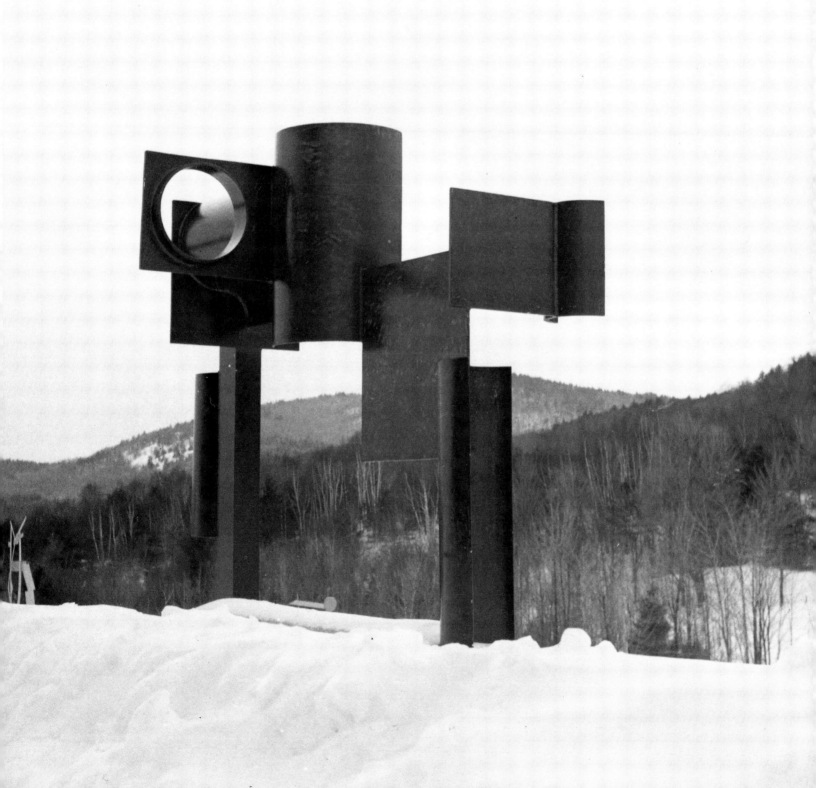

Zigs

1. *Zig I*, 1961
 steel, painted black and brown (K-531)
 245.1 x 146.4 x 81.9 cm (96½ x 57⅝ x 32¼ inches)
 inscribed on front of lowest horizontal plane: David Smith 4-15-1961; on reverse: ZIG I
 Private Collection

2. *Zig II*, 1961
 steel, painted black, red, and orange (K-532)
 255.3 x 137.2 x 85.1 cm (100½ x 54 x 33½ inches)
 inscribed on lowest horizontal element: ZIG II David Smith 2-18-1961
 Des Moines Art Center. Gift of the Gardner Cowles Foundation in memory of Mrs. Florence Call Cowles

3. *Zig III*, 1961
 steel, painted black (K-533)
 235.6 x 281.9 x 152.4 cm (92¾ x 111 x 60 inches)
 inscribed on base: Hi Rebecca; near edge of base: David Smith May 24, 1961 ZIG III
 The Museum of Modern Art, New York. Mrs. Simon Guggenheim Fund, 1966

4. *Zig V*, 1961
 steel, painted black, blue, white, and pink (K-535)
 282.6 x 214.0 x 69.2 cm (111¼ x 84¼ x 27¼ inches)
 inscribed on leg: David Smith July 17, 1961 ZIG V
 Collection of Candida and Rebecca Smith. Courtesy of M. Knoedler & Co., Inc., New York

5. *Untitled (Zig VI?)*, 1964
 steel I beams, painted yellow ochre (K-642)
 200.3 x 112.7 x 73.7 cm (78⅞ x 44⅜ x 29 inches)
 inscribed on bottommost horizontal beam: David Smith / March 17-1964
 Collection of Candida and Rebecca Smith. Courtesy of M. Knoedler & Co., Inc., New York

6. *Zig VII*, 1963
 steel, painted cream, red, and blue (K-627)
 238.8 x 269.2 x 215.9 cm (94 x 106 x 85 inches)
 inscribed on base plane: David Smith 7-22-63 ZIG VII
 Collection of Candida and Rebecca Smith. Courtesy of M. Knoedler & Co., Inc., New York

7. *Zig VIII*, 1964
 steel, painted red, white, and black (K-641)
 255.9 x 232.4 x 210.8 cm (100¾ x 91½ x 83 inches)
 inscribed on I beam extended behind sculpture: David Smith 1-15-64 ZIG VIII
 Museum of Fine Arts, Boston. Centennial Purchase Fund

CHAPTER 3 **The Zigs**

An affectionate term for ziggurat—ziggurat is too big a word and—I don't know—it [Zig] seems more intimate, and it doesn't have to be as high as the towers of Babylon.

David Smith, 1965[1]

During the last ten years of his life, Smith exhibited his work regularly and frequently, including fourteen one-man shows and seventy group exhibitions.[2] In almost every instance, the serious critical reception of the work was generous and appreciative. For the most part, however, published responses added little in the way of informed insight into the sculpture. The principal exceptions are the writings of Clement Greenberg and Hilton Kramer.[3] Interestingly, these two critics are also the exceptions to the generally praiseworthy reactions to Smith's exhibitions; although each writer found favor in almost all of his sculpture, both Kramer and Greenberg were critical of his *Zig* series.

Indeed, Kramer's comments are perhaps the most negative ones made about Smith's mature art. In reviewing Smith's 1961 exhibition at the Carnegie Institute in Pittsburgh, where the first five Zigs were shown, Kramer wrote:

Writing about this artist's work two years ago, I noted that "Smith's hold on his own syntax is now so firm and hard and unyielding that his fantasy has almost no functions to perform. . . . This means, I think, that there has been a loss in geniality and a gain in rigor." Looking at the enormous painted metal constructions in Pittsburgh—they are all huge—there could be no question about the loss of geniality. What I was unprepared for was the loss of rigor as well. Smith's new work impresses one as the effort of a major artist to create a gigantic statement that his imagination has quite failed to define; one is left gaping at a monument to the sculptor's expressive will, but not at anything that can be taken seriously as sculpture by the standards Smith has set for himself—and his generation—in the past. His increasing dependence on current painting for rhetorical, non-syntactical effects—echoes of Gottlieb, Noland and Kelly abound—suggests that the loss of fantasy in his work has deprived it of an essential sculptural energy which a concentration on syntax alone cannot restore. Only by means of fantasy has Smith been able in the past to make his experience, with its hard core of moral indignation, available to his art. In its absence his art has been reduced—for despite their physical enormity, the

new work is actually very small in concept—to being sculpture *about* painting. This is too meager a subject for an artist of Smith's power.[4]

Greenberg, on closer terms to the artist, did not directly review the Carnegie exhibition, or even the *Zig* series itself. However, in his later essay for the catalogue of the *Voltri-Bolton* exhibition in 1964, Greenberg observed: "I don't think he has ever used applied color with real success, and the 'Voltri Bolton Landing' pieces benefit by his having abstained from it." Greenberg's comments were made in reference to the Zigs and to the Circles, begun concurrently with the *Voltri-Bolton* works.[5]

In the subsequent years, however, the critical fortune of the Zigs has changed considerably. In 1966 Greenberg called *Zig IV* a "masterpiece," and in 1969 Edward Fry would write of the entire series that the pieces "number among them Smith's greatest achievements as a sculptor," and that *Zig IV*, again, "should be numbered among the artist's half dozen finest works." The work "attained a level of realization . . . Smith never surpassed and rarely equalled."[6] Two years later William Tucker continued the high regard, saying, "The *Zig* series . . . contains some of Smith's most original sculpture."[7] He also singled out *Zig IV* as well as the related *Zig VII* and *VIII*. Finally, in her 1971 monograph on the artist, Rosalind Krauss also cited *Zig IV* and, echoing Greenberg, called it a "masterpiece" and discussed it as a paragon of Smith's artistic achievements.[8]

The Series

Like Smith's other series, the Zigs have never been discussed at any length, with the limited exception of Kramer's 1961 article. Five Zigs were completed and exhibited when Kramer's essay appeared. At least two more, possibly three, were made after 1961. The count remains a puzzle because Smith skipped number *VI* in his series enumeration (see below). As a series, the Zigs are even more disparate in focus than the Agricolas or the Sentinels already discussed. Unlike the Agricolas, no material of shared origin, such as farm machinery elements, makes up the vocabulary of the Zigs; and unlike the aloof, sentry figures of the Sentinels, no conceptual imagery is common among the pieces of this later series. The Zigs form a group tied together principally by the formal aspects of shape characteristics, coloration, and scale.

After 1951 Smith's art moved, at least in part, toward a simpler and more geometric vocabulary in both the character of the elements and in their overall composition, although as Greenberg observed, "there is no flavor in it of the [de] Stijl or of the Bauhaus or even of Constructivism."[9] Smith's direction was to culminate in his last series, the Cubis, with their rigidly geometric shapes; but this is not so for their composition, for even in these works, the sense of a geometric underpattern is clearly absent in the face of formal improvisation and invention. In this regard, the Zigs are like the Cubis, being made up of elements that have no clear identity beyond that of being essential geometric shapes. In opposition to—or in tandem with—such geometric clarity, Smith used in the Zigs a surface of multicolored paint patterns, which Kramer and Greenberg opposed. As we will see, the surface varied from two or more interwoven colors used in a single piece, in the

early Zigs, to painting individual elements in the work a distinctly separate hue, in the later pieces.

A third characteristic sets the Zigs apart from the other preceding series: their monumental scale.[10] Included in the Zigs are some of Smith's then-largest works, both in terms of physical dimensions as well as sculptural and aesthetic presences. Indeed, if the later Sentinels with their flat stainless steel planes and trued and faired vocabulary are predictive of the later Cubis, the Zigs also serve as a preface in their insistence on geometry and in their denial of small detail in favor of large, full parts.

This trio of formal qualifications sounds rigid and restrictive in the abstract. Although they are the principle links between the various Zigs, they serve only to group the sculpture as a series and to define its essential character. But within the works of the *Zig* series we encounter a wider linguistic freedom than in any of Smith's other groupings.

All of the Zigs are related by stylistic factors and, to a lesser degree, by their materials. *Zig I, II,* and *V,* contributing to Smith's figural body of work, form one of these subsets. *Zig III,* with its architectural aspects, is the isolated entry in the series. The remaining titled Zigs, numbers *IV, VII,* and *VIII,* form another interrelated grouping within the series. The potential candidate for the missing *Zig VI* is most properly included in the initial figural category.

The hallmark aspects of *Zig IV, VII,* and *VIII* are their shared usage of a large, separate plane, which has either been tilted at an angle or placed in a vertical position, and the lifting of the plane into the air by means of a vertical plinth that is set on a horizontal base supported by wheels. Two of these works, *Zig VII* and *VIII,* may be further classified by their painted surfaces; Smith selected flat coverings of brilliant solid colors rather than the scumbled markings employed in the other Zigs.

Zig I

The formal traits of the initial work in the series, *Zig I,* are typical of the geometric restrictions Smith imposed on all of the pieces in the series. In *Zig I,* the major elements all derive from latitudinal sections of a hollow, vertical cylinder. These parts are in a sense flat rectangular planes that have been curved or bowed in space. They vary in diameter and are composed almost exclusively in a horizontal and vertical fashion. These aspects of *Zig I* are shared by *Zig II, III,* and *V* and inform portions of *Zig IV.*

Although these rounded forms are industrial in nature, that aspect is only vaguely present, in contrast to the more specific identities of the farm and mechanical pieces used in earlier series. To be sure, Smith could have seen forms such as these being used in all sorts of practical ways, among them the blades used for snowplows, certainly a constant presence during the winter in upstate New York.[11]

The three basic attributes of Smith's work are all present: the culminating vertical orientation of the composition, the division of that arrangement into distinctive parts, and the change in size of these separate pieces. *Zig I* is dominated by a central vertical spine, supplied by a long, narrow part-cylinder and the two flat pieces at the bottom that continue the core. The

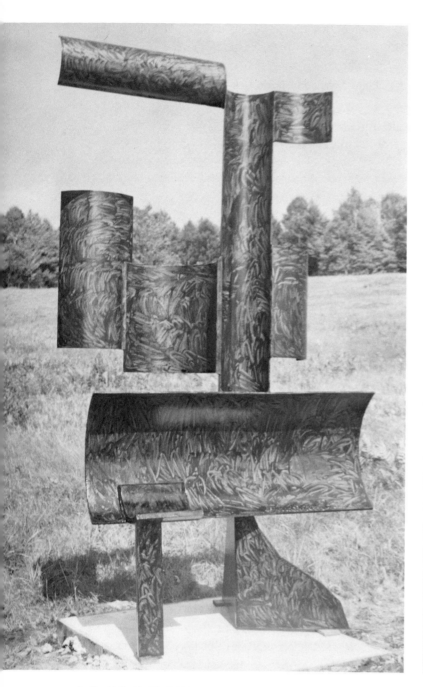

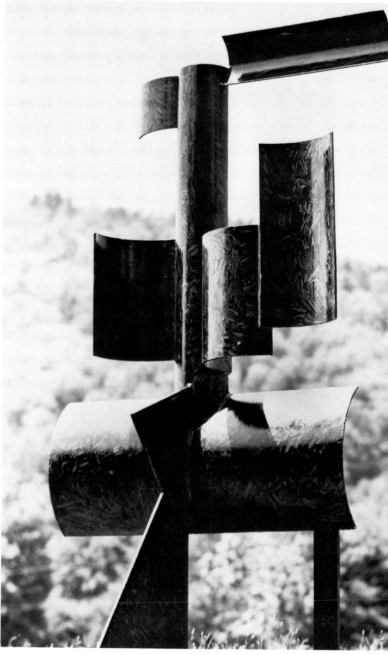

2. David Smith. *Zig I*, 1961. Steel, painted black and brown, 245.1 x 146.4 x 81.9 cm (96½ x 57⅝ x 32¼ inches). Private Collection.

orientation occurs despite the fact that the vertical is challenged three times by horizontal passages; two at the top set in opposite directions; a trio at the lower spine, divided two and one; and a single, very wide semicylinder at the bottom. The half-cylinders increase in scale from the smaller top pair to the big lower horizontal.

As is true with much of the earlier work, the compositional arrangement of *Zig I*, especially its central spinal core, lends itself to a figural reading. The divisions and distinctions make the upper elements read as an abstract head and the lower element as a pelvic region. But in understanding *Zig I* in this manner, we realize that its pattern is more precise. If the top is a head, with elements in both directions, and the long plane a waist, then the central trio falls into place as hands. Such a figural orientation connects directly with *Sentinel I*, which has a similar layout. Indeed, in *Zig I* we even find a separate vertical element at the lower left, serving as the second leg and echoing the one on the left in *Sentinel I*. As we have seen, *Sentinel I* leads in turn to Julio Gonzalez' *Cactus Man Number Two* as the source for its image. The internal identity of the sentry in the Sentinels provides the more abstract underpattern for *Zig I, II,* and *V*. But the image is transformed by Smith's employment of the partial cylinders, just as the image of *Mercury* was changed by being made out of farm parts. *Sentinel I* and *Cactus Man Number Two* thus form the starting point for the Zigs.

Zig II

The anthropomorphic aspects of *Zig I* are continued in *Zig II*, albeit more abstractly. Such a direction proceeds throughout the series as a whole.[12] *Zig II* uses similar semicylinder elements composed with the other pieces into a similar vertical orientation. However, the sense of a continuous internal core as seen in *Zig I* is dramatically lessened in favor of a reading of the image being the result of the parts touching.

Completed in February of 1961, *Zig II* shares less with the figuration of *Sentinel I* than it does with the two later Sentinels also underway in Smith's studio: *Two Circle Sentinel* (finished that February) and *March Sentinel* (completed in March). *March Sentinel* and *Zig II* share the same long, squat, and very wide rectangular head, made from a piece of channel stock in *Zig II*. All three (along with *Zig V* to a lesser degree) use a dominant plane for the torso, although in *Zig II* this piece appears less massive because of the longer neck of the work and its curvilinear surface. And just as *Zig II* is separate from *Zig I* because it gives a greater role of separate identity to the parts, so *Zig II* is far more casual, and abstract, than the compact and aloof Sentinels.

Separateness does exist for those elements that descend from *Zig II*, especially the horizontal semicylinder with its leg at the lower left, a portion of which recalls the wide plane and strut of the preceding work. But in *Zig II* this passage almost floats in front of the massive central torso rather than emerge out of the core as it does in *Zig I*. Even further apart in terms of formal vocabulary is the new central leg in *Zig II*, which descends from the core mass in steps, instead of dropping directly, and which culminates in the very sensitive turning of the small semicylinder lower plane away from the

3. Julio Gonzalez. *Cactus Man Number Two*, 1939. Ink and watercolor, 36.8 x 26.7 cm. (14½ x 10½ inches). The Museum of Fine Arts, Houston. Not in exhibition.

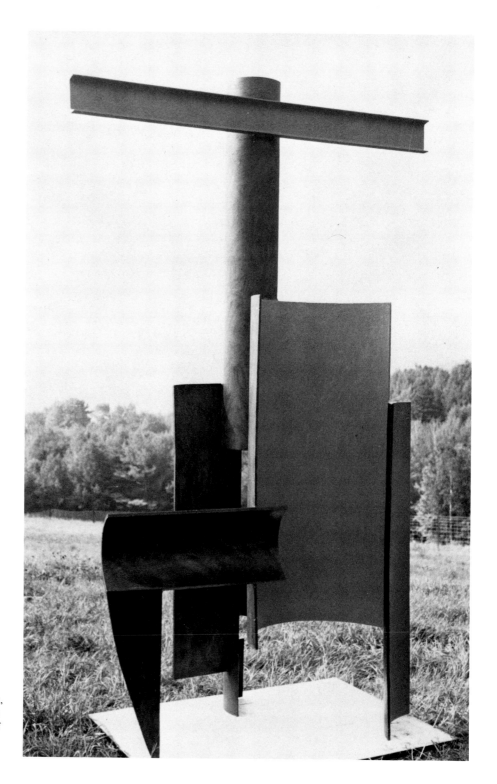

4. David Smith. *Zig II,* 1961. Steel, painted black, red, and orange, 255.3 x 137.2 x 85.1 cm (100½ x 54 x 33½ inches). Des Moines Art Center, Gift of the Gardner Cowles Foundation in memory of Mrs. Florence Call Cowles.

front, being attached only along one edge of the upper form. These steps in turn serve to lift the upper plane and deny its mass, again indicating a direction started in *Sentinel III* and *IV* that ultimately culminates in the Cubis.

The separateness of elements in *Zig II* is underscored by the manner in which they are painted. Already in *Zig I* Smith had introduced a new kind of surface, scumbling passages of dense black over an underlayer of solid dark

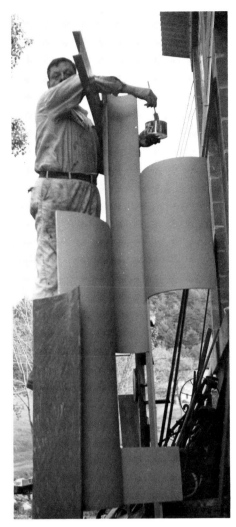

Smith painting *Zig II*.

Smith's sculpture studio with *Zig II* (unfinished).

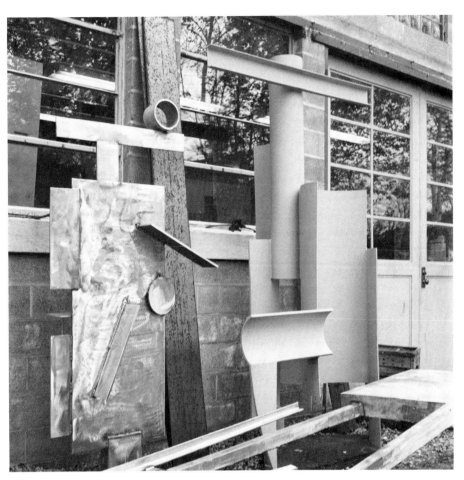

Zig II (unfinished) outside Smith's sculpture studio. *Two Circle Sentinel* is on the left.

pink. This technique creates a random pattern of markings, not unlike the abstracted burnishings on the stainless steel Sentinels and other pieces of the same period. Unlike the stainless steel works, however, the continual pattern of pink and black functions to more clearly unify the various parts of the *Zig*.

A similar random pattern was used in painting *Zig II*, Smith again scumbling one color over another. But unlike the earlier work, in *Zig II* Smith chose to use different color combinations on certain planes in the composition. *Zig II* is, then, Smith's first major polychromed sculpture.[13]

Contrasts of Forms

We can gain a clear idea of how these multicolored surfaces function in *Zig II* by comparing the work as it exists now to its own earlier state with a monochromed surface, as is shown in a photograph taken outside of Smith's studio. Taken sometime in the spring of 1961—witness the full leaves on the trees reflected in the windows—the photograph reveals Smith's comparison of *Zig II* with *March Sentinel,* a connection suggested above. The photo-

113

graph also shows that as with other painted sculpture Smith chose to study the work for some time before finally choosing its surface coating. He then painted it with a brush, as shown in other photographs made at the same time.[14]

The earlier photograph shows *Zig II* when it was covered with a light primer coat applied evenly to all of its constituted parts. In this state the various shapes are still identifiable, but the uniformity of the surfaces puts even greater emphasis on the edges of the curvilinear pieces, thus strengthening the drawn characteristics that emerge from the structure's varying profiles. By subsequently painting the work with separate colors in various parts, Smith shifted the reading of the work to a contrast of the forms of its separate elements, with the individual profiles thus assuming a secondary role.

In *Zig II* the upper horizontal is painted with a random scumble, while the neck and many of the other areas are covered with a black-over-blue pattern. Two dominant colors are given to the two major color planes: The massive center semicylinder is scumbled with a brilliant orange over yellow, and the tall vertical at the right is painted in tones of red.

Although the precedents for that kind of polychromed juxtaposition of elements are found in earlier constructivist sculpture, none used such a scumbled touch or worked in such a monumental scale. A related counterpointing of colored shapes also exists in de Stijl and Bauhaus art, although, as Greenberg has earlier observed, these works are not directly relatable to Smith's Zigs. The strongest heritage for Smith's works lies not in what we might call the geometric tradition but rather in that of the school of Paris, and specifically the cubist works of Fernand Léger. Between 1912 and 1914, Léger painted a series called the *Contrastes de Formes,* paintings which are surprisingly like Smith's Zigs. In these works Léger scumbled red, white, or blue in irregular fashion onto a surface of burlap, which is itself quite uneven in texture. These color areas serve to identify and separate various geometric shapes that Léger had earlier outlined in black. As such they perform a function quite similar to the way in which Smith's differing colors clarify individual components that are separated by their strong profile edges. The formal connection is even stronger when we realize that Smith's curvilinear planes also have a precedent in Léger's pictures. Indeed, so many of the shapes outlined by Léger were also semicylindrical in design that the style of the *Contrastes de Formes* series was called *tubism* when the pictures were first exhibited in 1911.[15]

To understand the connection and even suggest the origin of Zigs, we must also look at the closest precedent for the partial cylinders in Smith's art, namely his *Bouquet of Concaves,* which was finished slightly more than a year before. In reflecting on this work Smith wrote:

My thoughts saw concave and convex—and the sculpture I had recently finished called *Bouquet of Concaves,* and immediately my vision grew to concaves larger than my own being, and on a piece of cardboard, I made a unity of concaves in orders I had not found in my previous concaves. . . . This was a flash of recognition. . . . [I] appreciatively recalled Léger in 1913 like the pictures of so called Tubism in the Arensberg collection in Philadelphia.[16]

5. Fernand Léger. *Contrastes de Formes,* 1913. Oil on canvas, 100.3 x 81.3 cm (39½ x 32 inches). The Museum of Modern Art, New York. The Philip L. Goodwin Collection. Not in exhibition.

Zig III

The reference to cubism, here in the form of Léger's *Contrastes de Formes*, continues into the next work in the series, *Zig III,* also completed during 1961.[17] This sculpture marks a clean departure from the preceding two figured works, moving toward an abstract, architectural quality—the kind of structure the series title *Zig*—short for ziggurat—suggests.

Smith also used this title, as he said, because the compositional activity takes place on "more than one level," just as in the ziggurat the structure moves upward by a series of separately defined steps. In the initial two works these levels can be identified with the figural divisions. In *Zig III,* however, that is not the case. In the initial two Zigs, the horizontal levels are all geared to the dominant vertical spine, but in the third work the focal figural core is absent. Although we might define the former structure as a staff with crossbars, what we find in *Zig III* is essentially a post and lintel structure: a pair of vertical passages rising separately to support a very high horizontal construction. Spanning the lower portion of the work is the long rectangular slab into which are set the paired posts.

But clearly the vertical elements are not simple supporting vertical beams. Rather, like the other Zigs, they are multipart structures, which—somewhat like ziggurats—rise through a series of steps of compositional offsets. Indeed, on one side they shift from the semicylinder form common to the preceding Zigs to a flat plane that is set inward and carries the lift to the upper regions. The lintel itself is also a composite of semicylinders and planes, plus a thicker plane with a cut-out circle that juts off perpendicular to the horizontal orientation of the upper passage. The perpendicularity is echoed by another plane, terminating with a semicylinder, which projects forward in an opposing orientation at the other end of the work.

The juxtaposition of flat planes and semicylinders does recall Léger's *Contrastes de Formes* but only in the general way in which the sculpture spreads out and opens up across the viewer's perspective. A much more pertinent example for this kind of structure can be found in certain of Lipchitz' late cubist works, which not only spread the composition out laterally but also key the arrangement to a similar contrast of flat and concave. Lipchitz' works remain conventional and tame because of his maintenance of a solid figural block, whereas in Smith's *Zig III* the abstract nature of the construction lends itself to using more freely arranged planes and semicylinders. In this regard, and in its gatelike structure, *Zig III* also moves toward the Cubis and their celebration of the metal weld's ability to simply stick heavy steel up into the air.

Zig V

The figural traits of the first two Zigs and the more abstract flying of shapes seen in *Zig III* are reprised in *Zig V.* Here a similar curvilinear form is used for one leg, sweeping out across the base, while an echoing semicylinder and flat plane composes the other. As with *Zig II,* a third supporting prop is included in the middle, in this case another sweeping, curved plane. *Zig V* is like *Zig II* in using a large element for its central spinal core, although here

6. David Smith. *Zig III*, 1961. Steel, painted black, 235.6 x 281.9 x 152.4 cm (92¼ x 111 x 60 inches). The Museum of Modern Art, New York. Mrs. Simon Guggenheim Fund, 1966.

the piece is a long partial-cylinder that is not only unintercepted but cut from its original cylinder much less, so that its flanking ends move much closer to completing the parent circle.

Where *Zig V* differs from the initial two and draws from *Zig III* is at the top. Tangential to the upper edge of the nearly closed vertical cylinder, Smith inserts a massive rectangular plane that strikes out dramatically to the

7. Jacques Lipchitz. *Seated Guitar Player,* 1918. Bronze, 60 cm high (23⅝ inches). Courtesy of Marlborough Galleries, New York. Not in exhibition.

8. David Smith. *Zig V,* 1961. Steel, painted black, blue, white, pink, 282.6 x 214.0 x 69.2 cm (111¼ x 84¼ x 27¼ inches). Collection, Candida and Rebecca Smith, Courtesy of M. Knoedler & Co., Inc., New York.

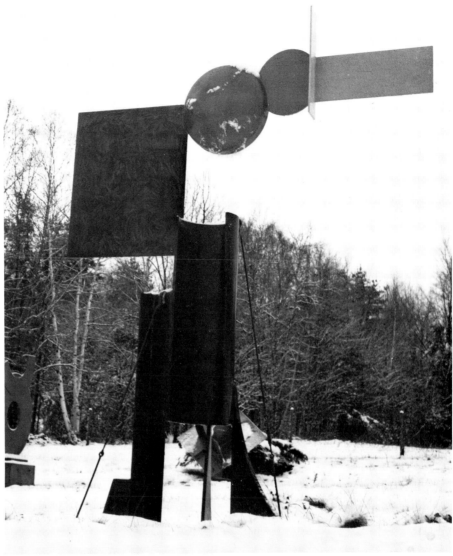

left. Indeed, this element is so "off" in comparison with the contrapuntal cohesion of the lower figural organization that the entire sculpture would be disjointed were it not for the remaining elements: a sequence of four pieces that juts off in the other direction, tangential to the upper edge of the rectangle and across the top of the piece. Made up of two circles, one a bulky tank end, and two planes, one set perpendicular to the other pieces, the horizontal passage recalls the lintel of *Zig III* except that one end stands independently in space. That extraordinary grouping is also separated from the other portions of *Zig V* by its coloration; it is painted blue, white, and pink, in contrast to the scumbled black surface of the figural structure below. Indeed, the grouping's only concession to a figural character is the location of the volumetric disk, which in being placed directly above the central figural spine reads like a large, culminating head.

117

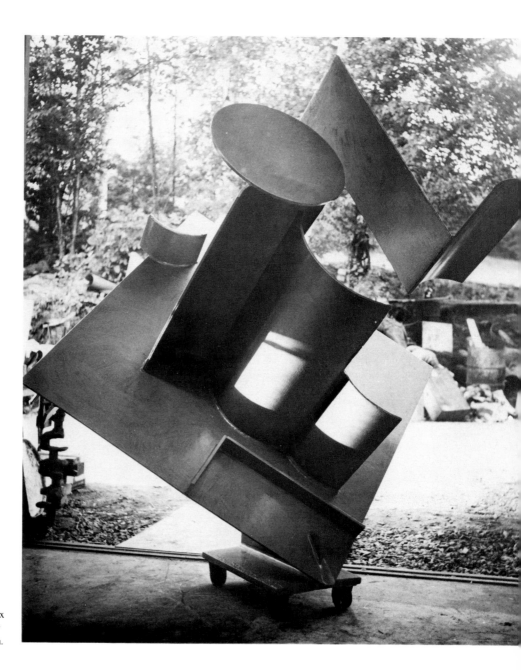

9. David Smith. *Zig IV*, 1961. Steel, painted, 241 x
194.3 cm (94⅞ x 76½ inches). Lincoln Center for
the Performing Arts, New York. Not in exhibition.

Zig IV

As we have seen earlier, *Zig IV* has been received in the literature on Smith
as one of the artist's greatest works. And indeed, its appearance and the con-
ception behind it are extraordinary. The sculpture is essentially based on a
flat, square plane that has been turned to stand on one end to form a dia-
mond shape, and this surface has, in turn, been tilted up along one point, so
that the diamond rests at a forty-five degree angle between the conventional
horizontal and vertical coordinates of Smith's—and traditional—sculptural
orientations. The angled plane rests on a vertical plane set upon small
wheels; a small section of the vertical support breaks through the diamond
plane as a small, bumplike shape at its lower point.

118

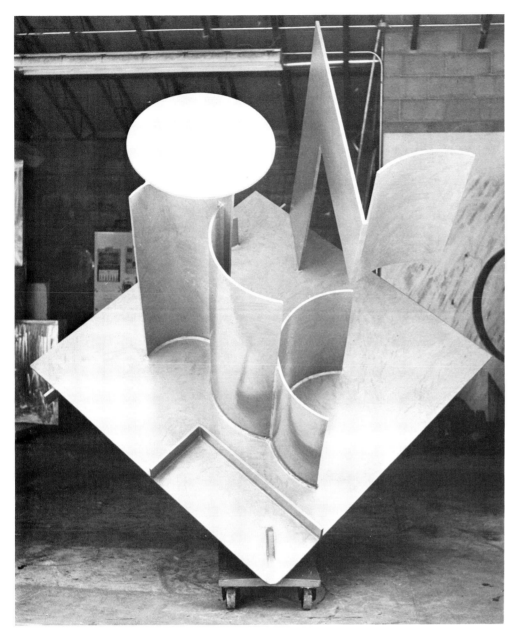

Zig IV, alternate view.

10. Piet Mondrian. *Lozenge in Red, Yellow and Blue,* 1925. Oil on canvas, 142.8 x 142.3 cm (diagonal dimensions) (56¼ x 56 inches). National Gallery of Art, Washington, D.C., Gift of Herbert and Nannette Rothschild, 1971. Not in exhibition.

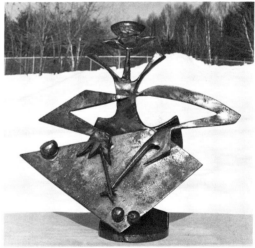

11. David Smith. *Billiard Player II,* 1945. Steel, 42.6 x 45.4 x 16.8 cm (16¾ x 17⅞ x 6⅝ inches). Collection, Candida and Rebecca Smith. Not in exhibition.

Rising from, and perpendicular to, the tilted diamond surface are four semicylinders, matching those used in *Zig I, II, III,* and *V,* made of different lengths and placed on end on their attachment plane. Near the top a flat plane is also used, rising vertically, then cut horizontally to form an inverted L-shaped piece. Off of this element is hung another semicylindrical form, tangential along one edge, that is matched by a flat disk that is cantilevered off the upper edge of the tallest vertical semicylinder. At the lower edge a squat L-shaped piece inscribes a rectangle by using two of the exterior edges of the large diamond plane.

Given the angular location of the dominant plane and its turning to be-

come a diamond-shaped platform, *Zig IV* makes less reference to the vocabulary of Léger's *Contrastes de Formes* as do the other works in the series, although the individual dialogue between the semicylinders and the planes does recall the cubist vocabulary. Given this unusual diamond surface—unusual in that it rarely occurs in painting, let alone in sculpture—precedents to *Zig IV* do lie with the constructivist tradition, Greenberg's comments not withstanding. Indeed, the only direct parallels for the diamond composition can be found in the diamond-shaped paintings that Piet Mondrian began around 1918, despite the fact that Smith's work does not restrict the composition to the trued and faired planes and lines of the de Stijl formulation.[18]

Given the radically different structure of *Zig IV,* and especially its abstract composition, it is surprising to discover that *Zig IV* has been associated with specific forms of imagery. To be sure, Greenberg would say in 1966 that *Zig IV* "escapes entirely from allusions to the natural world (which includes man) that abounds elsewhere in his art. Abstract form—perhaps with some references to urban landscape—guides the eye here"; Fry, writing in 1969, considered *Zig IV* as abstract, a "structure."[19] But by 1971, Tucker would propose that "its authority must relate to its evocation of a gigantic human head, or rather face," a suggestion that finds no comparable reference in Smith's work of this period and only dim echoes in *Agricola Head* and other heads of the early 1930s, which are quite different in character and radically separate in scale.[20] Krauss' identification of the (metaphorical) imagery or subject matter in *Zig IV* depends upon reading the work in the context of Smith's entire oeuvre. Indeed, in her thesis, Krauss writes that "we tend to think of the late sculpture in general, and the *Zigs* in particular, as being totally abstract. . . . However, *Zig IV* can be read at quite another level: with its mortarlike tubular segments poised on a tilted platform, like a partially dismantled antiaircraft gun, the sculpture makes (like *Zig VII* and *VIII*) an elliptical reference to a cannon."[21] For Krauss, this imagery, even if metaphorical or elliptically stated, was present because "the single factor that emerges from a survey of Smith's work is the recurrence of images, of which the cannon is a central member. . . . *Zig IV* was not the first cannon to appear in Smith's production."[22]

As insightful as Krauss' thesis may be in establishing the texture of Smith's career, nothing in his work specifically restricts itself to the Kraussian categories or, in an opposite way, seeks to align the works with them. Moreover, when Smith wanted to be precise about his imagery, as with the Sentinels, he went about making it so. Beyond the idea that *Zig IV* might indirectly look like a "dismantled antiaircraft gun," nothing in the work—or in its context with the other Zigs—particulary relates the work to Smith's earlier involvement with cannon imagery.

Is there a way to account for, or at least suggest a basis for, this radically composed work? One suggestion may be found in the formal aspects of the work itself. If we isolate the large rectangle and its perpendicular elements from the rest of the work, these sections appear much more in harmony with the other Zigs of 1961, and especially with the architectural *Zig III*. Indeed, if we imagine the square plane of *Zig IV* placed horizontally on the ground, then its semicylindrical and planate elements assume an even greater resem-

blance to the post and lintel structure Smith used in *Zig III*, although the elements in *Zig IV* are gathered in the center rather than being placed at the ends and then laterally in the air, as they are on the long horizontal composition of *Zig III*. That suggests *Zig IV* was a more conventional sculpture that Smith at some time drastically altered by tilting it diagonally and placing the plane on the vertical plinth supported by wheels. In doing so he might have been following a precedent in his own work, namely the *Billiard Player* of 1945, where the table is turned up in a comparable manner so as to also form a diamond shape.

Besides the resemblances between *Zig III* and *Zig IV*, there is another aspect of the latter to suggest it was at some point transformed. There is a relative formal weakness of the upper element by itself that suggests a tendency toward a bulky, boxlike presence. The projecting elements are of such measure that, combined with the proportions of the square base, they create "the volume of a virtual cube," as Fry has observed.[23] Because the cube suggests a container of space, the semicylinder and planes appear not only to sit within the cube but to function so as to further articulate the cube by alternatively occupying the volume and dividing up the contained space. As Tucker accurately notes of *Zig IV*, this "dense and massive structure [is] the work in which Smith came closest to carving."[24] But Smith overcame a sense of carving, at least partially, by pushing the plane into the air at a much more active angle. That is to say, the final appearance of the plane is formal rather than thematic.

Zig VI?

A similar act of revision, perhaps both thematic as well as formal, may explain the absence of *Zig VI* in the series. It is possible, of course, that Smith misnumbered the series, and accidently skipped *Zig VI*. Or he may have not yet completed (or begun) the work at the time of his death; we know that other works in other series were not completed in sequential order or even within a close period of time. However, several factors lead to a thesis that a work from 1964, called *Untitled*, may have initially been the missing Zig.[25]

The title *Untitled* was not Smith's. Although the work is dated and signed, it was left without a title; thus the *Untitled* was applied posthumously. Although not proof that the work was intended to be *Zig VI*, the lack of a real title does keep the possibility open, for the sculpture was not made a part of any other series.

Untitled is generally unlike the preceding Zigs in composition and materials. It does correlate with *Zig I, II,* and *V* in being a figural structure of vertical orientation, clearly separated parts, and a change in scale of these elements. But in the more specific formulation and its figure, *Untitled* more closely relates to the *Sentinel* series, as does *Zig I* discussed above. *Untitled*'s correspondent Sentinel is *Sentinel III*, both in formulation and materials. Both works are constructed of I beams stacked one on top of the other to make a vertical structure. The head in each work is defined by a horizontal passage projecting to the rear, formed of a pair of I beams in the *Untitled*. Both works create a torso out of a tall I beam; in *Sentinel III* the piece is long and very narrow, whereas in *Untitled* Smith uses a broad piece, creating

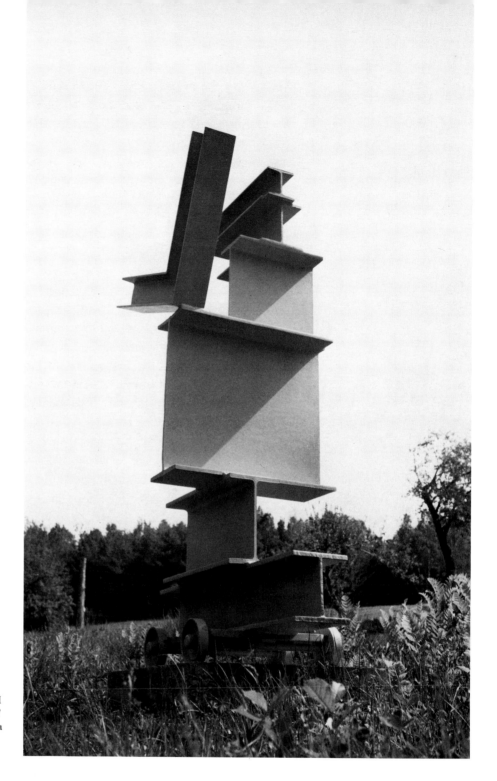

12. David Smith. *Untitled (Zig VI?)*, 1964. Steel I beams, painted yellow ochre, 200.3 x 112.7 x 73.7 cm (78⅛ x 44⅛ x 29 inches). Collection, Candida and Rebecca Smith, Courtesy of M. Knoedler & Co., Inc., New York.

a dominant plane like that used in *Two Circle Sentinel* and *March Sentinel*. Finally, like *Sentinel III*, *Untitled* rests on wheels: four small ones compared with the unequally sized trio used in the earlier work.

The wheeled platform, which also relates *Untitled* to the *Wagon* series, marks a connection as well with *Zig IV*, which rests on a similar support, and with *Zig VII* and *VIII*, which also use this element. *Untitled* relates to *Zig VIII* in another way: The dramatically balanced L-shaped I beam near the top of *Untitled* is a precursor to a similar I beam projecting from the front of the last work in the series (see below).

None of these aspects of *Untitled* posits—or denies—its being the missing *Zig VI*. What does raise the question are Smith's own words about the Zigs, made during a slide lecture given at Bennington College shortly before his death.

An affectionate term for ziggurat—ziggurat is too big a word and—I don't know—it seems more intimate, and it doesn't have to be as high as the towers of Babylon; but it is a vertical structure of more than one level, and that is on small wheels—which are functional—they pull that way.[26]

No notations were made of which slides Smith showed during this lecture, so which specific pieces he was discussing in any portion of his address can only be deduced from the descriptions contained in this remark. But in matching his comments with the work in the *Zig* series, it becomes readily apparent that none of the titled Zigs is both a vertical structure of many levels and rests on wheels. Only *Untitled* fits that description.[27] Less strictly relevant, but perhaps explanatory, is the fact that Smith installed *Untitled* in the south field in a line with other Zigs, which suggests that Smith was studying *Untitled* for inclusion with the other Zigs, deciding in the end it did not belong enough to bear the number *VI*.[28]

Zig VII and *VIII*

The last two works in the *Zig* series, numbers *VII* and *VIII*, were made in 1963 and 1964 and mark a return to the extraordinary construction of the earlier *Zig IV*. Each work uses the four-wheeled, rectangular base and a supporting vertical post to which is attached a large square plane, again turned forty-five degrees to form a diamond. Like *Zig IV*, the diamond in *Zig VII* is tilted at an angle to the horizontal and vertical coordinates, but unlike the earlier work, the plane in *Zig VII* is placed askew of the base, sitting at an angle to a conventional frontal/side orientation. *Zig VIII* also differs from *Zig IV*; the diamond is raised to a fully vertical position.

Zig VII can be distinguished in Smith's oeuvre by its clarity of means on the one hand—flat, clearly painted, basic geometric shapes—and on the other by the complicated manner in which its components are arranged. The upper surface of its diamond plane is much more Mondrian-like than *Zig III;* the diamond is crossed principally by straight linear bars placed perpendicular to it. That creates sculptural geometric drawing, although not keyed to the horizontal and vertical as in de Stijl pictures. At the lower edge of the diamond is a short semicylinder placed tangentially to the diamond's point, the last use in the Zigs of the semicylinder, which so fully composed the initial works.

What makes *Zig VII* exceptional are the circular elements that are hung off of the "backside;" backside is in quotes because although we read, and Smith photographed, *Zig VII* so that the diamond is face on, he aligned the work in the opposite direction when it was installed next to *Zig VIII* in the south field. These circles include a pair, one with a hole in its center, joined by a short bar. The pair juts out from the upper point of the diamond. Two other circles, or rings with larger holes in the center, also hang from the massive plane, one attached to a curving strut, the other tangential to the diamond. A fourth circle, much smaller, rests atop the vertical support. Like

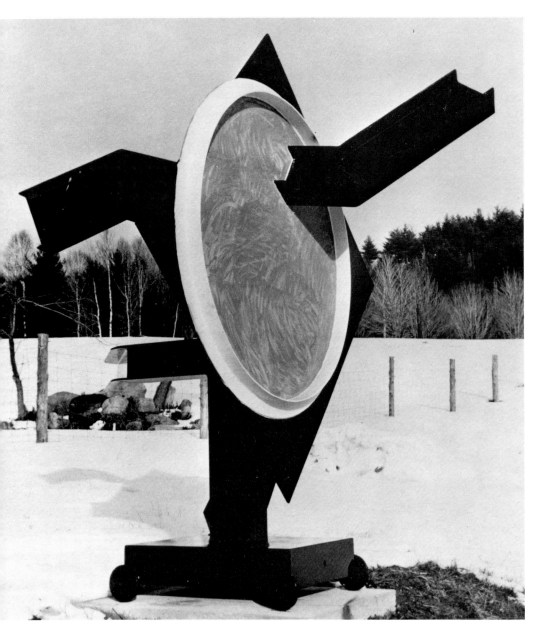

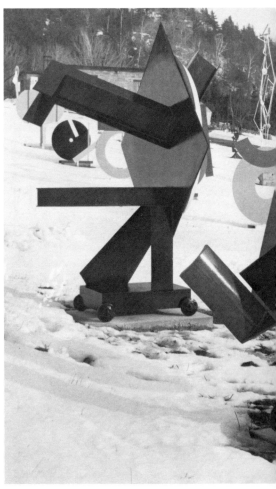

13. North field, Bolton Landing, with *Zig VIII* and *VII*.

14. David Smith. *Zig VIII*, 1964. Steel, painted red, white, and black, 255.9 x 232.4 x 210.8 cm (100¼ x 91½ x 83 inches). Museum of Fine Arts, Boston. Centennial Purchase Fund.

the upper horizontal assemblage of *Zig V,* the rings and other parts of *Zig VII* are painted in different colors so that the individual identities and the attached character of the elements is emphasized.

Zig VIII is less eccentric than *Zig VII* in its construction but no less so in its countenance. The large plane is placed in a vertical orientation, also turned forty-five degrees; the surface more fully resembles a diamond painting than does *Zig IV* or *VII*. The greater pictorial quality is underscored by the character of the applied elements and their surface. Unlike the sequential lines or projecting semicylinders of the preceding Zigs, Smith has collaged a complete ring centered on the diamond field. The surrounding diamond field is painted black; the raised ring itself is white, with its interior loosely painted and scumbled in strokes of red.

15. David Smith. *Zig VII*, 1963. Steel, painted cream, red, and blue, 238.8 x 269.2 x 215.9 cm (94 x 106 x 85 inches). Collection, Candida and Rebecca Smith, Courtesy of M. Knoedler & Co., Inc., New York.

The origins of the inscribed color circle and of the circles used in *Zig VII* lie in the series of polychromed circles Smith made in the fall of 1962 (see chapter 4). These circles derive in turn from Kenneth Noland's paintings of the early 1960s, the *Targets,* which use concentric rings of color placed on a white, square canvas. In *Zig VIII* Smith makes the reference to Noland's work more explicit by painting the enclosing ring white, echoing the bare white canvas left between the painted circles in Noland's targets. As if to underscore his reference to Noland's series title, Smith inserts a bent I beam in the front of *Zig VIII* and continues it out the back, so that the composition actually reads as if an arrow had struck a target.

16. East field, Bolton Landing, with *Zig II* and *III* on the right.

Possibilities

In the end the *Zig* series remains among the most curious of Smith's groupings and the one that allowed him the greatest degree of experimentation. The early works in the series, deriving from the Sentinels, suggest that in the Zigs Smith was working toward an enlargement of the accomplishments of the earlier series, transforming the flat rectangular structure into bolder dimensions both by using the larger bowed planes of the semicylinders and by opening up his composition by using the organization of core and struts and post and lintel. All of these aspects are shared by or predict the *Cubi* series. But in the wheeled Zigs, numbers *IV, VII,* and *VIII,* Smith took the inventive qualities of the earlier Zigs further, creating works that are both connected to works in the modern tradition (Mondrian, Noland) and yet radically different from them because of the unexpected newness of their structure. The works are audacious because we have never seen anything like them before.

Notes

1. David Smith, "Some Late Words From David Smith," ed. Gene Baro, *Art International, 9* (20 October 1965), 49.

2. Count from Rosalind E. Krauss, *The Sculpture of David Smith* (New York, 1977).

3. Greenberg began his strong support of Smith in the 1940s, and Kramer continued and added to it during the 1950s, culminating in Kramer's special issue of *Arts* devoted to Smith: *Arts, 34* (February 1960).

4. Hilton Kramer, "Latest Thing in Pittsburgh," *Arts, 36* (January 1962), 27.

5. Clement Greenberg in conversation with the author and in "David Smith's New Sculpture," Garnett McCoy, ed., *David Smith* (New York, 1973), 222.

6. Clement Greenberg, "Critical Comment," in Cleve Gray, ed., "David Smith," *Art in America, 54* (January–February 1966), 28; Edward Fry, *David Smith* [exh. cat., The Solomon R. Guggenheim Museum] (New York, 1969), 126.

7. William Tucker, "Four Sculptors Part 4: David Smith," *Studio International, 181* (January 1971), 25.

8. Rosalind E. Krauss, *Terminal Iron Works: The Sculpture of David Smith* (Cambridge, Massachusetts, 1971), 12.

9. Greenberg in McCoy, *Smith*, 222.

10. Smith made the elements in the Zigs, thus allowing him to work in a much bigger size than that given by found elements. Krauss makes a similar point about the Cubis, *Terminal Iron Works*, 186–187.

11. Phyllis Tuchman raised this point in conversation with the author.

12. See Fry, *Smith*, 125.

13. I use the term major in reference to scale.

14. "I don't like spray—it gets my skylights dirty, and it is bad for your health," Smith in Baro, "Late Words," 50.

15. Louis Vauxcelles first used the term *tubist*, according to Léger, in a letter to Alfred Barr, in John Golding, *Léger's Le Grand Déjeuner* [exh. cat., Institute of Fine Arts] (Minneapolis, 1980), 70.

16. David Smith, *David Smith by David Smith*, ed. Cleve Gray (New York, 1972), 75.

17. *Zig III* is dated only 1961, without an inscription of month or day.

18. For a discussion of this format, see E. A. Carmean, Jr., *Mondrian: The Diamond Compositions* [exh. cat., National Gallery of Art] (Washington, 1979).

19. Greenberg, "Critical Comment," in Gray, "David Smith," 28.

20. Tucker, "Four Sculptors," 27.

21. Krauss, *Terminal Iron Works*, 54.

22. Krauss, *Terminal Iron Works*, 56.

23. Fry, *Smith*, 126.

24. Tucker, "Four Sculptors," 27.

25. Peter Stevens, Rebecca Smith's husband, first suggested this idea in conversation with the author.

26. Smith in Baro, "Late Words," 49.

27. It is unclear from the tape if the "and that" in Smith's sentence might refer to another slide.

28. Its flat, even coat of yellow also raises the question of whether the work is unfinished. If that is the case, the work could still have become *Zig VI* upon completion.

Smith made smaller polychrome works much earlier, including the outstanding *Helmholtzian Landscape* of 1946 (Kreeger Collection, Washington, D.C.).

The Circles

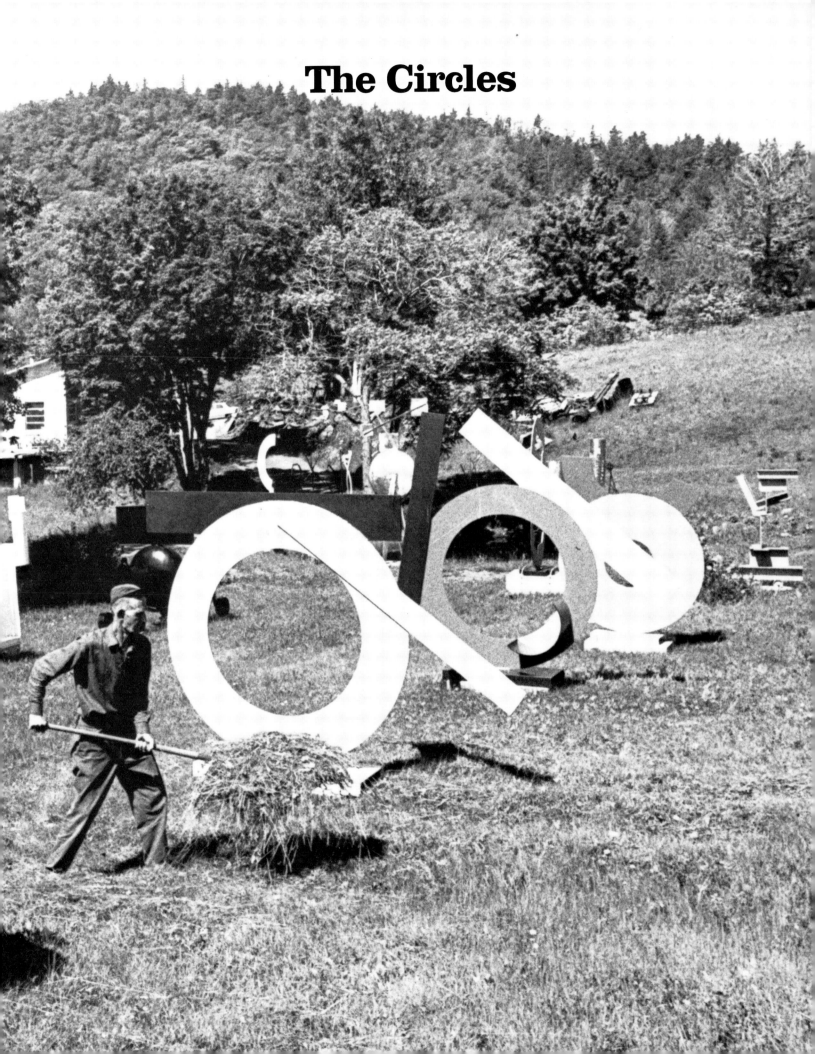

Circles

1. *Circle I,* 1962
 steel, painted pink, gray, black, and white (K-547)
 200.6 x 273.6 x 45.7 cm (79 x 107¾ x 18 inches)
 inscribed on base plane: David Smith CI. I 10-17-62
 National Gallery of Art, Washington, D.C., Ailsa Mellon Bruce Fund, 1977

2. *Circle II,* 1962
 steel, painted pink, black, and white (K-548)
 267.9 x 281.2 x 60.0 cm (105½ x 110¾ x 23⅝ inches)
 inscribed on base plane: David Smith CI. II 10-20-62
 National Gallery of Art, Washington, D.C., Ailsa Mellon Bruce Fund, 1977

3. *Circle III,* 1962
 steel, painted pink, white, and green (K-549)
 242.5 x 182.8 x 45.7 cm (95½ x 72 x 18 inches)
 inscribed on base plane: David Smith CI. III 10-22-62
 National Gallery of Art, Washington, D.C., Ailsa Mellon Bruce Fund, 1977

4. *Circle IV,* 1962
 steel, painted gray, black, burnt sienna, and white (K-550)
 214.6 x 94.0 x 38.1 cm (84½ x 37 x 15 inches)
 inscribed on base plane: David Smith CI. IV 10-19-62
 Collection of Candida and Rebecca Smith. Courtesy of M. Knoedler & Co., Inc., New York

5. *Circle V (Circle: Black, White, and Tan),* 1963
 steel, painted black, white, and tan (K-611)
 195.6 x 233.7 x 50.8 cm (77 x 92 x 20 inches)
 inscribed on base plane: David Smith CI. V 9-10-63
 The First National Bank of Chicago

6. *Bec-Dida Day,* 1963
 steel, painted yellow, red, and blue (K-610)
 215.9 x 165.7 cm (85 x 65¼ inches), on steel base: 10.2 x 137.2 x 45.7 cm (4 x 54 x 18 inches)
 inscribed on base at edge: Bec-Dida Day / David Smith July 12 '63
 Private Collection

CHAPTER 4 **The Circles**

Circles have long been a preoccupation, more primary than squares.

David Smith, 1962[1]

The circular form, either open as in a ring or closed as in a disk, played an important role in David Smith's vocabulary of shapes from the very beginning of his career as a metal sculptor. *Agricola Head,* one of his first works made in 1933, used a set of overlapping rings to create the head, and *Saw Head,* made at the same time, used a flat saw disk for the face of its composition. As we have seen, *Agricola Head* also focuses on the circle as an organizing form. Shapes were generated by the materials themselves, and found forms were always important to Smith. The circular tank ends he acquired in the early 1950s led to the *Tanktotem* series, figural forms that spring off of the circular component. Circles played similar, if more minor, roles in numerous other works during Smith's career, often appearing as details or secondary parts.

In the later 1950s, however, as one direction in his work tended increasingly to simple, geometric shapes, Smith began to make sculpture in which the circle itself played a major compositional role. We can see this in *Parrot Circle,* 1959, and in *Noland's Blues,* 1961, where a circle or set of rings dominates the sculptural image and the other parts are coordinated to it.

By the spring of 1962, this use of the circle as a compositional anchor had become so strong that Smith could use this simple geometric form as a base for works in which the other elements were highly irregular shapes, such as *Voltri XII* and *XV,* which juxtapose oddly shaped steel outcroppings with the uniformity of the shape of a flat steel ring.[2] These Voltris reflect a tendency of Smith's art to occasionally reverse directions in a series by mixing together vocabularies of quite different character. For the circle, employed as a component or the anchor, the most opposite use occurs in the Voltri-Boltons. Number *VIII* makes a circle out of roughly formed triangular parts, and in number *XVIII* the negative outline of a portion of a circle arcs its way through a conglomerate of irregular shapes (see the Introduction and chapter 5).

In the fall of 1962 Smith began a new series of works in which the circular shape became the central theme of the sculpture. Smith emphasized this by titling the series *Circle* and by making major formal changes in the way in which the circle was used. In his earlier circular works, Smith often employed or created a ring that was relatively narrow in the flat width of its band, as compared to its center opening, creating a margin only sufficient enough to key the other, irregular components. In these works, the circle functioned more as a line than as a physical plane. These circles were often lifted in the air on vertical plinths of various designs, further lessening the physical authority of the circle within the total image.

In the new works begun in October 1962, Smith eliminated the plinths. The circle rests directly on the base, focusing attention upon it as the total reference for the work. Furthermore, in these circles, the size of the ring—its proportions with respect to the hole in the center—is greatly increased, making it much more a plane rather than a line. And finally, like the later Zigs, the Circles are painted in brilliant colors, which emphasize the exact nature of the shapes and clarify the separateness of each element. These factors merge together to make the ring function visually as a large, colored plane that stands directly in front of—and spreads out before—the viewer and the ground of the sculpture. In this sense, the planes of the Circles are like the dominant planes of *March Sentinel* and *Two Circle Sentinel*, except that in those works Smith's figural details do not allow us to see the stainless steel sheet as a pure rectangle. In the Circles the rings are emphatically circles.

Circle I, II, and III

Smith made the first four Circles in October of 1962. Circles *I* through *III* follow the general composition outlined above; *Circle IV* differs greatly, and will be discussed later.

In *Circle I*, a large red ring with a wide band rests on a white base. Attached to the front of the circle is a long white rectangle, positioned at a decreasing angle to the right. Welded to the verso is another long rectangle, painted black and placed horizontally at the top of the ring. Although this composition is radically simple, it establishes Smith's major thesis, that the circle itself dominate the sculpture. By placing elements on both sides of the ring, Smith gives the circle a front and back and thus emphasizes that the circle itself is the focus—as a plane cutting across our vision rather than a background that simply supports various items.

Circle II echoes and reverses *Circle I*. Its ring is also painted red but of a deeper hue, and it rests on a rectangular black base rather than the white one used in the initial piece. *Circle II* also employs a white and a black rectangular plane but switches the sides to which they are attached. Now the black plane, here on the front, sits in an almost vertical position along the left edge of the ring, while the white rectangle is still on the right and still placed at an angle but now ascending. *Circle II* also differs from *Circle I* by having a small semicylinder attached to the front and painted white on the interior and black on the lower side.

Circle III is partially different from the first two. Like them, it also has a

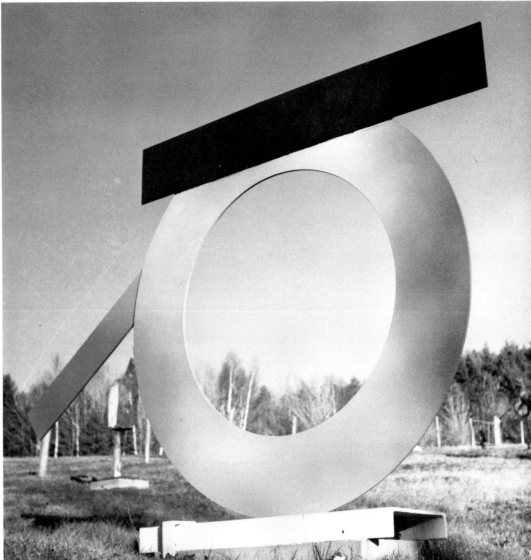

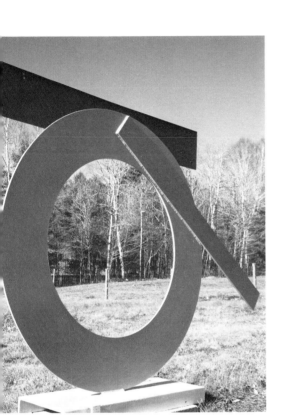

2. David Smith. *Circle I*, 1962. Steel, painted pink, gray, black, and white, 200.6 x 273.6 x 45.7 cm (79 x 107¾ x 18 inches). National Gallery of Art, Washington, D.C., Ailsa Mellon Bruce Fund, 1977.

ring that rests directly on a rectangular base, here painted white as in *Circle I*. This third work's circle also has a hole in the center but is much smaller, making the ring considerably wider and more physically apparent. The ring is also painted red but a much lighter shade like that used in *Circle I*. Where it differs is in the absence of longer, rectangular planes. Instead, a semicircular shape, less than half of a ring of nearly identical size, is applied to the verso, a flat echo of the small detail on the surface of *Circle II*. It is painted a strong green.

Targets

The literature on these three Circles make continued reference to their relationship to the target paintings of Kenneth Noland, who was a close friend of Smith's and lived nearby in South Shaftsbury, Vermont, near Bennington College.[3] This scholarly identification of the works of the two artists is

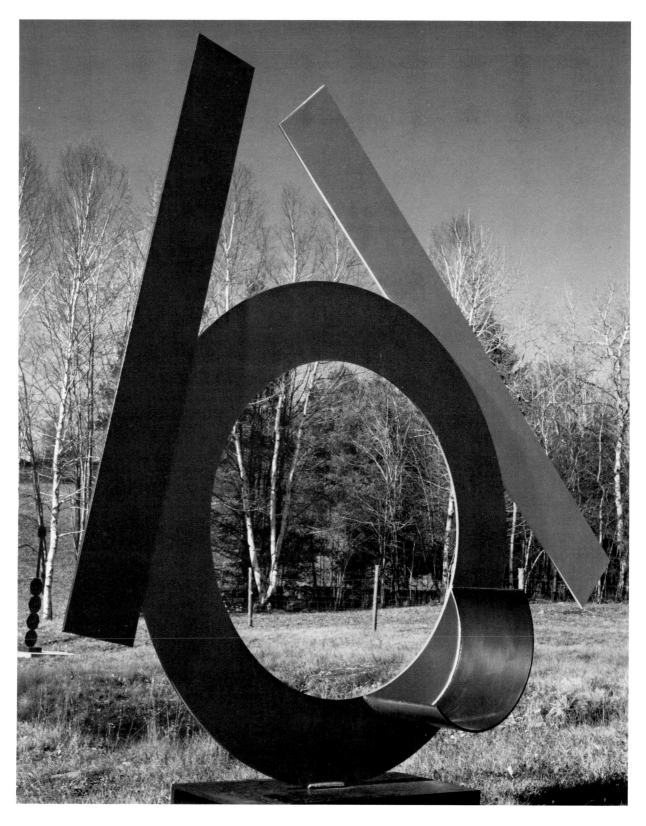

3. David Smith. *Circle II*, 1962. Steel, painted pink, black, and white, 267.9 x 281.2 x 60 cm (105½ x 110¾ x 23⅝ inches). National Gallery of Art, Washington, D.C., Ailsa Mellon Bruce Fund, 1977.

4. David Smith. *Circle III*, 1962. Steel, painted pink, white, and green, 242.5 x 182.8 x 45.7 cm (95½ x 72 x 18 inches). National Gallery of Art, Washington, D.C., Ailsa Mellon Bruce Fund, 1977.

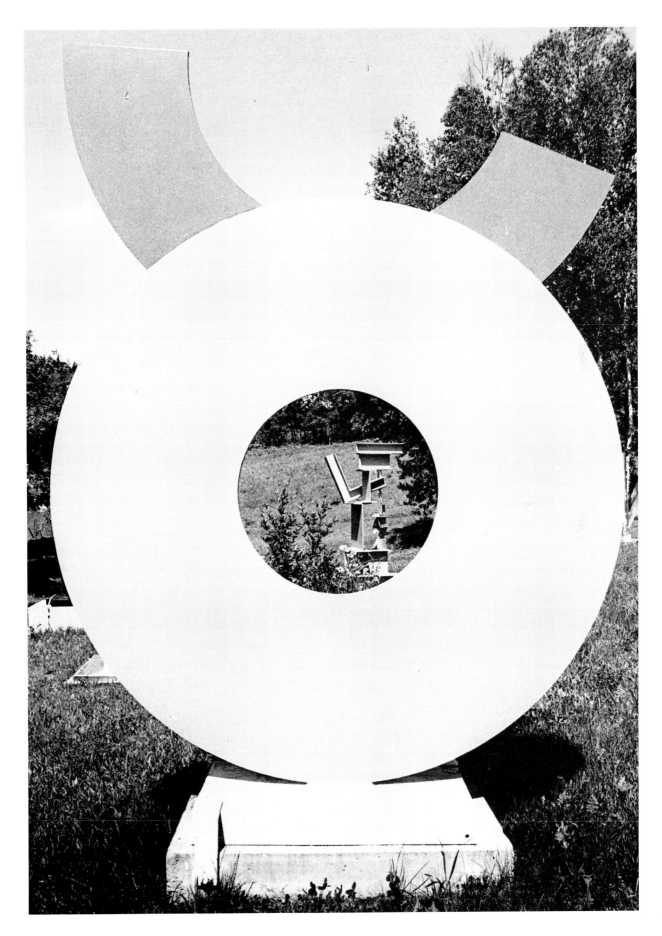

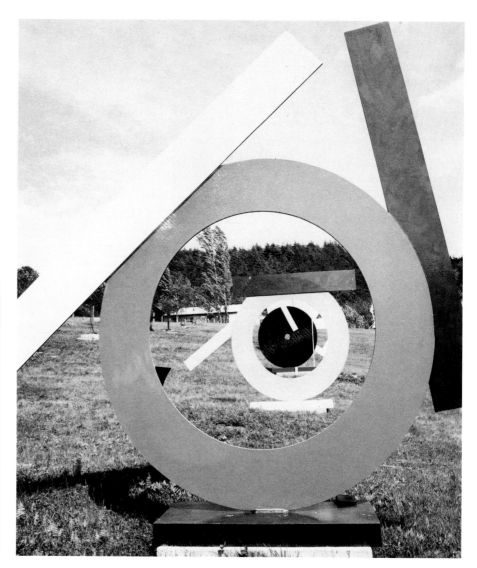

5. Kenneth Noland. *The Clown,* 1959. Oil on canvas, 171.2 x 116.9 cm (46⅛ x 46 inches). National Gallery of Art, Washington, D.C. Gift of Dr. and Mrs. Robert Wetmore, 1975. Not in exhibition.

6. Right. North field, Bolton Landing. *Circles II, I,* and *V.*

largely based on the manner in which Smith installed the three Circles in the north field at Bolton Landing: placed one after the other with their center holes directly on line and all turned front to the viewer.[4] Given this relationship, these three polychromed works become a kind of sculptural triptych. Edward Fry writes, "seen end-on in line, they become paraphrases of Noland's concentric circle stained canvases of 1960 and 1961."[5]

This is indeed how they worked when seen in the field. But this direct connection with Noland's *Targets* may have been more the result of Smith's experimenting by moving his works around in the field rather than a specific intention when the Circles were made. Two factors support at least a partial weakening of this *Target*-based conception: drawings of the Circles, which have only recently come to light, and the history of their placement and conditions in the field.

The relationship between this sculpture trio and the *Targets* largely rests upon their sharing concentric circular bands. But when each of Smith's Circles is seen independently, the connection is less obvious. Indeed, Smith's in-

7. David Smith. Drawings, 1962. Ballpoint, 27 x 21 cm (10⅝ x 8¼ inches). Courtesy of Mekler Gallery, Inc., Los Angeles. Not in exhibition.

dividual sculpture is about a circle, rather than many circles, and this separateness is emphasized by the attached planes in *Circle I, II,* and *III,* which find no direct correspondent elements in Noland's paintings. To be sure, the black and white rectangular planes can be connected to the *Targets* by an extended view of them as Smith's geometric variation of the irregular swirls Noland used in some canvases, but the green semicircle of *Circle III* cannot be. Furthermore, the drawings show several early ideas for individual Circles that use flat, nearly square planes, creating an image even more unlike the even pace of Noland's color rings.

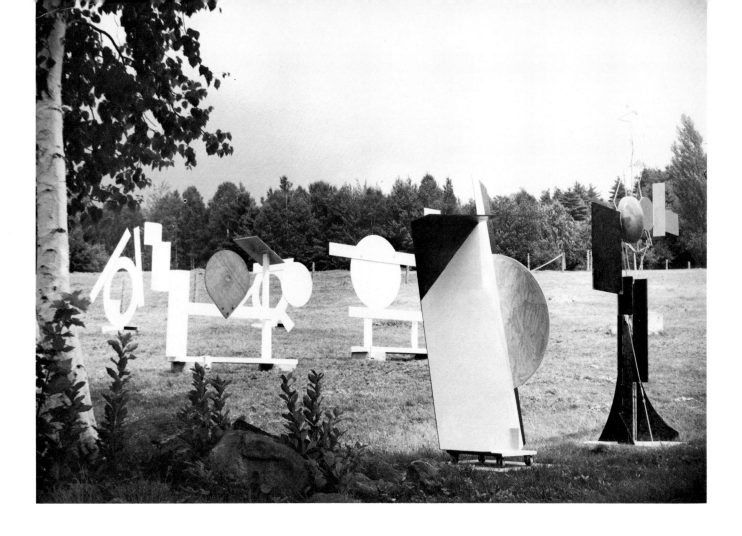

8. The north field at Bolton Landing, showing
Circle I and *II* unpainted. Spring or summer, 1963.

More importantly, a photograph taken shortly after they were completed
shows that when the Circles were first installed in the north field, they were
not aligned as a triptych. Rather, they were more widely spaced out in a tri-
angular orientation, each one placed on the point of a large triangle and fac-
ing inward toward the center. By December 1962, when Budnik first photo-
graphed them, Smith had moved them to their concentric placement; these
documents also show that at this time they were still unpainted, merely cov-
ered with a primary coating. They remained in this unfinished state until
the following fall, as other photographs record their unpainted state through
the summer. It is suggested here that Smith's deciding to paint them was
made concurrently with his decision in the autumn of 1963 to keep them in
their alignment. That is to say, it was this orientation more than the individ-
ual pieces that suggested the *Targets*. That is supported by the fact that dur-
ing the same fall period Smith created another work in the series, *Circle V,*
specifically in the style of the earlier Circles but with a much smaller center
opening. Painted black with a white rectangle, supporting struts, and an ele-
ment like a check mark, *Circle V* was moved into alignment with the others.
In that position it closed off the view made through the open centers of the
others. It should also be noted that in this field alignment the order of the
Circles runs *III, II, I, V,* again an indication that their concluding, concentric
nature was found rather than planned. Thus the painting of the initial three
Circles and the making and moving into position of the concluding fourth,

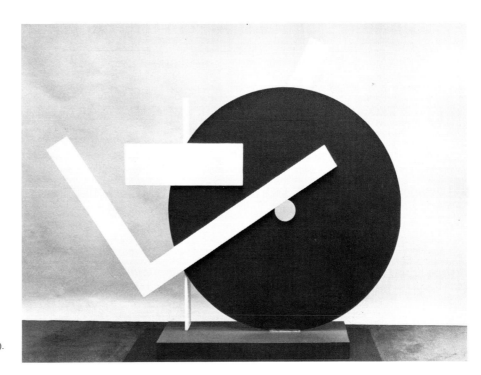

9. David Smith. *Circle V (Circle: Black, White, and Tan)*, 1963. Steel, painted black, white, and tan, 195.6 x 233.7 x 50.8 cm (77 x 92 x 20 inches). The First National Bank of Chicago.

number *V,* are all events that move the works much closer to Noland's *Targets* and are ones that occured at approximately the same time.

This is not to deny that the Circles were influenced by Noland's *Targets* in the initial stages. Part of Smith's art was moving toward the geometric during this period, a factor attested to in the concentric circles and specific title of Smith's *Noland's Blues*.[6] Noland's painting during the early 1960s stressed a simplicity of compositional layout—to contrast with his extraordinary color sense—and what this radically clarified art may have encouraged in the individual Circles was Smith's move to concentrate on the circle itself, making the ring the primary element of the sculpture.

Noland's multicolored rings may have influenced the polychromed Circles in more than the use of circles of different hues. Not only are they colored in more delicate hues; Noland's *Targets* are stain paintings, with the oil or acrylic applied onto raw canvas such that the texture or weave of the fabric runs through the painted areas and the surrounding zones of unpainted surface. Smith's Circles are also softly colored, more so than his other work, at least in the ring itself. And Smith's color is not quite as flat as it appears at a distance, for slight areas of white were left uncovered, providing both a subtle texture and a sense of color over a white ground, traits comparable with those in the *Targets*. This sculptural translation of a stained surface may also explain the odd semicircle in *Circle III,* which is unlike Noland's art. It does, however, echo a certain form in stain paintings by Jules Olitski, also made during this period. Indeed, Olitski's paintings were also exhibited at Bennington during the time Smith was beginning the Circles, and Noland recalls attending the show with Smith, who expressed interest in Olitski's work.[7]

By contrast, *Circle V,* the concluding sculpture in the north field assembly,

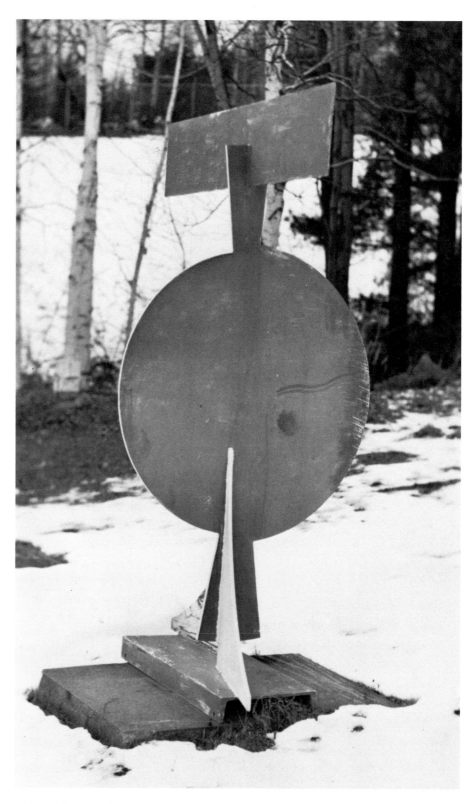

10. David Smith. *Circle IV,* 1962. Steel, painted gray, black, burnt sienna, and white, 214.6 x 94 x 38.1 cm (84½ x 37 x 15 inches). Collection, Candida and Rebecca Smith, Courtesy of M. Knoedler & Co., Inc., New York.

was made over a year later and differs in terms of its flatter paint surface and more forceful presence of its geometric elements. Indeed, of all of Smith's work, *Circle V*, with its pure, balanced composition, is the closest he came to the constructivist aesthetic.

Circle IV

Smith set *Circle IV* apart from the first three works—compositionally, thematically, and physically. This work uses a solid disk rather than a ring for its circle, one that is lifted by a wedge-shaped element at the bottom, which is itself lifted and structurally supported by two triangular flaring struts. These in turn rest on a rectangular base. Although they appear to be necessary to keep the work standing, these struts were not needed because a weld along the base would be sufficient, as evident in other Circles. Another wedgelike form emerges at the top of the circle, bisected by a rectangular plane that sits perpendicular to the frontal plane of the disk.

Given these changes from *Circle I, II,* and *III, Circle IV* is less focused than the others on the concept of the circle as the basis for the sculpture. Indeed, here the circle takes on the function of a torso, not unlike that served by the flat sheets in *Two Circle Sentinel* and *March Sentinel*. This sense is underscored by the manner in which the lifting of the flared planes makes them read as legs and the way in which the exterior one of their triangular sides is a sloping line, matching the form used for the abstract legs in *Zig I, II,* and *V*. Adding further to this reading is the wedge-shaped piece and the rectangular plane at the top, which rise above the disk like a neck and head, the latter akin to those used in the Sentinels and Zigs.

It is this anthropomorphic character of *Circle IV*—even if used only as a structural principle rather than as a sort of Circle personnage—that gives the work such a different sensibility than the other early Circles.[8] Smith returned to it in later works where the disk or ring is supported by legs or struts. These were not specifically entitled Circles or even numbered, suggesting Smith wanted to keep them separate from the *Circle* series proper. In this regard, Smith also kept *Circle IV* physically apart from *Circle I, II,* and *III;* for a while it was initially placed with them near the stand of birch trees in the north field, but by December of 1962 Smith had removed it, relocating it in the south field, where other leg-supported circular sculptures were placed nearby.

Bec-Dida Day

The superb sculpture *Bec-Dida Day*, made the summer after *Circle IV*, is the exception to the idea of the conflict between the work as circle, as in the first three in the series, and the work as figuration with a circle, as in *Circle IV*. In *Bec-Dida Day*, despite its anthropomorphic aspects, the circle itself remains the dominant element. We might even say this work is a circle that has been given figuration.

Smith accomplished this by reducing the scale of the added elements so that the huge tank end (the circle) is so large that it absolutely controls the work. The added pieces are all placed at the exterior and sit only tangentially to the circle rather than intruding and violating its shape. Smith fur-

141

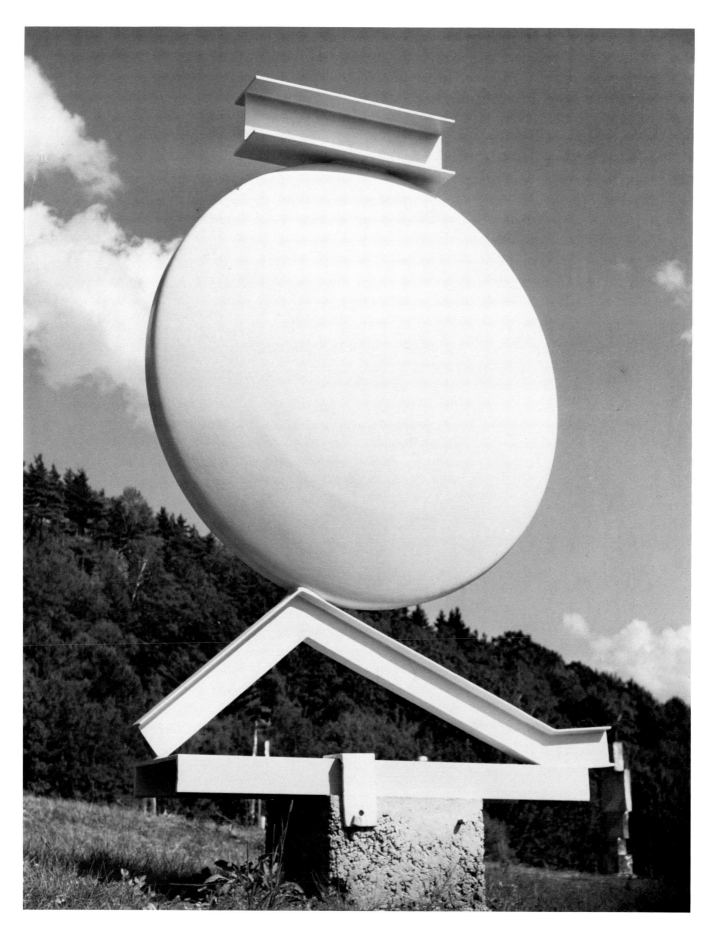

ther abstracted—and thus rather isolated—the circularity of *Bec-Dida Day* in his handling of its painted surface. As Fry observes of this complex program:

In *Bec-Dida Day* . . . Smith fully resolved for the first time the problem of using color in sculpture for purposes other than those of cubist pictorial aesthetics. Instead, color is here given primarily a phenomenological role, through which the identity of a structure in space is more clearly defined.

The huge tank end, assuming the role of torso in a roughly anthropomorphic composition, is painted blue within and yellow on its rear, convex side; the fact of this other side is emphasized through the yellow on the rim of the tank end; and this yellow is inescapably visible unless the viewer is very near the sculpture and directly in front of it. Similarly, the steel "I" beams at top and bottom (where the beam was cut and welded so that no break is visible) are polychromed in such a way that emphasis is given not only to their finite, separate existence within the sculpture as a whole, but also to the fact of their own three dimensional structure. Hence the "I" beam on top is brick red within its recessed channel but black elsewhere, including the ends and the entire reverse side. In similar fashion, the recessed channel of the lower "I" beam is painted the same yellow as the reverse, convex side of the tank end, but elsewhere it is black, as on the upper "I" beam; while on its opposite side Smith painted the recessed channel the same brick red that he also used on the upper "I" beam. From almost any position the viewer consequently is provided with information concerning the existence and structure of that which he cannot perceive directly, as well as that which is immediately visible to him; and thus the organization of color on what is structurally a thin, frontal composition invites a three dimensional apprehension of *Bec-Dida Day* exceeding that offered by much free-standing sculpture composed deliberately in the round.[9]

Despite the overwhelming dominance of the circle in the composition, *Bec-Dida Day* does have clear figural associations.[10] With the tank end serving as a greatly enlarged torso, the horizontal I beam tangential at the upper edge plays the role of the head, just as other long rectangular elements do in the Sentinels, Zigs, and, less directly, in *Circle IV.* The figure is rendered abstract here by the lack of a neck, which would supply a more figural presence.

In the same way, the I beam at the bottom functions as the legs of the figural image, one striding to the front at the right, the other trailing behind on the left, concluding with the suggestion of a foot on the left. This configuration of a personage in motion recalls an earlier Smith sculpture, *Running Daughter,* begun in 1956 and finished in 1960. This work, in turn, was based on a photograph of Smith's daughter Rebecca running across a field with her leg and foot trailing behind her but in a mirror image to that of the *Circle* figure. The recollection of this earlier sculpture in *Bec-Dida Day* is especially telling in this work, whose title makes reference to both Rebecca and Candida, Smith's two daughters. Its bountiful activity, its bright childlike primary colors, and the "Day" of its title suggests it commemorates a visit by the children to see their father at Bolton Landing.[11]

At the same time, this flat striding figure in *Bec-Dida Day* also finds ancestors in other earlier works by Smith, namely the Agricolas. As discussed previously, these works make reference to vase painting and mosaic sculpture, not only for the composition of a two-dimensionally rendered running figure but also to its inscribed circular rim. But in *Bec-Dida Day,* Smith expands this connection by moving the circular frame inside the piece to be-

12. Rebecca and Candida Smith at Bolton Landing.

11. David Smith. *Bec-Dida Day,* 1963. Steel, unpainted, 215.9 x 165.7 cm (85 x 65¼ inches). Private Collection.

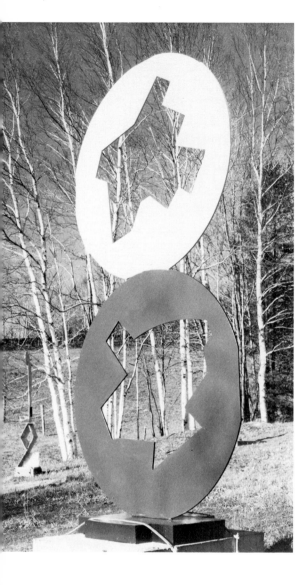

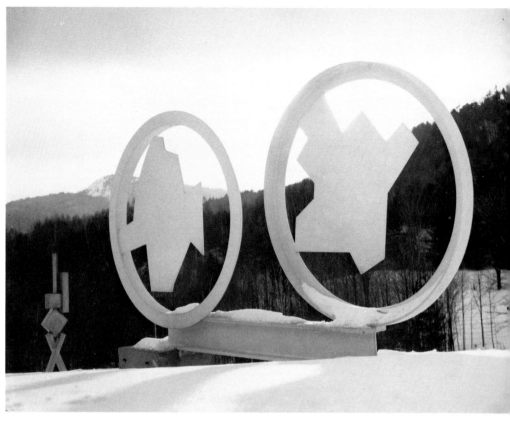

13. David Smith. *2 Circle IV*, 1962. Steel, painted yellow and blue, 304.5 x 153 x 71.8 cm (119⅞ x 60¼ x 28¼ inches). Collection, Candida and Rebbecca Smith. Not in exhibition.

14. Right. David Smith. *2 Circles 2 Crows*, 1932. Steel, painted white, 174 x 316.2 x 22.9 cm (68½ x 124½ x 9 inches). Collection, Baron Lambert, Brussels, Belgium. Not in exhibition.

come the principal component. He thus aligns the work—despite its figurations—with *Circle I, II, III,* and *V.*

Two Circles

Two interrelated works can also be joined to the initial series of Circles, *2 Circle IV* of 1962 and *2 Circles 2 Crows,* made the following year. The former work was completed the month after *Circle I* through *IV,* and Smith's curious repetition of the enumeration *IV* suggests he intended an even more direct connection with the series, for there are no earlier works called *2 Circle I, II,* or *III.*

Such a relationship also exists compositionally because *2 Circle IV* rests its lower circle directly upon the rectangular base as do *Circle I, II,* and *III.* The work differs principally in the use of two circles, which are painted solid blue and solid yellow, a color selection that maintains the identity of each as a circle. If the image were a single color, it would read like a large figure eight. Like the first three Circles, *2 Circle IV* is also not a flat disk, having an opening in the center of each circle. The work is not a purely geometric ring; abstract shapes of similar design have been cut out of the circles, leaving a negative figuration at the center of each. Such imagery exists only in the silhouette of the surrounding circular field. The modern precedent for this imagery is Jean (Hans) Arp's relief work. *Mountain, Table, Anchors, Navel* has the figure cut out of a solid field that has been thrust for-

144

ward, leaving a space visible through the physical opening. Smith's colors in *2 Circle IV* are also somewhat Arp-like. In a less direct fashion, Smith's enclosure of his abstract figure also finds parallel in certain Indian bronzes that show a dancing diety circumscribed within a ringlike circular frame. This connection becomes more apparent in *2 Circle IV* if we read a reproduction of the Indian sculpture in the negative, seeing its enclosed empty white space as the positive ground of the sculpture.

2 Circles 2 Crows, made three months later, is the reverse of *2 Circles IV* (and the match of the Indian bronze). Its figuration is positive, here a pair of abstract shapes, each one contained by a ring. But the relationship between these two circle works is very precise because the flat abstract elements in *2 Circles 2 Crows* are the two leftover shapes that Smith cut out of the flat disks of *2 Circle IV.* Here they each are attached by one side to the enclosing ring (by structural necessity) rather than being completely surrounded by a field, as the two shapes are in the parent sculpture. Like *2 Circle IV, 2 Circles 2 Crows* is organized around the juxtaposition of two circular elements with each placed at opposite ends of a long I beam rather than stacked vertically. With its rings placed directly on a base, *2 Circles 2 Crows* connects with the first Circles; its pairing of circles, like that of *2 Circle IV,* indicates Smith's move toward a multiple circle composition, which he subsequently achieved first in the triptych, then in the four-part polyptych of *Circle I, II, III,* and *V.*

145

The cutout shapes in *2 Circles 2 Crows* do resemble abstract birds, especially the one on the right with a head at the bottom, wings sloping down from each side, and a square tail attached to the ring. Seen as such, they are somewhat reminiscent of birds in later paintings by Georges Braque. The presence of a variety of birds would have been a natural and constant event in rural, upstate New York, including the crows of Smith's title. But Smith's metaphorical reference in this work may be more exact: One way in which he and his neighbors would have seen birds was through the scope of a gun, which would create a roughly equivalent image of a bird viewed at close range within a circle. Thus, *2 Circles 2 Crows* may refer to a common occurrence on a farm: shooting crows with a double-barrel shotgun. That reading is supported by the way in which the crow on the right is descending, as if hit and falling, while that on the left is just flying into the field of sight. In this configuration, the bird in the circle relates to the single gun scope and the two circles imply the double-barrel and two shots. Seen this way, *2 Circles 2 Crows* is similar to an image of a pair of ducks being hunted in *Left and Right* by Winslow Homer. Here we also see one bird being hit. Smith could have known the painting from the National Gallery in Washington, D.C. Interestingly, it was made by the other major American artist to have also worked in the same Adirondack Mountains that surround Bolton Landing.

Notes

1. David Smith, "Report on Voltri," in Garnett McCoy, ed., *David Smith* (New York, 1973), 162.

2. For the Voltri Circles see E. A. Carmean, Jr., "David Smith: The Voltri Sculpture," *American Art at Mid-Century: The Subjects of the Artist* [exh. cat., National Gallery of Art] (Washington, 1978).

3. Smith had known Noland since 1950.

4. Smith and Noland made a small sculpture together around this time, using a tin-can lid that was painted to resemble one of the Targets.

5. Edward Fry, *David Smith* [exh. cat., The Solomon R. Guggenheim Museum] (New York, 1969), 129.

6. Both Smith and Noland were interested in jazz music, so the title has more than one meaning.

7. Noland in conversation with the author. The Olitski paintings were shown in October and November 1962 at the New Gallery in Bennington.

8. Among the Budnik photographs is one showing parts for what appears to be a work related to *Circle IV*, never completed. This suggests the idea of a second subset of Circles.

9. Fry, *Smith*, 130.

10. Fry, *Smith*, 130.

11. Smith and his second wife Jean were divorced in 1961, and the children would spend parts of the summer with their father in Bolton Landing. Both Rebecca and Candida recall the excitement of the day of their arrival and the party they would hold for other children during their stay. This title could refer to either occasion.

1. Voltri-Boltons shown outside Smith's studio.
Smith is at the right.

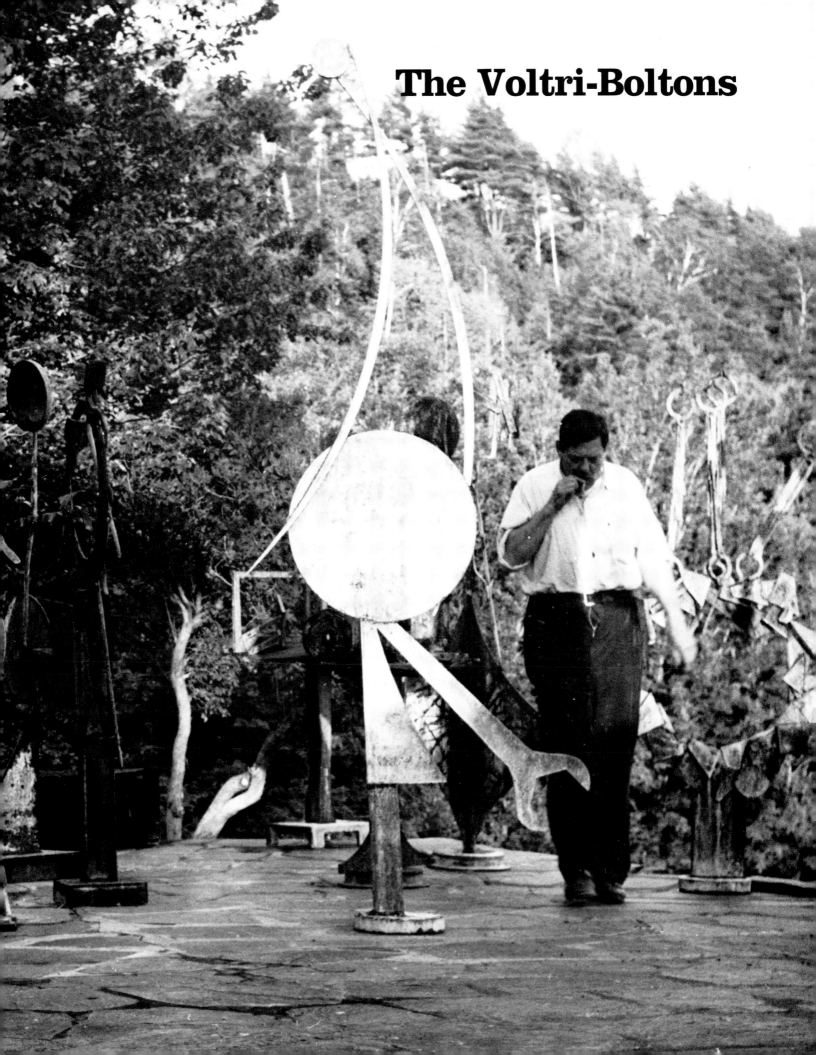

The Voltri-Boltons

Voltri-Boltons

1. *Voltri-Bolton I*, 1962
 steel (K-585)
 285.1 x 114.0 x 39.4 cm (112¼ x 44⅞ x 15½ inches)
 inscribed around perimeter of base plane: VOLTRI-BOLTON I
 David Smith 12-6-62
 Collection, Dr. and Mrs. Paul Todd Makler

2. *Voltri-Bolton II*, 1962
 steel (K-586)
 200.7 x 32.4 x 26.7 cm (79 x 12¾ x 10½ inches)
 inscribed on central disk: VOLTRI-BOLTON II David Smith 12-5-62
 Collection, Carl and Nancy Gewirz

3. *Voltri-Bolton IV*, 1962
 steel (K-588)
 198.4 cm (78⅛ inches)
 inscribed on base plane: VOLTRI-BOLTON IV / David Smith / 12-3-62
 Guido Goldman Sprinkling Trust

4. *Voltri-Bolton V*, 1962
 steel, dry-brushed with orange paint (K-589)
 218.4 x 85.1 x 72.4 cm (86 x 33½ x 28½ inches)
 inscribed on base plane: David Smith / VOLTRI-BOLTON V 12-2-62
 Collection, Rena Bransten

5. *Voltri-Bolton VI*, 1962
 steel (K-590)
 221.0 x 85.1 x 27.3 cm (87 x 33½ x 10¾ inches)
 inscribed on base plane: David Smith 12.7.62 / VOLTRI-BOLTON VI
 Collection, Mr. and Mrs. David Mirvish, Toronto

6. *Voltri-Bolton IX*, 1962
 steel, painted red (K-593)
 216.5 x 85.1 x 68.6 cm (85¼ x 33½ x 27 inches)
 inscribed on triangular leg: VOLTRI-BOLTON IX / David Smith 12.21.62
 Collection, Lois and George de Menil

7. *Volton XV*, 1963
 steel (K-599)
 190.5 x 23.5 cm (75 x 9¼ inches)
 inscribed on base plane: David Smith 1-14-63 VOLTON XV
 Museum Ludwig, Cologne

8. *Volton XVIII*, 1963
 steel (K-602)
 281.6 x 170.5 x 38.4 cm (110⅞ x 67⅛ x 15⅛ inches)
 inscribed on base plane: David Smith / 1/29/63 VOLTON XVIII
 State of New York, Governor Nelson A. Rockefeller Empire
 State Plaza Art Collection

9. *Voltron XIX*, 1962
 steel (K-603)
 239.4 cm (94¼ inches)
 inscribed on center square plane: XIX / David Smith 1963 VOLTRO
 Anonymous Loan

10. *Volton XX*, 1963
 steel (K-604)
 158.8 x 73.7 x 95.3 cm (62½ x 29 x 37½ inches)
 inscribed on base plane: David Smith Feb 4 '63 VOLTON XX
 Storm King Art Center, Mountainville, New York

11. *VB XXIII*, 1963
 steel (K-607)
 175.9 x 61.0 x 64.8 cm (69¼ x 24 x 25½ inches)
 inscribed on base plane: Mar 14-63 V. B. XXIII; and on
 perpendicular member: David Smith
 Collection, Miss Sarah Dora Greenberg

The Voltri-Boltons

But for me—I never made so much—so good so easy in such condensed time as in my 30 day Italian phase. [At the end] I had works in progress and parts—tongs, wrenches, wheels . . . all on the floor in one pile—and said—send them to me in USA—they did and I will finish my Italian period here.

David Smith, 11 December 1962[1]

In late May of 1962 David Smith went to Italy to accept the commission of making a sculpture for the Spoleto Festival of Two Worlds. As with other artists also invited for this project, Smith had been asked to create a new work in Italy, which was to be exhibited along with another already completed work. In Smith's case, his stainless steel *Cubi IX* had been shipped to Spoleto from Bolton Landing, and he intended to work in the same material using the Italsider factory in Cornegliano. Smith rejected this mill, however, as being too modern. Instead he was given full use of five closed mills at the nearby city of Voltri, including not only the manufactured steel elements that had been left behind when the mills at Voltri had closed, but any of the tools, machines, and steel-making implements that had been abandoned. "Italsider let me roam all the factories—pick out whatever I wanted," he later wrote.[2]

During the next thirty days Smith went far beyond making the one or two new pieces he had been expected to create. He astonished the sponsors of the Spoleto Festival by making twenty-seven works, at a rate of nearly a sculpture per day. Faced with this prolific outpouring, Giovanni Carendente installed the *Voltri* series in the ancient concert arena at Spoleto, providing a classical setting appropriate to the classical aspects that underlie the works. Smith wrote of the series that it was "installed so well it looked like it belonged."[3] The extraordinary presentation and Smith's astounding burst of creativity have given the *Voltri* series virtually the status of a legend.

In 1964, the University of Pennsylvania devoted a book to the Voltri experience, the only such publication during Smith's lifetime. Edward Fry, writing in 1969, called the pace and the quality of the Voltri series "without precedent in the history of modern sculpture," and in 1978–79, the Voltris were reunited in a special exhibition at the National Gallery of Art in Washington, D.C.[4]

Many of Smith's friends record how proud he was of the Voltri sculpture,

2. Installation view of Smith's Voltri sculpture in amphitheater at Spoleto, June 1962. Photograph by Ugo Mulas, Courtesy of Antonia Mulas, Milan. Reproduced from Carandente, *Voltron* (Philadelphia, 1964).

and how pleased he was of its installation and critical reception. Anne Truitt, for example, recalls how Smith came to visit her immediately after his return from Italy, bursting into her house with energy and showing her photographs of the work, commenting in detail on the pieces—something he had never done before.[5]

Smith wrote a long account of the stay at Voltri to David Sylvester. The letter was written after Smith had completed the first six works in a new American-Italian series, the Voltri-Boltons, during the preceding nine days, a pace almost like that of Voltri itself. By the following autumn of 1963, nineteen more works were added to the series.

The twenty-five Voltri-Boltons are numbered consecutively, although they were not completed in order (see the Introduction). The initial six works, from 1962, were all entitled *Voltri-Bolton*. Bolton, short for Bolton Landing, was where they were made and also probably the source for the non-Voltri material used in the works. Beginning with the eleventh work in the series, Smith shifted the title to *Volton*, an abbreviation of Voltri and Bolton, using this term until work number *XVII*, when he shifted again, now using *VB*, an abbreviation of *Voltri-Bolton*. Greenberg, seconded by others, has proposed the series be known as the ''Voltri–Bolton Landing,'' making their geographic locations full and explicit. Given that the second and third terms are shortened forms of Smith's initial title, we prefer to identify the series as the Voltri-Boltons.[6]

All of the writers who deal with the subject discuss the Voltri-Boltons as being a new series in Smith's work, one that is distinct from the preceding works even if materially similar. Greenberg, for example, wrote that "Smith *started* [emphasis added] the series in the fall of 1962," and although each work uses Voltri material, "nothing in it is directly related either stylistically or thematically to the monumental works he created . . . while in Voltri."[7] In a similar manner, Hilton Kramer observed that "they were *begun* [emphasis added] in the fall of 1962, after Smith had settled down again on home ground." Kramer differs from Greenberg, saying, "they are, however, directly related to the Voltri experience."[8]

Writing five years later, Fry identified the *Voltri-Bolton* series as "the direct sequel to Smith's work in Italy."

[The Voltri-Bolton series,] both in spirit and substance, was a continuation and outgrowth of [Smith's] Italian works. There are, however, marked differences between the two groups, for the very fact of being back among his own sculptures, tools, and familiar working methods inevitably had its effect; the Voltri-Boltons often incorporate motifs and compositional methods inspired more by his recent work in America than by his production in Italy.[9]

Although the Voltri-Boltons are clearly a new series, the distinctions between them and the preceding Italian works are not so clear-cut as these accounts suggest. To begin with, Smith's letter to Sylvester offers a much more amplified description of exactly what was sent to him from Voltri. To be sure, he does mention the tongs, wrenches, and wheels that are a part of the material cited as the connecting link between the two series. However, Smith more explicitly states that even though he had completed twenty-seven works in time for Spoleto, he had even more works underway: "I had works in progress and parts started." He then "piled" them up when he ran out of time.[10] That description implies that at least some of the pieces sent to him from Voltri were already being used in—or studied for—specific sculpture, the "works in progress" that would have been spread out on the factory floor but not yet welded together.

That understanding of the materials implies that certain Voltri-Boltons were not made entirely new at Terminal Iron Works but were already in the state of works in progress in Italy, and which Smith then finished in New York. The overlap of Italy and Bolton Landing may also explain why certain works in the *Voltri-Bolton* series bore the same number, written in chalk on various elements in the composition, such as *Voltri-Bolton I* and *II*, where corresponding arabic numerals are inscribed on the component parts. In order to keep straight the identification of the components of the different sculptures being taken apart from the floor and piled up for shipping, it is possible Smith marked a code number on each of the elements in the particular sculpture. When they were uncrated in Bolton Landing, the code would allow him to reposition the works in progress on his studio floor.

The Voltri-Boltons continue certain of the compositional themes of the *Voltri* series. In the Italian works Smith employed six major images: a linear figure, made out of tongs and other tools; a flat sheet figure composed of elements cut off of flat, milled steel plate; a circle raised on a plinth; a representational still life of a work bench; a more abstract still life of less identifi-

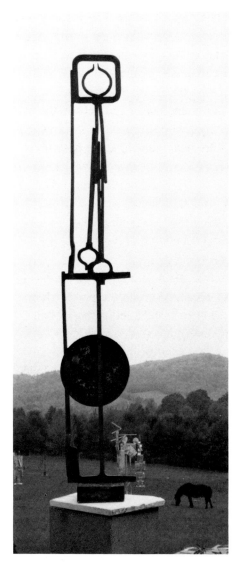

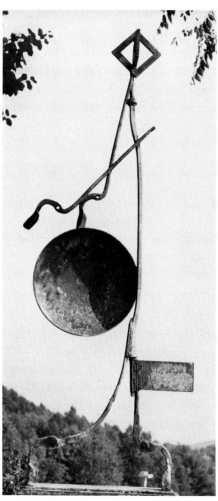

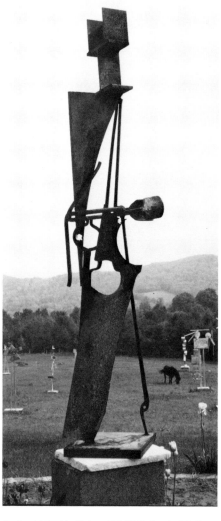

3. David Smith. *Voltri-Bolton II*, 1962. Steel, 285.1 x 114 x 39.4 cm (112¼ x 44⅞ x 15½ inches). Collection, Dr. and Mrs. Paul Todd Makler.

4. David Smith. *Voltri-Bolton VI*, 1962. Steel, 221 x 85.1 x 27.3 cm (86 x 33½ x 28½ inches). Collection, Mr. and Mrs. David Mirvish, Toronto.

5. David Smith. *Volton XV*, 1963. Steel, 190.5 x 23.5 cm (75 x 9¼ inches). Museum Ludwig, Cologne.

able elements; and large chariots set on wheels. As we might expect, the Voltri-Boltons draw from these themes and continue the linear figures, the raised circles, and the representational still life, while greatly expanding and revising the abstract still life. As discussed in chapter 6, the *Voltri* chariots were also continued but as a new series.

Figures

Many of the Voltri-Boltons can be characterized as figures. Like their predecessors in the *Voltri* series, these later works are constructed using tongs from the abandoned steel mill, long-handled implements with wide gripping plates paired at one end. Smith's making a figure out of functional elements goes back to the Agricolas, as we have seen. When Smith first saw the factory components at Voltri, he later wrote, he "thought of my *Agricolas*."[11] But

unlike the Agricolas, where the component elements merge their identity with that of the figuration, in these Voltri-Boltons the practical, functional usage of the employed material still remains clear, so much so that the figuration appears to result from the meeting of these disparate elements.

How each of the figural Voltri-Boltons state the figure is disparate. In *Voltri-Bolton II*, for example, the tongs fit together at the top to form the oval of a head; the remaining portions of the body are stated by straight, boxlike shapes. In *Voltri-Bolton VI*, similar tongs are bent outward at the bottom of the piece to rest on the base to form two legs. Here other tongs serve to define the back of the figure's torso, and two interlocking angles create the square head. The lower anatomy is boldly stated by means of a solid tank end. In other works, such as the figural *Volton XV*, tongs play a less important role, as the majority of the piece is established by flat pieces of stock, save for the head and neck, fashioned from two I beams.

Beyond serving to establish all or part of the figure's imagery, the tongs in these Voltri-Boltons also affect the overall character of the sculpture. Their long thin handles and flattened, curvilinear grips make a set of shapes that when combined give the works a skeletal appearance that is prehistoric in quality. The skeletal aspect also sets the works apart from the Agricolas, where Smith's tendency was to classicize, filling out the figuration and holding down any excessive drawing by the individual components. By contrast, in the tong Voltri-Boltons, Smith's steel drawing in the air takes on a nervous, quick quality that places the subset apart from almost all of his other mature work, save certain pieces made in Voltri and a few individual works of the 1950s/early 1960s, such as *Running Daughter*. Within his oeuvre, we must go back to works from the later 1940s to find any period where Smith worked consistently in this more spindly style.

Not all of the figural works in the *Voltri-Bolton* series share the skeletal characteristic; Smith also worked in a different mode and used different elements. In these works, such as *Volton XIII*, the linear elements are much more restrained and the drawing made regular in quality. The drawing also serves to connect other elements that are not so much linear as they are silhouettes, and that in turn are not so much drawn in space as collaged there, appearing as if glued to the frontal plane of our perspective. *Volton XIII* also uses tongs, but the handles are straight and meet exactly at their far end, forming the two stiff legs of the figure. They support, visually and structurally, the upper torso, made from a broad triangular piece, and the head, created from a simple flat disk. The arm reaching out in front completes the regularity in its right-angle formulation. Yet within that stricture, Smith gives the figure both a sense of energy—by bending it slightly forward—and a suggestion of whimsy through its large head. This stick figure can best be compared to similar people in the paintings of Paul Klee.

Such imagistic eccentricity is also apparent in *Voltri-Bolton V*, which also has a disk head. Here a long, slightly bent rod serves as the figural spine, set on a triangular base and rounded out by the arching plane behind. Attached near the top is a horizontal U-shaped bracket, which ends with two disks, capable of being read as short hands or perhaps more probably as breasts, given not only their round shape but also their being pushed forward. These shapes

155

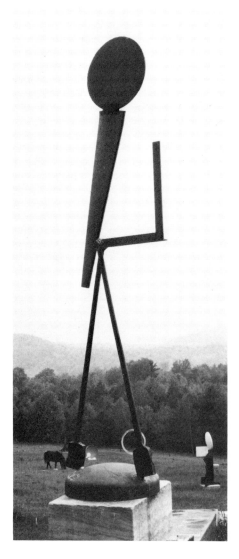

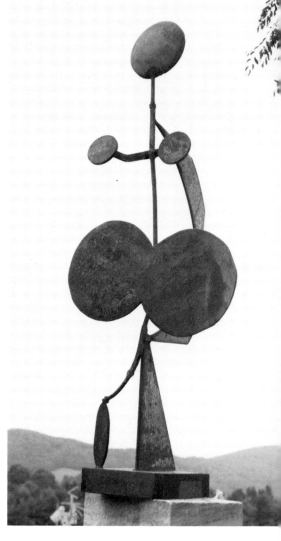

6. David Smith. *Volton XIII*, 1963. Steel, 214 cm (84¼ inches). State of New York, Governor Nelson A. Rockefeller Empire State Plaza Art Collection. Not in exhibition.

7. Paul Klee. *Revolutionary Figure*, 1930. Pencil. 32.7 x 21.0 cm (12⅞ x 8¼ inches). The Morton G. Neumann Family Collection. Not in exhibition.

8. David Smith. *Voltri-Bolton V*, 1963. Steel, dry brushed with orange paint, 218.4 x 85.1 x 72.4 cm (86 x 33½ x 28½ inches). Collection, Rena Bransten.

are then echoed in the larger round disks at the bottom, which form the abdomen of the figure.

Perhaps the most outstanding work of the *Voltri-Bolton* figural subset is the initial piece in the series, *Voltri-Bolton I*. Like *Volton XIII*, the first sculpture is essentially a flat image. To be sure, some sense of depth occurs where one element passes over another, but these are aspects of a furtive bas-relief —furtive because these spatial shifts contribute nothing to the articulation of the figure. The previous *Voltri-Bolton* figures, including *Volton XIII*, are linear constructions into which supplementary planar or three-dimensional pieces have been worked. By contrast, *Voltri-Bolton I* is almost entirely planar, with its cut sheet lower section, large flat disk, and the rather flat, large wrench from Voltri welded on at an angle. These parts all overlap each other directly without lighter, connecting pieces.

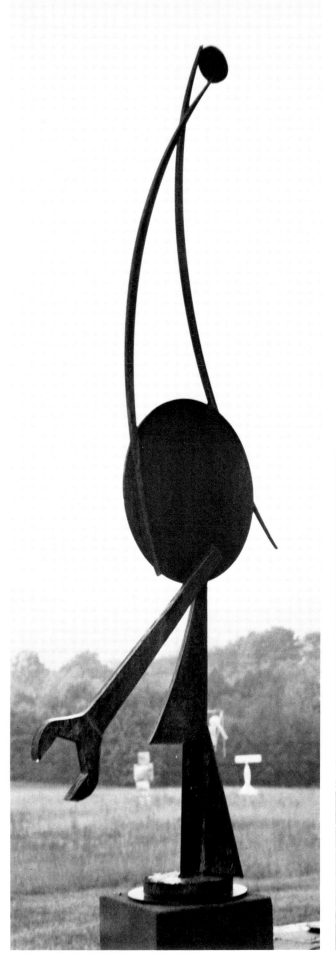

9. David Smith. *Voltri-Bolton I*, 1962. Steel, 285.1 x 114 x 39.4 cm (112¼ x 44⅞ x 15½ inches). Collection, Dr. and Mrs. Paul Todd Makler.

10. Smith making *Voltri-Bolton I*.

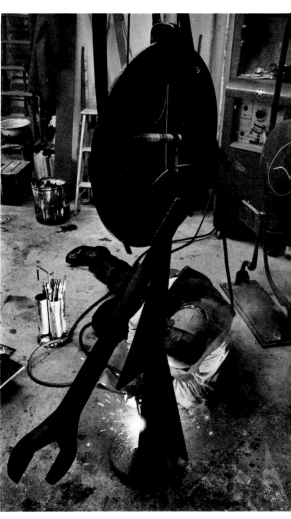

However, the remaining elements in the work are of this thinner definition; there are two long curves of the type used in earlier works, such as *Lunar Arcs on One Leg*, and a smaller, echoing disk placed at the top of the composition. These elements remain flat as well. Smith rarely equalled this bold use of a near-absolute silhouette.

The figure of *Voltri-Bolton I* can be read in two ways. The most probable is to see the large disk as an enormous head, with the notched plate below as a trunk. In this reading, the large wrench becomes an extended arm and hand, making the figure a metaphorical workman, the kind of personage Smith himself would have identified with. The alternative reading would see the small disk as a head and the large one as torso, giving the wrench a phallic meaning, something that seems out of character with the imagery in Smith's other mature sculpture. Furthermore, the two lunar arcs are poor elements of an upper torso. Although they are also out of place in the first reading, they serve to remind us that Smith's art was one in which the figure (generally) emerged from abstraction rather than being specifically depicted. Such abstraction could serve as a context for sculptural forms and at the same time allow flourishes—such as these arcs—to also find a compositional place.

Still Lifes

Within the sculpture made after 1951 there exist four clear and radical exceptions to that principle. These are the two veristic still lifes made in Voltri (*Voltri XVI* and *XIX*) and another pair made with the Italian material sent to Bolton Landing (*Volton XX* and *VB XXIII*). In these four sculptures various Italian elements—tongs, clamps, blocks, and other items—are placed on supports in such a manner that these parts retain their individual identities rather than being transformed into a larger, more formal context.

The presentation of actual materials in the veristic still lifes might be called premodern or traditional except that such a tradition does not exist; the idea of the still-life sculpture is an invention of the twentieth century.

It is often surprising to realize that there exists no tradition of the still life as theme in sculpture to parallel painting. With the probable exception of Canova's *Fruit Basket*, c. 1770, the subject in its pure form is unknown until cubism.[12] There are, of course, partial exceptions to this in the neoclassic tradition of allegorical still lifes, which feature musical instruments or palettes and brushes, yet these elements are presented more as symbols of the arts and are enlivened by putti who introduce active life into the compositions.

Several reasons can be advanced for this absence in Western art. The role of the still-life painting was often tied to symbolic presentations, and part of its message—as well as the source of its enlivening appearance—was geared to the color of the objects. Working much to the contrary, the monochromatic tradition of sculpture could not encompass that possibility. Furthermore, the painted still life could—by virtue of illusion—present complicated assemblages of elements, varying from fruit and flowers to dead animals. Sculpture, tied forever to a system of actual spatial construction in three dimensions, could not contrive to duplicate the energy of composition found in painting. Finally, an aspect of trompe l'oeil is probably present here as well. The still life, either painted or sculpted, is *nature morte*—dead life. In a pre-

sentation without color and tied to a direct verisimilitude of composition, sculpture would clearly be more static than the real still life. Only some feature of technical skill might redeem the work, but it would offer little evidence of artistic presence.

It was then left to cubism to introduce the still life into sculpture, for its fracturing of the surface enlivens the subject externally. First came the block-like divisions of surface in Picasso's small wooden *Apple* of 1909, quickly followed by Boccioni's *Development of a Bottle in Space*, 1912-13, where the spiraling composition of the futurist vocabulary serves further to energize the subject. But these works—joined by Picasso's *Absinthe Glass* pieces of 1914—that introduce color and texture into still-life sculpture are still of single objects and not the proper still-life assembly. The realization of the latter was again Picasso's, in the original idea for his *Guitar*, which included a table and other ancillary items in an ensemble. Although Picasso did not execute this project as planned, other constructions do go further toward it, such as the *Glass, Pipe and Playing Card*, 1914, a bas-relief that includes an indication of a back plane wall and the front edge of a tabletop. In 1919-20(?) Picasso made other still-life works that gather separate objects or present an entire tableau before a window. In Picasso's works, however, planes slice through objects, thus lessening their volume and depth. Derived from contemporary paintings, such handling of forms allows a pictorial illusionism to enter into the sculpted works, which is probably why they retain a relieflike character.

As a fully three-dimensional sculpture of a still life we can cite Giacometti's *Table* of 1933. The work clearly contains the spirit of the surrealist *objet-trouvé-aidé*, as William Rubin has observed. The force of its imagery is generated by the poetic joining of a severed left hand, a bottle, an abstract sculpture, and the bust of a woman.[13] Giacometti's tabletop still life is followed by another by David Hare: *Magician's Game*, 1944.

Smith's *Voltri XVI* and *XIX* differ from these precedents in the distinct manner of his presentation of the elements. Each Voltri ''is a workbench recreated in a formal manner as a work of art'' but without the formal fracturings of the cubist assembly or the futurist analysis and without the surrealist's poetic gathering of displaced objects.[14] Although Smith introduced the still life into earlier works—his *11 Books, 3 Apples*, 1959, for example—these works are clearly indebted to either the cubist collage or to surrealist combinations or distortions. *Voltri XIX* is distinguished precisely by its lack of any formal or thematic alterations; rather the objects—and their workbench support—were simply found at Voltri and left in their original state. Smith brought them together and left them as actual pieces.

The Voltri still lifes are decidedly autobiographical as records of Smith's encounter with the elements of an earlier age of making steel and with the atmosphere in the Voltri factories. He wrote of them:

Speciality tongs were hand-forged at stations. Since this method was abandoned, the work in process was left in varying stages of finish. . . . A thick steel layout table was never white. I had it painted with lime and water. Ancient in use, practical because it was there, it gave me an order contact which from then on let me work freely without order. . . . From factory to factory I laid out workbenches—I finished two there, left more.[15]

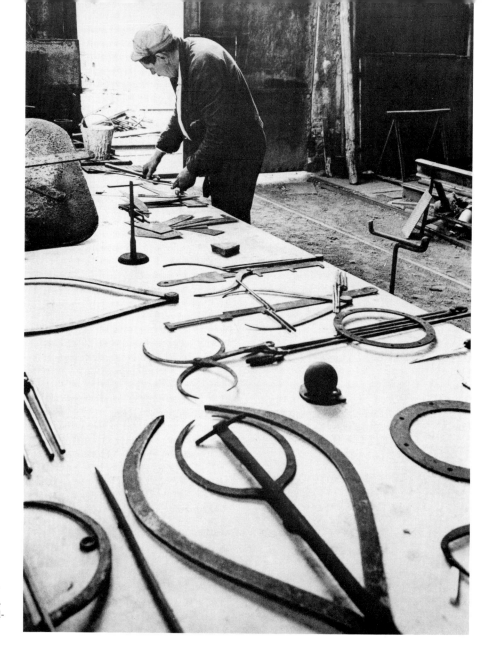

11. Smith in factory at Voltri, Italy, 1962. Photograph by Ugo Mulas, Courtesy of Antonia Mulas, Milan. Reproduced from Caradente, *Voltron* (Philadelphia, 1964).

As with some of the other Voltri-Boltons, we have to ask if all of the other "parts laid out" in Italy were actually left behind, or whether some of these were also sent to New York to become *Volton XX* and *VB XXIII*. Certainly these two works correspond to their Italian precedents in the veristic handling of the still-life subject and in some of the objects used.

As with Voltri XVI and XIX, the two Voltri-Boltons can be divided by their degree of abstraction within their realism. *Volton XX* is a still life set upon a round, single pedestal table with an open center. Gathered on its upper surface are a group of straight objects: a tong, a clamp, two balls on a wedge. Next to them are a small disk set on edge and a compound element made up of a somewhat triangular plane and a four-pointed, starlike shape. The latter construction is the only abstract element in the work, although its long support and broader upper piece suggest the image of a head and neck, like a bust upon a tabletop, the kind of component we find not only in conventional still-life paintings but also in Picasso's paintings of the 1920s.

160

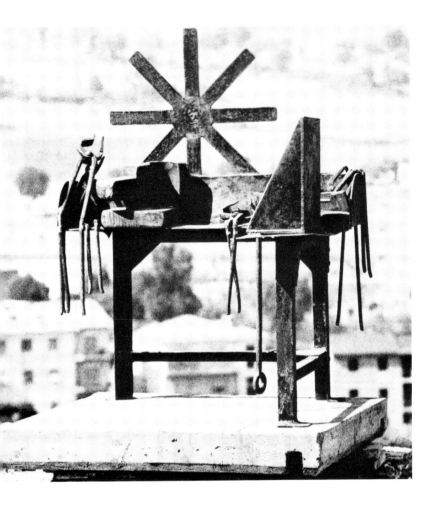

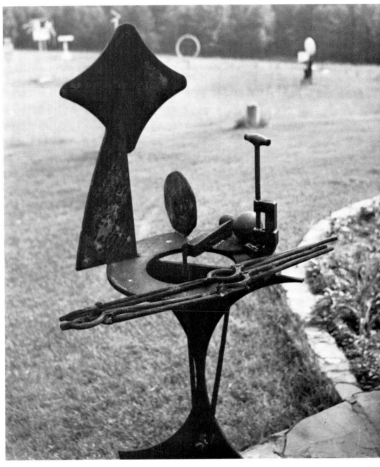

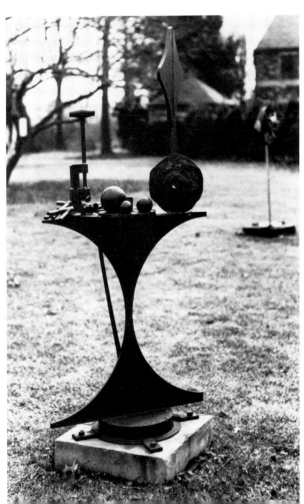

12. David Smith. *Voltri XIX*, 1962. Steel, 139.7 x 114.3 x 127 cm (55 x 45 x 50 inches). Private Collection. Photograph by Ugo Mulas, Courtesy of Antonia Mulas, Milan. Reproduced from Caradente, *Voltron* (Philadelphia, 1964). Not in exhibition.

13. Right, top, and bottom. David Smith. *Volton XX*, 1963. Steel, 158.8 x 73.7 x 95.3 cm (62½ x 29 x 37½ inches). Storm King Art Center, Mountainville, New York.

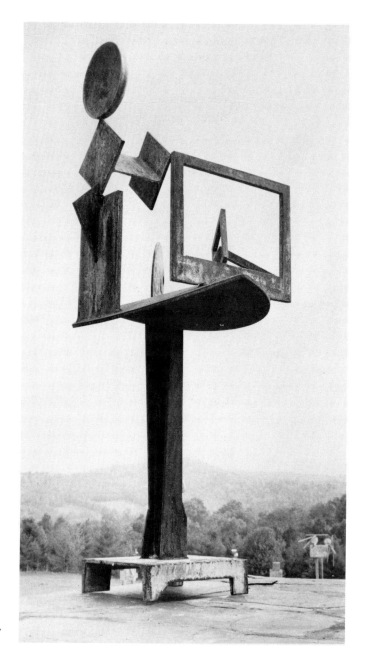

14. David Smith. *VB XXIII,* 1963. Steel, 175.9 x
61 x 64.8 cm (69¼ x 24 x 25½ inches). Collection,
Miss Sarah Dora Greenberg.

VB XXIII, the other still-life sculpture, employs less descriptive parts upon
its tabletop. Only the round disk, also set on edge, can be completely linked
with Italian materials, although the open framelike shapes may also be from
Voltri. But even these elements, like the others in the still life, are more ab-
stract within the composition. The tabletop of *VB XXII* is largely concerned
with the balance of parts and the manner in which they touch, stretch across
the plane, or reach upward. The major focus of these is the flat plane on one
side, with the small I beam, only barely tangential to the composition below.
Fry observes of *VB XXIII* that

it is comprehensible as a table-top *tableau* only to the degree dictated by the abstract
character of its component forms, while the frame explicitly provided in the composi-

162

tion itself is of too small a scale to function as a pictorial plane; *VB XXIII* thus exemplifies a mode within Smith's late work which . . . may be termed abstract surrealist.[16]

Of all of Smith's works, *VB XXIII* is the closest to the kind of metaphysical speculation we find in the photosurrealist paintings of Giorgio de Chirico, where various objects—including abstract planes and blocks—are viewed within the context of a traditionally clarifying perspective space. Unlike the other veristic still lifes of the *Voltri* and *Voltri-Bolton* series, in *VB XXIII* the tabletop serves to establish a conventional space, albeit at once abstract and real. Indeed, *VB XXIII* gains this surrealist quality because of the clarity of its composition and the abstraction of the upper elements. The components can be read as pure, unidentifiable shapes—circles, squares, diamonds—while at the same time they resist being read as part of a sculptural symbol and instead seem as real objects assembled into a mysterious still life.

Circles

Among the *Voltri* works were four major pieces made using flat circular rings, which are raised up on center plinths, and to which various secondary elements were attached. The pieces represent an extension of ideas established earlier in works like *Noland's Blues,* 1961, and partially articulated before in *Agricola XXI,* 1959. Upon his return from Italy, Smith continued the idea of circles, clarifying and focusing it in the series of brilliantly painted works known as the Circles (see chapter 4).

When Smith began—or returned—to the *Voltri-Bolton* series in December 1962, it was after the first *Circle* series works had been completed. Within the Voltri-Boltons we do find works based on the circle idea, especially *Voltri-Bolton X* and *Volton XXV.* In these works, however, the concept established in the *Voltri* circles undergoes a change, perhaps as a result of the intervening *Circle* series. The *Voltri-Bolton* circles are more closely aligned with a new kind of sculpture in Smith's oeuvre: the abstract still life.

Voltri-Bolton X may mark the distinction between those works partially planned in Italy and finished in New York and those Voltri-Boltons that are largely—if not wholly—American creations. As discussed earlier in this catalogue, the evolution of *Voltri-Bolton X* on Smith's studio floor was photographed in detail by Dan Budnik, and these prints document how the work moved through various stages. Thus its composition was decidedly less planned or worked out earlier in Voltri. The work's circle differs from those of previous works, being an assemblage of multiple steel plates of varying sizes rather than a single, solid ring. Raised upon a vertical support—as are the other *Voltri* circles—*Voltri-Bolton X* has its additional elements (a three-part group of various sized tongs from Italy) attached only along the upper edge.

The companion piece to *Voltri-Bolton X, VB XXV* also attaches steel milling items, six tongs used for pouring molten steel into molds of varying sizes. Unlike the calipers in *Voltri-Bolton X,* these tools run through the center of the sculpture as well as project beyond the central circumference of the circle. The circle is a solid ring, like those used in the *Voltri* works.

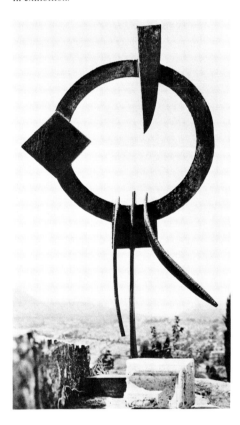

15. David Smith. *Voltri XII,* 1962. Steel, 221 x 121.3 x 34.3 cm (87 x 47¾ x 13½ inches). Collection, Mr. and Mrs. Gilbert Kinney, Washington, D.C. Photograph by Ugo Mulas, Courtesy of Antonia Mulas, Milan. Reproduced from Caradente, *Voltron* (Philadelphia, 1964). Not in exhibition.

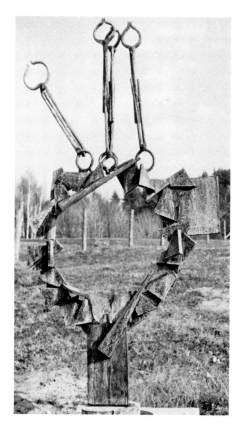 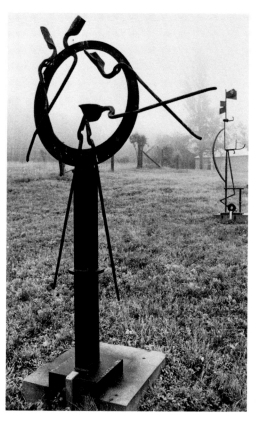

16. David Smith. *Voltri-Bolton X*, 1962. Steel, 206.4 x 106.7 x 28.6 cm (81¼ x 42 x 11¼ inches). Collection, Jerome Sterm. Not in exhibition.

17. David Smith. *Volton XXV*, 1963. Steel, 199.4 x 125.1 x 30.5 cm (78½ x 49¼ x 12 inches). Location unknown.

Elsewhere I have written that the image of *Voltri XV,* with its large rings, suggests a symbolic reference to the sun. Smith makes reference to the circles as ''all the suns,'' and the ''clouds''—Smith's own term for the steel tongs —cross the circle in a horizontal manner suggestive of natural imagery.[17] Upon his return to Bolton Landing—but before making *Voltri-Bolton X*— Smith extended the solar metaphor in spray drawings and paintings that are both suggestive of the sun and directly related to the subsequent Italian- American series. In these paintings and drawings, Smith has added long pieces extending outward from the rings, creating a composition suggestive of the sun and its projected rays. *Voltri-Bolton X* and especially *VB XXV* echo these sprays in their perimeter tools, although in a less direct manner because of the way in which the tools maintain their identity as tools, in contrast to the more abstract ''cloud'' shapes of *Voltri XV.*

Abstract Still Lifes

The distinction between the tools of the Voltri-Boltons and the clouds of the earlier works is basic to understanding Smith's other Voltri-Boltons and the major change they represent in his work. Beginning with the tools and imple- ments in the early Agricolas, Smith had used these materials in such a way that they either lost their identity or were assumed into the larger syntax of the entire sculpture. With the Voltris and even more the Voltri-Boltons, how-

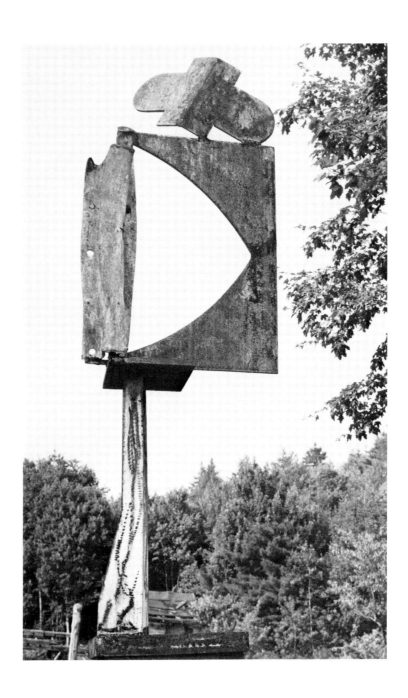

18. David Smith. *Voltri-Bolton IV*, 1962. Steel, 198.4 cm (78⅛ inches). Guido Goldman Sprinkling Trust.

ever, this changed, for the implements kept more and more their own mechanical or functional roles. In some of the Voltri-Boltons, the implements participate as themselves within the larger context. These pieces become abstract still lifes.

Such a new attitude to materials was forecast in the veristic still lifes of *Voltri,* where tools read as being what they actually are. That identity is underscored by the equally realistic aspects of the benches themselves. By contrast, in the abstract still lifes, the context is abstract, and the tools simply appear within the larger organization.

Voltri-Bolton IV is a transition between these two formulations. It is a large, opened sheet raised upon a support with a small tablelike, horizontal plane inserted atop the support. Smith simply attaches other elements: an old

165

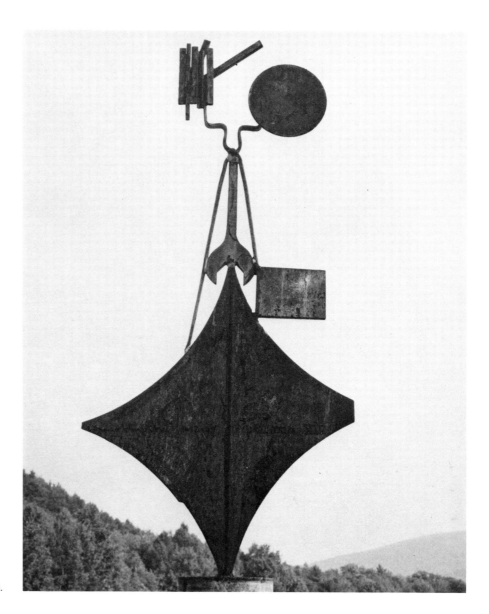

19. David Smith. *Volton XIV,* 1963. Steel, 215 x 98.4 x 31.8 cm (84⅝ x 38¾ x 12½ inches). Collection, Mrs. Anne Mirvish. Not in exhibition.

hinge along one side and a bracket at the top. These pieces fit into the composition but are not taken over by it. Likewise, in *Volton XIV,* a large abstract plane is present (the diamond form at the bottom), but atop this sheet tools and single abstract flat shapes freely intermingle. The large wrench at the center continues to be read as a wrench, one placed within the composition, as do the tongs set at the upper level of the similar *Voltri-Bolton XIX.*

In these works, and two other extraordinary Voltri-Boltons, *IX* and *XVIII,* the structure is abstract in that it makes no reference to figuration, landscape, or the tabletop; yet the structure works as a still life by the inclusion of material that retains its real identity. The parallel for the dual nature of these works lies in collage, just as their welding process parallels the pasting of paper. The work that comes closest to Smith's *Voltri-Bolton* abstract still lifes are the collages begun by Motherwell during the 1950s, in which pieces of paper—cigarette packages, letters, book pages—are placed into an abstract

166

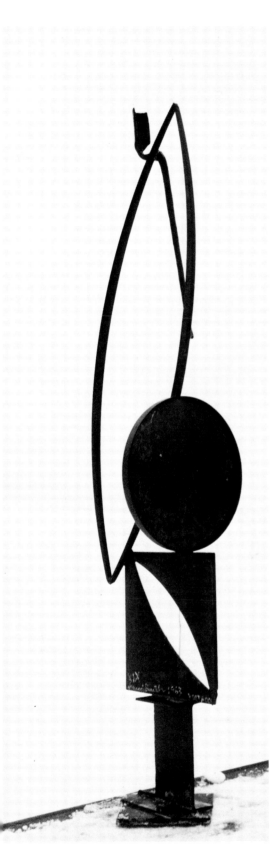

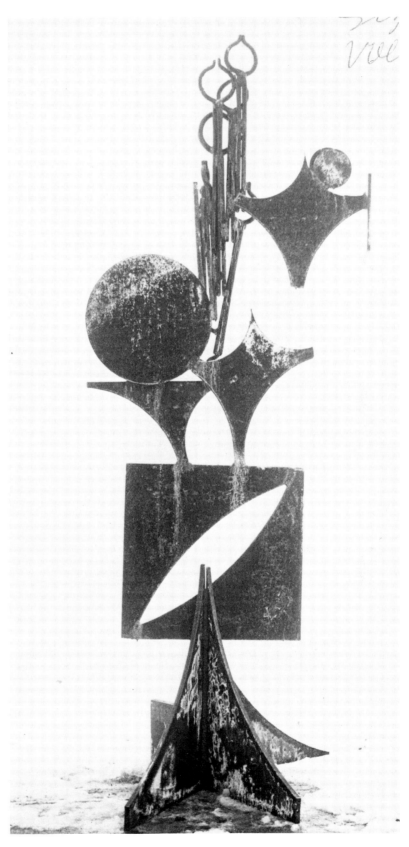

20. David Smith. *Voltri-Bolton XIX*, Steel, 239.4 cm (94¼ inches). Anonymous loan.

21. David Smith. *Voltri-Bolton IX*, 1962. Steel, painted red, 216.5 x 85.1 x 27.3 cm (85¼ x 33½ x 27 inches). Collection, Lois and George de Menil.

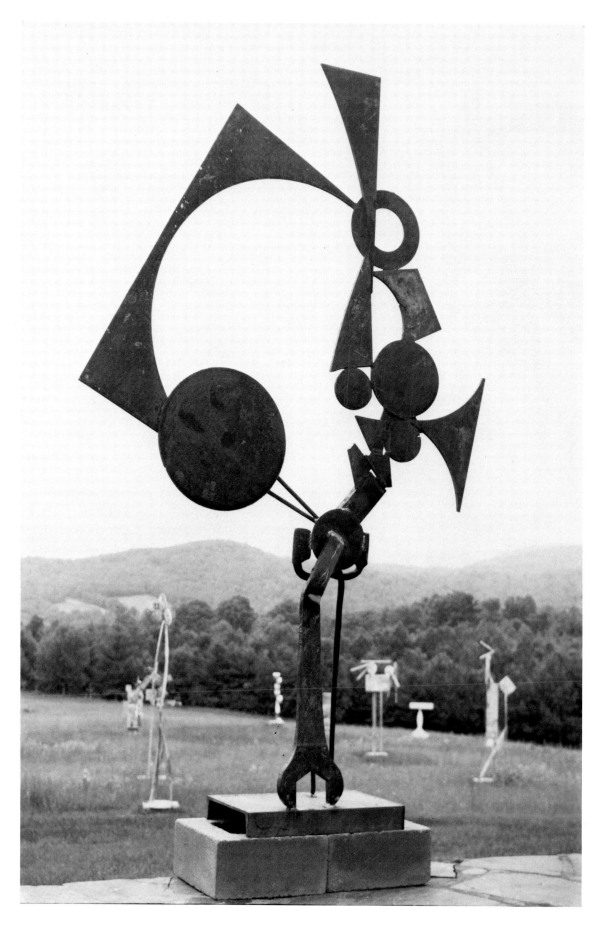

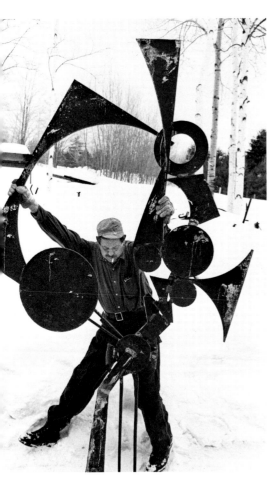

22. David Smith. *Volton XVIII*, 1963. Steel, 281.6 x 170.5 x 38.4 cm (110⅞ x 67⅛ x 15⅛ inches). State of New York, Governor Nelson A. Rockefeller Empire State Plaza Art Collection.

composition in such a way that the collaged elements continue to be legible as what they actually are.

It is important to observe that in these Motherwell collages the papers serve as autobiographical references, as in the *Berggruen Collage,* where a large sheet of wrapping paper is placed directly in the middle of a field of varying reds. Motherwell writes.

I always felt wrongly somewhat like a rejected lover about Paris. Heinz Berggruen alone offered me a Paris exhibition, and a magnificent catalogue done by the *pochoir* process. The paper in the collage is the wrapping the catalogues arrived in. The collage is meant, among other things, as a kind of commemoration.[18]

In the same way, Smith's Voltri tools appear as themselves in these abstract still lifes, as elements of autobiography or recollection of Voltri, but—as with the Motherwell collages—free of any sense of being nostalgic or of being composed in such a way as to articulate their associative function.

Given that shift, it is remarkable how abstract these Voltri-Boltons are. *Voltri-Bolton IX* is one of Smith's most graceful and yet intricate works, the curves of its base first answered by the oval opening in the rectangular plane (actually two overlapping sheets) and then extended—almost floated—into the open space above by the star-shaped plates and the two disks. The Italian components, whose shapes echo this vocabulary, sit as a solid unit, as palpable as the wrapping paper in Motherwell's collage. *Volton XVIII* is one of Smith's other great works, combining grace with boldness. Rising from its Voltri wrench and tongs, it steps its way up along one side, a collage of small curves, circles, and straights, ending with a ring and a long vertical. Against this, on the other side, is the sweeping silhouette curve on the inner side of the large rectangular plane, whose powerful arc establishes on a large scale a formal—rather than thematic—metaphor for the entire work.

Greenberg has written of the other Voltri-Boltons that their figuration served as a "pretext" for making the sculpture, suggesting a shift away from the earlier figural work, where Smith's particular figural definition served either thematic ends or a formal syntax.[19] But in these last two works—which ironically incorporate autobiographical elements on their own terms—Smith was moving into completely new territory.

Notes

1. Letter of David Smith to David Sylvester, in E. A. Carmean, Jr., "David Smith: The Voltri Sculpture," *American Art at Mid-Century: The Subjects of the Artist* [exh. cat., National Gallery of Art] (Washington, 1978), 217.

2. Smith in Carmean, Jr., *Subjects*, 217.

3. Smith in Carmean, Jr., *Subjects*, 217.

4. Giovanni Carandente, *Voltron* (Philadelphia, 1964); Edward Fry, *David Smith* [exh. cat., The Solomon R. Guggenheim Museum] (New York, 1969), 142; and Carmean, Jr., *Subjects*; the exhibition was held 1 June 1978–14 January 1979.

5. Anne Truitt in conversation with the author.

6. Clement Greenberg, "David Smith's New Sculpture" in Garnett McCoy, ed., *David Smith* (New York, 1973), 221. Smith varied between using and not using a hyphen in his inscription.

7. Greenberg, "New Sculpture," 221.

8. Hilton Kramer, "David Smith's New Work," *Arts, 37* (March 1964), 35.

9. Fry, *Smith*, 145.

10. Smith in Carmean, Jr., *Subjects*, 217.

11. Smith in Carmean, Jr., *Subjects*, 221.

12. Douglas Lewis, curator of sculpture at the National Gallery of Art, kindly pointed out the Canova exception.

13. William Rubin, *Anthony Caro* [exh. cat., The Museum of Modern Art] (New York, 1975), 141.

14. Smith in Carmean, Jr., *Subjects*, 230. The above discussion is adapted from this text.

15. Smith in Carmean, Jr., *Subjects*, 230.

16. Fry, *Smith*, 150.

17. Smith in Carmean, Jr., *Subjects*, 227.

18. Robert Motherwell in E. A. Carmean, Jr., *The Collages of Robert Motherwell* [exh. cat., The Museum of Fine Arts] (Houston, 1972), 75.

19. Greenberg, "New Sculpture," 221.

1. Wheel in Smith's scrap materials pile. Photograph by E. A. Carmean, Jr. Not in exhibition.

The Wagons

Wagons

1. *Gondola,* 1961
 steel, painted ochre and orange (K-514)
 175.3 x 154.9 x 45.7 cm (69 x 61 x 18 inches)
 inscribed on base plane: 4-12 / David Smith 1961
 The Chrysler Museum, Norfolk, Virginia, Gift of Walter P. Chrysler, Jr.

2. *Black White Backward,* 1961
 steel, painted black and white (K-506)
 254.3 x 136.5 x 122.2 cm (100⅛ x 53¼ x 48⅛ inches)
 inscribed on white surface: Birthday Candida / David Smith Aug. 12 1961.
 Collection, Anne MacDonald Walker

3. *Voltri VII,* 1962
 steel (K-564)
 215.8 x 311.6 x 110.5 cm (85 x 122¾ x 43½ inches)
 inscribed on horizontal bar near wheels: David Smith 1962; on horizontal bar toward center: VOLTRI-VII
 National Gallery of Art, Washington, D.C., Ailsa Mellon Bruce Fund, 1977

4. *Gondola II,* 1964
 steel, painted black, tan, and white (K-636)
 179.4 x 176.2 x 45.7 cm (70⅝ x 68⅜ x 18 inches)
 inscribed on base: David Smith Dec 20. 1964 GONDOLA II
 Collection of Candida and Rebecca Smith. Courtesy of M. Knoedler & Co., Inc., New York

5. *Wagon I,* 1963–1964
 steel, painted black (K-638)
 224.8 x 308.6 x 162.6 cm (88½ x 121½ x 64 inches)
 inscribed on hubs of four wheels: David Smith / 2-14-64-63; Hi Becca, Dida / NY; WAGON I / Δ Σ 1963/1964;
 Bolton Landing / T.I.W.
 National Gallery of Canada, Ottawa/Galerie Nationale du Canada, Ottawa

6. *Wagon II,* 1964
 steel (K-639)
 273.1 x 282.6 x 111.8 cm (107½ x 111¼ x 44 inches)
 inscribed around rim of largest wheel: Hi Candida WAGON II David Smith April 16-1964
 Collection of Candida and Rebecca Smith, Courtesy of M. Knoedler & Co., Inc., New York

7. *Wagon III,* 1964
 steel (K-640)
 252.7 x 419.1 x 74.6 cm (99½ x 165 x 29⅜ inches)
 Collection, Hallmark Cards, Inc.

CHAPTER 6 **The Wagons**

A dream is a dream, never lost. I found an old flat-car [in Voltri], asked for, and was given it. Had I used the flat-car for the base and made a structure on the top, the dream would have been closer. . . . In a year I could have made a train.

David Smith, 1962[1]

David Smith's Wagons form his smallest series, if we include only those works entitled *Wagon*. Three Wagons exist, numbered *I, II,* and *III;* all were created in 1964. The series can be significantly expanded, however, when we add to it four works that are the clear precedents for the Wagons: the three chariots and a small platform cart, all made in Voltri in 1962. As the names suggest, all of these works have wheels as an integral part of their composition; the Wagons and the cart have four, and the chariots have a single pair.[2]

But Smith's use of wheels was not limited to these seven works. Three works in the *Zig* series, *IV, VII,* and *VIII,* are set on wheeled platforms, as is the possible missing work, *Zig VI*. More similar to the Wagons are four other earlier works that not only use four wheels but establish ideas used in the Voltris and the Wagons: *Black and White Forward, Black and White Backward, Dida Gondola,* and *Gondola*. These works are preceded by another foursome of sculpture on wheeled platforms: two abstract compositions of 1959/60—*Doorway on Wheels* and *Land Coaster*—and two even earlier works, the figural *Sentinel III* and *IV* of 1957. Finally, the group of Wagons and related works can be expanded further by including Smith's unfinished work, a set of even larger Wagons that were to be made from railroad flat-cars and abandoned tractors.

Vertical Wagons

The use of wheels in modern sculpture is so rare that Smith's employment of them is treated in the literature as being his invention and the solution to the problem of how his sculpture should rest on the ground, that is, "the problem of gathering the base, pedestal or resting point of the sculpture up into its body."[3] But when Smith made his first vertical wagons in 1957, placing two *Sentinel* figures on wheels, another major work by a different sculptor already existed with this same thematic idea. That was Alberto Giacometti's

2. Alberto Giacometti. *Chariot,* 1950. Bronze, 164.1 x 68.6 x 67 cm (64⅝ x 27 x 26⅜ inches). National Gallery of Art, Washington, D.C. Gift of Enid A. Haupt, 1977. Not in exhibition.

Chariot, a large bronze from 1950 that Smith surely knew.[4] In *Chariot* we find a standing female figure, modeled in Giacometti's attenuated style, set upon a raised flat platform, also typical of his sculptural formulations. However, in *Chariot* the base is lifted into space by two vertical supports, which in turn rest on an axle running between two large, four-spoked wheels. The resulting image is somewhat unusual with the odd union of the small, thin figure and the oversized wheels; given the realism of Giacometti's style, the *Chariot* takes on a somewhat surrealist character.[5]

Smith's earlier sculpture of the 1930s and 1940s had been influenced by surrealism and by work in this style by Giacometti. Thus Smith would have been open to the *Chariot's* unusual idea of mounting a figure on top of wheels. Given the strangeness of that conception of the wheeled figure, it is difficult to imagine that Smith's works were not influenced by Giacometti's. However, with the two Sentinels Smith minimizes—if not avoids—the kind of figural reading that gives the *Chariot* its oddness as an image. In both Sentinels, Smith's figures keep their abstract, constructed nature. That in turn allows the wheels to shift their sculptural identity from being an alien element, as they are in the *Chariot,* to being merely another part of Smith's overall metal vocabulary.

The merger of the wheeled support and the upper composition was expanded in the more vertical wagons, the *Doorway on Wheels* and *Land Coaster,* both from 1959/60. We have already discussed how these two works were generated on Smith's studio floor, their various cutout and planate shapes curing into a final composition against a white painted ground. *Land Coaster* still retains a slight sense of the human figure, with its flat disk placed like a head at the top of the structure, whereas its compositional divisions recall Smith's usual figural definition, although far less directly. The work implies an abstracted figure seated upon a wheeled vehicle, an image that suggests precedents in classical Greek renderings of carts in procession. These precedents are also recalled in a later chariot *(Voltri VI).* The title *Land Coaster,* however, is not classical and is more likely a reference to the prairie schooner, a canvas-covered wagon lighter than the Conestoga, which was used by pioneers in crossing the North American prairies. Such a wagon would have been part of the Smith family lore of its pioneering of Indiana, with which he identified. Interestingly, similar Indiana memories occur in later Wagons.

Doorway on Wheels is far more abstract than *Land Coaster.* The conjunction of forms in the latter serve to imply figuration—albeit part-to-part in its image—but in *Doorway on Wheels* the cutout shapes, wide curves, and short bars are dispersed across a visual plane almost with abandon. They occupy space so freely that only the order of the rectangular open doorway, set at a ninety degree angle, can call them to sculptural coherence. The scattered pattern of these various elements is virtually random and certainly far from the figural implications set up in the other vertical wagons.

Given these open characteristics, there is only one parallel in nature that can be tentatively suggested: the distribution of the stars in the sky.[6] The starlike shapes of the cutout elements sweep across the composition like a constellation, with the cometlike or galaxylike curves set off to one side—

174

3. David Smith. *Doorway on Wheels,* 1960. Steel, painted black with orange on wheels, 241.3 x 101.6 x 58.4 cm (95 x 40 x 23 inches). Private collection. Not in exhibition.

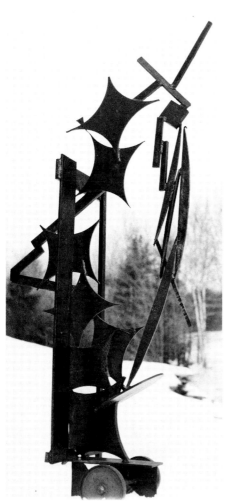

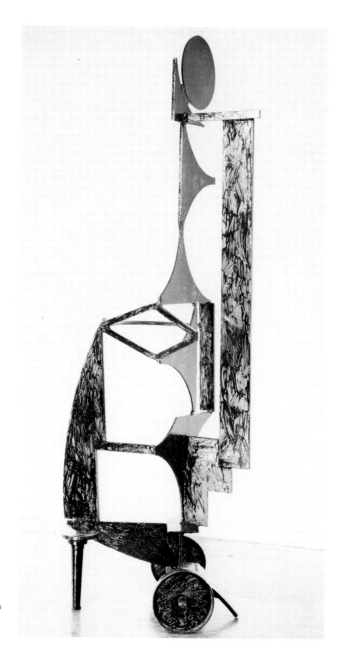

4. David Smith. *Land Coaster,* 1960. Steel, painted black, 245.8 x 82.2 x 66.4 cm (96¾ x 32⅛ x 26⅛ inches). Private collection. Not in exhibition.

although, as in Smith's other works, these references are metaphorical rather than descriptive. Although it seems an anomaly in Smith's work, the image of the starry sky is one of modern art's themes, for its appearance is both natural and abstract. For example, both Mondrian and Miró made works on this theme, the Dutchman in his early diamond paintings, the Spaniard in his *Constellations.* The latter were surely known by Smith. But we need not make any historical connection, for one of the phenomena of Bolton Landing is the night sky; the stars are not only large and brilliant, but they reach all the way across the heavens down to the horizon. Indeed, the visibility is so good that an observatory is located nearby. Smith's stars pouring through the doorway might be a metaphor for that form of viewing either at the planetarium or his studio/house. We should also note that Smith built all of the

doorways in his house, welding them out of steel rather than constructing them from wood; thus his own doorways were like this sculptural one.

As with the figures in the other vertical wagons, it should be emphasized that this figural imagery is secondary to the sculptural authority of the work's construction. This is especially true of *Doorway on Wheels,* as the above reading is very speculative. That interpretation finds support, however, in the fact that Smith specifically called elements in other sculptures by the term *Lunar Arc* and that in his painting some of the sprays are done in such a way as to suggest that their images are seen against a starry sky. Even more importantly, the last work in the series, *Wagon III,* returns to the constellation theme.

Mural Wagons

"Several times David said to me that I 'should make an Elegy sculpture,'" recalls Robert Motherwell, one of Smith's closest artist friends. "He said he would show me how, help me make it, everything. But I didn't do it because I could never imagine what an Elegy [to the Spanish Republic] would look like from the side."[7] However, Smith could not only envision what one would look like, he went on to make his own Elegy in the *Gondola* sculpture. Finished in March 1961, *Gondola* was the first of four mural wagons, in which a dominant flat plane is raised up on a set of small wheels.

Motherwell's series the *Elegies to the Spanish Republic* constitutes one of the classic images of abstract expressionist painting. Allowing for numerous variations, the essential image of the Elegies is a set of black, vertical ovals placed laterally across a white field, with shapes either tangential to or merging with one another along the sides. Although the shapes are painted rather loosely along their edges, their black forms still remain firm when seen in contrast to their white setting. Occasionally a rectangular bar or an irregularly drawn line also appears in the construct. The rectangular shape of the overall white field with its exterior lines is also important because the ovals sometimes explode into their surrounding space—by means of a dripped or splattered edge; in other works the ovals are compressed together and push against the outside of the pictorial field.

Many of these elements are echoed in Smith's *Gondola-Elegy* variation. Here an oval form at one end is combined with two elongated, more geometric shapes, with a black rectangle or bar at the opposite end. Like the Elegies, these shapes are painted black, and they are also disposed laterally across one plane, each form merging into the adjacent shape to create a unified construct.

Smith's *Gondola* differs from the Elegies in several ways. Here the shapes stand free in space rather than being seen within a confining rectangle, and their black forms contrast with the multiple colors of their surrounding space, as opposed to the white field of the Elegies. Furthermore, the edges of Smith's Elegy forms are clear-cut and firm, in contrast to the irregular perimeters in the Motherwell works.

But these distinctions were not always so in *Gondola.* As we can see in a photograph taken in Smith's studio, in making *Gondola* he began by mounting a flat rectangular sheet on wheels—creating a surface much like a

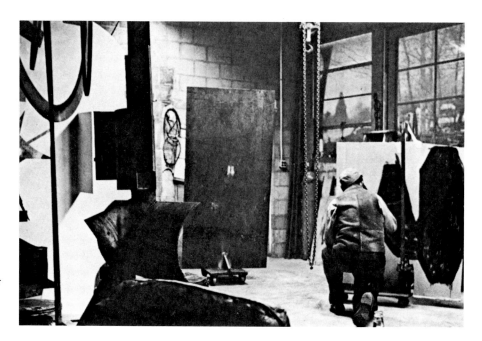

5. Smith working on *Gondola,* 1961. Photographer unknown. Reproduced from Rosalind E. Krauss, *Terminal Iron Works: The Sculpture of David Smith.*

6. David Smith. *Gondola,* 1961. Steel, 175.3 x 154.9 x 45.7 cm (69 x 61 x 18 inches). The Chrysler Museum, Gift of Walter P. Chrysler.

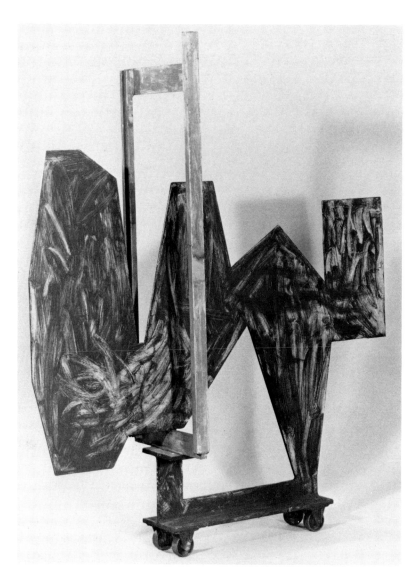

178

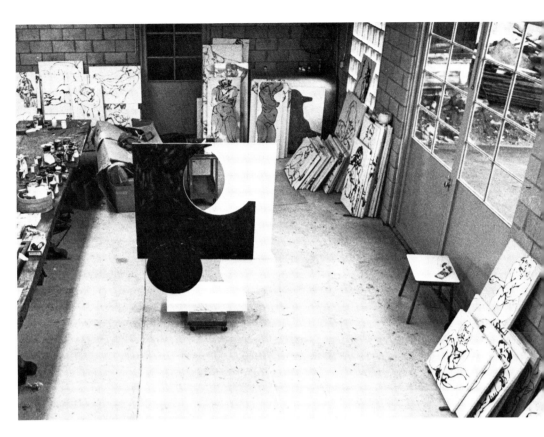

7. Smith's painting studio at Bolton Landing, with *Dida Gondola* in the center.

stretched, blank canvas. He then painted an Elegy-like image in black onto the surface. Even Motherwell's irregular edges, including runs of paint, were paraphrased at this stage, only to be eliminated when Smith cut away the surrounding white areas of the rectangular sheet. The photograph also indicates that the black rectangle at the upper corner was added later to this initial plane.

Gondola relates to *Doorway on Wheels* of the year before in sharing an open rectangular box, or doorway, turned ninety degrees to the plane of the composition, but in *Gondola* we can read the frame more abstractly as a literal metaphor for sculptural space in a work that is painterly in origin.[8]

The other mural wagons share the pictorial character of *Gondola* and its idea of a plane—a murallike surface—being the focus of the composition. *Dida Gondola* is actually made of two flat planes that overlap each other to form a virtually continuous surface, again set upon a wheeled base. In contrast to the irregular shaping of *Gondola,* here the two planes have been cut out in the same pattern of very geometric forms of arcs and circles. The layering of the planes creates an oval formed by two arcs in the center and two full circles below. The symmetry is broken on one side by Smith's using black paint on one sheet and white on the other. The verso of *Dida Gondola* is all white.[9]

The other two works in this subgrouping, *Black White Forward* and *Black White Backward,* also used painted areas to articulate the composition of the sculpture. But where color is confined to sculptural shapes in earlier works,

179

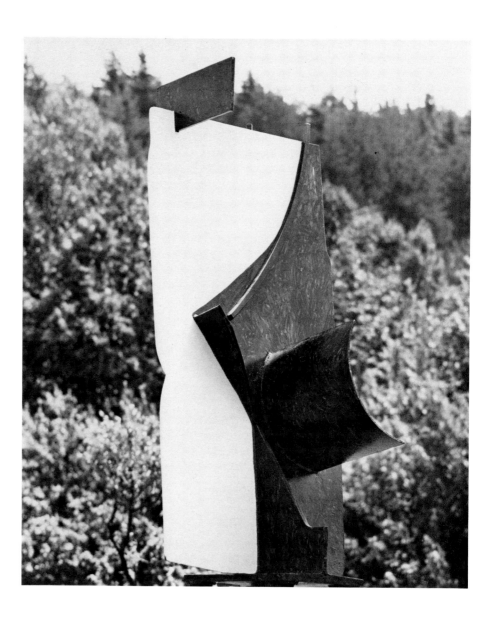

8. David Smith. *Black White Forward*, 1961. Steel, painted black, brown, and white, 223.8 x 121.9 x 96.5 cm (88⅛ x 53¾ x 48⅛ inches). Collection, Rebecca and Candida Smith. Not in exhibition.

here certain shapes—such as the triangular form on one side of *Black White Backward*—were created independently of any physical divisions.

In these works a large plane runs through the center of the composition, V-shaped in *Backward*. Against this are set smaller elements, such as the part-cylinder on the front of *Forward*, an element that connects this sculpture with the concurrent *Zig* series.[10] *Backward* is even more dramatic, with a huge disk sticking through the mural plane, further emphasizing its arrow-like identity and the sense of potential motion implied by its wheeled base.

Voltri Chariots

Smith's 1962 working stay in Voltri, Italy, was one of the most inventive and the most productive periods in his work. Given the run of an old abandoned steel mill, Smith was able to use anything he found there in his sculpture. Among the tools and metal-making implements remaining in Voltri, Smith found various wheels and wheeled equipment. They form the basis of his

180

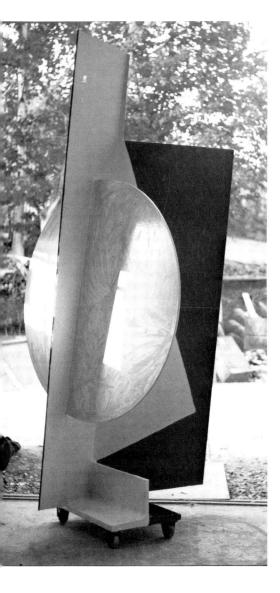

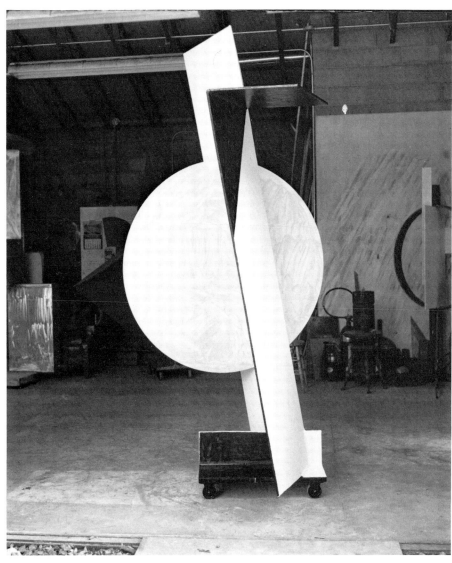

9. David Smith. *Black White Backward*, 1961. Steel, painted black and white, 254.3 x 136.5 x 122.2 cm (100⅛ x 53¼ x 48⅛ inches). Collection, Anne MacDonald Walker.

AUTHOR'S NOTE
Although the photographic records of *Black White Backward* show that it was mounted on wheels while it was being made and kept on them afterward, Smith apparently removed them sometime later, as they are no longer part of the sculpture. The wheels may have initially been a support for moving the piece about, but their continuing presence suggests Smith conceived of them along with the other Wagons, and indeed they were made in the studio at the same time. A similar situation exists for *Gondola II*, which was also kept on wheels that were later removed: *Gondola*(I) retained its wheels.

chariots, which were shown in the amphitheater in Spoleto after their construction in Voltri.

The concept of a wheeled sculpture for Spoleto initially occured in a different way. Sometime after finishing his Italian sculpture *Voltri I*, Smith planned an enormous railway flatcar piece, intending to send it to Spoleto. It was to be his major project, a "dream," to use his word, drawn from his Midwest childhood, about which he wrote the passage quoted above. Smith had hopped freight trains as a child in Ohio and had worked in locomotive plants during his career. In Voltri these autobiographical sources were apparently drawn upon as ideas for a monumental work. But Smith could not make the sculpture because a railway flatcar could not travel to Spoleto, and if shipped by truck, it would have been too high to clear low tunnels en route.[11]

When faced with these restrictions, Smith did not completely give up the idea of wheeled sculpture. Instead, he transformed the theme to a much

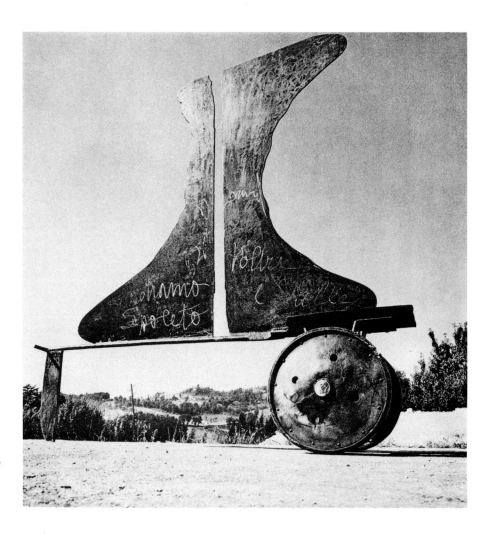

10. David Smith. *Voltri VI,* 1962. Steel, 261.6 x 261 x 64.8 cm (103 x 102¾ x 25½ inches). Collection, National Trust for Historic Preservation. Photograph by Ugo Mulas, Courtesy of Antonia Mulas, Milan. Reproduced from Carandente, *Voltron* (Philadelphia, 1964). Not in exhibition.

smaller version in *Voltri VI, VII,* and *XIII,* the Italian chariots, which are the most remarkable works of this period. "Since I had to abandon it [the flatcar]—I used wheels in many of the sculptures for mobility and aesthetic reasons . . . the practical fact [is] that my sculpture is getting too big to move without built-in rolling."[12]

Only rarely do we have a sense of the weight of a sculpture or the problems Smith encountered in moving his sculpture about Bolton Landing. Even *Wagon I,* with its wheels, presented difficulties. As Smith noted:

That's a wagon, and these wheels weighed two hundred and seventy pounds—this weighed six hundred and seventy-five pounds—and the axis for this wheel is higher than the axis for that one; and the big center thing is solid. I think it weighs—I don't know what it weighs—we have to use a derrick to move it.[13]

The wheels and the spine of the Voltri chariots were integral units found in the Voltri factories. Smith later reported:

Forgings too big for hand—worked by drop hammers—are transported from ovens to hammer by a tong which is a chariot on two wheels pushed by men. Three remained which I remade for carrying and being a part of in *Voltri VI, Voltri VII, Voltri [XIII].*[14]

Of the chariots, the first two, *Voltri VI* and *VII,* are the most radical in terms

of image. *Voltri VI* is the more dramatic piece, with its low spine and bold vertical elements above. Smith described it as "a tongue with wheels and two end clouds. One cloud rests in the spoon—each cloud end goes up from the tongue unsupported."[15] Smith's clouds are the leftovers that result from rolling steel plate, which is spread out and rolled like cookie dough. When the steel is cut or cropped into a rectangular plate, odd, usually curved shapes are left over at the end, just as they are in rolled dough. Smith made extensive use of these leftover clouds in the Voltri sculpture.

Voltri VI is distinguished from the other works in its scale. Smith used only two cloud elements, but they were of much larger scale and of more character. They appear as large curving bites that face one another. The tension between them is increased by the separation of the two sheets, leaving a gap between the chopped edges that creates a bold vertical element of negative space. The vertical element both reinforces and contests the perpendicular quality of the horizontal spine formed by the steel spoon.

The tension created by the vertical gap with its slightly ragged edges had invited comparison between *Voltri VI* and the vertical stripes that Barnett Newman used in his heroic paintings.

But a more likely comparison is with Smith's own earlier wheeled sculpture, *Gondola,* and its variation on the Motherwell Elegies. That connection exists not only in the way in which the Voltri shapes work pictorially as black forms seen in silhouette but also for their friezelike orientation across a frontal visual plane, aspects central to the Elegies and used in *Gondola.* Where *Voltri VI* differs from *Gondola* is in its shift in relative scale of its cut forms and wheels. In the other preceding wheeled sculptures, the wheels are relatively small, and even in their most compositionally integrated state they are one of many sculptural elements, even if more special in their identity. But in *Voltri VI* Smith sets up a direct juxtaposition between the wheels and the other elements both by the larger scale of all the parts and by limiting the work to only three basic components: the two clouds and the wheeled structure. Thus, *Voltri VI* shifts the theme of Smith's sculpture on wheels to being a wheeled structure as sculpture. That change is the essential development leading to the Wagons.

In discussing his Voltri works, Smith emphasized their abstract nature, and especially of the wheeled pieces: "Horse chariots are not in my picture," he wrote.[16] Yet faced with the forms of the work itself, Smith described them as chariots, and given the pattern of general references to ancient art found throughout the Voltri series, it is important to look at *Voltri VI* with these points in mind.

Giovanni Carandente noted that Voltri chariots evoke "Etruscan memories. They have the majestic carriage that was a property of classical sculpture."[17] Given Smith's interest in—or more importantly, his knowledge of—ancient art, there is one major work of Etruscan art Smith surely knew—the large ceremonial chariot of the late sixth century B.C., in the collection of the Metropolitan Museum of Art in New York. Its compartment for the rider—formed to curvilinear elements that meet along a vertical joining—might be echoed in Smith's works, just as its spoke wheels and long tongue are recalled in *Voltri VII.* Other possible sources for this work

are the same hieratic and stylized figural scenes in sixth-century B.C. vase paintings (the figures facing in opposite directions form an image echoed in the back-to-back chopped clouds in the composition of *Voltri VI*). And there are other ancient and classical representations of chariots that might also be mentioned. The important point here is that Smith's works—and in particular *Voltri VI*—call upon the ideas of these earlier works, and even if formed abstractly, they still suggest comparison with these precedents.

But it is also important to note how Smith makes the chariots horseless. In all of the chariots Smith moves the vertical elements to the center of the longitudinal spine, thus balancing the composition and removing exact reference to the chariot idea. Although the Etruscan chariot at the Metropolitan—with its compartment placed directly over the wheels—appears incomplete without the horses tied into their places, the Voltri chariots never indicate such an absence.

The final image of *Voltri VI* is that of a whole object, its composition balanced and focused along the dramatic vertical gap between the cloud ends. But, nevertheless, Smith does suggest a potential for movement in the work in the inscription he wrote on the side of the vertical cloud, using a blowtorch: "Andiamo a Spoleto" ("Let's go to Spoleto").

Processional

Certainly one of Smith's greatest works is *Voltri VII,* the second chariot piece that was installed as the focal point of the Spoleto arena exhibition. Different from the solid sheets, smaller wheels, and relatively lower compositional levels of *Voltri VI* and *XIII, Voltri VII* is made of thin linear elements placed on a structure with spoked wheels, aligned on an arched axis, with a long extended horizontal spine. *"Voltri VII,"* Smith wrote, "is a chariot ram with five bar forgings. They are not personages—they are forgings."[18] Like many of the other elements used at Voltri, these five elements were found by Smith in one of the factories. But their general S-shaped form corresponds to earlier works Smith made in 1955—each using a single bar —also called the forgings.

Smith made these earlier works based upon a series of ink drawings.

It is a drawing line really. I would never have done that if I hadn't been interested in drawing lines. . . . I don't think I could ever make a sculpture like that without making three hundred or four hundred drawings a year—I think it has to develop that way, if you are interested in making a vertical, simple vertical with the development of a drawing concept.[19]

As Krauss observes, "[The Forgings] are probably the most abbreviated sculpture Smith ever made."[20] And they are probably his most abstract as well. By considering, then, the nature of such precedents for the Voltri forgings, as well as Smith's denial of the Forgings as figuration, and by studying the manner in which they are placed on the chariot's spine—to form an abstract, rhythmic arrangement of A-B-A-B-A—it is correct to read the forgings as sheer design.

Significantly, if we read the bar forgings as abstract patterns—not figuration—we still encounter an association with classical art. The elongated and simplified S-shaped forms of the forging, especially when combined in a

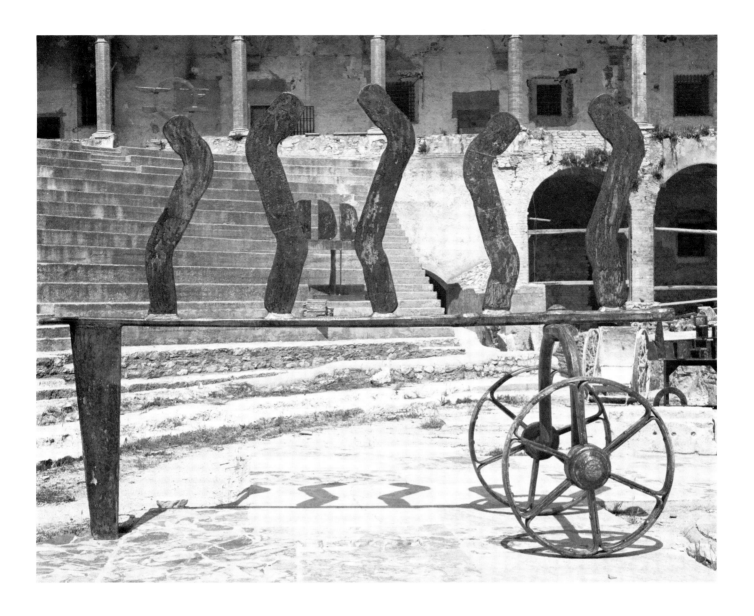

11. David Smith. *Voltri VII*, 1962. Steel, 215.8 x 311.6 x 110.5 cm (85 x 122¼ x 43½ inches). National Gallery of Art, Washington, D.C., Ailsa Mellon Bruce Fund, 1977. Photo by Ugo Mulas, Courtesy of Antonia Mulas, Milan.

pattern with a reverse *S* shape, recalls an almost identical pattern found in the strigilation on the sides of Roman sarcophagi. This Roman S-shaped pattern was derived from an instrument used by Greeks and Romans for scraping one's skin at the bath or in the gymnasium. Organized in a horizontal band of facing *S* shapes and reverse *S* shapes, strigilation was employed as decorative fluting in architecture as well as in the side registers of stone coffins. We must presume that Smith knew the use of the form on sarcophagi.[21] The particularity of its shape and Smith's use of *S* shapes in a similar reversing pattern suggest that, at the least, *Voltri VII* makes direct reference to a Roman motif and, at most, that the sculpture metaphorically presents an abstracted sarcophagus being borne on a cart. The latter reading is supported by the manner in which the elements are placed so as to form a long coffinlike rectangle along the horizontal tongue of the sculpture.[22]

The theme of a bier and sarcophagus would not be an isolated subject in Smith's art.[23] The earlier works, however, do not compare to *Voltri VII* in

185

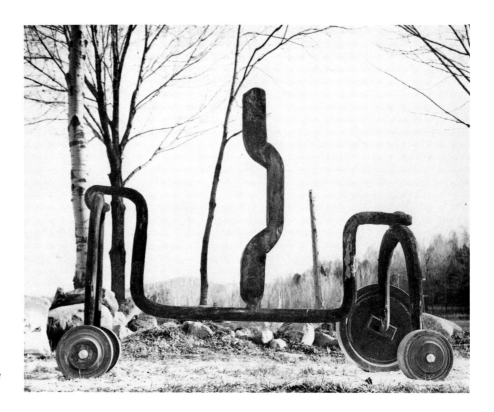

12. David Smith. *Wagon II,* 1964. Steel, 273.1 x 282.6 x 111.8 cm (107½ x 111¼ x 44 inches). Collection, Candida and Rebecca Smith, Courtesy of M. Knoedler & Co., Inc., New York.

displaying the richness of Smith's inventive powers. Although other Voltris combine multiple points of view or dual images, *Voltri VII* indicates a remarkable ability to combine in one work a bold abstract graphic statement with an allusion to a Roman funeral. By stressing only the strigilation pattern while leaving the cart in its original state, Smith is able to shift our readings between the two images. *Voltri VII* is the key to the Wagons.

Wagons

Smith's work at Voltri was so fulsome that when he left he had various materials crated up and sent to him in New York. There he began the *Voltri-Bolton* series (see chapter 5). Smith incorporated the Italian materials into the subsequent set of works and continued many of the forms and themes he had used at Voltri, including figures and verist and abstract still lifes.

It is somewhat curious that this second series of Italian and American elements did not include any wheeled sculpture, an omission made even more puzzling given the strength of the chariots. However, the absence of *Voltri-Bolton* wagons can be easily explained. They do exist, but in making them Smith chose to establish a new series, the Wagons.

The relationship between the Voltris/Voltri-Boltons and the Wagons has gone almost completely unremarked. Only Greenberg has written about how they directly connect:

Smith made two huge *Wagons* in 1964, harking back to the wheeled pieces he had left in Spoleto in 1962. Most of the elements of these *Wagons* come from the same place, the iron works in Voltri where he made his sculptures for the Spoleto Festival.[24]

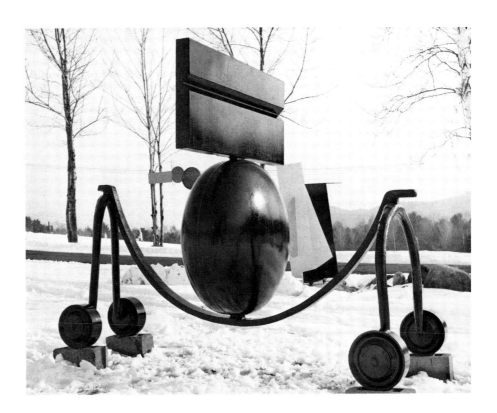

13. David Smith. *Wagon I,* 1963–64. Steel, painted black, 224.8 x 308.6 x 162.6 cm (88½ x 121½ x 64 inches). National Gallery of Canada, Ottawa/ Galerie Nationale du Canada, Ottawa.

We can see the relationship between the series most directly in *Wagon II,* which can be directly connected with *Voltri VII,* the major chariot. Like its Italian predecessor, *Wagon II* contains a dominant vertical compositional element placed atop an extended horizontal spine. Where the five verticals in *Voltri VII* follow an S-shaped pattern, the one vertical in *Wagon II* is essentially a straight line bowed to one side then pulled back again. However, the verticals are alike in that the one in *Wagon II* is also a forging and was most likely part of the materials shipped to Smith after Spoleto.

Where *Wagon II* differs from the chariots is in the design of its vehicle. In *Voltri VII,* the full *S* shapes contrast to the long horizontal spine, which runs straight through the sculpture. In *Wagon II,* the spine curves back upward to become a vertical passage, half as high as the forging, before flattening again to a horizontal, one end curving around to form a hook, the other flattened and punctured with a hole. Attached at each end is a reverse U-shaped arm, which lifts the structure up and is attached to the wheels. The four-wheeled structure makes the piece properly a wagon—as opposed to the Voltri chariots.

The connection to the Voltri series is continued here; the central spine and the arms are Italian, and the wheels are commercial American stock.

Arms from Voltri are used in *Wagon I,* completed two months before *Wagon II.* Smith inscribed the work 1963–64, a temporal period of sufficient duration to allow *Wagon I* possibly to have been begun during the same time as the Voltri-Boltons. Conceivably, the other two wagons could have also been begun in 1963, although Smith did not give any indication of this in his dating of the pieces.[25]

The other elements in *Wagon I* are American. The wheels are of the same industrial character as those used in *Wagon II* (and in *Wagon III*). *Wagon I* initiates the compositional format we have already seen in *Wagon II*, a long central spine between the pairs of wheels, with a vertical element at the middle. Unlike the U-shaped, irregular forging in *Wagon II*, the spine in *Wagon I* is a long clean curve, drawn by using a heavy leaf from a commercial spring. Atop this bow sits a compound vertical construction, formed from two tank ends welded together to create a thick, somewhat bulging disk, which is surmounted by a thick bar of steel with a long, deeply inscribed horizontal line predominant upon one side.[26]

We have seen how Smith identified the five forgings on *Voltri VII* as being abstract—"they are not personages"—but such a reading is less certain with the first two Wagons. Indeed, as early as 1969, Fry wrote of *Wagon I*:

Like a robot centaur of the machine age, whose features are reduced to a straight beveled slit in a plate of steel, it compels recognition as a disquieting, threatening personage more forcefully than any work preceding it. Smith has achieved this expressive force not through associative imagery, as he did in the 1940's, but solely with color, scale, and the organization of abstract, geometrical forms.[27]

And we might further note that the horizontal bar that serves as a head in this reading corresponds with those elongated horizontal planes and half-cylinders used for the same purpose in the Sentinels and Zigs. We must be somewhat careful in making that identification, however, as Smith's intended image may have been abstract, or less figural. Indeed, Robert Murray recalls that the upper element was "put on and taken off, put on and taken off, and finally put back on," indicating a more abstract conception of the piece.[28] Abstract or figural, *Wagon I* and *II* each continue the sense of the processional that we associate with the earlier chariots.

Another characteristic that these Wagons share with the Voltri chariots is a quality of brute strength; their elements are thick and crudely fashioned and their composition directly and boldly established. In this regard, *Wagon III* marks a wide departure. In this work, the components are almost exclusively linear; they are thin forgings from Italy in drawn shapes of half-circles, right angles, and straight lines. Only the horizontal bar in the center has any real weight, and that sense is lessened by the way in which the bar is half-twisted in three areas, forming narrow points of tension along its run.

Wagon III is like *Voltri VII* in having the horizontal bar extend all the way through the composition with several elements placed above it. But rather than the simple pattern of the matched forgings of *Voltri VII*, in *Wagon III* we find a frieze of drawn, iron signs. Beginning at one end, Smith fashions a cresent moon from an arc forging, and at the other a full circle—or sunlike shape—is created by merging two of these pieces. In between a six-pointed star is made from a vertical element and two angles and paired with an open diamond created by two more angles.

The linear, celestial signage is virtually unique in character and theme in Smith's mature work, echoed only in the lunar arcs and far more speculative stars of *Doorway on Wheels*.

The pictorial qualities of *Wagon III* are found in paintings by other art-

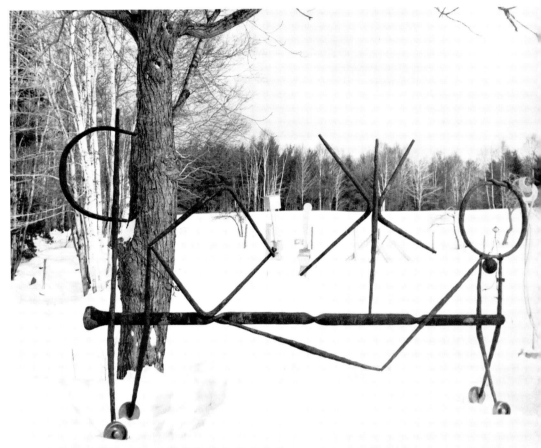

14. Joan Miró. *Painting.* 1949. Oil on canvas, 64.8 x 80.3 cm (25½ x 31⅝ inches). The Morton G. Neumann Family Collection. Not in exhibition.

15. David Smith. *Wagon III.* 1964. Steel, 252.7 x 419.1 x 74.6 cm (99½ x 165 x 29⅛ inches). Collection, Hallmark Cards, Inc.

ists, including Paul Klee and Joan Miró, and perhaps especially the works of Adolph Gottlieb, a member of the abstract expressionist generation like Motherwell, whose Elegies influenced *Voltri VI* and the earlier wheeled *Gondola.*

Flatcar

"Why haven't you made a lot of steel boxes all shapes & piled one upon each other—put together on wheels," Smith wrote above a drawing in a sketchbook from 1959.[29] As Edward Fry was the first to point out, *Voltri XVIII*, the small cart made near the end of the series, relates to that earlier idea. *Voltri XVIII* is composed of anvils, blocks, and wrenches set upon a wide platform, which rests on four tiny wheels. Being a *Voltri*, the work automatically falls into the chariot subset. Seen as a cart, however, the work also relates to the three Wagons just discussed.

But another identity can be proposed for *Voltri XVIII*, one which is also in keeping with Smith's desire to record autobiographical themes, namely that it represents in miniature an image of what Smith's initial railway flatcar at Voltri might have been. In discussing his dream, Smith's statement reads in full:

A dream is a dream never lost. I've had it inside a 4-8-4 on the top of a Diesel en-

16. David Smith. *Voltri XVIII*, 1962. Steel, 106.7 x
101.6 x 82.2 cm (42 x 40 x 32⅜ inches).
Collection, Candida and Rebecca Smith. Not in
exhibition.

gine, they have been in a size dream. I found an old flatcar, asked for, and was given
it. Had I used the flatcar for the base and made a sculpture on the top, the dream
would have been closer.

I could have loaded a flatcar with vertical sheets, inclined planes, uprights with
holes, horizontals supported—

I could have made a car with the nude bodies of machines, undressed of their de-
tails and teeth—

I could have made a flatcar with a hundred anvils of varying sizes and character
which I found at forge stations.

I could have made a flatcar with painted skeletal wooden patterns.

In a year I could have made a train.[30]

Certainly, the base of the sculpture, a flat, thick platform, and the position
and relative scale of the wheels to it correspond to the general configuration
of a railway flatcar. Upon the horizontal plane the wrenches and the raised
box in the center can be related to the "uprights with holes, horizontals sup-
ported," Smith had planned, while "a hundred anvils of varying sizes and
characters" can be seen represented in two small examples.

If there is a relationship between Smith's dream flatcar components and
certain Voltri works—not, however, in their individual compositional ele-
ments, which were drawn from the earlier project—they also relate as an en-
semble. Smith wrote of his dream: "The closest to realization came when
Mulas chose to put finished work on the flat [car] for his photos."[31] Mulas
included Smith with his sculpture in one photograph: the expression on his

17. Funeral wagon, c.600 B.C. Terra-cotta group found at Vari. National Archaeological Museum, Athens. Photo reproduced from Gisela M. A. Richter, *A Handbook of Greek Art* (New York, 1959). Not in exhibition.

18. Sun Temple of Konarak, Orissa, India (south side), thirteenth century A.D. Photograph by Eliot Elisofon, *Life* magazine, copyright 1949 Time, Inc.

face, the turning up of his head, and his pose display his own awareness of the nearness of realizing his dream, displayed behind him in the Voltri pieces placed across a flatcar, not unlike the arrangement of anvils, blocks, and wrenches in *Voltri XVIII*.

We can find many precursors for Smith's dream, and he may have been aware of some of them. For example, works such as the Greek terra-cotta *Funeral Wagon* of 600 B.C. with its casket covered with cloth, surrounded by mourning women, all on a flat platform attached to wheels. This work, which Smith could have known in Athens or from reproductions, offers a clear precedent not only for large compositions on a flatcar but for the figural *Voltri IX* and the funeral wagon of *Voltri VII*.

Another source is far more speculative, especially as it is removed from the context of classical art. It is mentioned by Smith in his "Report on Voltri" in discussing the circles and the chariots: "Wheels are circles with mobility, from the first wheel of man to wheels on Indian stone temples."[32] Smith was more expansive about that reference in a later discussion of the chariots with Thomas Hess:

Of course I've used wheels a lot. As far as I know, I got the wheel idea from Hindu temples. . . . They cut them out of stone on the temples to represent the processions where they carry copies of temples down the streets in wagons. Carved stone wheels. It's a fascinating idea.[33]

The work to which Smith refers is the Orissan *Sūrya Deul*—or temple of the sun—at Konārak in the northeast section of Puri. Although conceived as a Hindu temple, this extraordinary work includes large stone-cut wheels along its base walls, thus likening the temple itself to the *Vimāna*, or chariot, of the sun god as it moves through the sky.[34] Clearly, however, the images of the Hindu temple do not correspond in any specific way to what we know of Smith's intentions in his flatcar. Rather it was the image or the idea of the massive *Vimāna* that may have been inspiring to Smith—in its scale and its complexity.

Thus the realization of the dream at full scale was ruled out, and only the

19. Smith and several of the twenty-seven
sculptures he made in Italy. Photograph by Ugo
Mulas, Courtesy of Antonia Mulas, Milan.
Reproduced from *Art News Annual*, 1964.

small *Voltri XVIII* cart and the Mulas photograph of Smith survive as evidence of its presence. Wrote Smith:

So many dreams have been lost to lack of material, workspace, storage, etc., that one more becomes another wish. The flatcar I had is now melted in the open hearth and rolled into sheet. The beauty of the ballet of a white-to-red-to-black sheet in a fast-rolling mill at different speeds running back and forth billowing steam with the quenches is a memory for me of automation fed by my flatcar.[35]

Smith's dream was certainly not laid aside, but continued to be a central ambition. Recalling his past, Smith told Thomas Hess in a 1964 interview:

When I was a kid, I had a pretty profound regard for railroads. I used to sit down on the edge of town and watch trains go through. I used to hop trains, ride on the tops of boxcars. We used to play on trains and around factories. I played there just like I played in nature, on hills and creeks. I remember when I first sat in my father's lap and steered a car. In fact, I've always had a high regard for machinery. It's never been an alien element; it's been in my nature.

And don't forget I've worked in locomotive plants. I've sat on those goddamned engines, welding them up, hoping I could someday make sculptures as big. And I will someday. I think.

Hess remarked:

There was a certain social setup when you were a kid in Indiana, and you had certain ideas about machinery and materials. And on your farm you've set up those huge "useless" sculptures which, to me, have a certain symbolic effect—like a book in a secret language.

Smith continued:

The secret language, Tom, is very simple: I'm building the biggest, the best goddamned sculptures I can make within my present limits, conceptually and financially. If I could have built sculpture within my conception several years ago, they would have been twenty-five to thirty feet high.[36]

Trains and Tractors

Concurrent with the Cubis, Smith was working toward another series that would have extended the Wagons to an unprecedented new scale, that of a train or a tractor.

James Rosati has recounted comments Smith made shortly before his death about building a flatcar with sculpture on it. Smith called it a "traveling exhibition," suggesting it would go from town to town like a circus.[37] The image of the railroad car and the circus world would again come from Smith's childhood in the Midwest.

Smith transferred his Italian flatcar dream back to a revised Agricola theme in 1964, when he renewed the idea of an enormous sculpture which would be movable, like a train. Motherwell wrote of Smith's plans in February 1965:

Lately he has been buying up ancient tractors with gigantic steel wheels, and even an enormous old road grader. He wants to incorporate them into sculpture, sculpture so tremendous that this industrial machinery will have no larger rôle in the whole sculptures than the clockworks have in a grandfather clock, or the elevator in an elevator shaft.[38]

Smith himself commented shortly before his death:

20. Tractor in Smith's scrap material, 1965.

There are some old tractors sitting over there that a former professor of Bennington bought for me in Buskirk—he had a couple of neighbors who had some old steel tractors to sell so I bought them. I need a few more and I am going to make them into sculptures—I am going to make the sculptures on top of them, so that I can drive the tractors. . . . Sometimes, if you say your secrets, you may not do it. It doesn't matter, I'll use them one way or another, even if I don't do it that way.[39]

Smith did not live to expand his Wagons into Tractors and Trains. Like the stockpile of yet-to-be-used Cubi elements, the old steel tractors remained unaltered outside his studio.

Notes

1. David Smith in E. A. Carmean, Jr., "David Smith: The Voltri Sculpture," *American Art at Mid-Century: The Subjects of the Artist* [exh. cat., National Gallery of Art] (Washington, 1978), 237.

2. As with the terms *Agricola* and *Sentinel*, Smith was precise in what his titles were.

3. Clement Greenberg, "Critical Comment," in Cleve Gray, ed., "David Smith," *Art in America, 54* (January–February, 1966), 30.

4. The *Chariot* was illustrated in *The Art Digest, 26* (15 January 1951), 17, opposite an article on Pablo Gargallo's welded iron sculpture, which Smith certainly would have seen.

5. "I saw the sculpture before me as if it were finished. . . . It became impossible for me not to make it," said Giacometti, in *Alberto Giacometti* [exh. cat., The Museum of Modern Art] (New York, 1965), 60.

6. Rebecca Smith called my attention to the powerful presence of the night sky at Bolton Landing, in conversation.

7. Motherwell in conversation with the author.

8. Such an indication for depth goes back to the perpendicular attachment in *Agricola I*.

9. *Dida Gondola* was still in the studio when Smith died, raising the question of its being finished; it is dated (4-12-1961) and signed, however.

10. *Zig I, Black White Backward*, and *Gondola* were all in the studio at the same time, as a photograph demonstrates.

11. Phyllis Tuchman raised this connection in conversation with the author.

12. Letter of David Smith to David Sylvester, in Giovanni Carendente, *Voltron* (Philadelphia, 1964), 12.

13. David Smith, "Some Late Words from David Smith," ed. Gene Baro, *Art International, 9* (20 October 1965), 50.

14. David Smith, "Report on Voltri," in Garnett McCoy, ed., *David Smith* (New York, 1973), 162.

15. Smith "Report on Voltri," 162.

16. Smith, "Report on Voltri," 162.

17. Carendente, *Voltron, 7.*

18. Smith, "Report on Voltri," 162.

19. Smith in Baro, "Late Words," 50.

20. Rosalind E. Krauss, *The Sculpture of David Smith* (New York, 1977), 66.

21. Robert Motherwell and Helen Frankenthaler had a Roman sarcophagus—but with a different pattern—in the garden in New York, where Smith visited.

22. For further discussion of this point see Carmean, Jr., *Subjects*, 236.

23. For example the *Table Torso* of 1942 (Rose Art Museum, Brandeis University, Waltham, Massachusetts).

24. Clement Greenberg, "Critical Comment," in Cleve Gray, ed., "David Smith," *Art in America, 54* (January–February 1966), 30.

25. *Wagon II* is dated "April 16-1964" by an inscription. *Wagon III* is not dated.

26. Vertical cuts appear on the other side of this steel plane.

27. Edward Fry, *David Smith* [exh. cat., The Solomon R. Guggenheim Museum] (New York, 1969), 134.

28. Robert Murray in conversation with the author.

29. Illustrated in Krauss, *The Sculpture*, fig. 838.

30. Smith "Report on Voltri," 161.

31. Smith, "Report on Voltri," 161.

32. Smith, "Report on Voltri," 162.

33. Smith in an interview with Thomas B. Hess, "The Secret Letter" in McCoy, *David Smith*, 185.

34. See Benjamin Roland's discussion in *The Art and Architecture of India* (Baltimore, 1953), 171.

35. Smith, "Report on Voltri," 161.

36. Smith and Hess in "Secret Letter," 179.

37. Rosati in conversation with the author.

38. Motherwell, quoted in Carmean, Jr., *Subjects*, 239.

39. Smith, "Late Words," 49.

1. Rebecca and Candida Smith with *Cubi VII*.

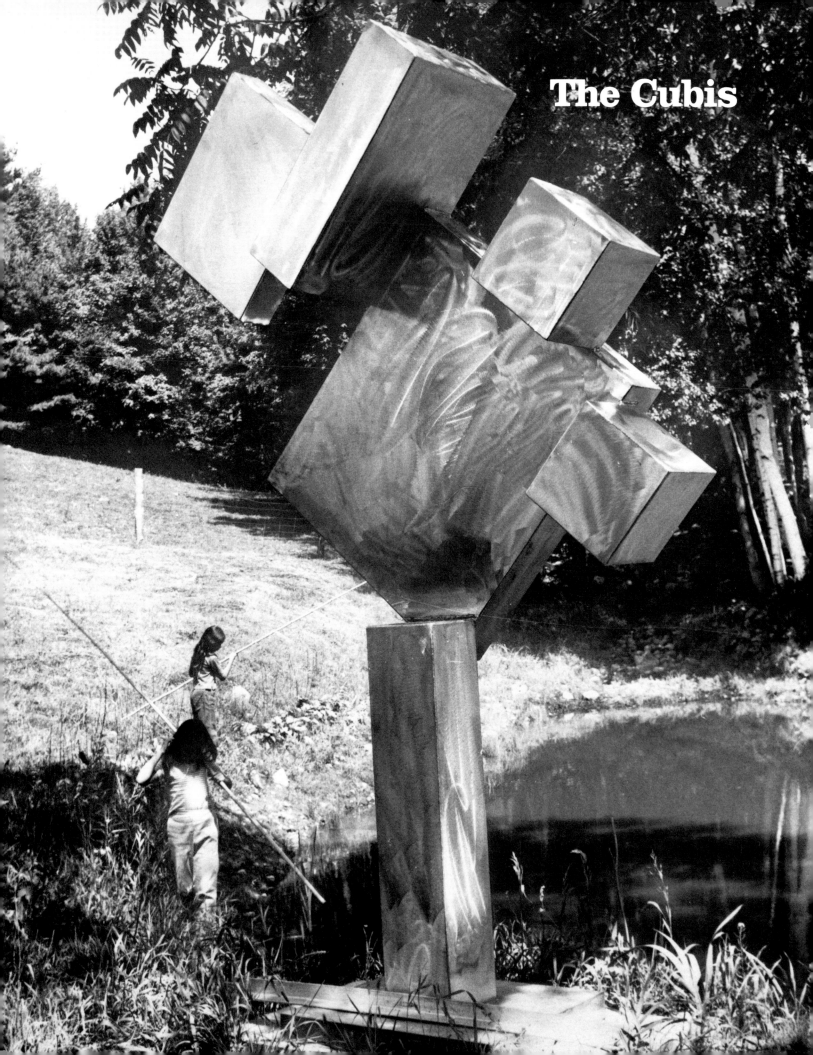

The Cubis

Cubis

1. *Cubi I,* 1963
 stainless steel (K-649)
 315.0 x 87.6 x 85.1 cm (124 x 34½ x 33½ inches)
 inscribed on base plane: David Smith March 4-63 CUBI I
 The Detroit Institute of Arts, Founders Society Purchase,
 Special Purchase Fund

2. *Cubi II,* 1963
 stainless steel (K-650)
 331.5 x 93.7 x 60.6 cm (130½ x 36⅞ x 23⅞ inches)
 inscribed on base plane: David Smith OCT. 25 '62
 Collection of Candida and Rebecca Smith. Courtesy of
 M. Knoedler & Co., Inc., New York

3. *Cubi V,* 1963
 stainless steel (K-653)
 243.8 x 185.4 x 55.9 cm (96 x 73 x 22 inches)
 inscribed on base plane: David Smith / CUBI V / Jan. 16 / 1963
 Collection, Mrs. H. Gates Lloyd

4. *Cubi VI,* 1963
 stainless steel (K-654)
 285.0 x 73.5 x 54.5 cm (112³⁄₁₆ x 28¹⁵⁄₁₆ x 21½ inches)
 inscribed on base plane: David Smith 3/21/63 CUBI VI
 On loan from the Israel Museum. Donated by Mr. and
 Mrs. Meshulam Riklis

5. *Cubi VIII,* 1962
 stainless steel (K-656)
 233.1 x 96.5 x 86.4 cm (91¾ x 38 x 34 inches)
 inscribed on base plane: David Smith / Dec 24 '62 / CUBI VIII
 The Meadows Museum, Southern Methodist University, Dallas

6. *Cubi IX,* 1961
 stainless steel (K-657)
 269.9 x 142.2 x 116.8 cm (106¼ x 56 x 46 inches)
 inscribed on base plane: CUBI IX DAVID SMITH Oct. 26-1961
 Collection, Walker Art Center, Minneapolis;
 Gift of the T. B. Walker Foundation

7. *Cubi X,* 1963
 stainless steel (K-658)
 307.3 x 199.4 x 60.3 cm (121 x 78½ x 23¾ inches)
 inscribed on base plane: David Smith April 4 '63 Hi
 Rebecca / CUBI X
 Collection, The Museum of Modern Art, New York.
 Robert O. Lord Fund

8. *Cubi XIV,* 1963
 stainless steel (K-662)
 308.6 x 209.9 x 78 cm (121½ x 82¼ x 30¾ inches)
 inscribed: CUBI XIV David Smith 9-25-63
 The Saint Louis Art Museum (32:1979)

9. *Cubi XVII,* 1963
 stainless steel (K-665)
 273.7 x 164.8 x 96.8 cm (107¼ x 64⅞ x 38⅛ inches)
 inscribed on base plane: David Smith Dec. 4-'63; on base
 plane in back: CUBI XVII; on inside of base: Terminal Iron Works;
 at back: Bolton Landing N.Y. 2-14/681245 1/16/52
 Dallas Museum of Fine Arts, The Eugene and Margaret
 McDermott Fund

10. *Cubi XVIII,* 1964
 stainless ssteel (K-666)
 294.0 x 55.3 x 52.7 cm (115¼ x 21¼ x 20¼ inches)
 inscribed on top of base: David Smith 2-14-64 CUBI XVIII
 Museum of Fine Arts, Boston: Anonymous Centennial Gift

11. *Cubi XIX,* 1964
 stainless steel (K-667)
 286.4 x 148.0 x 101.6 cm (112¾ x 58¼ x 40 inches)
 inscribed on base plane: David Smith 2-20-64 CUBI XIX
 The Trustees of the Tate Gallery

12. *Cubi XXI,* 1964
 stainless steel (K-669)
 303.5 cm (119½ inches)
 inscribed on base plane: David Smith CUBI XXI Becca April 4-64
 Collection, Howard and Jean Lipman

13. *Cubi XXIII,* 1964
 stainless steel (K-671)
 193.7 x 439.1 x 68.0 cm (76¼ x 172⅞ x 26¾ inches)
 inscribed on top of cylinder: David Smith / November 30 /
 CUBI / XXIII / 1964
 Los Angeles County Museum of Art—Museum Purchase,
 Contemporary Art Council Funds

14. *Cubi XXIV,* 1964
 stainless steel (K-672)
 290.8 x 214.0 x 81.3 cm (114¼ x 84¼ x 32 inches)
 inscribed on top of element at fourth level: David Smith Dec. 8,
 1964, CUBI XXIV
 Museum of Art, Carnegie Institute, Pittsburgh. Howard Heinz
 Endowment Purchase Fund, 1967

15. *Cubi XXVI,* 1965
 stainless steel (K-674)
 303.5 x 383.4 x 65.6 cm (119½ x 151 x 25⅞ inches)
 inscribed on side of bar projecting from Cubi: David Smith /
 January 12 1965 / CUBI XXVI
 National Gallery of Art, Washington, D.C., Ailsa Mellon Bruce
 Fund, 1978

16. *Cubi XXVII,* 1965
 stainless steel (K-675)
 282.9 x 222.9 x 86.4 cm (111⅜ x 87¾ x 34 inches)
 inscribed on lowest horizontal beam, left: David Smith Mar 5 1965;
 on right: CUBI XXVII
 The Solomon R. Guggenheim Museum, New York

17. *Cubi XXVIII,* 1965
 stainless steel (K-676)
 274.3 x 284.8 cm (108 x 112⅛ inches)
 inscribed: David Smith 5-5-65 CUBI XXVIII gate 3
 Sid Richardson Foundation

CHAPTER 7 **The Cubis**

A structure that can face the sun and hold its own against the blaze and the power.

David Smith[1]

David Smith's monumental Cubis form his last series of sculpture, the one still underway at the time of his accidental death in May 1965. Collectively and as individual pieces the Cubis have continually been regarded as among the artist's greatest works, and these twenty-eight Cubis have inspired the most awe in their critical reception.[2] Hilton Kramer, for example, said of the works, "In the 'Cubi' series Smith crowned his career as a constructor with the most monumental work of his life."[3]

The Cubis are curiously Janus-faced in both stylistic and thematic characteristics. Throughout the series we encounter aspects of Smith's earlier work, including his use of abstract figuration, the compositional freedom he developed out of the welding process, and his use of burnished stainless steel material. Yet, at the same time these Cubis stand apart from the previous sculpture in their constructivist—almost architectural—character, in their new organizational inventions, and for their exclusive usage of solid, three-dimensional elements. These quite different qualities, when combined, make the Cubis seem simultaneously to be two things. "In one sense these sculptures only fulfill a principle already evident—indeed central—in his earlier work," wrote Kramer, "but in a deeper sense they represent something radically new."[4] They remain puzzling, at once the final realization of Smith's major concerns made on a heroic scale but also the first, but fully realized, steps toward a new sculptural definition, which was left unfinished.[5]

The dualistic nature of the Cubis has struck critics and art historians of Smith's sculpture since 1965. In writing his elegiac article on the work, Gene Baro observed of the Cubis:

This newest (and last) work differs from Smith's dominating concerns in a number of ways. It is monumental and architectural, classically reposeful in feeling, free of figurative allusion. . . . [However,] I am not suggesting that Smith's last sculpture is a radical departure, wholly uncharacteristic. Its vocabulary of elements, its techniques, its visual imagination are demonstrably his, but in chastened combinations.[6]

199

Rosalind Krauss wrote five years later that

no other series has elicited such diverse and mutually contradictory interpretation. Some writers treat the *Cubis* as abstract gestures or rhythms—as allusions to the stretching, striding, turning movements of a heroically scaled figure. Others, moving with striking symmetry to the opposite point of view, think of them as colossal constructions—the first wave of sculpture's migration into the realm of architecture. Those in the first group generally describe their formal experience of the works as colored by a sense of antimateriality; they speak of the illusion of masslessness and weightlessness, of light so captured and reflected that the sculptures dissolve into "dazzling emblems" and create "an energy that is purely optical." As we would expect, the second group's perception of the works is the absolute reverse of this. For them the excitement of the *Cubis* resides in the unalloyed massiveness of the individual elements, in the sculptures' presentation of corporealized solid geometries.[7]

Part of the perceptual division lies in the varying bases of the critical or art historical positions being taken, with only certain Cubis—or even partial aspects of individual works—being singled out because they fit a particular theoretical stance. In turn, that singling out is possible because the Cubis offer such a wide variety of different critical possibilities: In this series Smith not only ranged wider and with greater invention than he had in previous works, but he did so with greater conviction.

Cubes

The *Cubi* series numbers consecutively from one to twenty-eight, dating from *Cubi IX*, the first work to be completed (on 26 October 1961) to *Cubi XXVI*, Smith's last sculpture, finished only days before his death. As dis-

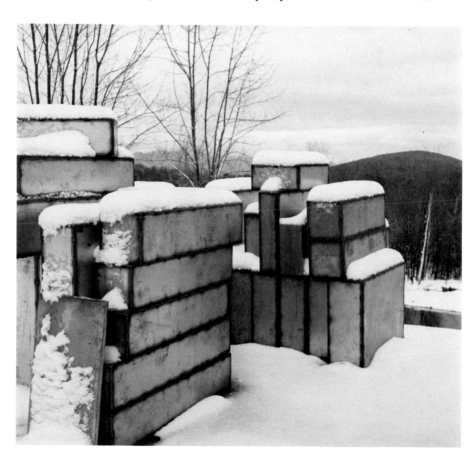

2. Cubi elements on deck outside studio at Bolton Landing.

cussed earlier (see the Introduction), there exists a wide discrepancy in certain instances between the numerical sequence of the Cubis and the completion dates that are inscribed upon them, the most notable being the gap between *Cubi IX* and *Cubi I*, finished 4 March 1963. This space of over fourteen months suggests that numbers were assigned to works not upon completion but when they were first conceived, either in drawings, paintings, cardboard maquette studies, or directly upon the floor. A lag between the idea and its sculptural fruition was most likely to occur with the Cubis, given their larger scale and the three-dimensional complexity of their components and their compositions.

Rather than being linked for compositional or thematic reasons, the Cubis group as a series principally because they share a common material, like the Agricolas or the Voltri-Boltons. In these two series Smith employed found, mechanical elements, but in the Cubis he used components that were made either by himself or his assistant, Leon Pratt. These are solid, squared geometric units, more often rectangular boxes rather than the pure cubes that Smith's series title implies. Other regularized shapes, such as disks and cylinders, were also fashioned and used. All of these elements were sharply defined, as the welded seams joining the flat elements together were ground down to leave a relatively crisp edge. And all of these forms were burnished with an abstract, random pattern.

Despite the clear uniformity of these elements, their geometric aspects are formal rather than theoretical in the sense of the de Stijl or the Bauhaus aesthetics, which placed restrictions on using rectangular components. As Smith said, "I have no ideology in this form," and it is clear that he thought of the cubic shapes as having a similar kind of natural, found sculptural identity as the tools used in other series.[8] Smith kept a large stock of these various stainless steel elements, from which he could draw as freely as he could from his junk pile of abandoned metal.

What most sets the Cubis apart from Smith's other works is that their components are all thick, bulky three-dimensional objects, in contrast to the flat sheets and silhouetting tools that form most of the vocabulary of the earlier works. Going hand in hand with this greater plastic presence is the manner in which the Cubis are composed, again far more three-dimensional.

Within the *Cubi* series, there are four different compositional ideas, although no subgrouping can be as clearly defined as in the early Circles or Zigs, for example. Among the Cubis are works that continue Smith's concern with a figural image, although here it is more abstractly rendered. Other Cubis offer a kind of still-life composition, albeit one of geometric units. Certain Cubis are more architectural in their construction, a new direction in Smith's work that culminated in the massive "Gates" made at the end of the series. Finally, the last works, *Cubi XXIV* and *XXVI*, mark a return to the figure, although now a fully metaphorical one.

Origins

The combination of stainless steel surface, crisp geometric elements, and freely organized composition make the Cubis unique in modern sculpture. To be sure, there are some precedents in the works of earlier artists, but they

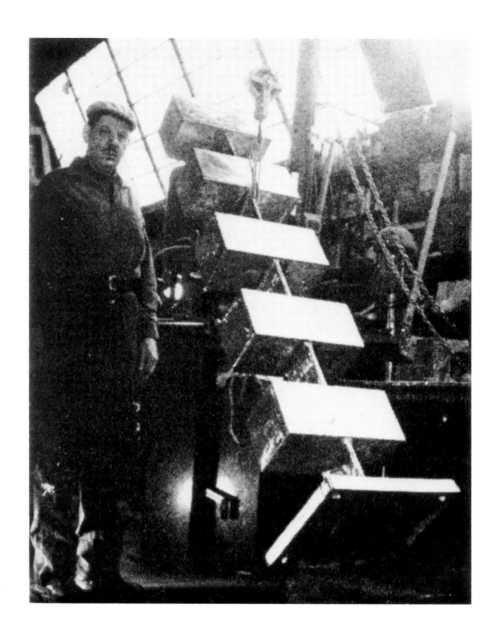

3. Smith with *Five Units Equal* at Bolton Landing, 1956.

seem alien both to Smith's way of working and to how the Cubis emerge within the context of his career. Cubism, despite its similar title, did not produce a body of geometric sculpture, and the Cubis should not be seen as derivative of that movement. A partial exception can be made to the sculpture of Jacques Lipchitz, to which Smith may have paid some attention (see below). Both Dutch de Stijl and Russian constructivism did involve a sculptural style that exclusively used geometric components, but even in a work such as Alexander Rodchenko's *Construction of Distance* of 1920, which superficially resembles a *Cubi*, the conceptual restriction of using forms of equal sizes separates it from Smith's widely varied scaling of components and his more freely composed final work. Furthermore, nothing except Smith's own sculpture predicts the stainless steel surface and the heroic scale of the Cubis.

Smith's use of strictly geometric forms goes back to the 1930s, in works such as *Suspended Cube* of 1938, where a long, solid block is held aloft within a larger geometric structure. His more specific interest in the juxtaposition of several cubic elements dates as an idea at least as early as the 1950s, as seen in Smith's notes on the Italian painter Cambiaso, who developed a drawing style that rendered figures as cubic constructions made out of rectangular blocks.

Smith's first direct essays toward the Cubis came in 1956, with two related works entitled *Four Units Equal* and *Five Units Equal*. These are relatively simple, symmetrical constructions consisting of solid rectangular blocks, four and five respectively, placed one above the other and separated by equally scaled planes of metal set on edge to the front of the piece. In each case the whole is supported by a similar but slightly taller plane that is set into a square base. These closed geometric elements suggest the cubes of the vocabulary of the later Cubis not only in their shaping but in their surface, for although these works were made out of conventional steel rather than the stainless material, Smith painted them with a loosely brushed and interwoven random pattern of colors, creating a surface suprisingly similar to the burnished markings on the *Cubi* surfaces.[9] These two works were followed by a third, related sculpture made in 1960, *Four Units Unequal*, which arranges four differently sized boxes in the same composition; but here Smith shifted to the same stainless steel used in the later series, making these 1960 closed forms his first burnished cubes. As if to emphasize the relationship between the *Units Equal* and *Unequal* works and the Cubis, Smith later wrote, "I had been working on cube unities since 1955."[10]

There were several other forces at work in Smith's sculpture that also influenced the invention of the Cubis. Foremost among them was his increasing usage of stainless steel, which had expanded during the later 1950s in the five concluding works in the *Sentinel* series (see chapters 1 and 2). But although these works developed from the up-in-the-air, flat planes of *Sentinel V* to the dominant sheets of the first two 1961 *Sentinels*, stainless steel itself remained a material used more in a collage technique than in a full fashion, except for the *Four Units Unequal* work of 1960. It took the *Zig* series with its partial cylinders to show how massive sculpture could be achieved within the many formulations of composition that Smith's art had articulated.

Smith was able to expand on the lesson implicit in the Zigs because of the physical factors inherent in his stainless steel cubes and in how he composed them. It is essential to realize that Smith's art represented a different conception of sculpture than had traditionally been conceived. Smith's work is almost entirely presented by its surface, and volume is metaphorically or diagrammatically stated—as in the element that expresses the curvilinear torso of *Sentinel I*, for example—rather than displayed as a necessary spatial zone behind a closed surface.

But the cubes are just such closed, bulky objects. What makes them different is their highly polished surface and Smith's intended placement of these under natural daylight. As Kramer first observed of daylight on these boxes:

Smith designed the "Cubi" sculptures for the sun. Their brilliantly polished surfaces absorb the light with a stunning intensity, lifting their earthbound masses into the air until, at certain moments, it seems as if these sculptures are actually constructions of light itself, not so much occupying as illuminating the space that contains them. Far from conserving the sculptural monolith, Smith's use of it seems to dissolve it, to disarm its materiality, and endow it with an energy that is purely optical.[11]

Whatever remaining identity as bulky objects the cubes retain in the face of their shining surfaces is lessened even further by Smith's usage of the forms within the series. A general principle of Smith's art is that it tends to embrace conflicting compositional tendencies, as in the Voltri-Boltons, where taking elements of eccentric shapes, sizes, and design, Smith constructed the series with a sense of ordered, controlled composition. Indeed this principle of forcing his material into an alternative mode was a constant aspect of the mature work, beginning with the farm parts worked into configurations in the Agricolas. Yet it has not been observed that the Cubis also undertake just such a forcing. Few things could be more boring as art than Smith's basic cubes, even if a number of them are stacked together. But in composing with them, Smith brought these moribund forms into life and made them function as energetic units in an enlivened whole. The Cubis have compositional effects of balance, thrust, turning, even lyricism, all characteristics completely unassociable with the qualities of the basic cube components. It is not only that the whole is greater than the sum of its parts but that the interconnecting, synergetic aspect of the work means that its authority derives from seeing these elements work together compositionally—indeed sometimes almost magically. Despite the volume of the individual elements or of the whole work itself, it is the syntax of their union that we read in the sculpture; when seen apart from that union, the individual cube is forced out of any sculptural identity.

Figuration: Construction, Abstraction

Cubi IX and *III* were the first two works completed in the series, finished in 1961 on 26 October and 10 November respectively and photographed side by side outside the studio with *Cube Totem* and the unfinished *Sentinel*. Of all of the Cubis, *Cubi III* is the closest to the preliminary essay work *Four Units Unequal* in its simple, vertical composition and its straightforward location of the cubes. In this respect, it harks back to Smith's 1959 note, also relevant to the Wagons, in which he suggested to himself, "Why haven't you made a lot of steel boxes all shapes & piled one upon each other—put together on wheels—even a rotisserie."[12] *Cubi III* does that more than the chronologically closer *Four Units Unequal*, for in *Cubi III* Smith eliminated the connecting, sequencing strut planes of the earlier work and joined the cubes directly together. The restriction to only cubes removes any contrast in the work between various kinds of elements—i.e., solid planes versus lines—and instead focuses our reading on the manner in which the boxes are juxtaposed—the syntax discussed above.

In the earlier construction *Four Units Unequal*, the box elements just sit in space, unarticulated by either the planar structure or their relationship to

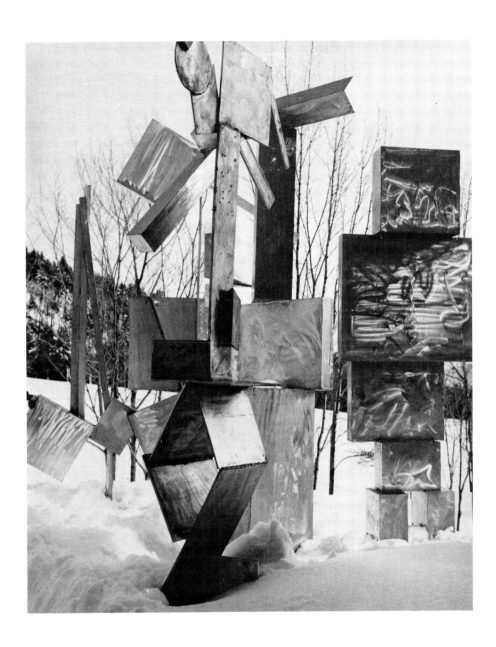

4. Left to right, *Cube Totem, Sentinel* (unfinished), *Cubi IX,* and *Cubi III,* winter 1961/62.

each other, and unmoving in their simple changes in size. By contrast, in *Cubi III* the odd, off-center, direct juxtapositions of the cubes and their in-and-out frontal location spell out a sculptural presence, to which the differing sizes further contribute.

The changes in the sizes of the elements and their vertical orientation in *Cubi III* serve to connect the work to Smith's particular figurations. Here the box at the top projects forward like a head over the more massive cube of the torso, while two smaller boxes lead downward to the cube feet. These smaller elements are slightly offset, the one on the left pulled forward, giving *Cubi III* a sense of slowly stepping forward.[13]

It may seem almost heresy to speak of *Cubi III* as figural, for the literature on the series treats them almost exclusively as Smith's final realization of sculptural abstraction.[14] I am encouraged to do so, however, not only because *Cubi III* follows Smith's basic figural definition so closely but because two

205

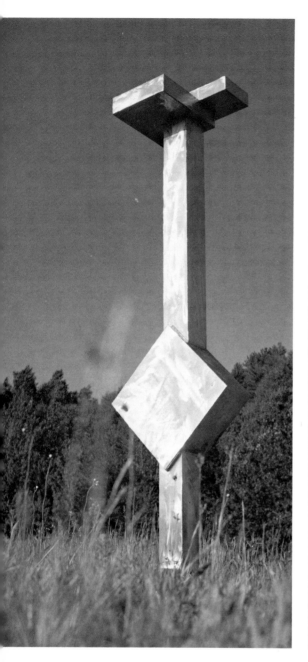

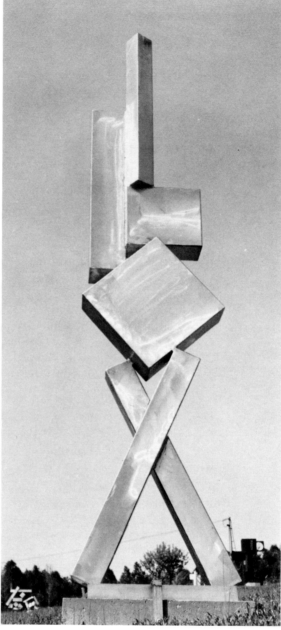

5. David Smith. *Cubi II*, 1963. Stainless steel, 331.5 x 93.7 x 60.6 cm (130½ x 36⅞ x 23⅞ inches). Collection, Candida and Rebecca Smith, Courtesy of M. Knoedler & Co., Inc., New York.

6. Middle. David Smith. *Cubi VI*, 1963. Stainless steel, 285 x 73.5 x 54.5 cm (112¹/₁₆ x 28¹⁵/₁₆ x 21½ inches). Israel Museum, donated by Mr. and Mrs. Meshulam Riklis.

7. Right. Smith with August Rodin's *Walking Man*, date, location, and photographer unknown. Reproduced from *Art in America*, January–February 1966.

other works, *Cubi II* and *VI*, can also be seen as anthropomorphic. *Cubi II* is the most stark work of the series, being simply a very long vertical shaft, intercepted by a diamond-shaped block along its lower passage, with two flat boxes placed on top, one projecting forward and the other, atop, jutting out to the side. But even in this reduced format, these two capping elements recall the planes that crown *Sentinel I* and serve as the observing head (itself drawn from Gonzalez' *Cactus Man Number Two*). Likewise, the vertical stance implies a figural image, especially as it is broken by the diamond in such a way as to suggest a torso.

That reading of the diamond in *Cubi II* is supported by the reappearance

in *Cubi VI* of a similar diamond box that serves the same function of establishing a torso. Here it is crowned with a square box and two longer rectangles, which are harder—if not impossible—to read in any clear figural manner. (Although, as with a few other Smith works, *Cubi VI* does have stylistic affinities with figural works by Lipchitz, such as his 1916 *Man With a Guitar*.) In contrast to this upper area, however, *Cubi VI* has two legs. These are the long rectangular cubes that are placed at an angle, crossing each other under the diamond torso. They give the figure of the *Cubi VI* the clear striding motion that is only implied in *Cubi III*. That kind of figural activity appears in Smith's other work, expecially *Running Daughter*, based on a photograph of Rebecca Smith running, and its more abstract *Circle* variant, *Bec-Dida Day*. *Cubi VI*, with its more massive presences, seems to stride or step rather than run, a characteristic emphasized in the manner in which both legs are placed firmly upon the ground rather than lifting up as they do in the earlier works. Indeed, this activity is so particular that rather than being related to Smith's other works, *Cubi VI* is more favorably compared with Rodin's, where the theme is identical.[15]

Abstraction

The gait of *Cubi VI* is metaphorically stated rather than described. It results from the manner in which the elements are composed to imply the striding figure, but the elements do not fuse together to present a unified object doing such an act. In Smith's earlier sculpture the joined elements had also retained their separate identities, while also fitting into the syntactical imagery or overall composition. But in *Cubi VI* and the others in the series, the geometric characteristics of their forms makes the parts more readily identifiable, even within the context of the sculptural image; this individuality of the cubes shifts our attention to their constructed nature.

The shift in attention emerged along with a new sense of scale and of composition, all deriving from the cubes themselves. Rosalind Krauss notes:

Because their elements were fabricated by Smith and his assistant, the *Cubis* could be much larger than the *Voltri-Bolton Landing* pieces, which were limited by the size of the metal-working tools that were the basic units of their construction. The great scale of the *Cubis* is important to their visual meaning, since it makes even more disconcerting the way perception of the objects equivocates between flatness and bulk, between line and volume[16]

As we have seen, the new scale was largely true of Smith's materials in the *Zig* series, whether they were found or commercially manufactured. But it should also be stressed that the Zigs' forms are open shapes standing in space, and the cubes are solids of some volume. This too changed Smith's conception of the sculpture.

When Smith wanted to make an important change in the depth or location of an element in his more linear or planate sculpture, an additional component was often required to shift from one level to the other. By contrast, the blocks in *Cubi IX* and other works in the series already had sufficient depth—in addition to their height and width—that by their positioning they could both establish a frontal plane and move into or out of depth.

In the magnificent *Cubi IX* we can almost sense Smith's enthusiasm for

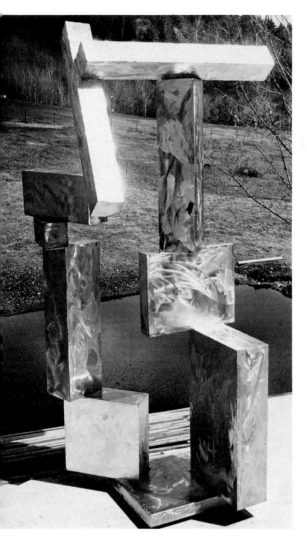

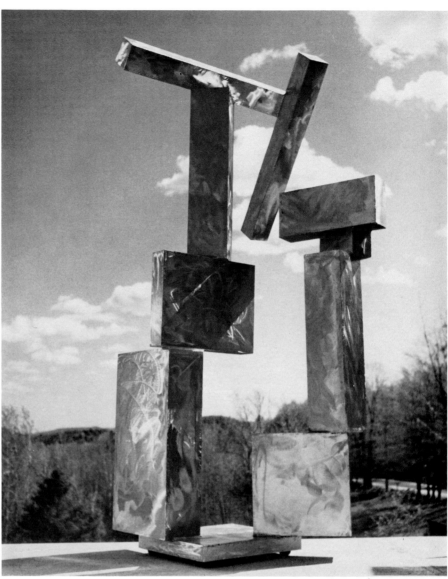

8. David Smith. *Cubi IX*, 1961. Stainless steel, 269.1 x 142.2 x 116.8 cm (106¼ x 56 x 46 inches). Collection, Walker Art Center, Minneapolis, Gift of the T. B. Walker Foundation.

what his material could do. Building from one end of a rectangular base, *Cubi IX* steps upward through a tall box, with a horizontal cube attached to its inner edge. Sitting on this is another vertical, only here turned ninety degrees to the plane of its lower element. This vertical in turn is capped by a long horizontal, also turned on end as a diamond. Off of this hangs a similar long box, simply jutting into space. From certain vantage points this hanging element seems to connect to the second stack of elements, when in fact it merely passes close to them.

The second vertical stack starts with a box placed diagonally to the base, supporting a longer box also set at an angle. This is capped by two smaller cubis, which sit precariously on each other and the taller rectangle below.

Cubi IX can be paired with another double stack work, *Cubi VIII*, which was not completed until over a year later.[17] *Cubi VIII* is less baroque in its

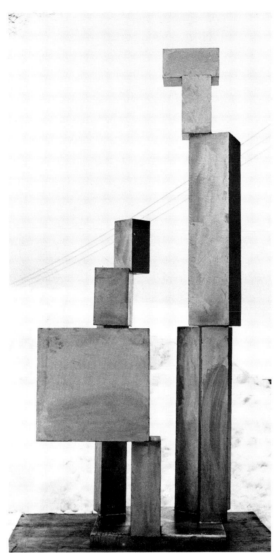

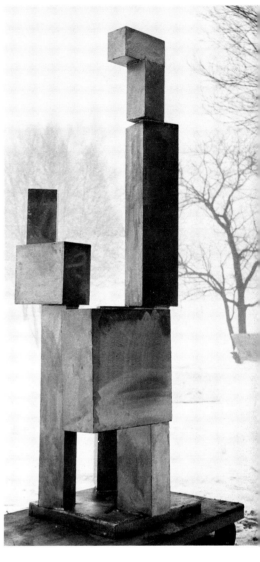

9. David Smith. *Cubi VIII*, 1962. Stainless steel, 233.1 x 96.5 x 86.4 cm (91¾ x 38 x 34 inches). The Meadows Museum, Southern Methodist University, Dallas.

10. Max Ernst. *Capricorn*, 1948–1976. Bronze, 240 x 204.8 x 130.2 cm (94½ x 80⅝ x 51¼ inches). National Gallery of Art, Washington, D.C. Gift of the Collectors Committee, 1979. Not in exhibition.

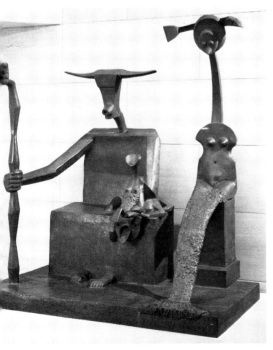

composition; the tower on one end rises up vertically through long boxes and is crowned with two smaller units, a horizontal box capping a vertical one. On the other side, a broader cube is attached to a pair of supporting struts, a taller one passing one face to the larger element, also crowned with two smaller elements.

These slightly anthropomorphic aspects of *Cubi VIII* suggest the theme of two figures, a subject that appears in several major works by important modern artists, including Henry Moore's *King and Queen* (1952–53) and Max Ernst's *Capricorn* (1948). Formally, however, *Cubi VIII* is quite distinct from these earlier works and cannot be said to represent an expansion of their more traditional aesthetic. *Cubi VIII* does find an echo in certain works in the later cubist style of Jacques Lipchitz, especially his *Seated Man* (1922), where a similar stiffness and geometric regularity of shaping is ap-

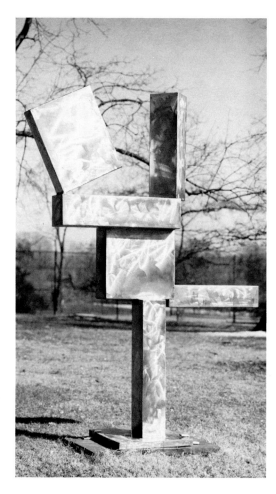

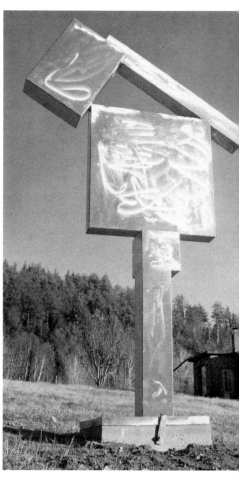

11. David Smith. *Cubi V*, 1963. Stainless steel, 243.8 x 185.4 x 55.9 cm (96 x 73 x 22 inches). Collection, Mrs. H. Gates Lloyd.

12. Right. David Smith. *Cubi XIV*, 1963. Stainless steel, 308.6 x 199.4 x 60.3 cm (121 x 78½ x 23¾ inches). The Saint Louis Art Museum (32:1979).

parent. Lipchitz' works of this same period can also be connected to certain formal ideas in Smith's Zigs (see chapter 3).

What is astounding about both *Cubi VIII* and *IX* is their three-dimensionality as sculpture. As we move around them, they dramatically open and close, and the boxes take on new configurations. *Cubi VIII*, when seen from the side, clearly shows its two figures, with one plane stuck out to the left. But when viewed from the side, this separation is not visible and the jutting block appears contained within the overall composition.

Still Life

As discussed earlier in the essay on the Voltri-Boltons, one of Smith's greatest thematic inventions was that of the still-life composition. In that series and the preceding grouping of the Voltris, Smith worked in two distinct manners: the veristic still life that presents objects straightforwardly, as in the work benches, and the collaged still life, where associative elements are juxtaposed in an abstract composition. It perhaps followed naturally that his latter concept was carried over into the Cubis, especially because some Voltri-Boltons and Cubis were being made at the same time.[18]

Smith had experimented with the stainless steel still life even before the *Voltri* series, in his *XI Books, III Apples* of 1959, which was itself an out-

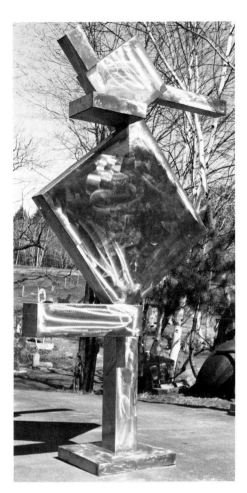

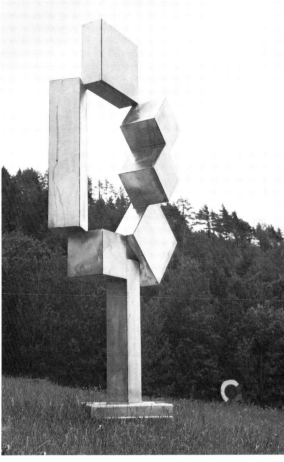

13. David Smith. *Cubi X*, 1963. Stainless steel, 307.3 x 169.9 x 60.3 cm (121 x 78½ x 23¾ inches). The Museum of Modern Art, New York. Robert O. Lord Fund.

14. Right. David Smith. *Cubi XII*, 1963. Stainless steel, 280 cm (110¼ inches). Hirshhorn Museum and Sculpture Garden, Smithsonian Institution, Washington, D.C. Not in exhibition.

growth of a silver sculpture *Books and Apples* of two years earlier. In these two pieces, the elements we associate with the still life derive their identity from the shapes of the assembled flat planes, rectangles as books, disks as apples. But in the Cubis, these associations are not carried forward, because the rectangular boxes retain their abstract, individual identity within the compositional framework. That organization in turn is drawn from the concurrent Voltri-Boltons where the abstract steel elements are placed up into the air on a vertical plinth and/or scattered out along a frontal visual plane. But where in the Voltri-Boltons the tools retain their associations, in the Cubis the cubes continue to be abstract, thus forcing our attention to how they are joined together within the composition. The abstract nature of the Cubis is emphasized by the way in which the elements "float" in the air, unlike the figural or dual-stack works where the cubes play two roles, that of raising the structure physically upward while aesthetically composing.

We have already seen in *Cubi V* how Smith worked out this kind of organization by studying the construction in various phases before arriving at an image that is both contained and vital. Two later Cubis in the same subset *(Cubi XII* and *XI)* are even closer to the Voltri-Boltons, using their elements to build a construction with an empty space in the center. While this opening in the Cubis is very irregular compared with the outlined circle of

Voltri-Bolton IX, for example, it is also more clearly stated because of the simplicity of the stainless steel cubes. In *Cubi XII*, the opening is established conventionally on one side, with a post directly rising upward to meet a long box; on the other side three diagonal cubes zig-zag their way to the top. In *Cubi XI*, an equally striking work, the lower elements are even more restrained, but at the top they leap off in more varied directions, an elaboration of the baroque aspects of *Cubi IX*. This crowning aspect is also found in *Cubi XIV* in the odd juxtaposition of the tilted rectangular box and the long diagonal of the elongated cube. Here this cube is set in contrast to the very strong presence of the massive block that rests on a smaller cube that has been merged into the plinth.

Guéridons

Although the literature on the Cubis makes repeated reference to the fact that Smith wanted them shown out-of-doors or under natural light, these discussions limit their comments to the effects of sunlight on the stainless steel surfaces (see Kramer above).[19] But the Cubis are more than surface; they express volume, and these three-dimensional, solid objects cast shadows under strong light. Thus it is important to realize that the dazzling surfaces of the Cubis are often contrasted with other areas of shadow, giving a natural chiaroscuro to the composition wherever a cube sticks out or sets behind another element. Such detailing is especially important to the still-life Cubis, which, like the Voltri-Boltons, work as a freestanding bas-relief.

Again, one of the lessons of these cubic shapes was that Smith could move them into real compositional depth. He began to do so in another set of still-life works that followed the Cubis just discussed. *Cubi XVII, XVIII,* and *XIX* were made one after the other, and Smith may have even considered them as a trio. The themes and variations operate somewhat like the interplay between the initial three Circles. These three Cubis differ greatly from the early abstract still-life Cubis. It is almost as if Smith turned the massive central box of *Cubi XIV* on its side so as to form a new horizontal plane supported by a central plinth. The new orientation gave Smith a broad surface on which he could position cubic elements in all directions. At the same time, being raised up into the air meant these elements were the crowning feature of the composition and could be arranged without regard for the need to build up from a ground base, as had been the case with earlier complex works.

In a sense, the new raised platform, which is rectangular in two works and round in the other, functions much like a tabletop, with the cubic elements then arranged like pieces in a still life. That formation represents the third variation on the still-life theme in Smith's work, a sculptural subject that was almost entirely his own invention. To be sure, there are partial precedents in paintings, especially the later cubist works by Picasso and Braque that portray a still life on a tabletop raised on a central plinth. This kind of still life is called *guéridon,* after the French name for this kind of table.

In Smith's *guéridons,* the forms retain their abstract character, as they do in the previous still-life Cubis. Indeed, in these later works the composition atop the platform is so eccentric that the shapes could not take on any kind

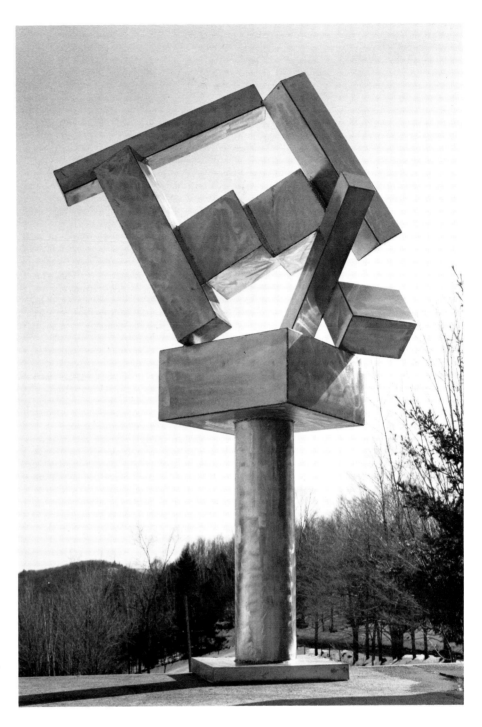

15. David Smith. *Cubi XVII*, 1963. Stainless steel, 273.7 x 164.8 x 96.8 cm (107¾ x 64⅞ x 38⅛ inches). Dallas Museum of Fine Arts, The Eugene and Margaret McDermott Fund.

of associational identity. In *Cubi XVII*, these blocks are all set at angles to the tabletop, pointing off in varying directions. Although their position requires the viewer to walk around the structure to comprehend its compositional richness, Smith's open structure and the clarity of the cubic elements still allows an understanding of the work from only one direction.[20] In this context *Cubi XVIII* is more conventional in its positioning two diamond shapes and a rounded disk along the horizontal plane. At the same time the

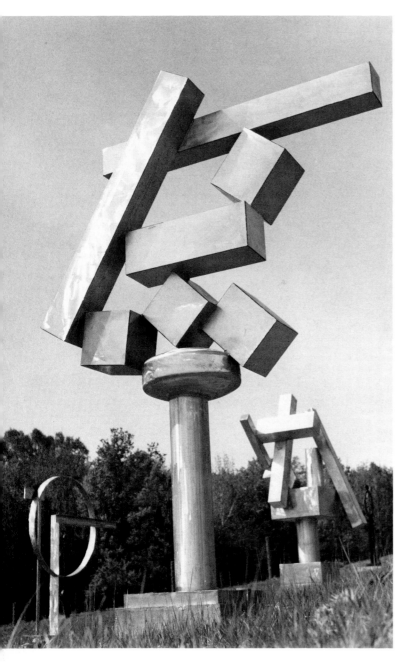

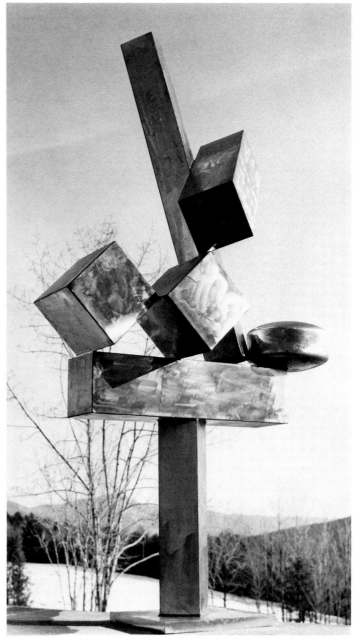

16. David Smith. *Cubi XVIII*, 1964. Stainless steel, 294 x 55.3 x 52.7 cm (115¾ x 21¾ x 20¾ inches). Museum of Fine Arts, Boston, Anonymous Centennial Gift.

17. Right. David Smith. *Cubi XIX*, 1964. Stainless steel, 286.4 x 148 x 101.6 cm (112¾ x 58¼ x 40 inches). The Trustees of the Tate Gallery, London.

work is more radical in the way in which the two massive blocks dramatically stand out into space. *Cubi XIX* combines features of both works, but in a more intricate balancing act. All of the works celebrate the magic of welding, its ability to stand a piece on its tip and hold it in space by means of a very small join, a compositional freedom unknown in previous forms of sculpture.[21]

The *guéridon* still life also marks the introduction of a second kind of element into the previously rectangular *Cubi* series: the rounded element, which appears either as a cylinder or a slightly puffy disk. Although Smith did not use the cylinder extensively in the series, we can surmise from the large

number of them that he had made that he intended to work further with this form. The use of the cylinder indicates further his shifting concept of the Cubis, a change also evident in the diamond-shaped elements he had already created but never got the opportunity to use.

Both the cylinder and the disk appear in *Cubi XXI,* one of the most dynamic works in the series. Here a long cylinder is placed between two very big near-cubic boxes, one twisted on an angle to the other. This tripartite element—a sort of barbell with square weights—rests on top of a puffy disk in a seemingly precarious manner. Furthermore, the entire construction is tilted backwards to lie against a vertical plinth. More than the other Cubis, this work stresses the bulk and weight of its elements and the drama of their being hoisted.

The "Gates"

A pair of these cubic barbells are a prominent feature of one of the later works in the series, *Cubi XXIV,* the first of three abstract "gates" or "arches," to use Smith's terms. Smith's earlier sculpture often used found

18. Georges Braque. *The Guéridon,* 1929. Oil on canvas, 147.3 x 114.3 cm (58 x 45 inches). The Phillips Collection, Washington, D.C. Not in exhibition.

19. David Smith. *Cubi XXI,* 1964. Stainless steel, 303.5 cm (119½ inches). Collection, Howard and Jean Lipman.

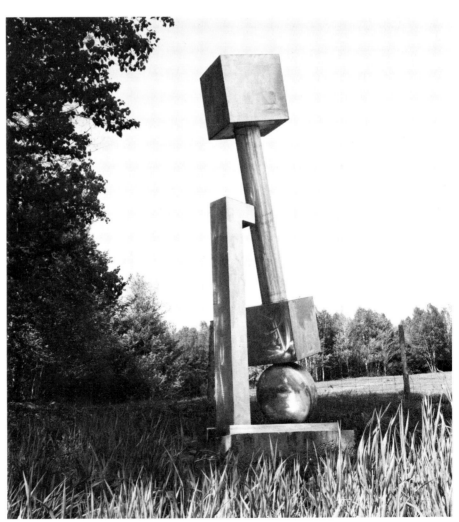

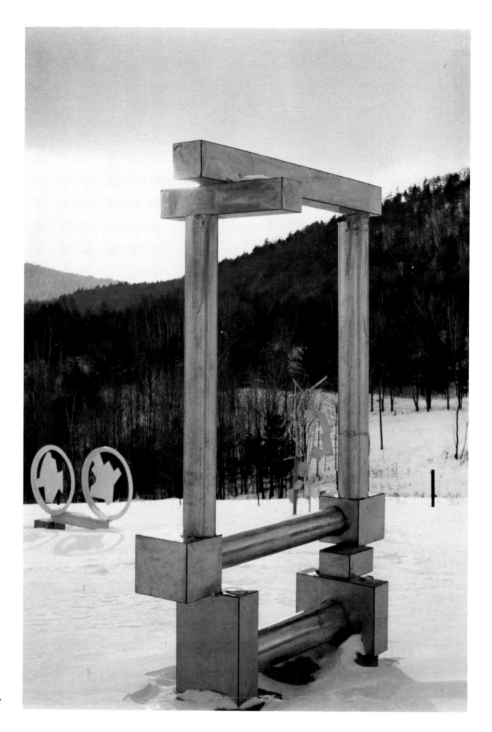

20. David Smith. *Cubi XXIV*, 1964. Stainless steel, 290.8 x 214 x 81.3 cm (114¼ x 84¼ x 32 inches). Museum of Art, Carnegie Institute, Pittsburgh. Howard Heinz Endowment Purchase Fund, 1967.

items, but in the case of the "gates" it was the concept itself that was found. He recounted his discovery:

I had made a long sculpture, and while I was working on it, I had it on a chain hoist and turned it upright, and it sat like an arch. So I put another form underneath it and made an arch out of it, and now I am very convinced of arches. I want to do some more. I made three, and I will make another half dozen before I exhaust the arch point of view.[22]

216

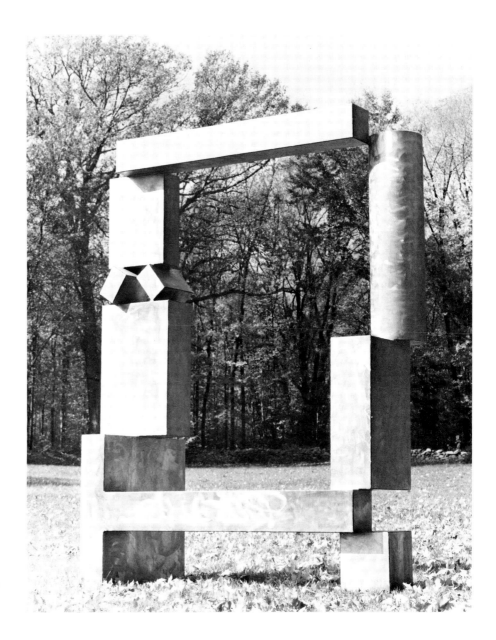

21. David Smith. *Cubi XXVII*, 1965. Stainless steel, 282.9 x 222.9 x 86.4 cm (111⅛ x 87¾ x 34 inches). The Solomon R. Guggenheim Museum, New York.

Presumably, in looking at *Cubi XXIV*, the sections now at the top were the later additions, welded on when the lower section was inserted. Without these we can see Smith was experimenting with another new direction, a sort of double-tiered tower structure, off of which—presumably—two cylinders of differing height were to rise vertically, creating a composition somewhat akin to that of the earlier and more constructivist two-part *Cubi VIII* and *IX*.

The traditional reading of *Cubi XXIV* and its companions *Cubi XXVII* and *XXVIII* is that by capping the top, Smith created a new kind of structure, one where attention is focused on a surrounding frame of sculptural elements, leaving the center of the work as an abstract, empty field of openness.[23] Smith's art had already used such a concept, if less emphatically, in the Cir-

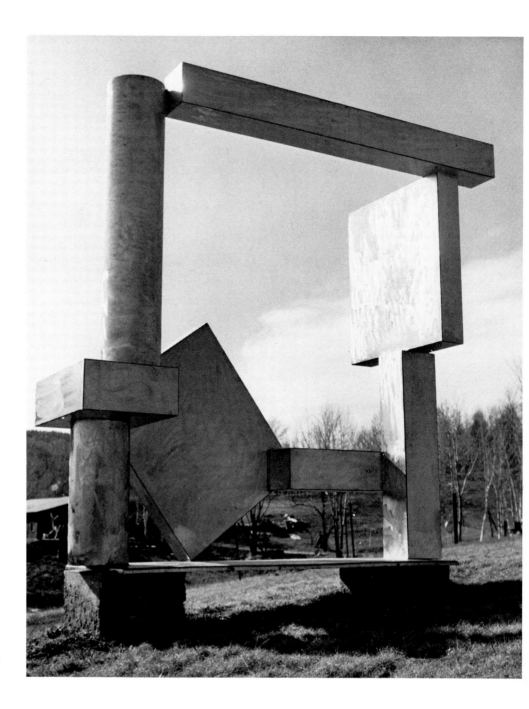

22. David Smith. *Cubi XXVIII*, 1965. Stainless steel, 274.3 x 284.3 cm (108 x 112⅛ inches). Sid Richardson Foundation.

cles, where the center of the ring played a crucial role through its negative presence. That openness was also explored in *Zig III*, the only direct precedent for the "Gates," both in its open center and its post and lintel construction.

But what sets the "Gates" apart from these other open works is the manner in which the center counts thematically as well as formally. As Fry observes of *Cubi XXVII*, it "is monumental, but also anthropomorphic in scale—one can imagine passing through it."[24] This sense, in turn, derives principally from the new scale and bulk of the stainless steel cubic forms.

218

There are numerous precedents for Smith's gates, or arches, but on an even larger scale, beginning with the Mycenaean Lion Gate and the triumphal arches of the Roman period and extending to the Arc de Triomphe in Paris. But these works are all architectural in concept and scale, and their sculptural aspects are limited to the relief work applied to the surface. By contrast, Smith's arches only imply the architectural; they remain sculptural through compositional variations within the mode of the post and lintel construction. In all of the works, the vertical posts are actually part-to-part assemblies made of elements differing in scale and character, such as the two blocks and cylinder to one side in *Cubi XXVII*. In other areas, such as the opposite side of this same sculpture, shapes are introduced that change the pace of the composition, such as the two small blocks set on angles and inserted between two larger cubes. In this work and the other two "Gates," the lintel is even less structured, one end only touching alongside of the vertical rather than resting upon it as it conventionally would. Furthermore, as Fry observes of *Cubi XXVII*, its structure and "the slight elevation of its threshold separates this gate from a pragmatic world."[25] That denial of entrance is even stronger in *Cubi XXVIII*, where a large diamond and a bar block the path, and in *Cubi XXIV*, where a double tier of cylinders crosses the center.

In the end, then, the three "Gates" still belong within the vocabulary of the other Cubis but they are composed in such a way as to feel architectural and thus even more monumental. They are sculpture approaching the condition of architecture rather than architecture with sculpture, as traditionally found. In this regard, one partial precedent does stand out, the four great *torana*, or gates, which were placed at the cardinal points along the perimeter wall of the Great Stupa at Sanchi in India, and which relate to the Cubis in terms of structure, monumentality, and theme. Derived from wooden architecture, these stone gates have a structure very similar to that of the *Cubi* gates, not only in their double vertical and multiple horizontal composition but also in the manner in which they are oriented to a simple frontal plane. Furthermore, on and around these gates there exists an elaborate series of reliefs, which break the surface into a rich texture, while other more elaborate, near-freestanding elements fill the open spaces and crown the upper lintel. Both serve to lessen the architectural feeling of the gate and to move it toward independent sculpture. Smith could have known the gates at Sanchi through his study of Indian architecture, which had earlier influenced the Wagons through his knowledge of the Orissan sun temple (see chapter 6). The possible echo of Sanchi here in these *Cubi* gates indicates further the richness of Smith's sculptural imagination.

Upward

The term *monumental* is often applied to modern works of sculpture but usually to mean "having impressive bulk or size." That usage has been especially true—perhaps ironically—of works made since Smith's death, when private, commercial, and governmental monies were made available for large commissioned pieces and sculptural ateliers were founded to carry them out. But Smith's *Cubi* gates are also monumental in another sense of the term, "of, relating to, or belonging to a monument," although their ab-

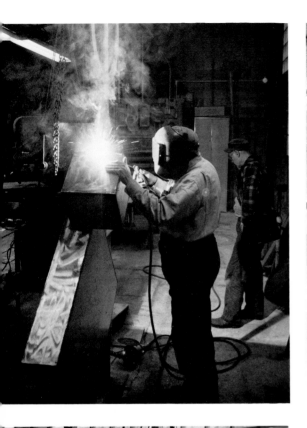

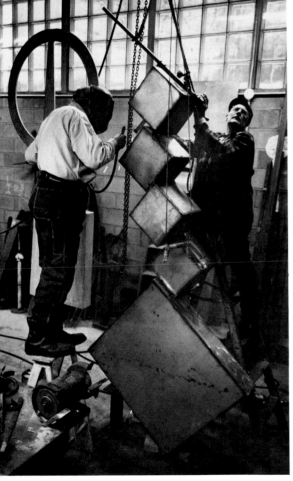

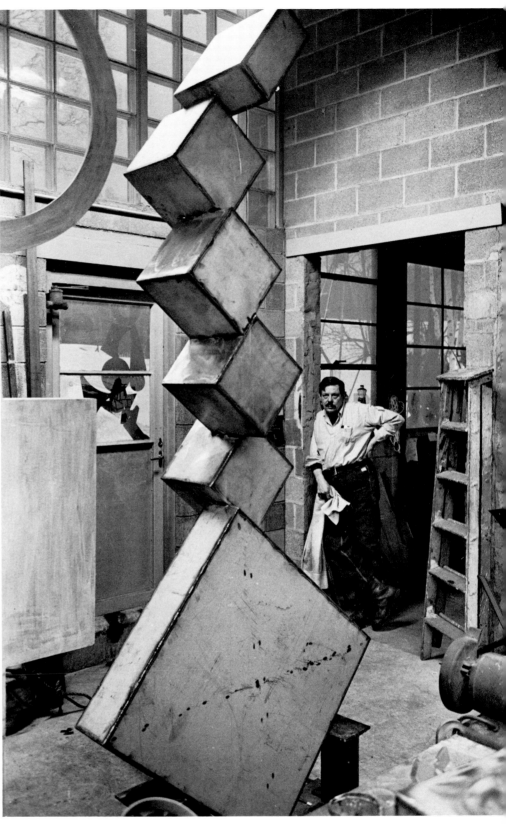

23. Smith making *Cubi I*, with Leon Pratt.

stract character denies any reading of them as memorial. Nevertheless, their gate or arch definition sets them apart from the other Cubis in effecting an architectural presence.

The term *monumental* was also applied to *Cubi I* by Clement Greenberg, writing in 1965, again more in reference to its compositional presence than to its size, the latter being large but not grandly so.[26] Despite its premier enumeration and its chronological completion date in the middle of the series, *Cubi I* belongs more properly with the later, more abstract works.

In the most general sense, *Cubi I* can be connected with the *Units Equal* and *Unequal* grouping, for the work is also a simple composition of cubes stacked one above the other. As with the other Cubis, however, no struts are employed in the stacking of one rectangular box above the other. However, *Cubi I* goes far beyond the simplicity of the *Units*. Building from a large diamond-shaped planate box, five cubes reach upward, all kept on the same diagonal orientation but offset in their surface-to-surface connections, with the second highest projected forward. Photographed from below so as to be seen against the sky and clouds, *Cubi I* becomes the most soaring image in Smith's oeuvre.

Whether this was Smith's initial idea for *Cubi I*—and thus presumably for the start of the series—we do not know. The general idea may go back even further to 1951 and a notebook that contains a clipped magazine reproduction of a microphotograph of diatoms, showing a similar overlapping structure of diamond shapes. There also exists a spray drawing related to the work, but because the sheet is undated, we cannot label it as a study. It differs in having four rectangles instead of five and in arranging them in a more conventional fashion with one above the other.[27]

The major precedent for the composition of *Cubi I* is found in the *Endless Column* works of Constantine Brancusi (made between 1918 and 1937), where a similar stacking of somewhat diamondlike shapes occurs. But in the Brancusi, these forms are cut from one solid piece of material and are kept strictly in vertical alignment. That points to a difference between the works and to a central aspect of Smith's art. Both *Cubi I* and the *Endless Column* are works whose theme is ascension. But Brancusi's series of repeated forms are meant to suggest an idea of a structure that in theory could be extended upward endlessly by the continual addition of more unit pieces. Brancusi's work, in this sense, says *how* a sculpture could rise, by being an endless column. In contrast, Smith's sculpture *does* ascend. By setting the blocks slightly off from each other and by shifting locations—either on plane or on lateral faces—the cubes in *Cubi I* literally step upward. Juxtaposing its stainless steel surface with the bulk of the cubic shapes, *Cubi I* defies gravity, in practical terms in the method of its welded seam construction and visually by reaching upward. It becomes an abstract metaphor for the act of ascension, "a soaring gesture of the human longing for transcendence."[28]

Walking and Soaring

Although Smith's work was influenced directly or indirectly by that of his fellow contemporary painter friends, such as Motherwell, Gottlieb, or Noland, and by works of historic sculpture of all kinds, the work of his con-

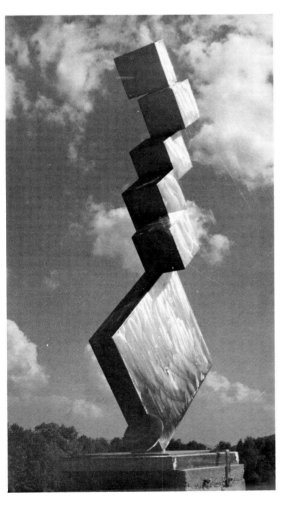

24. David Smith. *Cubi I*, 1963. Stainless steel, 315 x 87.6 x 85.1 cm (124 x 34½ x 33½ inches). The Detroit Institute of Arts, Founders Society Purchase, Special Purchase Fund.

25. David Smith. *Cubi XXIII*, 1964. Stainless steel, 193.7 x 439.1 x 68 cm (76¼ x 172⅞ x 26¾ inches). Los Angeles County Museum of Art, Museum Purchase, Contemporary Art Council Funds.

temporary sculptors seems not to have touched his mature art at all. The one exception to this is the often discussed relationship between *Cubi XXIII* and the sculpture of Anthony Caro.[29] Caro's work had itself developed out of Smith's, around 1960, and even in 1964 still showed clear signs of Smith's influence. However, even at the beginning of his making welded sculpture, Caro was more resolutely abstract in his compositions, especially the manner in which he organized his work across the ground rather than building it upward from a pedestal or base. This aspect of his work and his sense of sculptural economy in using only a few forms (during this period) find a parallel in *Cubi XXIII* in the manner in which *Cubi XXIII* stretches out and rests on five points—the ends of the two inverted V's (one with a block positioned at the end) and the vertical cylinder—and in the geometric regularity and sparsity of these forms.

Because of its orientation, *Cubi XXIII* differs from the vast majority of Smith's works, which use a base integral to the sculpture—in the later works often a flat plane to which a plinth or other elements are attached. He continued this type of base to the last works, including *Cubi XXVI* finished in January of 1965. However, Smith did make sculpture that avoided the supporting base; those temporally closest to *Cubi XXVI* are *Cubi XXIV* and *XXVIII*, which stand upon independent blocks. The Wagons and related

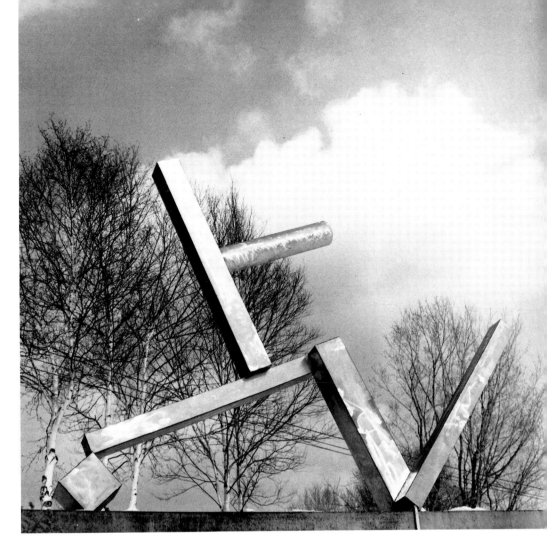

26. David Smith. *Cubi XXVI*, 1965. Stainless steel, 303.5 x 383.4 x 65.6 cm (119½ x 151 x 25⅞ inches). National Gallery of Art, Washington, D.C., Ailsa Mellon Bruce Fund, 1978.

wheeled works are also separate, and other, earlier sculptures stand directly upon the ground, such as *Zig I, II,* and *V.* But these latter works were figural in character, and their supports read as a metaphorical leg.

A figural reading is also possible in *Cubi XXIII,* despite its abstraction, which suggests that its relationship to Caro's work may be overemphasized. With its greater mass and deliberately measured stretch of overlapping V's countered by the vertical post, *Cubi XXIII* is also a metaphor of human motion, a formal structure that in its organization and pace recalls the walk of a human figure.[30] At the same time, *Cubi XXIII* can also be seen as a landscape, its overlapping angles suggestive of the sequential mountains around Terminal Iron Works and the vertical cylinder standing like a sculpture.

The figural content of *Cubi XXIII* is shared with *Cubi XXVI.* That work was probably Smith's last sculpture and was still in place on the platform outside the studio on the day he died. *Cubi XXVI* is also Smith's most radical sculpture. Like *Cubi XXVII,* it is constructed of a few elongated elements: four long rectangular boxes, one cylinder, and a much larger cube. Unlike any other *Cubi,* however, in *Cubi XXVI* these elements are strung out along the frontal plane, the lower four pieces touching only end to end with the upper pair set in straight juxtaposition. Furthermore, the alignment is not regular throughout; the center elements are placed at ninety degree angles to

223

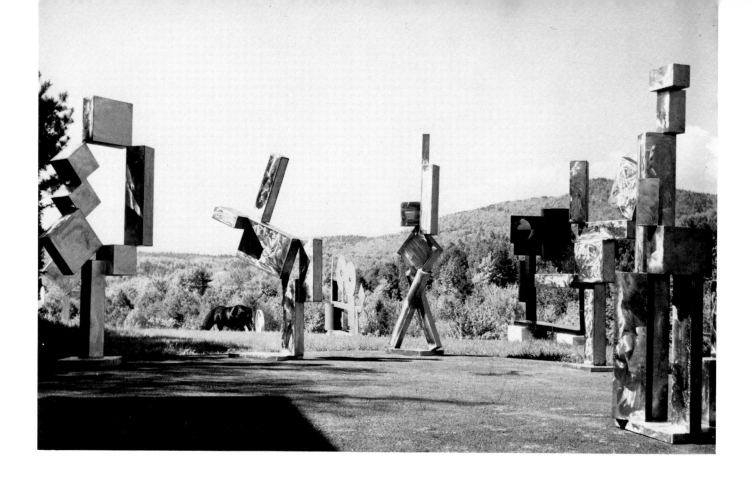

27. North field with *Cubi XII, IV, VI, V,* and *VIII.*

each other, but the end elements veer away in a much more acute fashion. *Cubi XXVI* rests on only two points, with virtually everything dramatically lifted diagonally above, recalling *Cubi I.*

The gesture of *Cubi XXVI* is not only up into the air, however, for it has a lateral movement as well. Thus its metaphor is that of running and jumping, in contrast to the walking, measured stride of *Cubi XXIII.* In this regard it can be linked with *Running Daughter, Agricola I,* and particularly *Bec-Dida Day,* for the legs and back foot of *Cubi XXVI* echo the open gait of the running *Circle* child.

Although other works in the series—such as the still lifes—embraced different concerns, the metaphorical presence of the human beings—by scale, image, or action—remained a central aspect of many of the Cubis, even in the face of how abstract they became in structure. As Greenberg has observed:

No matter what, Smith returned periodically to the scheme—not so much the forms or contours—of the human figure as though to a base of operations. . . . But as he turned increasingly abstract in latter years, in conception and scheme, not to mention execution, the human figure became more and more the one constant attaching him to nature. It was the soar of the human figure that held him, the uncompromising upward thrust it makes, the fight it carries on with the force of gravity.[31]

Such an understanding makes it possible to trace *Cubi XXVI* back not only to *Agricola I,* but even to the source of that work, the Adrian de Vries *Mercury,* whose gesture of leaping into space inspired the works that inaugurated Smith's mature career. Between the image of the *Mercury* and its *Agricola* and the making of *Cubi XXVI,* the final work, lies one of the greatest odysseys of sculpture.

224

Notes

1. David Smith, *David Smith by David Smith*, ed. Cleve Gray (New York, 1972), 151.

2. The exhibition of the Voltri sculpture in the National Gallery of Art's *American Art at Mid-Century: The Subjects of the Artist* served to "acquaint people with this superb series," wrote Karen Wilkin in *David Smith: The Formative Years* [exh. cat., Edmonton Art Gallery] (Edmonton, 1981), 5. The exhibition has lead to a comparison between the Cubis and the Voltris. For example, Richard Dellamore wrote that "Smith's best works are the Cubis, of the mid 60s, an impression generated perhaps because he died tragically while still working on them. . . . The best later works, however, may well be the Voltri series." In "The Sculpture and Drawings of David Smith: 1933–1950," *Artmagazine, 56* (November–December–January, 1981-82), 36. Hilton Kramer earlier observed that "a complete account of Smith's work in the sixties would give a prominent place to the 'Voltri' sculptures . . . and to the 'Voltri-Bolton Landing' series. In "David Smith (1906–1965)" in *David Smith: A Memorial Exhibition* [exh. cat., Los Angeles County Museum of Art] (Los Angeles, 1965), 7.

3. Kramer, *Memorial Exhibition*, 6.

4. Kramer, *Memorial Exhibition*, 6.

5. "Everytime I do four or five [Cubis] I think I've exhausted my thinking in that way; but then I buy more stainless steel and make more sculptures, but I hope it finishes off pretty soon," said Smith in "Some Late Words from David Smith," ed. Gene Baro, *Art International, 9* (20 October 1965), 49. Smith seemed somewhat impatient to begin his larger Tractor series (see chapter 6).

6. Gene Baro, "David Smith (1906–1965)," *Arts Yearbook, 8* (1965), 100.

7. Rosalind E. Krauss, *Terminal Iron Works: The Sculpture of David Smith* (Cambridge, Massachusetts, 1971), 175.

8. Smith in Baro, "Late Words," 49.

9. For a discussion of the surface of these two works, see Rosalind E. Krauss, *The Sculpture of David Smith* (New York, 1977), 70–71.

10. Smith in Krauss, *The Sculpture*, 71.

11. Kramer, *Memorial Exhibition*, 6–7.

12. This drawing is illustrated in Krauss, *The Sculpture*, fig. 838.

13. Smith's striding figures are usually seen from the side, as in *Agricola I, Running Daughter*, or *Bec-Dida Day*, in comparison to *Cubi III*, which is predominantly frontal.

14. The principal exception is Krauss, who argues that "the *Cubis*' drawing continues to allude to the totem figure," in *Terminal Iron Works*, 178.

15. William Tucker compared Smith's work to that of Rodin's in terms of ambition, in "Four Sculptors Part 4: David Smith," *Studio International, 181* (January 1971), 29.

16. Krauss, *Terminal Iron Works*, 187.

17. *Cubi VIII* is dated "Dec. 24, 1962" by inscription; however, it does not appear in Budnik's studio photographs taken around this time.

18. See the chart published in the Introduction.

19. Smith liked the quality of changing light on the Cubis, not just bright light, and this is possible only under natural light. The worst example of misunderstanding Smith's intention occurred recently in a major American museum that installed a large stainless steel Smith in an enclosed, artificially lit gallery and spotlit the work using a revolving color transparency so that alternating light toned red, yellow, blue, and green fell on the sculpture.

20. See Krauss, *Terminal Iron Works*, 175–186.

21. Picasso's welded sculpture steel retains a sense of the cohesive power of the body core, whereas Gonzalez' work remained light because of his emphasis on drawing.

22. Smith in Baro, "Late Words," 50.

23. See Walter Darby Bannard's essay on this point: "Cubism, Abstract Expressionism, David Smith," *Artforum, 6* (April 1968), 22–32.

24. Edward Fry, *David Smith* [exh. cat., The Solomon R. Guggenheim Museum] (New York, 1969), 162.

25. Fry, *David Smith*, 162.

26. Clement Greenberg, "Critical Comment," in Cleve Gray, ed., "David Smith," *Art in America, 54* (January–February 1966), 28.

27. Fry first made these connections, in *David Smith*, 154.

28. Greenberg, "Critical Comment," in Gray, in "David Smith," 28.

29. Greenberg, "Critical Comment," in Gray, in "David Smith," 29, and Fry, *David Smith*, 161.

30. Fry, *David Smith*, 161.

31. Greenberg, "Critical Comment," in Gray, in "David Smith," 32.

Smith at work in the sculpture studio, Bolton
Landing, 1962-63. Detail of Fig. 3, Introduction.

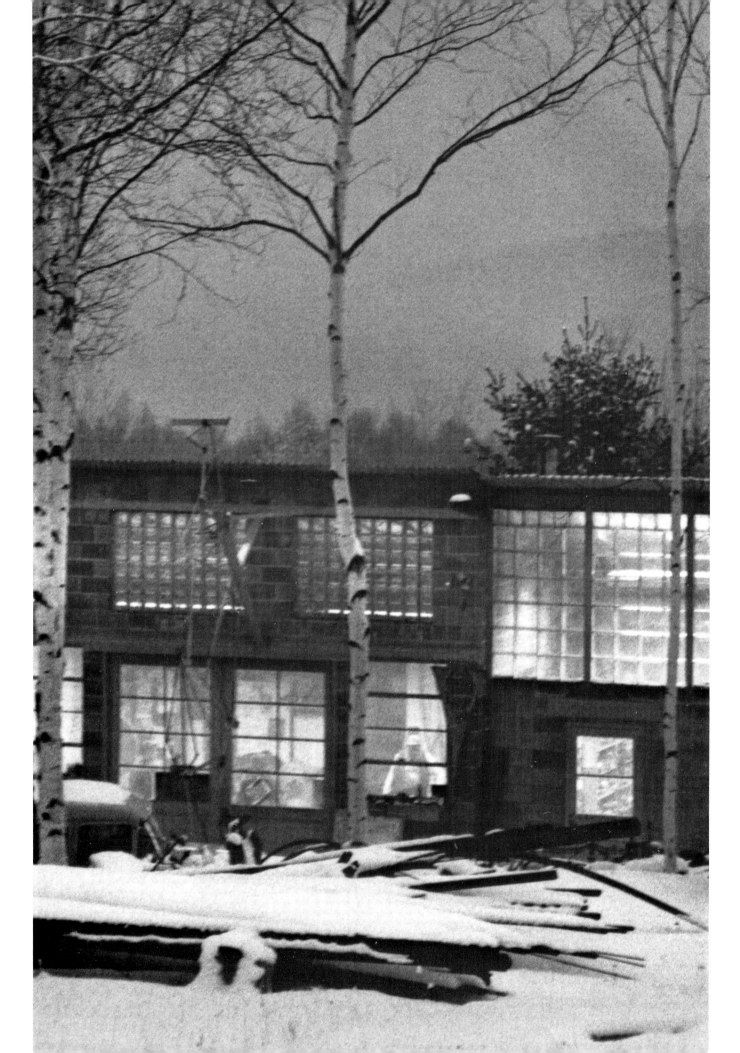

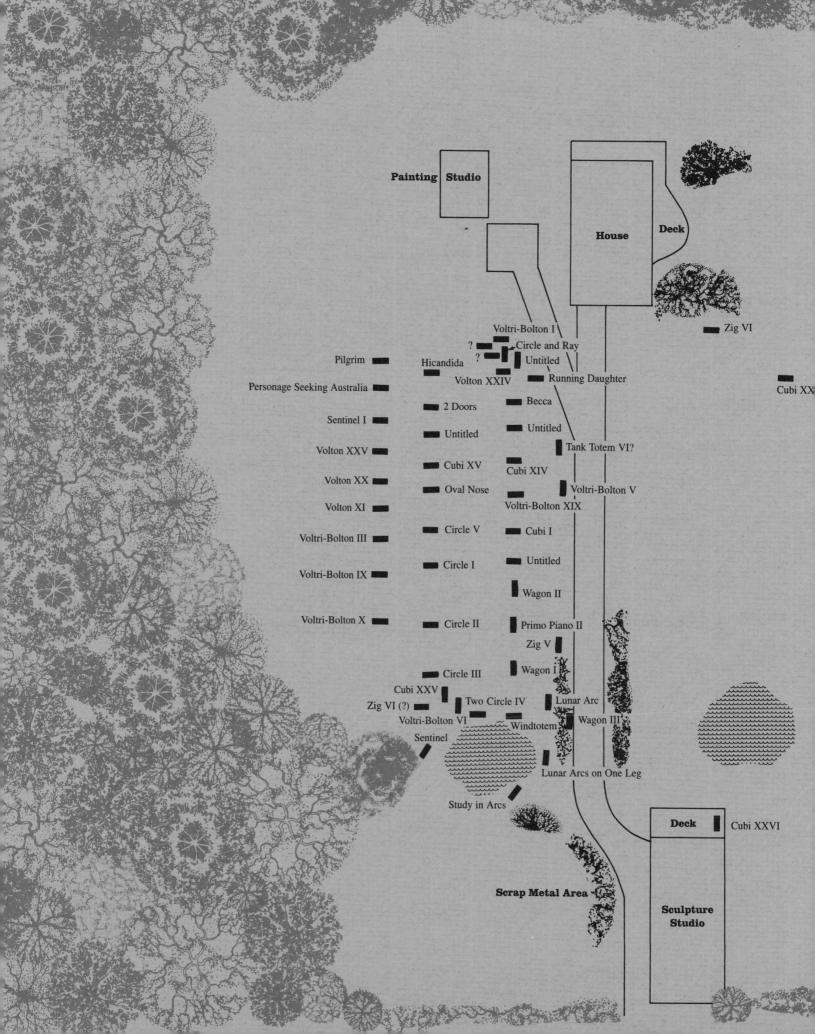

Painting Studio

House

Deck

Voltri-Bolton I

? Circle and Ray

? Untitled

Pilgrim

Hicandida

Running Daughter

Personage Seeking Australia

Volton XXIV

Becca

Zig VI

Cubi XX

2 Doors

Sentinel I

Untitled

Volton XXV

Tank Totem VI?

Cubi XV

Cubi XIV

Volton XX

Oval Nose

Voltri-Bolton V

Volton XI

Voltri-Bolton XIX

Voltri-Bolton III

Circle V

Cubi I

Voltri-Bolton IX

Circle I

Untitled

Wagon II

Voltri-Bolton X

Circle II

Primo Piano II

Zig V

Circle III

Wagon I

Cubi XXV

Zig VI (?)

Two Circle IV

Lunar Arc

Voltri-Bolton VI

Windtotem

Wagon III

Sentinel

Lunar Arcs on One Leg

Study in Arcs

Deck

Cubi XXVI

Scrap Metal Area

Sculpture Studio